Waanders Publishers, Zwolle
Museum Catharijneconvent, Utrecht

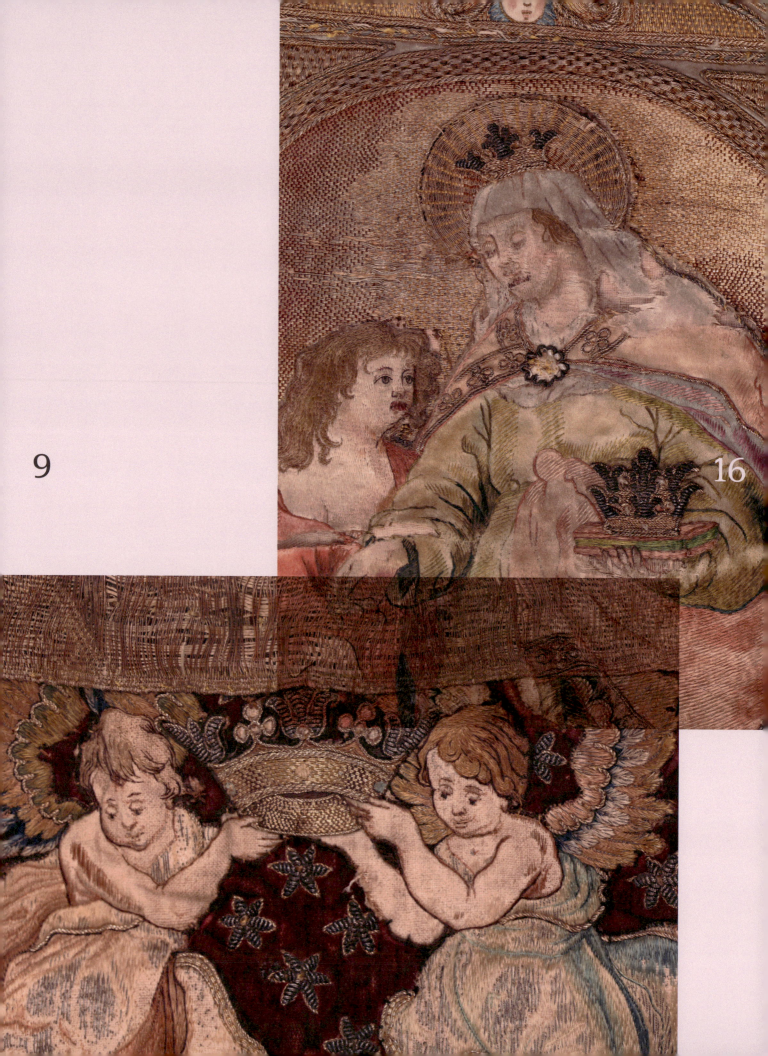

# Fashion

Religious textiles from hidden churches
in the Dutch Republic 1580-1800

for God

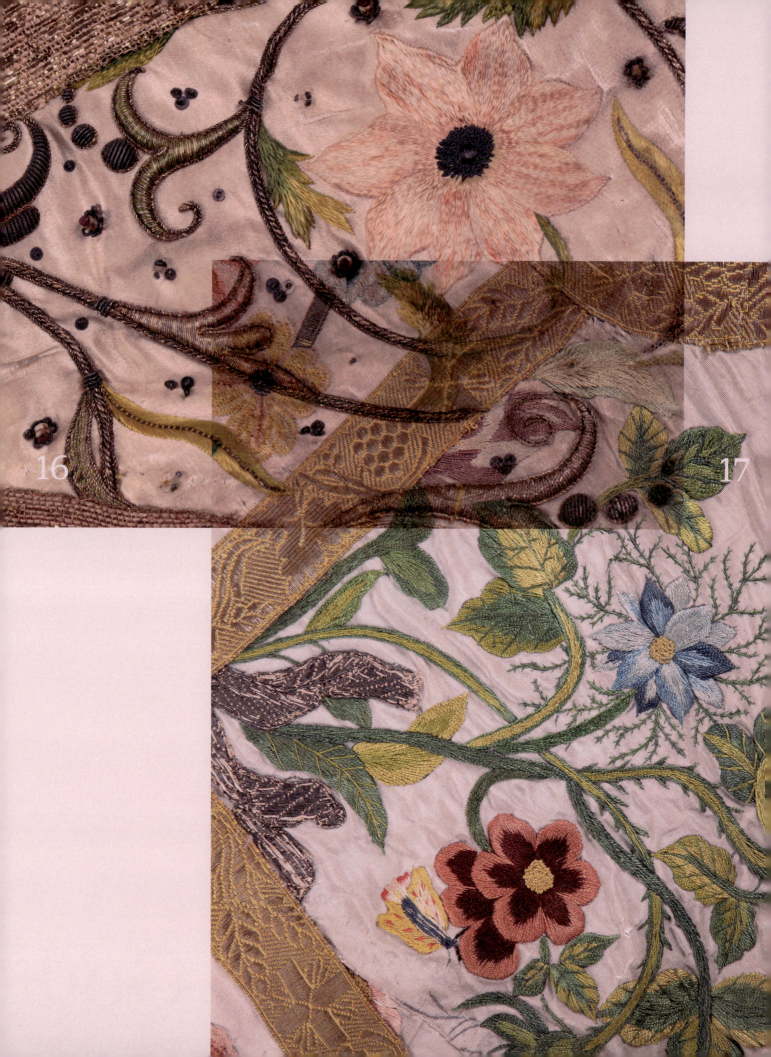

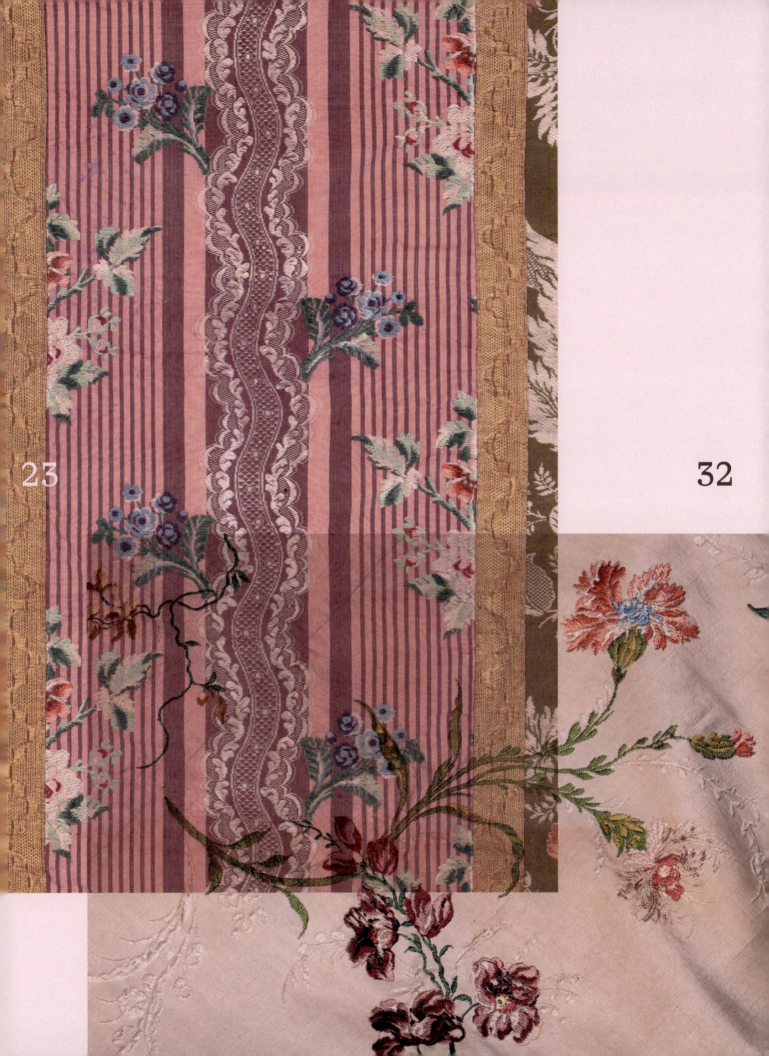

23

32

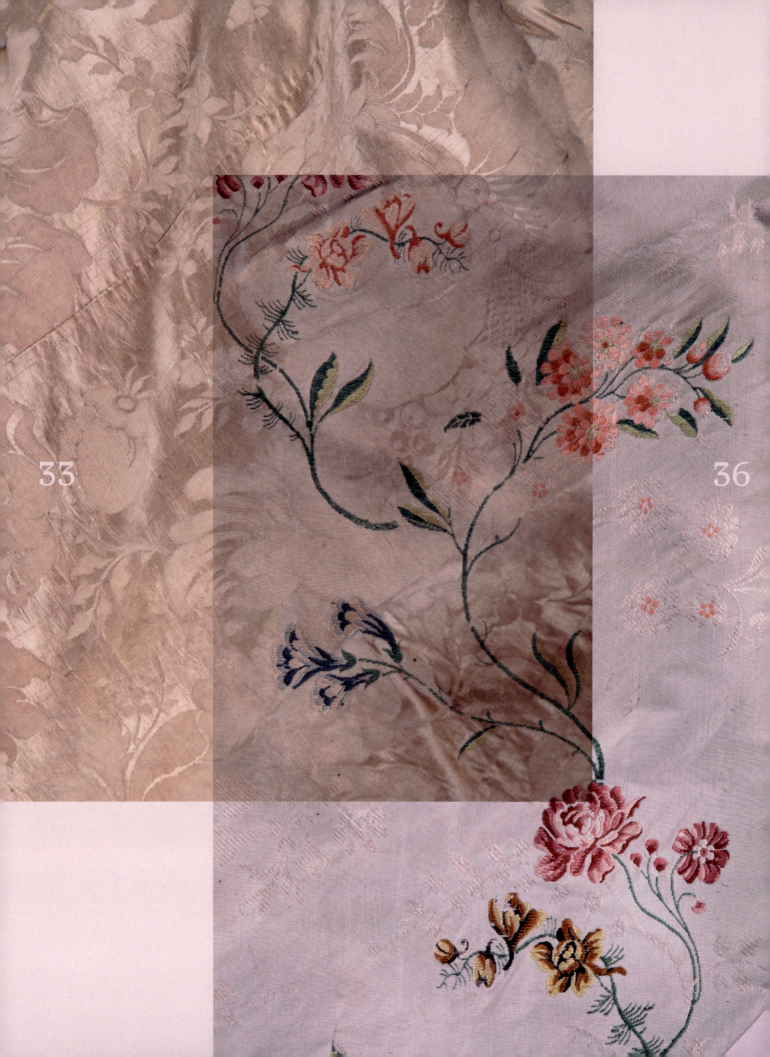

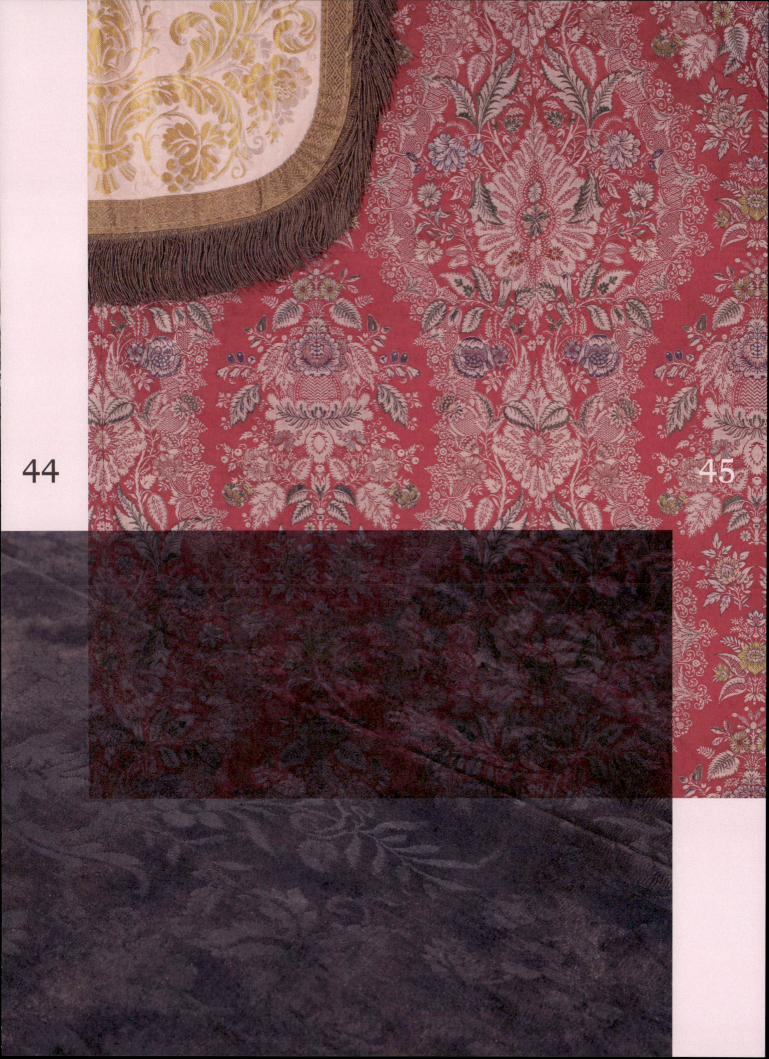

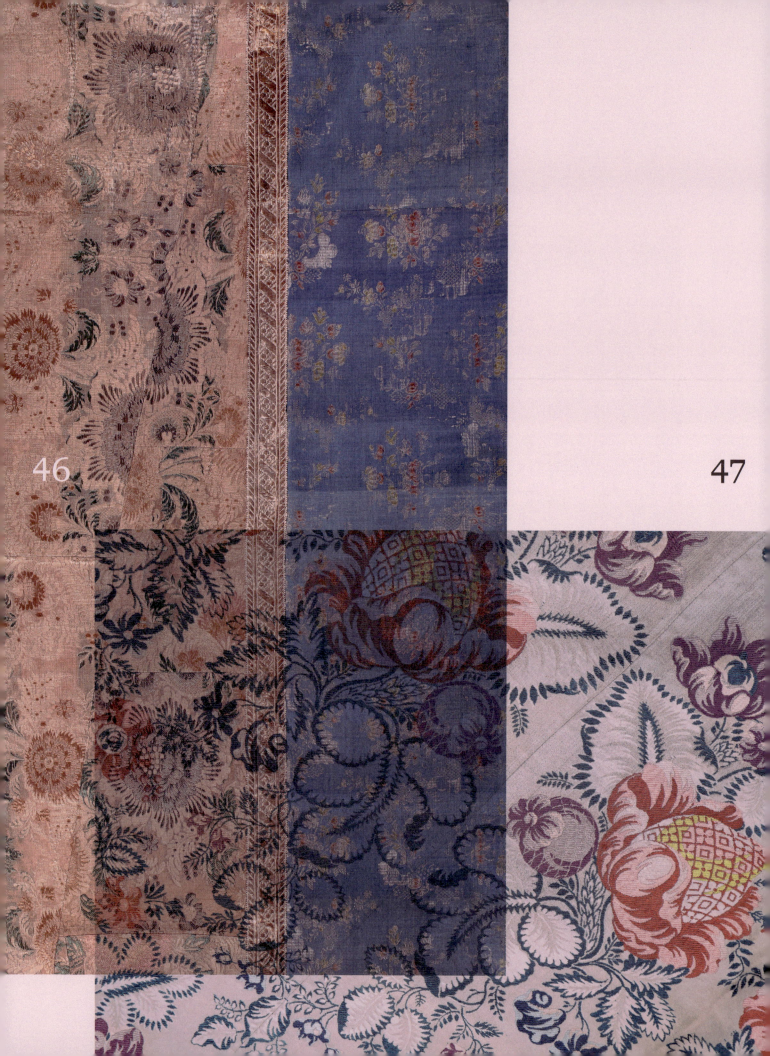

Foreword — 12 — Marieke van Schijndel
Introduction — 13-14 — Richard de Beer en Pim Arts

Essays — 16-24 — Dirk Jan Schoon
## The Church of Utrecht and the Dutch Mission: Synonyms and Schism

25-37 Richard de Beer
## Women at Work
*Catholic Church Vestments in the Northern Netherlands 1580-1700*

38-43 Marike van Roon
## The Opulence of Gold, Silver and Silk
*Embroidery in fashion 1580-1650*

44-53 René Lugtigheid
## Eighteenth-century Vestments with 'Coloured' Flowers

54-63 Pim Arts
## Silk: Trade and Production in the Dutch Republic

| | | |
|---|---|---|
| Visual essay | 64-80 | Religious textiles |
| Catalogue | 82-151 | Seventeenth century |
| | 152-214 | Eighteenth century |

With contributions from:
Pim Arts
Richard de Beer
Ria Cooreman
Madelief Hohé
René Lugtigheid
Susan North
Marike van Roon

| | |
|---|---|
| 216 | Glossary — Paraments |
| 217 | Archives |
| 218 | Bibliography |
| 223 | Photo credits |
| 224 | Credits |

Foreword
Introduction

Foreword
11-14

# Foreword

Marieke van Schijndel, director of Museum Catharijneconvent

*Fashion for God* is the intriguing title of an exhibition about Catholic church vestments in the period of the clandestine churches in the Netherlands, at Museum Catharijneconvent from 13 October 2023 to 21 January 2024. An intriguing title for an extraordinary exhibition. Fashion is often temporary, transient, whereas church vestments seem to represent the importance of the eternal. The title does not refer to merely any old fashion, however, but fashion for God. Fashion made to honour God. *Fashion for God* tells the story of an art form that is the quintessential expression of identity. This publication is about the artistic splendour of precious ecclesiastical textile, about the identity of the Catholic church in times of oppression, and about those who made, wore and donated these garments.

The story behind *Fashion for God* and this publication is a long one. It begins with the previous exhibition on ecclesiastical textiles in 2015. Soon after the success of *The Secret of the Middle Ages in Gold Thread and Silk*, it became clear that a follow-up exhibition would be needed, focusing on post-Reformation ecclesiastical textiles: a part of the richly varied, unparalleled and fragile collection of Museum Catharijneconvent that is well worth exploring and studying in detail.

Various churches in the Netherlands also house a treasure trove of ecclesiastical textiles from the period up to 1800, many of these priceless items still kept in the place for which they were made. Interestingly, they tend to be Old Catholic churches. The Old Catholic Church and the Old Catholic Museum, one of the forerunners of Museum Catharijneconvent, are an invaluable source, for which the curators of this exhibition are very thankful.

2023 and 2024 are memorable years for the Old Catholic Church, as it commemorates the election of Cornelis Steenoven as Bishop of the Netherlands in 1723 and his consecration in 1724. This cemented the schism between the Roman Catholic Church and the Old Catholic Church in the Netherlands. *Fashion for God* shows in unexpected ways how this part of church history can be told through ecclesiastical textiles.

We are grateful to the Old Catholic Church of the Netherlands for its generous loans of its textile heritage. Thanks also to the funds that sponsored the publication, and in particular to Frank Vroom, whose Frank N. Vroom Fund paid for the restoration of some important pieces. The academic research on the ecclesiastical textiles collection was awarded a museum grant by the Dutch Research Council, and was partially funded by Ms De Boeck-Rinkel's bequest for the preservation of Old Catholic heritage. I would particularly like to thank Dr. Richard de Beer and Pim Arts for compiling this catalogue, all the other authors who wrote a contribution, and expert advisors Professor Peter-Ben Smit, Dr. Dick Schoon, Dr. Marike van Roon and Dr. René Lugtigheid for their invaluable advice.

This important publication and the exhibition it accompanies would not have been possible without the vital input and support of many parties.

# Introduction

**Richard de Beer and Pim Arts**

Since time immemorial, textiles have played a prominent role in religious ceremonies in many cultures and religions. Priests have worn special vestments and cloths have been used to conceal certain items and enhance the mystery of the occasion. In some cases, the design and use of religious textiles has remained the same for centuries, but others have changed along with the associated traditions. The purpose of the textiles was generally to underline the exalted nature of the ceremony, the mystique of the ritual or the status of a priest.

Paramentics dictates the use of textiles in the Catholic church. In the broad sense, paraments are all textile items and vestments that a priest wears or uses at or on the altar during mass and other religious services. The paraments are part of a larger whole, known as the liturgy. Along with other prescribed objects, such as the silver on the altar, and objects that are less subject to certain rules, like painted or sculpted altarpieces, they enhance both the lofty character of the ritual and the viewer's experience. But less tangible elements such as light, sound and fragrances also play a role in defining rituals.

## Paraments in the Catholic church

The paraments that priests still wear during mass originated in garments worn in late antiquity: the priest's chasuble, the assistant priests' tunicle and dalmatic, and the cope that a priest would wear during a service without the eucharist. These vestments changed little during the course of the Middle Ages; only the chasuble became slightly narrower. Their shape, colour and decoration were not dictated or regulated at that time, except in the form of centuries of custom and tradition. The more luxurious the material or decoration, the more suitable it was for the special celebrations held during the ecclesiastical year. Many medieval vestments were made of silk and had decorative embroidery in silk, gold and silver thread, often depicting saints or scenes from the Bible. Since the priest stood with his back to the congregation throughout much of the mass, it was on the back of the chasuble that the most decorative elements would be.

It was not until the Council of Trent (1545-1563) and the subsequent Roman Missal of 1570 that centralised orders were issued regarding paraments, under the influence of the Counter-Reformation. The missal, which for many years defined the standard in the Catholic church, introduced various altar paraments — the chalice veil, the burse and pall — and it also defined the liturgical colours in the Catholic church: white, red, green, purple and black. Carolus Borromeus (1538-1584), Archbishop of Milan, who attended the Council of Trent, explained in his 1577 publication Instructiones Fabricae et Supellectilis Ecclesiasticae that every church should ideally have a full set of paraments in each of the five liturgical colours. These new guidelines introduced changes, and more standardisation. Officially, they remained in force until the Second Vatican Council (1962-1965).

## Paraments and identity

As well as honouring God and elevating the ritual, paraments also express identity. During the period of the Dutch Republic (between circa 1588 and 1795), when Catholics were forbidden to openly practise their religion or have church buildings that were visible from the street, their identity came under pressure. The liturgy and the interiors of Catholic churches — of which paraments formed an important part — served to express the church's identity, using design and iconography to trace a direct line from the Catholic beginning of the church in the Netherlands to the oppressed Catholic church in the Protestant Republic.

This continuous line not only enhanced the unity and solidarity of the Catholic community, it also served as a response to the perceived lack of recognition from Rome. Since the Republic was a Protestant nation, Rome regarded the country as a missionary district where no official Catholic church existed. This felt like a denial of the Catholic structures and congregations that still existed, albeit underground. The quest to define the identity of the Dutch Catholic church led to a schism three hundred years ago. Some Dutch Catholics chose to continue without Rome, electing and consecrating their own archbishop, Cornelis Steenoven, in 1723-1724. This event is also highlighted in the exhibition, illustrated with paraments.

*Fashion for God*

## Paraments and women

The act of survival in an atmosphere of oppression led to a reversal of traditional gender roles. Many tasks that had generally been the preserve of men prior to the Reformation were now taken over by women — religious, semi-religious and laywomen. It was easier for them to escape the impact of the circumstances, and this allowed them to take the lead in continuing and promoting Catholicism. Parament production also shifted in the late sixteenth century from the male-dominated public arena to the private arena, where it became almost exclusively a matter for semi-religious women and laywomen. These women largely determined the designs and iconography themselves, favouring female saints and scenes from the life of the Virgin Mary, in order to express their identity as female parament makers. This produced an interesting combination of a formal and exclusively male identity in terms of the wearers of the paraments, and the female identity of both the makers and the paraments themselves.

A similar situation existed in the eighteenth century, albeit differently manifested. Paraments were generally made from gowns donated or bequeathed to the church by wealthy ladies. These often voluminous gowns contained many metres of silk, frequently enough to make a full set of paraments. Like the seventeenth-century vestments produced by women, these garments worn and donated by women brought a strong female presence to Catholic altars.

## Saved and preserved

Paraments have always been distinguished and very costly elements of the Catholic liturgy. Although most vestments were lost during the Reformation and the iconoclasm, years later it turned out that many vestments had been taken to a place of safety in time. Old and new paraments were kept, cherished and repaired if necessary for many generations. Church sacristies generally have a credenza: a low cabinet with wide drawers which can accommodate even large copes without folding. Vestments are still stored in this way, and to this day it is often volunteers who care for this priceless heritage with great love and devotion.

In the Netherlands, it is in the sacristies of the Old Catholic Church that a remarkably large, rich and varied collection of paraments has been preserved. While the innovations of the neo-gothic in the second half of the nineteenth century, and the wholesale clearouts during the second iconoclasm in the 1960s saw many old paraments replaced by new ones in the Roman Catholic Church, the Old Catholic Church was almost entirely unaffected by these developments.

Nevertheless, some important pieces have survived from Roman Catholic churches. In the past, many of them were incorporated into the collections of the Archdiocesan Museum in Utrecht and the Diocesan Museum in Haarlem, for example. When, in 1979, these two museums merged with others, including the Old Catholic Museum, to form what was then known as the Rijksmuseum Catharijneconvent, three of the leading parament collections in the Netherlands were united.

## Textiles at Museum Catharijneconvent

Museum Catharijneconvent has an important collection of paraments and other religious textiles. It is a key reference collection, in both qualitative and quantitative terms, which enjoys growing international recognition and interest. In recent decades it has frequently been the subject of research and exhibitions. In 1987 (*Painting with Gold Thread and Silk*) and 2015 (*The Secret of the Middle Ages in Gold Thread and Silk*) the museum staged survey exhibitions, mainly featuring medieval paraments. Now, in Fashion for God, it is focusing for the first time on seventeenth- and eighteenth-century paraments, showcasing both the museum's own collections as well as items on loan, mainly from Old Catholic churches in the Netherlands.

Until 2004 the museum had a textiles curator — the passionate Tuuk Stam — who performed research on many of the items in the collection. Since 2013, researcher and curator of Old Catholic heritage Richard de Beer has focused on the textile collection. His doctoral research on the paraments from the first period of the clandestine churches, from 1580 to 1650, which among other things describes the vestments produced by the Haarlem Virgins of the Maagden van den Hoeck community, provides the basis for Fashion for God and this catalogue.

## Fashion for God

As well as descriptions of the paraments and other items in the collection in the catalogue section, this book also contains five essays that provide context and identify links between some of the items. In his essay, Dick Schoon summarises relevant developments in the history of the church at the time of the Dutch Republic. Richard de Beer describes the production and design of liturgical textiles in the seventeenth century, while Marike van Roon's essay discusses the subject of gold thread and the secular embroidery of the seventeenth century. René Lugtigheid examines the paraments and secular fashions of the eighteenth century, while Pim Arts discusses the availability of silk — along with gold thread, the main material of the paraments — at the time of the Republic.

Research, exhibitions and publications like these ensure that the important parament collections at Museum Catharijneconvent and the Old Catholic Church of the Netherlands receive the attention they deserve, expanding our knowledge of the items in the collection and enriching their context. They also hopefully inspire museum visitors, researchers and museum professionals to discover more about them.

# Essays

15-63

# The Church of Utrecht and the Dutch Mission: Synonyms and Schism

Dirk Jan Schoon

16-24

The exhibition *Fashion for God* takes place in the year when the Old Catholic Church of the Netherlands celebrates the three-hundredth anniversary of the election of Cornelis Steenoven (1662-1725) as Archbishop of Utrecht. Such an election in the Catholic church would not normally be an extraordinary event, as bishops come and go, and new ones need to be elected or appointed on a regular basis. But this was an extraordinary event in the Church of Utrecht in 1723, as it had not had a bishop for some twenty years, and deep internal divisions had developed.

Petrus Codde (1648-1710), Steenoven's predecessor, had been suspended by Rome in 1702, and was removed from office two years later. At virtually the same time, the powers in Rome had decided that the chapters of Utrecht and Haarlem, the local bodies that usually took over the administration of the church when there was no bishop, and were responsible for ensuring that a new bishop was found, were no longer allowed to exercise their powers. These measures on the part of the authorities in Rome unleashed a storm of protest in the Dutch Republic, resulting in a two-way split among Catholics. The majority followed Rome, submitting to the authority of the papal nuncio in Brussels and the Sacred Congregation de Propaganda Fide in Rome, as the Catholic church of the Dutch Mission. The other group resisted the measures instituted by Rome, supported the administrators and priests appointed by Codde and, later, by the chapters, and called themselves the Catholic Church of the Episcopal Clergy. It was this latter group who elected Steenoven archbishop in 1723, without the approval of Rome, and were excommunicated a short time later. There was now a de facto schism, with one group accusing the other of precipitating the split.

Despite later efforts to resolve the dispute, these two Catholic churches still exist in the Netherlands to this day, enjoying friendly relations as the Roman Catholic Church and the Old Catholic Church. To explain how this came about, we need to look further back in time.

## The reorganisation of 1559

After Protestantism had become the dominant religion in the Dutch Republic, the Catholic church had to reorganise.[1] Although they were not allowed to have an official presence — churches, clergy or an administration — anywhere, Catholics formed a large minority in cities like Haarlem and Amsterdam and in districts like Twente and Salland.

The ecclesiastical reorganisation that the pope announced in 1559, at the instigation of King Philip II, existed largely on paper. Under this scheme, in the district of the Northern Netherlands the old diocese of Utrecht was to be elevated to the status of archdiocese, overseeing the dioceses of Haarlem, Deventer, Leeuwarden, Groningen and Middelburg. In the years that followed bishops were

appointed, but by no means all of them were able to actually take office and, even if they were, they generally had to flee or go into hiding shortly afterwards.

Little had come of the plan to establish chapters to help the bishop with the administration of his diocese and elect a new bishop when the seat became free. This was also true, to an even greater extent, of the seminaries. According to the decrees issued by the Council of Trent, seminaries were to be established for the training of priests in every diocese, but this was impossible in the Protestant Republic. An archbishop had been appointed only in Utrecht, but he was the last for the time being and the posts of canon in the chapters there increasingly came to be occupied by Protestants, who also enjoyed the income that went with the position. Haarlem had managed to set up and retain a diocesan chapter, despite the absence of a bishop, thanks to the tacit support of the city administration.

### Directives from Rome

Amid all this confusion, the old episcopal province of Utrecht was also referred to as the Dutch Mission or Holland Mission, though these terms did not yet have the polemical overtones they would later acquire. The pope and the Roman Curia tried to accommodate the Catholics in the Republic in various ways. In 1560 Philip II had appointed Frederik Schenk van Toutenburg Archbishop of Utrecht; a year later the Utrecht chapters approved the appointment, and the pope confirmed it. After Schenk's death in 1580 it took two years before the pope granted authority for the subdelegation of the church administration in the Northern Netherlands to the nuncio in Cologne. He passed on this authority to Sasbout Vosmeer (1548-1614) in June 1592. Sasbout was officially already vicar general of the dioceses of Utrecht (since 1683) and Middelburg (since 1684) and now became administrator of the entire church in the new Republic on behalf of the Holy See. In 1602 he was consecrated as a bishop in Rome, with the title Archbishop of Philippi.

The combinations of the various roles in the confusing time around the turn of the seventeenth century would lead to a difference of opinion later in the century concerning the precise authority of Sasbout and the vicars apostolic who succeeded him. In such matters, a distinction is drawn in the role of the vicar between *potestas ordinaria*, the ordinary administrative power that every local bishop possesses, and *potestas delegata*, which is authority exercised on the basis of delegated powers. In Sasbout's case, these two types of power coincided: as vicar general of several dioceses he had the authority of the local bishop or archbishop, while as vicar apostolic he also acted on behalf of the Holy See.

Like Sasbout, his successor Philippus Rovenius (1571-1654) travelled to Rome in 1622 to obtain support for his policy. He acquired it first

and foremost thanks to the establishment that year of the Sacred Congregation de Propaganda Fide, 'in order to expand the faith'. Its role was to organise Catholics in 'missionary districts', as they were known, where there was no church structure because it had yet to be formed or, as in Protestant districts like the Dutch Republic, it had been lost. A training institute was then set up for the Sacred Congregation, known as the *Collegio Urbano*, where students from the missionary districts could train as priests. The Congregation also created the role of vicar apostolic, which allowed someone who had been consecrated as a bishop to perform duties in districts where there was no bishop.

Rovenius subsequently introduced an administrative change to the Church of Utrecht. While the Haarlem chapter was able to remain Catholic, positions on the old Utrecht chapters came to be occupied increasingly by Protestants, and Catholics were explicitly excluded from 1622 onwards. To guarantee continuity, Rovenius established the Vicariate alongside the existing chapters, and it gradually took over the duties of the chapters. This mainly involved helping the bishop with the administration of the church and having a say in the appointment of a new vicar apostolic. The fact that Rovenius also appointed the members of the Vicariate canons suggests that he perhaps believed the Spanish would return to power and Catholicism would be restored. This is also reflected in the reference to King Philip in his title, 'Archbishop of Philippi'.

## Growing tensions

Both matters — the authority of the vicar apostolic and the status of the Utrecht Vicariate — would soon become controversial, driven by the friction that existed from the outset between regular clerics — priests who were bound by the rules of a monastic order or congregation — and secular clerics or secular priests who were not bound by such rules, but were associated with a diocese. The latter took their mission from the vicar apostolic, as their local bishop, while the former generally received their mission from the superior of their monastic congregation or order, sometimes with the approval of the papal nuncio in Cologne or Brussels. Given the unclear delineation of powers between the latter and the vicar apostolic, friction regularly led to open rivalry on the ground. The initially synonymous titles 'Church of Utrecht' and 'Dutch Mission' gradually acquired a polemical connotation.

The dispute with the independently operating regular clerics had begun with the first three Jesuits who, starting in 1592, left their home base in Louvain and came to the Republic as missionaries. Sasbout Vosmeer complained to the archdukes and, while the nuncio in Brussels supported the priests, Sasbout received the support of the pope. This led in 1610 to an initial arrangement between the vicar apostolic and the superior of the Jesuits, known as the Articu-

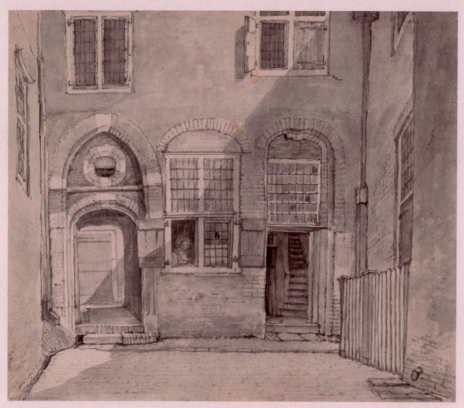

01 The entrance to the Old Catholic church in the former Kraaiengang on Prins Hendrikkade in Amsterdam, Gerrit Lamberts, c. 1825. Chalk and pen and ink drawing on paper. Amsterdam City Archives (Royal Antiquarian Society Collection), KOG-AA-2-02-094.

li, whereby monastic priests would be required to obey the instructions of the vicar apostolic. They may administer sacraments only with the permission of the local priest and were obliged to give him the names of any who did so. Nor were any more than two of them allowed to gather in one place at any one time. The conflict persisted, so a new arrangement was needed, and this came in 1624 in the form of the Concordia. It was reiterated not only that monastic priests may not work without the permission of the vicar apostolic, the new regulations also explicitly stipulated how many clerics regular there could be, in specifically named places: 21 Jesuits, eight Dominicans and seven Franciscans — 36 clerics regular, therefore, most of them with a companion or socius.

Rovenius' view on the matter is apparent from his book on rebuilding the church, the *Tractatus de Missionibus*, published in that same year, 1624.[2] He believed that missionary work was actually the responsibility of the pope, bishops and parish priests. Clerics regular could preach and hear confessions, but only to assist secular clerics, or to spread the faith and convert believers in places where there was no church as yet. Once there was a church, with a bishop and priests, regular clerics should refrain from pastoral care.

Under Rovenius' successors, the number of regular clerics continued to grow, and it became gradually more difficult to keep matters under control. Under Jacobus de La Torre (1608-1661), the *Concessiones Ephesinae* of 1652 expanded their number and stations. Though this expansion was not reversed under Johannes Baptista van Neercassel (1626-1686), Rome did order a return to the arrange-

ments agreed in Rovenius' Concordia.³ How this was to be reconciled, or what practical form it should take, was not made clear.

One factor that interfered with the tensions between the regular and secular clerics in the Dutch Republic was Jansenism.⁴ A 'Jansenist' was the term used in the Southern Netherlands and France in the second half of the seventeenth century to refer to theologians who defended the Augustinian theological tradition at the universities of Louvain and Paris, resisted the Jesuits' growing influence on theology and theological education and, above all, disputed their views on the doctrine of divine grace.

One of those theologians was Cornelius Jansenius (1585-1638), a professor in Louvain who, in his posthumously published magnum opus *Augustinus,* disputed the doctrine of divine grace propounded by the Jesuit Luis de Molina (1536-1600). Fellow members of Molina's order launched a legal challenge against Jansenius' book in Rome. It was first denounced in general terms, later more specifically, and ultimately, in 1665, on the basis of five propositions, in the Formulary of Alexander VII.

Jansenius' sympathisers acknowledged that the propositions could be regarded as heretical, but refused to subscribe to the Formulary for two reasons. The first was that they could not find the propositions in the *Augustinus*. The second was that they could not judge whether Jansenius had intended them heretically.

The signing of the Formulary unleashed fierce conflict in France and the Southern Netherlands, not only between Jesuits and other clerics, but also between the church and secular authorities. What started as a theological dispute about the doctrine of divine grace soon expanded into other, more public areas of church life. The question arose, for example, of whether someone who had refused to subscribe to the Formulary and was therefore deemed a Jansenist could take part in the sacraments, and could be buried with normal church rites after their death.

## Escalation: the Codde affair

Things escalated under Van Neercassel's successor, the Petrus Codde mentioned at the beginning of this essay. Immediately after assuming the role of vicar apostolic Codde had faced accusations of alleged Jansenist misconduct in his views and his policy.⁵ In 1694 those accusations had led to an investigation in Rome, which turned out relatively well for the accused, who was found innocent on four of the five points, while no pronouncement was made on the fifth. Three years later, he found himself in difficulty again, however, and this time it was more serious. In 1697 multiple accusations, some more serious than others, had been summarised in a pamphlet, the *Breve Memoriale*, after which Codde was summoned to Rome to defend himself.

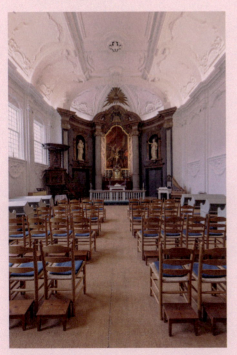

02  Interior of an eighteenth-century clandestine church in The Hague: the Old Catholic Church of St James and St Augustine.

Codde was in the Eternal City from December 1700 to April 1703.[6] He was repeatedly interrogated about a range of incidents in which he is said to have expressed secular clerical Jansenist views, and he published a detailed defence against the accusations. Though the case was still being heard, and no decision had yet been taken, Codde learned from correspondence he received from the Dutch Republic that the pope had suspended him. Furthermore, without consulting the chapters of Utrecht and Haarlem, he had appointed one of Codde's former members of staff, now an opponent, Theodorus de Cock (1650-1720), as Pro-vicar in his stead. This unleashed a storm of protest, with Codde's supporters receiving the backing of the States of Holland. A placard they issued in 1702 banned De Cock from exercising his office and determined that a vicar apostolic would be appointed only in the customary way, that is only if elected with the cooperation of the chapters of Utrecht and Haarlem.[7] Rome hardened its stance and stripped the chapters of their authority. A complete impasse had been reached, for how would a new vicar apostolic now be elected or appointed?

The parties briefly appeared to agree a compromise in the appointment of Gerardus Potcamp, but he unfortunately passed away before he could be consecrated. After that, Rome single-handedly appointed vicars apostolic, who were then endorsed by the States of Holland. In the meantime, the chapters of Utrecht and Haarlem ran their dioceses as well as they could. The Utrecht chapter remained loyal to Codde, while the Haarlem chapter aligned itself with Rome. Codde spent the rest of his life demanding the restoration of his good name and office, and died an embittered man in 1710.

## Out of the impasse

After the dismissal of Codde and the rejection of De Cock the two parties attempted to find a compromise. As noted above, this appeared to succeed in 1705, with the appointment of Gerrit Potcamp (1645-1705), but after his death the conflict became even more acrimonious. The clerics and laity who now presented themselves as the Church of Utrecht and the Episcopal Clergy remained committed to the right of the chapters to elect a new vicar apostolic. They were opposed by the clerics and lay members of the Dutch Mission, who accepted the vicars apostolic appointed by Rome, such as Adam Damen (1649-1717) in 1707, Joannes van Bijlevelt (1671/2-1727) in 1717 and Joannes van den Steen (1674-1748) in 1723, and lobbied the States of Holland to ensure that these individuals were admitted to office. Their attempts failed, however, because the States adhered to the placard of 1702.

Despite this support, the Episcopal Clergy's support shrank, for various reasons. Since Rome had banned the chapters from exercising any administrative authority, doubts arose as to the validity of the parish priests appointed by the Utrecht chapter. To safeguard

their own spiritual welfare, the faithful preferred to turn to the priests of the Dutch Mission, who were recognised by Rome. Since the training of priests increasingly took place in compliance with guidelines issued by Rome, the Episcopal Clergy soon experienced a shortage of candidates for vacant parishes. And even when suitable candidates were available, it was becoming increasingly difficult to find friendly bishops in other countries to ordain them as priests.

To avoid its apparently imminent demise, the Episcopal Clergy came up with the idea of electing and consecrating a new Archbishop of Utrecht, without the approval of Rome if necessary. The first plans were devised around 1720, and involved the establishment of a seminary to train priests in Amersfoort. In the hope of finding friendly bishops who were inclined to ordain priests, the Episcopal Clergy also joined the appeal movement, the large French protest movement against the apostolic constitution Unigenitus.[8] In order to be thoroughly prepared for the election and consecration of a bishop, it sought the advice of renowned theologians and experts in ecclesiastical law in Paris and Louvain.[9] Dominique-Marie Varlet (1678-1742), a friendly bishop who had been suspended because of his association with the appeal movement, and had relocated to Amsterdam for reasons of security, was willing to perform the consecration. On 23 April 1723 the Utrecht chapter elected Cornelis Steenoven archbishop, and he was consecrated on 15 October 1724. The excommunication by Rome of all concerned, and anyone who joined the Episcopal Clergy, announced in early 1725, did not prevent the Church of Utrecht from securing its own continuity. When Steenoven died less than six months after his consecration, it immediately elected a successor, Cornelis Joannes Barchman Wuytiers (1693-1733).

## The Church of Utrecht and the Dutch Mission

The movements within the Catholic church in the Dutch Republic that had manifested themselves since the early eighteenth century as the Dutch Mission and the Church of Utrecht of the Episcopal Clergy veered between continuity and discontinuity. While, in the seventeenth century, the two names had originally been synonymous, used in tandem and interchangeably, later that century — and certainly after the events surrounding Codde and Steenoven — they acquired polemical connotations, as a result of the schism. The two poles — continuity and discontinuity — can be identified in both groups, however.

Though the Catholics of the Dutch Mission regarded themselves as a missionary district, and were administered from abroad, in many places they were nevertheless a continuation of the old ecclesiastical province of Utrecht, with its dioceses — just like the parishes that regarded themselves as part of the Episcopal Clergy. The liturgy was based on the same old model, with vessels and vestments that had survived the Reformation.

One sign of discontinuity was the measures introduced in response to the Council of Trent. This was perhaps more pronounced among the Catholics of the Episcopal Clergy, with their focus on the authority of the bishop as the representative of the local church, on the proper training of clerics and the requirements which the faithful were expected to comply with as regards their handling of the Bible and the sacraments.

The Episcopal Clergy claimed continuity in terms of the status of the administrators of the local church, particularly as regards the authority of the old Utrecht metropolitan chapter, which had transferred to the Vicariate.

Innovation in response to a change in situation also implies a choice to preserve what is essential and valuable. These are two sides of the same coin, and Museum Catharijneconvent is profiling both in all their glory in this exhibition marking the three-hundredth anniversary of the election of Steenoven.

1 Knuttel 1892... and Rogier 1945... remain the classic studies of this period. More recent studies, focused on specific aspects of the development: Spaans 1997; Parker 2008; Pollmann 2011; Yasuhira 2019; Lenarduzzi 2019.
2 Visser 1966, pp. 54-60.
3 Post 1934; Schoon 2018.
4 Lamberigts 2000.
5 Spiertz 1992.
6 Schoon 2019.
7 Polman 1957.
8 Schoon 2014.
9 Hallebeek 2000; Hallebeek 2011, pp. 165-171.

# Women at Work

## *Catholic Church Vestments in the Northern Netherlands 1580-1700*
Richard de Beer

When the Reformation was implemented in the regions of the Northern Netherlands around 1580, many of the existing church structures were lost, and the Catholic church found itself under increasing pressure. Although Catholics did not face any restrictions as regards their beliefs, they were not allowed to practise their religion. They thus fairly abruptly found themselves displaced from large, lavishly decorated public churches into small private domestic churches where they held clandestine religious services. Since the Catholic churches were no longer permitted to own property, they had to make an urgent appeal to the lay members of their congregation. Care and ownership of places of worship, and financial support for priests and the Catholic poor — which had hitherto been matters for the church itself — now rested almost entirely on their shoulders.[1] In towns and cities, for example, wealthy Catholic families, some of them merchants, made spaces in their homes available as clandestine churches.[2] The nobility in the Dutch Republic who had remained Catholic did not simply accept the new ideas of the national authorities either. They donated money for the training, maintenance and protection of priests, and offered their houses in towns and cities and, more especially, in the countryside as venues for Catholic worship.[3] They were therefore a significant factor in the successful preservation and restoration of the Catholic church, or at least formed a serious barrier to the spread of the Reformation in the Republic.

At the same time, it was not unusual for traditional gender roles to change in order to survive in the face of oppression.[4] Many tasks which, before the Reformation, had been the preserve of men were, for example, taken over by women. They were better able than men to evade scrutiny, so could take the lead in the preservation and promotion of Catholicism. As we shall see, the production of paraments largely shifted from the male-dominated public domain to the private domain, where it became almost entirely a matter for religious, semi-religious and lay women.

In the first period of the clandestine churches, from 1580 to 1650, when the situation was still highly uncertain and difficult, the Catholics were very keen, come what may, to stick to their old traditions and objects in order to affirm and manifest their identity. The most effective way of surviving when faced with oppression is to emphasise the collective identity of the group relative to the party in power. In this case, the Catholics stood in opposition to the Reformed Church. They regarded themselves as the first practitioners of the Christian faith in the Netherlands, and believed that they were the only ones who could trace this continuous line to the present day. The best way they knew of distinguishing themselves was through their rich liturgy and church interiors, which contrasted sharply with those of the Reformed Church.[5]

The Catholics consciously used their material heritage as a means of identification. The most defining and characteristic elements of that heritage were the vestments or paraments. Lavish vestments — particularly the embroidered examples from before the Reformation — were regarded as commensurate with the dignity of church worship.

## The preservation of old vestments and the role of the convents

Most paraments were destroyed, dismantled[6] or sold abroad[7] during the iconoclasm of 1566 and the transition to the Reformation around 1580. A small proportion of the old vestments, or what remained of them, mostly dating from the fifteenth and sixteenth centuries, had been rescued, in a somewhat disorderly fashion, by priests, canons and the laity from medieval churches and monasteries. Catholics tried to salvage what they could, enjoying success in some cases. We can conclude that all the medieval paraments from the Northern Netherlands that exist today spent the seventeenth and eighteenth centuries in clandestine churches. The vestments that had survived the upheavals were cherished as relics of better times. The first vicar apostolic of the Dutch Mission, Sasbout Vosmeer (1548-1614), for example, collected many old paraments, restored them as well as he could, embroidered some parts of the vestments himself [cat. 4] and distributed them to clandestine churches which had absolutely nothing. However, given the fact that these churches were initially raided on a regular basis, it was generally deemed more prudent to keep the old embroidered vestments hidden. They did not reappear until the first permanent clandestine churches were set up around 1620. At that point, it was possible to determine what could still be used, and what could not, and intact pre-Reformation vestments were adapted to the new liturgy where necessary.

The declining convents played a special role in all this. While monks who had not opted for the new religion were generally forced to leave their monasteries immediately in the transition to the Reformation, religious women were generally treated with more caution and tolerance. There was a reluctance to turn them out on the street, so they were tolerated and received money to live on out of the income from their convent property, on condition that they did not engage in any religious activities or, more especially, admit any new members. The idea was that they would then die out naturally.

In practice, therefore, many nuns were not required to leave their convent immediately. But since they could not live in a community without a male spiritual leader or rector, they approached the parish priests of the first clandestine churches. Around 1620, one of the last nuns would generally leave the remaining possessions of the convent to the parish priest. This was how fifteenth- and six-

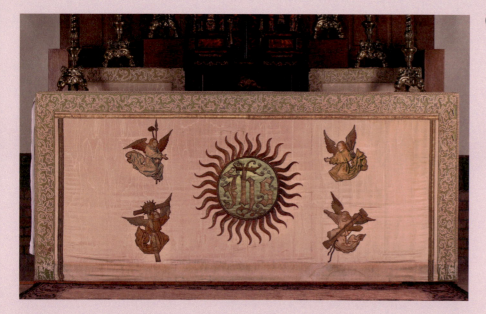

03 White altar frontal from Amersfoort, Northern Netherlands, c. 1475-1525 (embroidery), 1700-1800 (other elements). Silk, gold thread, 105 × 242 cm. Amersfoort, Old Catholic Church of St. George, 461-71.

teenth-century vestments found their way to the early clandestine churches in Gouda (cat. 1), Amersfoort (fig. 03), Delft and possibly also in Kampen, Oudewater (cat. 2) and Dordrecht (fig. 04). The nuns thus formed a bridge, as it were, between the pre-Reformation church and the Catholics of the clandestine churches in the seventeenth century.

## The Trent reforms

At almost the same time as the implementation of the Reformation in the Northern Netherlands, the Roman church introduced a range of reforms in response to the Council of Trent (1545-1563), including reforms pertaining to the church's material culture. This meant the oppressed Catholics faced a dilemma. As believers loyal to Rome, they were obliged to comply with the new instructions. The Trent reforms had been laid down in the new Roman missal of 1570, which every priest was required to have in his possession.[8] Thanks to the printing press, the missal could be quickly disseminated over a wide area, and it was available in the Northern Netherlands soon after it was published.

The missal did not contain many new rules about the paraments, save for new directives on liturgical colours and the number of accessories. These were binding, however. A new canon was adopted on the colours, which in the pre-Reformation church had been subject to local variation. In terms of accessories, the chalice veil was introduced for the first time, while the burse and pall, which were generally autonomous items in a church inventory prior to the Reformation, became part of the chasuble and its accessories.

Carolus Borromeus (1538-1584), Archbishop of Milan, who had attended the Council of Trent, made additional recommendations on the interiors of churches and the paraments, though they were not mandatory.[9] The most radical pertained to the shape of the chasuble, which was made narrower and adapted to the 'Roman

28                    Women at Work

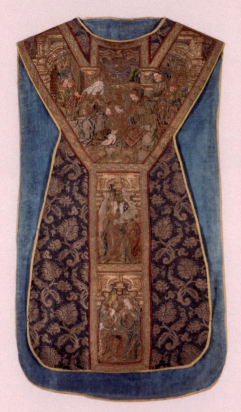

04  Blue chasuble from Dordrecht, Southern Netherlands, c. 1530. Silk, gold thread, 127 × 73 cm. Utrecht, Museum Catharijneconvent, OKM t66.

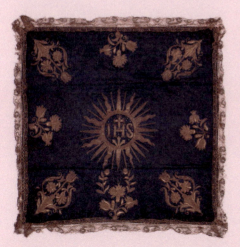

05  Blue chalice veil from Dordrecht, Dordrecht, c. 1600-1625. Silk, gold thread, gold lace, beads, 53.5 × 57 cm. Utrecht, Museum Catharijneconvent, OKM t66c.

model'. This was in fact part of a process that had been happening for centuries, which saw the original poncho-shaped design gradually reduced to a type of scapular.

The Catholics complied with the reforms to the extent that they did not alter the old vestments too radically. Compromises were also found. The surviving material suggests the following. Chasubles that had been saved from the old church were almost all remodelled. There is virtually no surviving pre-Reformation chasuble from the Northern Netherlands that escaped this fate. It appears that people were most keen to preserve the old embroidery, when it came to ensuring that links with the past remained visible, but were quite happy to remodel the basic shape. The base fabric was also changed occasionally in order to bring the liturgical colour of the old paraments into line with the new colour canon. The rigorous changes this sometimes led to can be seen, for example, in a small number of surviving copes at the Old Catholic churches in Gouda [cat. 1] and Delft.

The requirements pertaining to the new sets of chasuble accessories (chalice veil, burse and pall) that were also included in the missal are generally less well known. Analysis of the more or less intact sacristy inventories of the Old Catholic churches of Culemborg, Dordrecht [figs. 04 and 05] and Oudewater [cat. 2] has revealed that new sets of Baroque accessories were added to surviving late-medieval chasubles in the early seventeenth century. In terms of their embroidery, they are by no means the same standard as the old chasubles, in our view. The standard of execution was however generally regarded as adequate at the time, and this explains the many individual Baroque chalice veils, burses and palls from the seventeenth century in the collection of Museum Catharijneconvent. They arrived in the second half of the nineteenth century with the late-medieval gothic chasubles collected at that time, and subsequently became isolated from them, due to the fact that they were of a different style and period.

Carolus Borromeus was also in favour of a radical simplification of the paraments. Figurative embroidery was to be largely removed, for example. This was implemented to only a limited extent in the Northern Netherlands, however, probably because it was not consistent with the idea of a rich liturgy, which the Catholics were keen to present as their distinguishing feature. Simple vestments as recommended by Carolus Borromeus were apparently worn only when strictly necessary in the period of the first, non-permanent, home churches, between 1580 and 1620. They were easier to handle, and probably to fold, if news arrived of an imminent raid. A few examples of such vestments without embroidery have survived in the Northern Netherlands [fig. 06]. Comparisons between late-medieval and Baroque paraments revealed that old leftover materials were sometimes used in new vestments. Since this was

sacred material, reuse in this way would have been regarded as highly appropriate. Examples of these vestments, which can also be seen in contemporaneous engravings and paintings, are found almost exclusively in the well-preserved inventories of Old Catholic churches <sup>(fig. 07)</sup>.

### New production — a job for women

It is not yet clear precisely who was responsible for making these alterations to the old vestments, and for adding new accessories. The changes may have been made both by professional male tailors and by semi-religious women or laywomen in private circles who were responsible for the embroidery, although we cannot rule out some involvement by professional male embroiderers. However, women seem to have produced the lion's share of the new embroidered paraments. Throughout the seventeenth century, the manufacture of lavishly decorated liturgical vestments remained largely a task for spiritual virgins and beguines. They therefore exercised great influence over the spiritual life and identity of the oppressed Catholics.

### *Beguines*

Initially, beguines lived half in a religious community and half 'in the world', as it were. After the implementation of the Reformation in the Northern Netherlands, it was no easy matter to disband the beguine communities, as they were in fact private, living in their own homes from which they could not simply be evicted. Although it did become more difficult to assume the status of beguine, we can say that the beguines were the only religious community that was able to continue to exist, accepted to a greater or lesser extent, after the arrival of the Reformation, and were therefore able to continue their work on church vestments. This was an ancient tradition, and it formed part of their spiritual life.

The inventories of the beguines' church in the Begijnhof in Amsterdam from circa 1650 to 1750 generally refer only to simple textile accessories which the beguines gifted to their own church, which they had possibly made themselves, such as tabernacle curtains and veils for the statue of the Virgin Mary.[10] Occasionally a dress was given, from which a simple parament set would be made. If embroidery was required on paraments, this would be contracted out on an ad hoc basis to a professional embroiderer, such as Dirck Elaerdis, in 1637.[11] This was probably also the case in the beguine communities in Haarlem and Delft.

### *Spiritual virgins*

The largest group of women engaged in the production of paraments in the 17th century were, however, the 'spiritual virgins'. They emerged as a more or less new phenomenon in the Northern Neth-

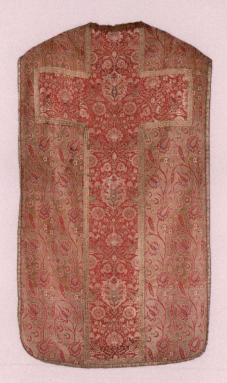

06  Gold chasuble from Enkhuizen, Asia Minor, circa 1600 (base fabric, cross and column). Silk, gold galloon, 123 × 69 cm. Utrecht, Museum Catharijneconvent, OKM t164.

07  Red chasuble from Haarlem, Northern Netherlands, c. 1600-1625 (chasuble); c. 1600 (base fabric); c. 1450-1550 (cross). Silk, gold galloon, incorporating fabric from 1450-1550. Haarlem, Old Catholic Church of St. Anne and St. Mary, 5649-197.

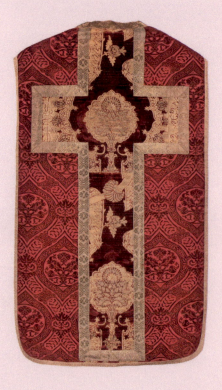

08 Red chasuble from Krommenie, Haarlem, Haarlem Virgins, c. 1600-1625 (cross and vertical column), 1725-1750 (base fabric). Silk, gold thread, gold galloon, 134 × 80 cm. Krommenie, Old Catholic Church of St. Nicholas and St. Mary Magdalene, 5981-53a.

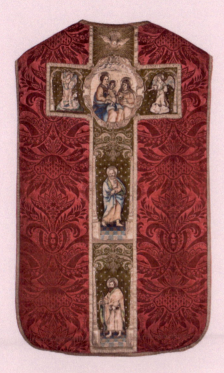

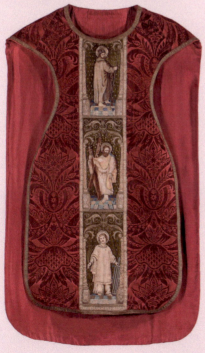

erlands after the arrival of the Reformation around 1580.[12] Young women and older unmarried women were no longer able to enter a convent. Women still felt a need for a spiritual life, however, and an independent existence outside marriage. Many women chose a spiritual life in the normal world as an alternative.

There were therefore great similarities between the spiritual virgins and the beguines, with whom they are sometimes confused.[13] In fact, the ideal of the spiritual virgins was a life as a beguine, and they strove to adopt their way of life and religious practices. These semi-religious women lived in private homes, alone or in groups, had their own possessions and theoretically enjoyed full legal capacity. This way of life offered all kinds of opportunities for apostolic works which would have been impossible in a convent. The spiritual virgins, too, were fairly unassailable as regards the Reformed authorities, given their ambiguous status.

Besides providing a helping hand to parish priests and home churches, they saw the production of liturgical vestments and accessories as a special element of their calling, continuing the traditions of the medieval beguines, and giving them a useful purpose in life. The paraments they made were given free of charge, 'for the glory of God', usually to their own church, so the production of them was no subject to any guild regulations. It appears that the production of paraments in the Northern Netherlands from 1580 to the late 17th century, was largely in the hand of spiritual virgins.

The most important community of spiritual virgins was the *Maagden van den Hoeck* in Haarlem, known more commonly in English as the Haarlem Virgins. They were the only community with influence beyond its local area, and they set an example known throughout the provinces of Holland and Utrecht, at any rate. They must have set up some kind of parament workshop in Haarlem from where vestments were distributed to churches in these regions. This is apparent from accounts of the lives of the virgins (the *Levens der maegden*) written upon their death by Trijn Jans Oly (1585-1651), one of their first mothers general, between 1625 and 1651, which could serve as an example to the new community in Haarlem [cat. 5]. This is the only 17th-century source which gives the names of spiritual virgins who engaged in embroidery, such as Agatha van Veen of Leiden (1569-1623), Brechgen Pietersdocher of Enkhuizen (died 1626), Reinou Gerretsdochter of Grootebroek (who lived around 1600) and Baefgen Gerrets Wy (died in 1622).

Furthermore, the accounts describe their actual contributions to the production of paraments. The spiritual virgins mainly embroidered chasuble crosses with figures of the saints, and Baefgen Wy focused in particular on the production of altar frontals edged with capital letters embroidered in gold thread. These activities can be linked to a group of 16 very closely related chasubles [cat. 9 and figs. 08] and six altar frontals [fig. 09] from the period 1600-1650,

of which surviving fragments are preserved at Museum Catharijneconvent and a few Old Catholic churches in Noord-Holland province.

It seems that the Haarlem Virgins were the only ones still applying figurative embroidery to paraments between 1580 and 1650. They did so in an old style, sticking to pre-Reformation traditions. The images suggest that they took the initiative as both makers and donors, choosing what was depicted.

A description of the Virgins' own church, the clandestine church of St Bernard in den Hoeck, was written in 1671: '[...] and in the sacristy I saw all kinds of altar decorations and the most costly and lavish vestments of high-ranking clerics that one can imagine. Some of these vestments had survived from earlier times, but some were of recent manufacture; and these pious women make them still.'[14] The vestments from earlier times were probably from the period before the Reformation. Some had also survived in Haarlem, including a red cope from the Southern Netherlands[15] (fig. 10), a chasuble with late-medieval embroidering that was probably made for the founder of the community of the Haarlem Virgins, Nicolaas Wiggers Cousebant (1556-1628)[16], a purple cope with medieval orphreys (cat. 3) and possibly a cope with medieval orphreys and shield that is now kept in the treasury of St Bavo's Cathedral in Haarlem[17].

During this first period of the clandestine churches, accessories fully embroidered with small leaves and flowers in symmetrical patterns were added to the chasubles with figurative embroidery by the Haarlem Virgins (fig. 11). They were in the same style as the secular embroidery made in professional workshops. The embroidered ecclesiastical textiles from other towns and villages in the Northern Netherlands that can also be attributed to spiritual virgins — par-

09 Red altar frontal from Akersloot, Haarlem, Haarlem Virgins, c. 1600-1625. Silk, gold thread, spangles, beads, gold galloon, gold fringing, 104 × 224 cm. Utrecht, Museum Catharijneconvent, BMH t516a.

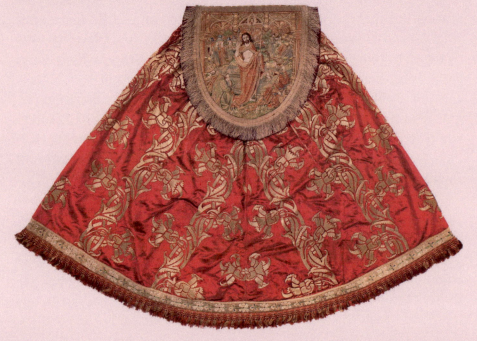

10 Red cope from Haarlem, Southern Netherlands (Antwerp?), circa 1490 (orphreys), circa 1520 (base fabric and cope shield). Silk, gold thread, 148 × 332 cm. Utrecht, Museum Catharijneconvent, BMH t622.

Women at Work

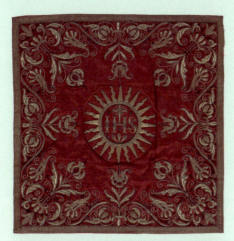

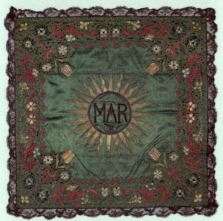

11 Red chalice veil from Wormer, Haarlem, Haarlem Virgins, c. 1600-1625. Silk, gold thread, gold galloon, spangles, 53.5 × 53.5 cm. Utrecht, Museum Catharijneconvent, BMH t9002.

12 Green chalice veil from Utrecht, Utrecht, spiritual virgins, c. 1600-1650. Silk, gold thread, spangles, silver lace, 57 × 58.5 cm. Utrecht, Museum Catharijneconvent, OKM t220c.

ticularly accessories like chalice veils, burses and palls — are decorated exclusively with this type of floral embroidery [fig. 12]. Flowers as symbols of virtues played a major role in the visual culture of the spiritual virgins.[18] Whether they did the embroidery themselves — which is likely — or had it done by professional embroiderers is not entirely certain.

Figurative embroidery was replaced entirely by floral embroidery around 1640-1650. These changes occurred under the influence of the international Baroque, which was introduced to Western Europe under the influence of the Jesuits from 1580, although the spiritual virgins probably had some share in it too. The style of embroidery that had represented a continuation of the old pre-Reformation traditions was slowly but surely abandoned. Only a few religious symbols remained, such as the letters 'IHS' and the pelican feeding her young, for example. The reason for this turning point may have been the Peace of Münster, agreed in 1648. The war with Spain was at an end and the Republic was officially recognised as a state, including by the king of Spain, which meant there could no longer be a return to the pre-1568 situation. The white parament set made for the parish priest Pieter Purmerent of Gouda in 1639-1640 [cat. 21] and the white frontal from Zaandam, made in 1645 [fig. 13], are the first examples of this development from the Northern Netherlands. The white set from Gouda was probably made by the women and girls of the school run by Jesuits on Spieringstraat, and the altar frontal from Zaandam may have been made by local spiritual virgins.[19]

The Haarlem Virgins gradually shifted to designs appropriate to the current age during the second half of the seventeenth century. The chasuble they made for vicar apostolic Boudewijn Catz in 1662-1663 [cat. 16] is a mix of old and new designs. The columns on the chasuble still feature the medieval positioning of saints, one above the other, as a kind of final outburst, while the rest of the surface of the chasuble is decorated in a lavish and colourful floral pattern. A variation on the cross on the back of this chasuble is seen on the chasuble said to have belonged to Stalpaert at the Bagijnhof in Delft [fig. 14] — further evidence of the far-reaching influence of the Haarlem Virgins. A series of similar chasubles with accessories, most of them still kept at Old Catholic churches, resemble the chasuble made for Boudewijn Catz. The crosses and columns on these vestments are decorated with festoons of large coloured flowers [cat. 16]. At the heart of the cross on the back is a pelican and its young.

There is also evidence that spiritual virgins did beadwork. A composite cope from the clandestine church of St. Bernard in den Hoeck in Haarlem, the base fabric of which dates from the mid-eighteenth century, has a shield and orphreys decorated with symmetrical festoons of foliage made of beads and flowers which in stylistic terms belong to the second half of the seventeenth century [cat. 18].

*Catholic Church Vestments in the Northern Netherlands 1580-1700*

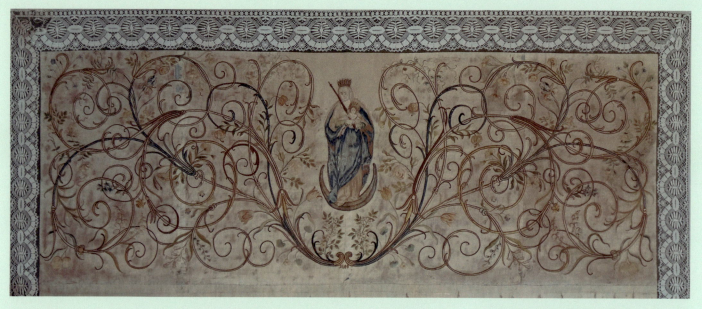

In the centre of the shield is an embroidered image of the Presentation of the Blessed Virgin Mary, taken from an engraving in the front of Heribert Rosweyde's book of spiritual virgins of 1626 (cat. 7). Add to this the iconography and the history of this garment, and we cannot rule out the possibility that the Haarlem Virgins did the decorative beadwork. At the same time, we are reminded of the parament set with beadwork from circa 1650 at the Old Catholic Paradise Church in Rotterdam, which was originally the church Bernardus Hoogewerff's community of spiritual virgins (cat. 18).

## *Laywomen*

Finally, certain aristocratic and wealthy Catholic women without any specific religious status also resolutely continued to support the church. They included Andriese Lucia van Bronkhorst of Hallum in Friesland (circa 1604-1666)[20] and Maria van Nesse (1588-1650) in Alkmaar.[21] These provided for material needs, making a space available for church service, and providing an altar and paraments for their home chapel.[22] An unmarried laywoman like the extremely wealthy Maria van Nesse (1588-1650) also enjoyed full legal capacity, so in theory could make all kinds of legal transactions and gifts without the permission of a man. Maria made a mourning chasuble and frontal with accessories for the local clandestine Dominican church. The description suggests these were simple paraments with little decoration. Such involvement on the part of laywomen was new to only a certain extent, as it had been common in the Middle Ages for women to donate their robes to the church to be made into paraments, a practice that would become much more widespread in the eighteenth century.

## Imports from the Southern Netherlands

Alongside the local embroidery featuring floral motifs which, as we saw, became dominant in the mid-seventeenth century, entire para-

13  White altar frontal from Zaandam, Zaandam, spiritual virgins (?), 1645. Silk, gold thread, pearls, 109,5 × 261 cm. Krommenie, Old Catholic Church of St. Nicholas and St. Mary Magdalene, 6288-44.

14  Chasuble of Stalpaert van der Wiele, Haarlem, Haarlem Virgins, or Delft, spiritual virgins, c. 1625-1650 (cross); c. 1700-1725 (other elements). Delft, Old Catholic Church of St. Mary and St. Ursula, 294-177.

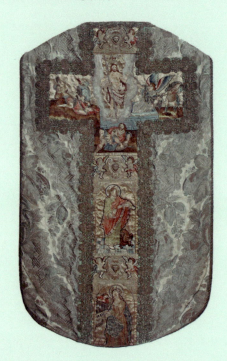

Women at Work

ments began to be imported from the Southern Netherlands. This continued until the early eighteenth century. These paraments are distinctive for their floral festoons in thick relief embroidery done in silk thread and, above all, gold thread, which must have been irresistibly attractive to the Catholics in the Northern Netherlands.[23] These large-scale Baroque designs, combined with the great regularity of execution, suggest they were produced by a professional workshop. The use of gold thread in this way and on this scale would at any rate require skill and training.

Parament workshops had existed in Flanders since the late sixteenth century and they supplied the churches that had been stripped during the Calvinist interlude with Baroque textiles that reflect the grand designs of Rubens and Van Dijck. Antwerp and Lier were the most important centres of embroidery in the seventeenth century. The industry gradually went into decline in the eighteenth century.[24] The churches of today's Flanders still contain significant quantities of Baroque paraments that are of a piece with the items imported into the Northern Netherlands, most of which date to the second half of the seventeenth century. Thus far, however, almost nothing has been found in archives in the Southern and Northern Netherlands concerning the production of these very costly items, let alone exports to the Dutch Republic. Any supporting arguments therefore have to be based on visual comparisons.

The peace between the Dutch Republic and the Spanish lands had probably made it easier to import and export larger valuable items. It is highly significant that the first parament set in the Republic that came from the Southern Netherlands, at the Old Catholic Church of St. John the Baptist, bears the date 1648, the year in which peace was concluded [cat. 20]. The new form language signified a further break in the continuity of the Catholic church in the Northern Netherlands since the late Middle Ages. The only remaining identifying feature was the general opulence that distinguished the Catholic church in the Republic from the other denominations. The new paraments added to this picture perfectly. This can best be illustrated by the inventories of the Old Catholic churches in Gouda and the surrounding area.[25]

The red parament set of 1648 in Gouda is one of the most luxurious Baroque sets in the Northern Netherlands. Closely related altar frontals from the second half of the seventeenth century can be found at the Beguinage church in Antwerp, dedicated to St. Catherine [fig. 15], so we can be fairly certain that Pastor Purmerent imported it from the Southern Netherlands, perhaps using the Jesuits in Gouda as intermediaries, as mentioned above. The new paraments must have immediately made a big impression in Gouda and the surrounding area. The Catholic church in Oudewater purchased a chasuble virtually identical to that in Gouda.[26] And the neighbouring 'De Tol' home church in Gouda, keen not to be out-

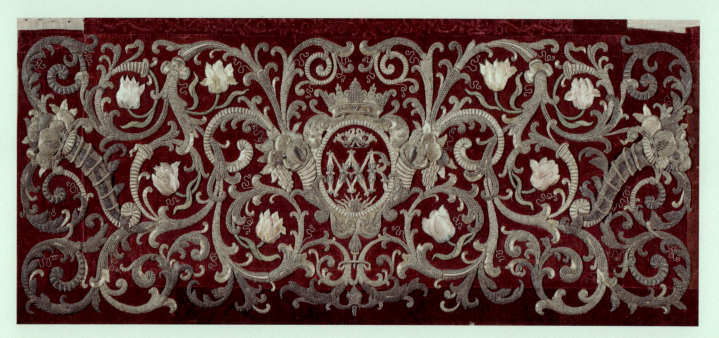

done by the Church of St. John the Baptist, acquired a white and a red set from the Southern Netherlands in the second half of the seventeenth century.[27] These parament sets also bear a strong resemblance to the work done in Flanders, particularly Antwerp, in the same period.

The white chasuble with altar frontal from the Church of St. John the Baptist that was sold to the Old Catholic church in Dordrecht [(fig. 16)] is a fairly unique example. The white set must have been purchased by Pastor Purmerent in 1658, probably in the Southern Netherlands. The very regular, very flat embroidery is executed in a highly professional manner, and it is virtually impossible for this to be the work of a local Gouda workshop, as has been suggested.[28] Another chasuble with similar embroidery comes from the Old Catholic church of Zaandam.[29] It is by no means clear that spiritual virgins were capable of such work. No vestments of this type have yet been found in Belgium.

15  Red altar frontal from Antwerp, Southern Netherlands, c. 1650-1700. Silk, gold thread, 100 × 229 cm. Antwerp, Roman Catholic Church of St. Catherine ('Begijnhofkerk'), 59623.

## A shift in the late seventeenth century

Towards the end of the seventeenth century the activities of spiritual virgins and beguines began to decline. Imports of paraments from the south also came to an end. These developments were associated with radical changes in secular fashion. In the eighteenth century the elegant black dresses that women had worn in the seventeenth century made way, under the influence of French and English fashions, for gowns in a range of colours. The colours made the gowns suitable for reuse as church vestments, no longer just the black of mourning paraments, but also other liturgical colours. Nor was there any objection to floral patterns, as they made the highly labour-intensive embroidery common in the second half of the seventeenth century unnecessary. There was a boom in the donation of women's gowns to churches in the eighteenth century.

16  White altar frontal from Dordrecht (Southern Netherlands, 1658). Silk, silver thread, galloon, lace, 101 × 262 cm. Dordrecht, Old Catholic Church of St. Mary Major, 1881-159.

Women at Work

To summarise, we can conclude that in the seventeenth century it was mainly spiritual virgins and beguines who made church vestments, while wealthy laywomen donated secular garments to churches on a small scale to be made into paraments. In the eighteenth century, the situation was reversed, as donations of secular gowns by laywomen came to dominate, and the production of paraments by spiritual virgins and beguines receded into the background.

---

1. Parker 2008, pp. 149-189.
2. Dudok van Heel 2008, pp. 112-113, pp. 117-121; Yasuhira 2022, pp. 39-86; Lugtigheid 2021, pp. 87-88.
3. Geraerts 2019, pp. 190-220.
4. Seguin 2021, pp. 155-177.
5. Frijhoff 2009, pp. 2, 15-16.
6. Verwer 1572-1581, p. 34 (remodelling of vestments from St Bavo's in Haarlem); Vredenberg 1983, p. 47, Van Bemmel 2005, p. 95 (remodelling of vestments from St Catherine's Hospital in Arnhem).
7. Defoer 2015, pp. 37-38, fig. 3.6 (the chasuble from St Lucy's Convent in Amsterdam).
8. Missale Romanum 1570.
9. Borromeus 1577.
10. SAA 740.29.
11. Voets 1953, p. 300, note 4.
12. Theissing 1935; Monteiro 1996; Verheggen 2006; Spaans 2012.
13. Verheggen 2006, p. 71; Spaans 2012, pp. 8-10, pp. 46-52, pp. 122-123.
14. Account by John Brenan (Bishop of Waterford, Ireland) in 1671. Brom 1890, pp. 179, 270-271; Graaf 1905, p. 321; Stam 2001-II, p. 10.
15. Utrecht, Museum Catharijneconvent, BMH t622. Leeflang / Van Schooten 2015, pp. 248-249, cat. no. 82; De Beer 2023-II, pp. 145, 382-383, figs. 224-225.
16. Weert, Museum Weert. De Beer 2023-II, pp. 144, 437-439, figs. 215 and 216
17. Haarlem, Treasury of St. Bavo's Cathedral, inv. no. 16634-204. De Beer 2023-II, pp. 385-386, figs. 237, 238 and 239.
18. Verheggen 2020, pp. 67-86.
19. Krommenie, Old Catholic Church of St. Nicholas and St. Mary Magdalene, inv. no. 6288-44. De Beer 2023-II, pp. 475-476, figs. 449, 451 and 452.
20. Stoter 2016, pp. 53-82.
21. Noorman / Van der Maal 2022.
22. Lugtigheid 2021, pp. 87-89.
23. Church silver was imported from the Southern Netherlands to the Northern Netherland from at least the beginning of the seventeenth century.
24. Thijs 1987, pp. 140-141; Van Roon 2010, p. 29.
25. Imported paraments from the Southern Netherlands from the second half of the seventeenth century can also be found in other churches in the Northern Netherlands, albeit to a lesser extent than in Gouda. The surviving paraments tend to be red.
26. Oudewater, Old Catholic Church of St. Michael and St. John the Baptist, inv. no. 4192-51. De Beer 2023-II, p. 221, figs. 480 and 481.
27. Now at the Old Catholic Church in Culemborg, inv. nos. 11319-69 and 11319-71. De Beer 2023-II, p. 221, figs. 482-486, 488-491.
28. Dordrecht, Old Catholic Church of St Mary Major, inv. no. 1881-159. Van Eck 1994, pp. 56-57 (reported as missing), p. 196; De Beer 2023-II, pp. 221-222, figs. 495-497.
29. Utrecht, Museum Catharijneconvent, OKM t136. De Beer 2023-II, p. 222, figs. 498-500.

# The Opulence of Gold, Silver and Silk

*Embroidery in fashion 1580-1650*

Marike van Roon

Gold — the most noble, costly and desirable of metals — has been used to decorate clothes for centuries, though it does have its limitations. Solid gold thread is expensive and fragile; if it bends too often, as happens when clothes are worn, it will break. It was for this reason that membrane gold thread was soon developed. It was made by coating a thin sheet of tanned leather or gut with a layer of gold leaf and then cutting it into thin strips. These thin strips were then wound around a spun thread. This composite thread was strong and required little gold in its manufacture. It was fairly supple, and so suitable for weaving strips, or it could be couched on the surface of the fabric and sewn in place using small stitches. The art of embroidery using gold membrane thread flourished in the Northern Low Countries until the mid-sixteenth century.[1]

## Drawn wire

Around that time, there was an innovation that would have a great impact on embroidery and fashion, when drawn gold wire was introduced in the textile industry. The technique of wire drawing had probably already been developed in the fourteenth century, in towns like Augsburg and Nuremberg, where it was used to decorate weaponry. It involved drawing a hammered gold rod through a hole with a slightly smaller diameter, so that it was stretched evenly.[2] This step could be repeated until a wafer-thin drawn wire several metres long was obtained. The use of a rod of silver gilt or even cheaper gilded metal made the wire more affordable.

By the mid-sixteenth century the technique was refined enough for the resulting wire to be used in textiles. The round metal wire was first flattened to form a thin strip which was then wound round a woven core, as with gold membrane thread [fig. 17]. The technique of drawing, flattening and spinning wire soon allowed large amounts of supple gold thread to be produced.

Drawn metal thread was also used in other applications. The flattened wire could for example be used to make bullion or purl — spirally twisted threads. It was possible to affix embroidery thread to the fabric by threading it through the centre of a small section of purl. These were often positioned adjacent to one another in a ribbed pattern, sometimes on a raised surface, to form small ridges. The curvature produced a pronounced shine. A piece of wire could also be shaped into a ring and flattened to make a spangle, which further enhanced the sheen of the embroidery. From the late sixteenth century onwards more and more clothing and accessories used by the elite were covered with embroidery in drawn gold wire, purl and spangles.

## Immigrants

Drawn wire was initially imported to the Northern Low Countries, but after 1600 wire drawers settled in all major towns and cities.

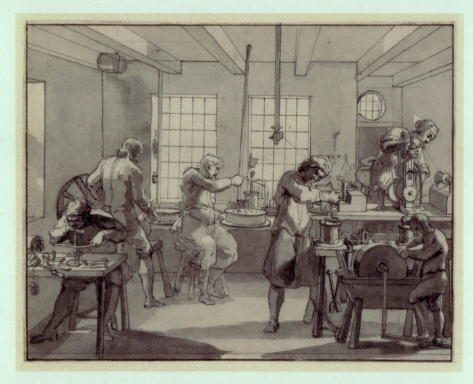

17 Izaak Swigters' wire drawing and flattening workshop on Leliestraat in Amsterdam, Jan Wandelaar, c. 1719. Drawing on paper, 133 × 180 mm. Amsterdam, Amsterdam Museum, TA 14254.

This drawing shows all phases of the process: drawing, flattening and spinning. The work was done by men, except for the spinning, which is being done here by Izaak Swigters's young daughter.

The arrival of wire drawers and embroiderers in the Republic resulted from political and social unrest in the second half of the sixteenth century. After the fall of Antwerp in 1585, for example, this city which had long been a safe haven for Reformed refugees was no longer safe for those who supported the reforms. This resulted in a large flow of refugees, including craftspeople working in the textile industry. Gold wire drawers and embroiderers from Antwerp and other places where the Reformed were no longer able to practise their religion moved to the Northern Low Countries, either directly or indirectly, via other countries like England, or Reformed enclaves in France and Germany.

These skilled workers found themselves in a favourable environment. Wealth was increasing rapidly, along with imports of raw materials, and now it was not only the old elite who dressed in lavish modern fashions, but also a new group of wealthy merchants and manufacturers. Every self-respecting wealthy citizen owned embroidered garments or accessories in the early seventeenth century. The industry experienced explosive growth.

Opulent embroidery remained popular until around 1650, and was at the height of its popularity in 1610-1640. The names of some 150 embroiderers are known from this thirty-year period, though there must have been many more. They lived mainly in towns and cities like The Hague, Middelburg, Rotterdam, Delft, Leiden, Haarlem[3], Amsterdam[4] and Leeuwarden.

18 The embroiderer and his apprentice, Jan Luyken, c. 1694. Drawing on paper, 9 × 7.3 cm. Amsterdam, Amsterdam Museum, TA 13448.

The fabric to be embroidered was first stretched across an embroidery frame. The drawing clearly shows that the embroiderer used one hand to push the needle up, and the other to push it back down through the fabric.

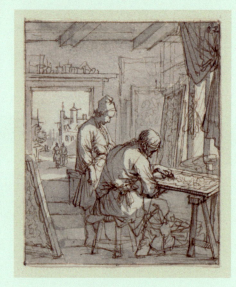

### Men and women

Embroidery was a job done by men (fig. 18). The profession of embroiderer was passed on from master to apprentice, and embroiderers

40    The Opulence of Gold, Silver and Silk

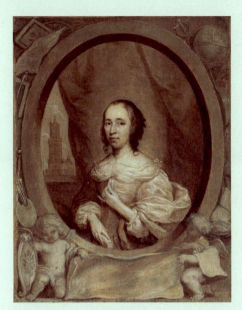

19 Portrait of Anna Maria van Schurman, Cornelis Jonson van Ceulen, 1657. Oil on panel, 31 × 24.4 cm. Washington DC, National Gallery of Art, 2002.35.1.

In the background of this portrait of Anna Maria van Schurman we see the cathedral tower (Domtoren) in her home town of Utrecht. Around the oval frame are attributes that represent her talents, including an embroidery of a tulip on an embroidery frame in the top left.

had to be members of a guild in order to practice. An apprenticeship took three to eight years, which indicates how difficult gold embroidery is. We know virtually nothing of these embroiderers, and no individual piece can be attributed to a specific practitioner. The only thing we know is that there were many foreigners among them. The first embroiderers in Leiden, for example, who settled in the town between 1590 and 1610, were from Jever and Wesel in Germany and Antwerp, Ghent and Lier in the Southern Low Countries. One of the first embroiderers in Leiden was Ghent-born Lieven Henricxz, father of the well-known painter Jan Lievens. They were followed after 1615 by embroiderers from British towns and cities like Norwich, Denbigh, Colchester and London.

This is not to say that women did not embroider. On the contrary, embroidery was regarded as a real feminine virtue, and every girl learned it, though only as a domestic skill, and not practised for profit. Costly raw materials like gold and silver thread and silk were available only to the upper classes. We know, for example, that the scholar Anna Maria van Schurman, daughter of a wealthy family from Antwerp, had excellent embroidery skills. Her work was however somewhat freer than the professional work; in his *Trou-ringh* of 1637 Jacob Cats praised her as someone 'Who could embroider silk flowers and such from life'.[5] The portrait of Anna Maria by Cornelis Jonson van Ceulen painted in 1657 includes an embroidery frame in the top left corner with a piece of embroidery of this type, depicting a large tulip (fig. 19).

Both men and women wore embroidered clothing (figs. 20). Men often had a narrow embroidered belt, and their sleeves were sometimes also richly decorated. The heaviest gold embroidery was found on the broad bandoliers worn by soldiers. Women wore embroidered gloves, and their sleeves were sometimes also embroidered. The accessories they wore on their belts, such as a purse, a knife with a sheath, and pin cushion or a small prayer book might also include some embroidery. But it was above all the so-called 'borst, a type of bodice where only the visible front was decorated, that was most suitable for the heavier gold embroidery.

## Workshops

The gold embroidery produced in workshops between 1580 and 1670 is instantly recognisable (fig. 21).[6] It always has outlines of couched gold or silver thread attached with invisible stitching. Only the ends of the thread are pulled through the fabric. These are sometimes single threads, but more often they were twisted threads, or even cords made of several twisted metal threads.

The composition would almost always consist of festoons of leaves and flowers. The flowers would often be executed in relief, created by layer upon layer of small stitches in undyed linen thread.

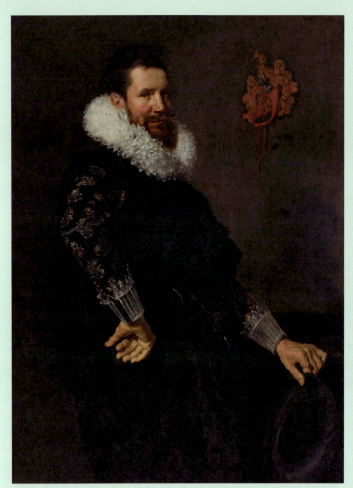 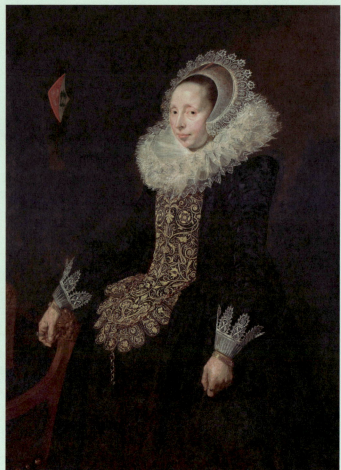

The curved surface would be covered with adjacent pieces of purl or flattened wire in gold or silver. The empty spaces between the festoons would generally be broken up with scattered sequins and small dots or strips of purl. The gold embroidery might be very simple, perhaps taking the form of a simple line drawing, or extremely complex, with motifs like flowers or fantastical creatures in high relief. The same techniques used in costly gold embroidery were also used for multicoloured or black embroidery, the metal thread being replaced by thin glossy cords. Black-on-black embroidery was particularly fashionable between 1620 and 1640. In this technique, the motifs are visible mainly as a result of differences in the relief and the gloss of the finish.

Gold embroidery could also be enlivened with small picturesque images executed in floss, depicting things like colourful flowers, birds, insects and small animals. These colourful additions were generally applied to smaller items like gloves, belts, purses and book bindings. Small pearls might also be added to the main accessories.

## Peak and decline

The production of embroidery in the Northern Low Countries between 1590 and 1650 must have occurred on a very large scale. Yet professional embroidery rarely ended up in the Catholic church.

20 Portraits of Paulus Arentsz van Beresteyn and Catharina Both van der Eem, Frans Hals and Pieter Soutman (?), 1619-1620. Oil on canvas, 139 × 102 cm (each). Paris, Louvre, RF 424; RF 425.

Paulus van Beresteyn was a lawyer in Haarlem. He was already 37 when this portrait was painted, and Catharina van der Eem, who was from Leiden, was 30. Paulus was definitely painted by Frans Hals, probably just before their wedding on 12 December 1619; Catharina was not painted until after they were married, possibly by (or completed by) Pieter Soutman. Their clothing indicates that this Catholic couple were well-to-do. There was no more expensive attire than black silk damask decorated with gold embroidery and set off with starched linen, lace colours and cuffs. Catharina's bridal stomacher is covered with the finest embroidery of the time, made completely of gold wire, featuring flowers, leaves and birds in relief. Paulus' black satin sleeves are decorated with gold embroidered bouquets, in a manner particularly extravagant for a man's attire, which was generally more modestly decorated.

42     The Opulence of Gold, Silver and Silk

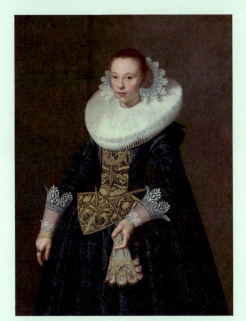

21  Portrait of a Young Woman, Nicolaes Eliasz Pickenoy, 1632. Oil on canvas, 144.5 × 114.9 cm. Los Angeles, The J. Paul Getty Museum, 54.PB.3.

This portrait of an unknown young woman, aged 21, which is one of a pair, was made for her wedding. It perfectly shows the two styles of embroidery that were in fashion at the time. The stomacher is decorated with gold embroidery on a black background, with vines, leaves, flowers, and fantastical creatures executed in flat gold wire and cannetille over a complicated high relief. The lobed cuffs of her white satin gloves feature a combination of gold embroidery in relief and colourful birds and flowers embroidered in flat satin stitch.

Firstly, because the embroiderers tended to be first- and second-generation Reformed refugees and secondly, because the market for Catholic textiles was small. Nor will it have been easy to openly produce items that were manifestly intended for Catholics. The decoration of Catholic vestments and accessories — which did revive after 1600 — appears to have been taken over largely by women living in closed communities, such as the spiritual virgins of Haarlem.[7] Imports will also have had an impact, particularly those from the Southern Low Countries. The embroidery industry in Antwerp flourished again after 1600, when very high-quality gold embroidery was produced there (fig. 22). The quality of the gold thread used and certain stylistic features, such as the broken lines of silver purl, resemble the work of the Haarlem virgins.

Embroidery fell out of fashion in the mid-seventeenth century. From then on, clothes made of plain glossy satin were mainly decorated with woven ribbon or lace made of gold and silver thread. The embroidery industry collapsed and after 1660 only a small number of embroiderers were still active, producing work of a standard similar to that of a century earlier. But there was no such decline where the Catholic church was concerned, where the demand for embroidery in fact grew. However, most of this embroidery was imported, rather than being made by the domestic industry.

22  Miniature altar frontal, Antwerp, circa 1600. Museum Mayer van den Bergh, Antwerp, MMB.0981.

Gold embroidery quickly recovered in Antwerp after 1600. This miniature altar frontal shows work typical of the Antwerp workshops, with sharp outlines in gold wire, and details in silver cannetille over relief, decorated with small pearls and gems.

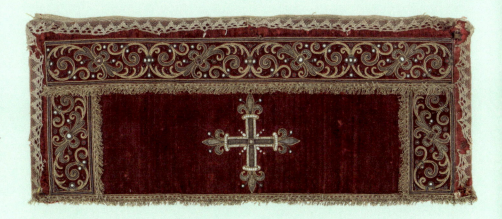

1  De Bodt 1987-II.
2  Van Ranouw 1719, pp. 152-184.
3  Miedema 1980.
4  Dillen 1929; Dillen 1933; Dillen 1974.
5  Cats 1637.
6  De Bodt 1987-I.
7  De Beer 2023-II.

*Embroidery in fashion 1580-1650*

# Eighteenth-century Vestments with 'Coloured' Flowers

René Lugtigheid

23 A white fabric with a black motif and a black fabric with a white motif, inspired by an eighteenth-century fabric from circa 1770.

Fabric from a lady's gown with an unusual pattern — black flowers on a white background — was used in 1787 for a new set of mourning vestments for the clandestine church of St Maria Minor on Achter Clarenburg in Utrecht. Such a fabric pattern was not customary in the church. Vestments worn during a funeral service were generally black in this period, occasionally with white motifs or galloons. White fabric with black motifs must have been an unusual sight. Unfortunately, no elements of the vestment set have survived, so we must use our imaginations to conjure an image of the white fabric with a black floral pattern (fig. 23).

Remarkably, the set can be traced in the church's records for over a century, thanks to its unusual fabric. We know, for example, who once wore the dress, what her intention was in donating it to the church, and how much it cost to have the set made by a professional tailor.[1] This was not just any mourning set. The unusual vestments were used regularly for funeral and memorial services of the highest class, and great efforts were made to keep them in good condition.

This is not the only example of its kind. Secular fabrics were often donated and used in the Catholic Church. It was indeed so common that clothing donations had a lasting impact on the appearance of the traditional church vestments.

## An expensive gift

The white fabric with the black motif is an interesting case for anyone interested in eighteenth-century textiles. Others will mainly be struck by the fact that a lady's gown that had been worn was cut up to make liturgical vestments. This was more common then than one might assume nowadays. From the Middle Ages onwards, expensive garments like cloaks of silk velvet or fabrics decorated with gold and silver thread, were generally used by the nobility to maintain relations. They would donate something valuable, expecting loyalty in return.[2] Expensive clothes were also gifted to consolidate the ties between secular and church power.

This custom can be explained partly by the high costs of the materials. People treated clothes with great care in the past. They would be altered, repaired, reused to make children's clothes, for example, and even used as collateral or sold. The labour costs were only a few guilders, while the metres of fabric required for a cloak or gown could cost twenty to a hundred times that amount. Records of estate auctions show that a lady's silk gown could command a high price secondhand, thanks to the metres of fabric in it. The trade in used clothes was a respected and lucrative business until the late eighteenth century.[3] So it is not surprising that garments made of expensive fabrics were regarded as a valuable gift, and reused, even as church vestments, for economic reasons.

There may have also been another motivation for donating clothing. Like today, clothes were more than a functional, sometimes costly, way of covering the body. In the pre-industrial era ordinary people would often possess only one coat, pair of trousers or skirt made of wool and a number of linen undershirts. The upper classes also wore silk clothing. A person's clothes, the fabric, cut and decorations, were an indication of their social class.

This was all governed by unwritten but widely known rules, and people were not expected to dress above their station.[4] There were strict rules of dress, not only at the various courts in Europe, but also at the court of the stadtholder in The Hague, particularly regarding the number of items of jewellery, the fabrics (silk) and the width of ladies' skirts. The nobility were of course expected to dress in silk.

The growing group of wealthy citizens in the Republic also dressed 'according to their class'. The quality of the clothes worn by merchants and regents signified their social status, just as it did with the nobility. The more gold details such as buttons, and lace collars and cuffs, the more distinguished the wearer, who deserved respect and esteem for this reason alone. Nevertheless, only a small group of citizens could afford the luxury of silk. Inventories show that only 30 per cent of the bourgeoisie owned silk clothes in the eighteenth century, and a much smaller group of women had several silk dresses in their wardrobe at the same time.[5] It is not surprising that people regarded their clothes as a reflection of their status, and also to a large extent derived their identity from them.

This will have especially been the case for women. They did not generally have control of their own assets, which would be overseen by a male relative or guardian, but the things they wore — their clothes and jewellery — were their personal possessions. By wearing a silk dress, a woman from the bourgeois elite could show the world who she was. The symbolic value of the dress as a substitute for the woman as an individual will have been an important factor in the donation of clothing to the church.

### The donor

Was this also true of the white and black dress? Who was the woman who had owned it, and why did she donate this particular dress to the church on Achter Clarenburg? It appears to have been worn by Mistress Aletta van Wijck (1717-1787) of Utrecht. Several documents in the Utrecht Historical Archives (HUA) record the donation, and give us an insight into the life of Aletta and her family.[6]

Aletta must have been an educated lady. On her death, she left an extensive library to the church that not only consisted of religious books. The parish priest drew up a list of fifty titles which were added to the presbytery library. Not all the books in her estate received his approval, for reasons of quality, according to a note. Besides the

edifying works that will have inspired Aletta to devout mediation and religious contemplation, the list of books that were accepted also included a biography of Princess Marie Louise of Hesse-Kassel (1688-1765), Princess of Orange-Nassau, dowager to Prince Johan Willem Friso, written in 1765 (published and purchased by Aletta shortly after the Princess's death). The parish priest gratefully noted that all books added to the library had Aletta's initials on the front page.[7]

Aletta van Wijck was the second of three daughters from a wealthy, intellectual middle-class Catholic family. She died at an advanced age, the sole surviving member of her family. Her father was a brewer and her grandfather a 'doctor of medicine'. The family attended mass at the St Maria Minor clandestine church on Achter Clarenburg, a parish that had chosen the side of the Roman Catholic Church of the Episcopal Clergy. Membership of a clandestine Catholic church in the Republic meant, effectively, that people could not hold any position in the town or national administration, though it was no obstacle to acquiring wealth and status. Opting for the church which had separated from Rome was not an obvious choice, and most Catholics chose the traditional church which continued to accept the authority of the pope.

Nevertheless, Aletta would remain loyal to the separatist denomination her entire life. In her will, for example, she left a bequest of 800 guilders for three memorial services for herself, her sisters, parents and a number of other relatives, for the attention of the parish priest of the Achter Clarenburg church — provided he was on the side of the Episcopal Clergy.[8]

## 'Three virtuous young ladies'

Aletta's mother, Johanna Maria van Beest, died before the youngest sister Elizabeth's second birthday. The three sisters were able to live well on her estate. Mother Johanna Maria had inherited from a wealthy aunt, Jacoba van Schuylenburgh, who had led a pious life as a spiritual virgin.[9] Although the three Van Wijck sisters would lead a devout life, and do lots of charitable works, they did not choose such a restrained religious lifestyle for themselves. It is therefore logical that they would have worn silk gowns in their daily lives, as befitting their social status.

None of the three sisters married. Was this their own choice? It seems so. Their assets allowed them to live as they wished, without the obligations of marriage. This had its advantages. It was not uncommon for a woman to risk her life in her attempts to provide her husband with an heir.

During their lifetime, the Van Wijck sisters regularly donated large sums for the poor of the parish, as well as silverware and textiles for the church. In September 1785, for example, they donated a green altar frontal made of a floral fabric. It replaced a frontal that

had been in daily use, and was now old and worn. Previously, in 1772, the 'three virtuous young ladies' had donated a white cope.[10] The fabric used to make the cope had a white satin background with a woven motif of 'coloured flowers'. This description suggests a fashionable silk fabric with a figure motif, as was commonly worn at the time [fig. 24]. The cope itself has not survived, though the embroidered shield with an image of Christ the Good Shepherd has [fig. 25]. This cope was a prestigious gift. According to the church archives, the cost of the cope, including materials and labour, was over 300 guilders, equivalent to the average annual salary of a craftsman at that time.

Aletta's final gift also indicates her involvement with the accessorising of the religious services she and her family regularly attended. The white gown with the black motif was to be made into a mourning set.[11] She had specified in her will that, at the requiem services for herself and her relatives, and also the 'leading dignitaries of the municipality', the priest and the church should be dressed in a manner befitting their social status [fig. 26]. She apparently felt that the three other mourning sets that the church owned were not fine enough.

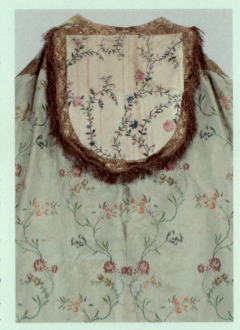

24  Light blue-green cope, c. 1760 (base fabric), c. 1750 (cope shield). Silk, gold galloon, gold fringing, h. 129 cm. The Hague, Old Catholic Church of St. James and St. Augustine, 2198-113 (cat. 36).

## Think of me

Strikingly, Aletta did not pick out a new fabric for this mourning set, as she had done previously. Furthermore, it was not just any dress from her wardrobe that she donated, but a dress with a striking motif. As has been noted, her intention was recorded in writing: to make a mourning set of vestments that should be used at the requiem masses for Aletta and her relatives. Unfortunately she did not mention why she chose this particular gown. It was rare for women to make a written record of their inner thoughts at that time, or at least few such accounts have survived.

Similar gifts do reveal a pattern, however. The women who donated dresses were very wealthy, owned several silk garments, and gave their most beautiful gown to the church. What is more — this is a striking fact — they were unmarried or had remained childless. For these women, the function of these donations as a way of being remembered will have carried extra importance.[12]

Women of the elite had few opportunities to distinguish themselves socially, except as wives and mothers. Money and possessions were kept in the family as much as possible, but clothes and other personal items such as jewellery remained the property of the woman, as noted above. On their death, they would generally be passed on to female relatives, preferably daughters. This was for example the case with another cope in the exhibition, whose provenance has been traced [fig. 27]. It was probably the wedding gown of Engelberta Groen (1736-1816), which her children or grandchildren donated many years later to the church on Achter Clarenburg.

25  Cope shield, Northern Netherlands (Utrecht?), c. 1770. Silk, silk thread, gold galloon, 48 × 49 cm. Utrecht, Old Catholic Cathedral of St. Getrude, 469-561.

This is the shield from the white cope which the Van Wijck sisters gifted to the clandestine church on Achter Clarenburg in 1772. The cope itself has not survived.

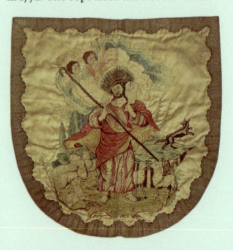

Eighteenth-century Vestments with 'Coloured' Flowers

26 A note in the church archives of the clandestine church of St Maria Minor on Achter Clarenburg concerning the white and black fabric from which a mourning set for the memorial services of the 'Leading Dignitaries of the Municipality' should be made. HUA- 842-2.259.

Unmarried women generally gave their clothes to close relatives or chambermaids with whom they had built up a long-standing relationship, and occasionally to the church, as we have seen. The donation of a dress was not only a charitable act, it was also a tangible reminder of these women as individuals. It will have been extraordinary for parishioners to recognise the fabric of the dress in the solemn vestments worn by the priest at the altar.

The idea of being closer to the centre of her devotion than during her life will have made such a donation all the more attractive to such a woman. She will have left bequests for annual memorial services at which prayers were said for the salvation of her soul, just as Aletta did. It was of course a good thing if the priest's vestments were recognised as her former dress. This was a way for Aletta — who as far as we know had no direct relatives when she died — to ensure that she would be remembered.

A gown that the donor herself had worn was a very personal gift. The woman in question was not only making an expensive donation for the dressing of the church, but also giving part of her personality, as a form of remembrance, and a reminder to pray for her soul.

### Secular fashion in the church

From the eighteenth century onwards, it became increasingly common for vestments to be made of secular fabrics, at the expense of the costly embroidery that was common until the seventeenth century. This is all the more remarkable because the Catholic Church was very keen on tradition, including the vestments used during mass, and was not susceptible to the whims of secular fashion.

It seems that the Catholic faithful in the Republic followed the foreign trend. This stylistic change was also occurring in other Catholic countries.[13] One of the causes of the change in the style of vestments was undoubtedly the advent and the huge success of silk

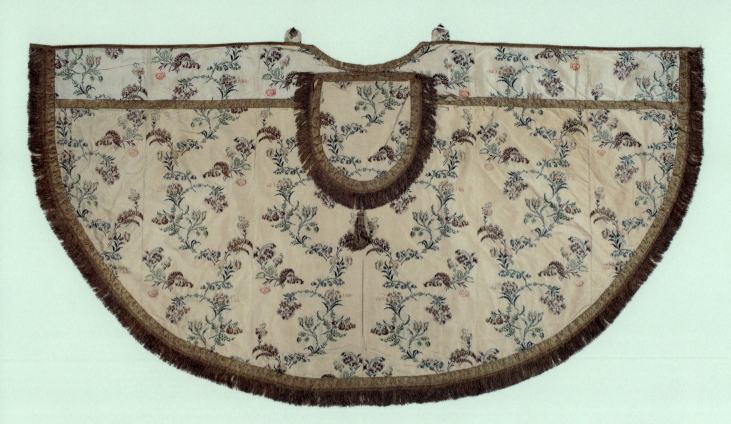

production in France. Under Louis XIV there was a revival in the silk industry, prompted by the exuberant court life of Versailles. Sophisticated production and sales techniques ensured that this trend also reached other countries, some of which developed their own silk industry, including England and the Netherlands (fig. 28). Countries copied fabrics and motifs from each other. Nowadays, it is virtually impossible to establish whether silk fabrics were woven in France or elsewhere.[14]

Another striking phenomenon that will have influenced the change in the style of vestments was the trend among wealthy Catholic women of the bourgeoisie to adopt the practice of the nobility in donating used clothes to the church. This trend was part of the 'aristocratisation' of the bourgeoisie in the eighteenth century. Following the example of the nobility, merchants and rentiers built country houses, bought carriages drawn by several horses, dressed in velvet and silk and had liveried staff. Such an aristocratic lifestyle increasingly came to be regarded as respectable and genteel.

At the same time, women of the bourgeois elite began to donate clothing to the church in their wills. It would for example be specified that their finest silk dress was to be given to the church for the specific purpose of using the material to make vestments.[15] That dress would generally be a robe à la française. These very wide dresses with a broad box pleat down the back were worn over a separate petticoat of the same fabric, beneath which was a wide crinoline. It would take 15 metres of material or more to make such a gown. These gowns were not only standard at court, they were also worn at all official occasions of the bourgeois elite, when visiting others

27 White cope, c. 1860, fabric c. 1750 (design of base fabric by Anna Maria Garthwaite?). Silk, 143 × 296 cm. Utrecht, Museum Catharijneconvent, OKM 469-272; Old Catholic Cathedral of St. Gertrude, Utrecht (cat. 27). The bodice of the gown and a broad strip of fabric have also survived.

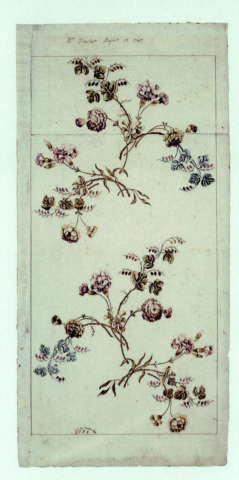

28  Anna Maria Garthwaite, Spitalfields, design for a silk fabric, 1747. Watercolour on paper, 550 × 267 mm. London, Victoria and Albert Museum, 5985:9 (cat. 31). The style of Anne Maria Garthwaite's designs was also very popular in the Republic.

at home, and attending dinners and parties. The cut of this highly voluminous garment would remain virtually unchanged throughout the eighteenth century (fig. 29). Any changes in fashion were reflected above all in the decorations and accessories, such as lace, galloons, bows, caps and jewellery. These could be changed quite easily, as dictated by taste and fashion.

In the church, too, the secular fabrics of the gowns, with their opulent materials such as silk and gold thread, will have caught the eye, and impressed the congregation. The church therefore took grateful receipt of the splendid garments, even though the fashionable secular fabrics, with their exuberant floral motifs, included no reference whatsoever to any religious intention or symbolism (fig. 30). It would, after all, have cost a lot of money to buy such high-quality fabrics. There were no objections to repurposing such used garments provided they were consecrated before their first use as liturgical vestments.

### From dress to mourning set

The fabric from Aletta's party dress did not lie unused for long. Just a few months after her death the church commissioned a tailor to convert the striking white and black dress into a mourning set, which was used for 'stately' funerals, the highest class of funeral. Besides a chasuble, there was enough fabric to make an altar frontal, a stole and a maniple, plus altar accessories.[16] A robe à la française, with its overdress and petticoat, contained enough material for all of these items. The church itself paid for the cost of making the vestments, and extra materials such as the silk galloons, fringing and ribbons that were used to finish the items, as evidenced by a memorandum kept in the church archives (fig. 31).

Almost a century later, the mourning set is mentioned again in the minutes of a church meeting, when it was noted that a piece of 'silk damask, white background with black flowers' was being gifted, and would be a good match for the 'memorial mass black', as the mourning set made from Aletta's gown was known. The new fabric would allow the old set to be repaired, and perhaps some additional items made.[17]

Silk fabrics were of the highest quality in the eighteenth century, as is clear from those that have survived. Once the fabric had been converted into vestments, it could be used for years. The most prestigious vestments were generally stored in the dark, in well-sealed wardrobes in the sacristy, and were used only occasionally. Centuries later, these beautiful textiles have lost none of their luxurious appeal (fig. 32).

### A story in ecclesiastical robes

The donation of clothing by wealthy Catholic women continued throughout the eighteenth century. Indeed, vestments made of new

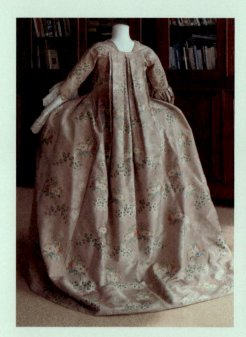 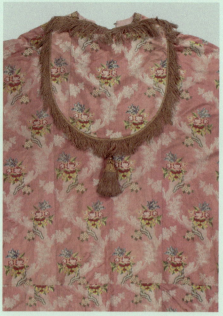 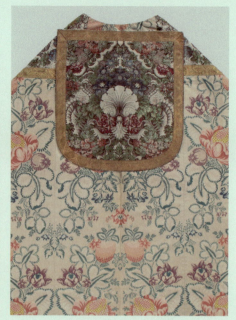

fabrics were more the exception than the rule. We know that dresses were donated not only from archive evidence, but also from the vestments themselves, which provide a dynamic account of use and reuse. The secondhand fabrics in vestments are evidenced by folds, seams and stitch marks in unexpected places (fig. 33).

It is exciting to discover signs of reuse in eighteenth-century liturgical vestments. Such garments exist at churches and museums in the Netherlands, if one cares to track them down. As this exhibition shows, there is much to delight and interest researchers and enthusiasts interested in eighteenth-century fabrics. The changes in fashion in fabric motifs inspired by the French silk industry are more easily traced in the vestments than in the gowns themselves, fewer of which have survived, because as a rule they were altered and worn until they were virtually threadbare.

Finally, one surprising additional fact is that it was not the church authorities that initiated stylistic changes in liturgical vestments in the eighteenth century, but the women who donated their finest and most expensive dresses — out of devotion, of course, but possibly also out of a desire to leave something tangible and personal behind. The colourful fabrics in their gowns sparked a trend. For almost three centuries, fabrics featuring floral motifs inspired by their beautiful silk gowns would continue to be used for church vestments.

29  Robe à la française, c. 1760-1770. Silk, linen, h. 155 cm. Brussels, Royal Museums of Art and History, C.0270.00 and C.0271.00 (cat. 37).

A robe à la française had an overdress with a wide box pleat down the back. The outfit also included a petticoat, under which a wide crinoline was worn.

30  Pink cope, c. 1775. Silk, gold brocade, gold fringing, 111 × 700 cm (zoom). Krommenie, Old Catholic Church of St. Nicholas and St. Mary Magdalene, 5981-73a (cat. 38).

There are no religious motifs on the secular fabrics of which the vestments were made.

31  White cope, c. 1750 (base fabric), c. 1740 (cope shield and orphreys). Silk, gold brocade, h. 138 cm. Haarlem, Old Catholic Church of St. Anne and St. Mary, 5649-201 (cat. 47).

Eighteenth-century silk fabrics were of the highest quality. This can often still be seen two centuries later.

32  Bill for the making of the mourning set from the white and black gown donated by Aletta van Wijck. The various vestments are listed, as are the costs for the passementerie maker, who supplied the decorative band and the fringing. The tailor is also named. He also supplied the haberdashery items (listed as 'verschot'). The church had negotiated a discount with the passementerie maker. HUA 842-2. 220.

33  Traces of stitching and folding that show that the fabric in this cope had previously been used for a lady's dress (cat. 27).

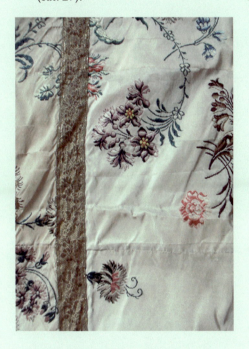

1  Archive research was performed by the author in connection with doctoral research on the reuse of eighteenth-century fabrics in church vestments at the University of Amsterdam. The resulting thesis, entitled *Van aardse stof tot hemels lof*, was published by Verloren Publishing of Hilversum in 2021.
2  As such, a gift can be regarded as 'social capital'. Bourdieu 1986, pp. 241-258.
3  Montijn 2017.
4  Le Francq van Berkhey 1772, p. 707; Groeneweg 1991, pp. 60-98.
5  Lugtigheid 2021, pp. 90-93.
6  HUA 842-2.219; HUA 842-2.220; HUA 842-2.259.
7  HUA 842-2.259, List of the books bequeathed by the late Miss Aletta van Wijck to this Clarenburch Presbytery, compiled by Pastor Andreas Schravelaar, nd.
8  HUA 842-2.259, Extract from Aletta van Wijck's last will and testament, dated 24 May 1786, notarised by C. van Vloten of Utrecht.
9  HUA 34-4.953, document no. 83, Jacoba van Schuylenburgh's last will and testament, 16-11-1717.
10  HUA 842-2.219.
11  HUA 842-2.259, codicil 5 January 1786, notarised by C. van Vloten of Utrecht.
12  Lugtigheid, 2021, pp.257-261.
13  Aribaud 1998; Sporbeck 2001.
14  See the essay by Pim Arts in this catalogue (pp. 54-63).
15  Dorothea Ackerman (1734-1792) of Amsterdam stipulated in her will that after her death the parish priest may choose four of her finest dresses to have them made into vestments. SAA 434.30.
16  HUA 842-2.220, 1787.
17  HUA 842-2.70-81, minutes of the meetings of the church council 1861-1899, 9 August 1880.

# Silk: Trade and Production in the Dutch Republic

Pim Arts

Throughout the centuries, silk and gold and silver thread have helped define the opulent look of Catholic paraments. Until the twentieth century, the base fabric used was almost always silk. Gold and silver thread were often used in the Middle Ages[1] in decorations that took the form of embroidery, and also woven patterns, such as in Italian velvet from the fourteenth century onwards, or in fashion fabrics until the eighteenth century. Since the manufacturing process depended on the availability of these materials, it is interesting to explore where they came from and how they found their way to those who made the items. The production of gold thread is discussed elsewhere in this catalogue.[2] This essay focuses on the trade in and production of silk in the Dutch Republic, and also on the origins of the raw materials and fabrics, in so far as they originated in other countries.

Silk comes from the silkworm. The larvae eat up to ten thousand times their own weight in leaves from the white mulberry bush. The cocoon that the larva spins contains an average of 1000 to 1500 metres of silk, and the silk produced by the male silkworm is particularly suitable for making fabrics. The earliest evidence of the production of raw silk comes from China, and dates from around 2700 BC. Shortly after this, silk fibres were present in other places. Fibres dating back to 2000 BC have for example been found in Cyprus and in the Aegean.[3] Centres of raw silk production were soon no longer limited to China, but were also found in Persia and India.[4] Both the trade in and production of silk underwent constant change throughout the seventeenth and eighteenth centuries, as a result of the constant battle between innovation, commercial interests and fashion.

## Silk imports

In the sixteenth century, silk was brought to the Northern Low Countries largely in the form of woven fabric. The main source was Italy, where the silk industry flourished first in Lucca and later also in Bologna and Verona, partly because of the demand from a new, confident bourgeois elite. Its favourable geographical position on international trade routes, a good climate for craftsmen, unrest elsewhere in Europe resulting from repeated invasions by the Ottoman Empire and improvements to the looms invented in China also gave the Italian silk industry a boost.[5] Italy imported raw silk from China, India and Persia along complex trade routes, via rivers and over land and sea, until the Portuguese found an alternative route via the ocean.[6]

This route around Africa did not pass through the Ottoman Empire, which was not only safer for the Portuguese — and the Dutch — but also meant that they did not have to pay tolls. Yet this route, too, was not without danger, and ships did not always return from Asia. Although China was an important and major producer of

raw silk and silk fabrics, foreign merchants had difficulty accessing the market, and the silk itself was expensive.[7] High prices combined with considerable fluctuations means higher risk in an open economy based on supply and demand. A high purchase price in China was of course no guarantee of a similarly selling price in Europe some considerable time later.[8] To mitigate these risks, staple markets developed all over Europe. The staple market in Amsterdam would remain one of the largest and most important until well into the seventeenth century. Silk accounted for only a modest proportion of the Amsterdam staple market, however. Around 1670 France took over from Italy as the leading exporter of woven silk.[9]

While the staple market had been able to temper price fluctuations by holding stocks of silk, the decision to source the majority of raw silk in India brought the price down. Bengali silk was considerably cheaper than Chinese silk, and it gave the Dutch Republic a distinct advantage over its European competitors. Until 1680 a lot of Indian raw silk was sold to Japan, but after that it was sold virtually exclusively to Dutch buyers. Silk thread was one of the few Asian products that did not merely pass through Europe, but was intended almost exclusively for the domestic market (the silk industry in Amsterdam and Haarlem).[10] An agreement (effectively a cartel agreement) between silk merchants in Amsterdam in 1634 to guard against powerful buyers by imposing minimum prices and repayment terms indicates that the domestic market was never entirely free and open.[11]

The growth in the international trade in silk by the United East India Company (VOC) occurred almost simultaneously with the growth of the silk industry in the Netherlands. This began in the late sixteenth century, and reach its height around 1685-1740, when the Dutch silk industry became a formidable competitor to the French silk industry, which by then had taken over from the Italians. Incidentally, while imports of raw silk were vital for the Dutch silk industry, importing woven silk was actually a disadvantage. In 1643, for example, the Amsterdam silk industry suffered greatly as a result of the renewal of the VOC's silk monopoly. More than half the people working in the industry lost their jobs as a result of an increase in imports of woven silk from Asia. Given the fact that around one in six of the working population of Amsterdam depended on the silk industry, this must have had a huge impact.[12]

## The Dutch silk industry in the sixteenth and seventeenth centuries

The first signs of a professional silk industry in the Northern Low Countries emerged in the late sixteenth century, mainly as a result of the many immigrants who came from the Southern Low Countries. After the fall of Antwerp, many newcomers settled in Haar-

34 Cavalier in a Draper's Shop, Frans van Mieris, 1660. Oil on panel, 54,5 × 42,7 cm. Vienna, Kunsthistorisches Museum, G-586.

lem and Amsterdam, in particular, and they included a large number of Flemish silk weavers.[13] They not only brought new knowledge and skills, but also often the capital needed to build up the industry.

Initially, it was mainly the cheaper types of silk that were produced, but from the beginning of the seventeenth century production also included the more luxury versions, both for domestic consumption and for export.[14] Many types of silk fabrics were woven in Amsterdam from the outset, including the heavier kinds, using lots of different weaving techniques (such as damask, satin and velvet) and complex patterns. In Haarlem there were many silk thread weavers; they made the lighter silk fabrics, and also blended fabrics, containing cotton or wool as well as silk.[15]

When King Louis XIV (1638-1715) revoked the Edict of Nantes around 1685, and the Protestant Huguenots could no longer be sure of protection in France, many of them fled to northern Europe. This wave of immigration also contributed to the growth of the silk industry in the Dutch Republic, although since the industry was already well established and mature, their contribution here was less significant than it was in England, for example. France, the biggest silk fabric producer in Europe, not only suffered from the emigration of the Huguenots, but was constantly at war between 1670 and 1713. This harmed its sales in Europe, but it was good for the export potential and production of silk fabrics in the Dutch Republic.

After France and England introduced protectionist measures to safeguard their own silk industries in the seventeenth century, the States of Holland considered doing the same in the 1670s. The responses to these planned measures give a very interesting glimpse into the production of silk in the Republic. Although import restrictions on finished products from France should have benefited Dutch manufacturers, a reduction in imports could have had a negative impact on local Dutch production, for two reasons. Firstly, expensive imports of French fabrics would also make onward exports to northern Germany and Scandinavia much more expensive, so customers might simply buy their silk fabrics directly from France or England, entirely overlooking the Dutch offerings. And secondly, restricted imports of French silk fabrics made it difficult to imitate them, and this was seen as an existential threat to the sector.[16]

Imitation became increasingly important in the silk weaving industry, both in the Dutch Republic and in the rest of Europe. The fashionable colours and patterns for silk fabrics changed from the late seventeenth century, under the influence of the French court, and the concept of spring/summer and autumn/winter collections emerged, so there was increasing pressure to produce new patterns on a more frequent basis. What is more, these had to be in line with the latest fashions from France.[17]

Imitation back and forth, fashion trends in general and the fact that materials and techniques were broadly similar in all countries makes seventeenth- and eighteenth-century fabrics, including silk fabrics, difficult to tell apart. The widths of the fabrics (and therefore also the widths of the looms) can be used only in exceptional cases to identify the origins of a fabric.

## Commercial interests and trading restrictions in the eighteenth century

The Dutch Republic lost its commercial supremacy during the course of the eighteenth century. Although the overall volume of trade did not necessarily shrink, it was mainly the growth in trade by the French and British, and to a lesser extent also by Hamburg, Norway, Sweden, Prussia and Russia, that caused a decline in the Dutch Republic's relative share of global trade. The countries of Europe increasingly introduced measures to promote their own silk industry and restrict imports and this, coupled with the many wars in the eighteenth century, caused growth in the competition between different national trading companies, such as the East India Companies of the Netherlands and Britain.[18] But although this increased foreign competition led to a decline in the Republic's international importance, in relative terms, it by no means meant that there was less wealth there, so there was no decline in the consumption of luxury goods like silk.

Both raw silk and silk fabrics were still being imported from Asia. Whereas the VOC sourced most of its raw silk in northeast India in the seventeenth century, from 1748 onwards the majority of raw silk came from China, as lower prices improved the price-quality ratio. A lot of silk came from Ghuangzhou (formerly Canton) and fine, high-quality silk came from Nanjing (formerly Nanking).[19] It was impossible to import to the Dutch Republic from China for a short time from 1759 onwards, as the Chinese government banned exports of raw silk, but it soon bowed to the vociferous protests that this elicited, and exports were permitted again from 1762. The price of Chinese silk doubled during the export restrictions, and would not return to its old pre-restrictions price level until 1767.[20]

Woven silk fabrics were also imported from China. One striking new product was white, hand-painted silk from Ghuangzhou. It was produced specially for the European market, and rapidly gained in popularity around 1740 [cat. 39].[21] In addition, from 1736 onwards the VOC sent European silk samples to China to order imitations there.[22] This was not, of course, in the interests of the Amsterdam and Haarlem silk industry, and weavers there undertook several attempts (none of them successful) in the eighteenth century to put a stop to these imports. France (in 1702) and England (in 1699) did ban imports of Chinese woven silk, however.[23]

France and England were the leading European exporters of silk fabrics to the Dutch Republic. Although the most important French customer, the royal court, was in Paris and Versailles, Lyon had been the most important centre for the production of silk fabrics in France since the sixteenth century. It had a very favourable geographical position, accessible by boat, road and by fast, direct mail coach services from Paris, but from 1725 it was also permitted to levy a tax on all raw silk entering France. This prompted innovations in weaving techniques and the development of new fabrics, which enhanced the city's reputation for textile manufacturing.[24]

In England, a sizable silk industry developed in Spitalfields in London (partly because a large group of Huguenots from Lyon and Tours settled there in the late seventeenth century) and it became a major competitor to Dutch and French manufacturers. The light silk fabrics with floral patterns, such as those designed by Anna Maria Garthwaite (1688-1763), were particularly popular throughout Europe in the second quarter of the eighteenth century, and they were imitated in many places.

Although the Dutch staple market had declined in relative importance, it was still an important player. Silk was still exported to England, Scandinavia, Russia, the German states, Austria and Spain, both imported silk fabrics and fabrics manufactured in the Dutch Republic. The Republic benefited in particular from the War of the Spanish Succession in the early eighteenth century, which meant that the silk manufactured in France (the most important producer of silk since the seventeenth century) could barely be sold outside the country.

## The Dutch silk industry in the eighteenth century

The Dutch silk industry reached the height of its success around 1700, driven by a robust export market. Amsterdam and Haarlem were still the main centres of production. From the 1720s, however, the industry faced major challenges as a result of the restrictive mercantilist policies imposed by other countries. Key export markets like Spain, England, Sweden, France, Prussia and Russia banned imported silk products to protect their own domestic industries, or introduced heavy import tariffs. These protectionist measures drastically restricted the overseas market of the Dutch silk industry, and had a devastating impact on silk exports.

The significant decline in the Dutch silk industry in the first half of the eighteenth century is reflected in the reduction in the number of looms in operation. In a 1752 the Amsterdam commissioners for silk production reported that the number of looms had fallen by three-quarters over the previous thirty to forty years. In Haarlem, too, once a booming textile town, the number of looms

fell from around 3700 in 1710 to approximately 900 in 1753.[25] This resulted in severe unemployment, forcing many to leave the towns or live in poverty.

Like a century earlier, a large variety of silk fabrics were woven in Haarlem and Amsterdam in the eighteenth century, from plain, modest fabrics to the most complex multicoloured patterns with brocade in gold and/or silver thread. The silks made in the Dutch Republic were exported on a large scale, and largely met the international quality standards, were woven in common widths and kept up with international fashion. In most cases, it is difficult to determine the origin of silks, unless pattern books from silk mills and other documentation are available. One exception, however is *indiennes*: silk fabrics with Chinese-inspired patterns produced in exceptionally large 78 cm widths. These fabrics were probably only made in the Dutch Republic, and were popular throughout Europe.[26]

Despite the challenges, Dutch silk remained influential on the international market. Evidence that Dutch silk was copied in London shows that the designs were appreciated within the close community of designers in Spitalfields.[27] But silk manufacturers in Amsterdam, Haarlem and Lyon imitated French silk, which indicates that imitation was an integral part of the silk industry, a common practice in all the leading European centres of silk production.[28]

## Consumption: new marketing methods

When it came to European fashion, it was France — more specifically, the French court — that set the tone. Developments in fashion and innovations in silk fabric patterns that were not to the taste of the court had barely any chance of success. The trends popular at the French court trickled down the international social ladder to foreign courts, the lower aristocracy and the bourgeoisie, and eventually to the ordinary people, to the extent that they could afford silk.[29] Developments occurred in small steps, and in rapid succession. Every season there was something new that allowed the court and its followers to distinguish themselves from the less fashion-conscious.[30] The influence of the court was the key to the growing importance of the textile industry, which was reflected in new ways of selling textiles, the advent of lightweight silk for the lower classes, and a burgeoning secondhand market.

International fashion trends and political events also influenced the demand for silk and silk blend fabrics. A period of royal mourning in France, which required a change to court dress, significantly disrupted the silk market, for example.[31] International conflicts like the Seven Years War (1756-1763) also caused serious disruption.

35 Illustration featuring a draper's shop in Johann Bernard Basedow's *Elementarwerke für die Jugend und Ihre Freunde*, Daniel Nicolaus Chodowiecki, 1774. Engraving on paper, 9 × 11 cm. London, Victoria & Albert Museum, E.2249:18-1889.

A large stock of fabric can clearly be seen in the back of this draper's shop. A number of sample books lie on the counter, from which customers could select and order fabric.

Silk: Trade and Production in the Dutch Republic

36 A Draper's Shop, Matthijs Naiveu, 1709. Oil on canvas, 53 × 62 cm. Leiden, Museum De Lakenhal, s-567.

The liberalisation and abolition of the guild system led to the marketing of fabrics largely by means of samples that could be used to demonstrate innovations.[32] This was particularly the case in Lyon, where samples became the main marketing method from the mid-eighteenth century. Well-educated, experienced travelling salesmen with good social skills also played a vital role in the silk industry, ensuring regular orders through their correspondence, and travelling round to meet customers and suppliers. Sample books became the ideal way to sell new silk fabrics. Fabric is after all a product that potential buyers first want to see and feel, particularly when there is a plentiful supply, high demand and rapid development in innovations and patterns (fig. 37). The silk fabric manufacturers in Lyon had a large network of agents working on commission who offered fabrics to other merchants, retailers and private individuals. If there was sufficient interest in a particular sample (the combination of pattern and colour) the weaver could produce the

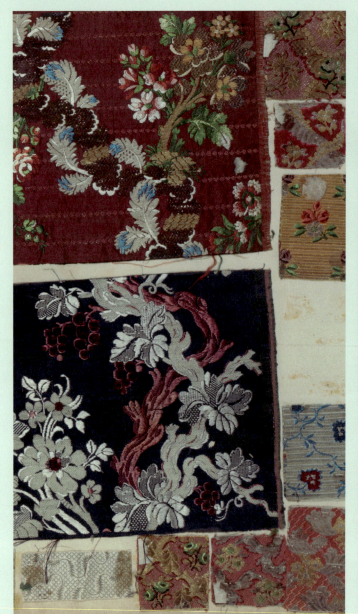 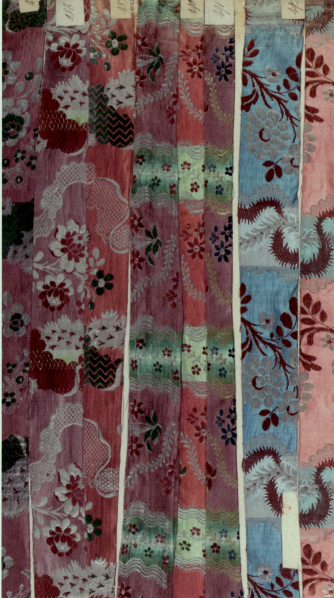

fabric and delivery would be made as quickly as possible.[33] These networks were international, extending as far as the court and the elite in The Hague, and even all the way to Suriname.[34]

In the Dutch Republic, too, more and more draper's shops opened selling cotton, woollen and silk fabrics, with a remarkable increase from 1721 onwards. By the middle of the century some 30 per cent of all shops specifically traded in textiles.[35] In the cities there were shops specialising in silks, which kept stocks of a wide variety of fabrics, both Dutch- and foreign-made. These stocks would include the latest patterns, as well as slightly older ones. Many shops also had sample books, so that customers could order silk fabrics that were not in stock.

The sample books are now an important source of information about the developments in patterns and fashion in the eighteenth century. The same was also true back then, of course. Sample books made imitation all the easier, and a cunning sales representative

37 Sample book, Lyon, 1764. Leather, paper, silk, gold thread, silver thread, 54.0 × 39.4 cm. London, Victoria & Albert Museum, T.373-1972, f.98v (fig. left) en f.26r (fig. right).

This sample book from 1764 was confiscated by British customs when French salesmen illegally tried to sell these silk fabrics in London. The book contains hundreds of patterns and colours, from simple plain or striped fabrics to highly complex designs featuring gold or silver thread.

could order silk fabrics from one weaver on the basis of a sample from another. The growth of such practices led to a ban on the use of sample books in Lyon in 1766.[36]

## Plenty of silk in the Dutch Republic

Throughout the seventeenth and eighteenth centuries there was plenty of silk to be had in the Dutch Republic, of both domestic and foreign manufacture. Imports of silk fabrics from Asia posed a threat to domestic production. The competition between the silk industries in France, England and the Dutch Republic was fierce, though it was tempered by import restrictions in the eighteenth century. This had a negative impact on the silk industry in Haarlem and Amsterdam, as it became more difficult to export, though this did not lead to a decline in demand for silk fabrics in the Dutch Republic. Ultimately, it was changes in fashion following the French Revolution and the growing popularity of cotton fabrics that caused the demand for silk fabrics to decline dramatically around 1800.

1. In the Northern Low Countries gold thread was used in religious embroidery until the mid-seventeenth century; see the essay by Richard de Beer on pages 25-37 of this catalogue.
2. See the essay by Marike van Roon on pages 38-43 of this catalogue.
3. Whitfield 2019, p. 311.
4. Matthee 2018, p. 75.
5. Schoeser 2007, pp. 42, 45
6. Matthee 2018, pp. 75-76. Sardar 2013, p. 66.
7. Matthee 2018, p. 75.
8. Veluwenkamp 1993, p. 70.
9. Israel 1989, pp. 231, 352.
10. De Vries / Van der Woude 1995, pp. 533-534.
11. Posthumus 1920, pp. 217-219.
12. Colenbrander 2010, pp. 31-32.
13. Veluwenkamp 1993, p. 70.
14. De Vries / Van der Woude 1995, p. 347.
15. Colenbrander 2010, p. 268.
16. Colenbrander 2010, p.p 101-102.
17. Miller 2014-II, p. 87.
18. Gaastra 1994, pp. 66-67; Veluwenkamp 1993, p. 71.
19. Jörg 1982, p. 83.
20. Postmus 1943, p. 298.
21. Jörg 2008, p. 8-9.
22. Jörg 1982, p. 83-84; Anderson/Kehoe 2023, p. 12.
23. Colenbrander 2010, pp. 165-166.
24. Miller 2014-II, p. 87
25. Colenbrander 2010, pp. 35-36.
26. Colenbrander 2010, pp. 163-173.
27. Rothstein 1964, p. 157.
28. Colenbrander 2010, p. 245.
29. Miller 2014-II, p. 88
30. Sargentson 1996, p. 97.
31. Sargentson 1996, p. 104; Colenbrander 2010, p. 267.
32. Miller 2014-II, p. 86.
33. Miller 2014-I, p. 39.
34. Miller 2014-II, pp. 90-91.
35. Van den Heuvel 2014, p. 120.
36. Sargentson 1996, p. 107.

# Religious textiles

64-80

16

17  18

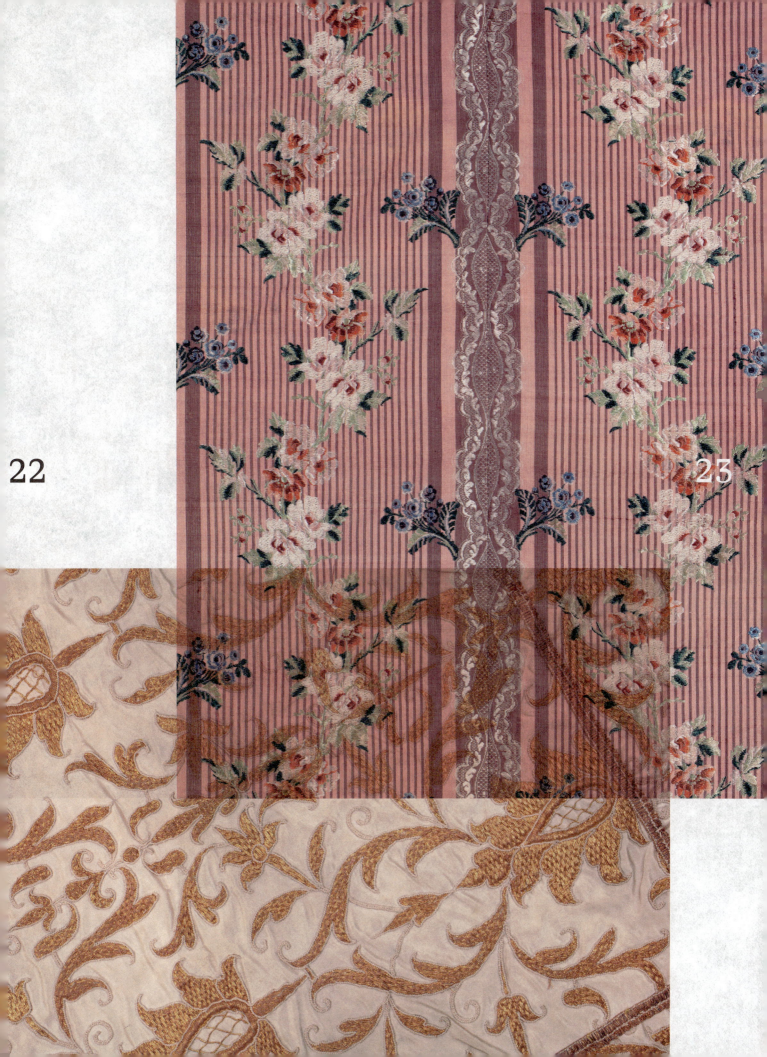

22

23

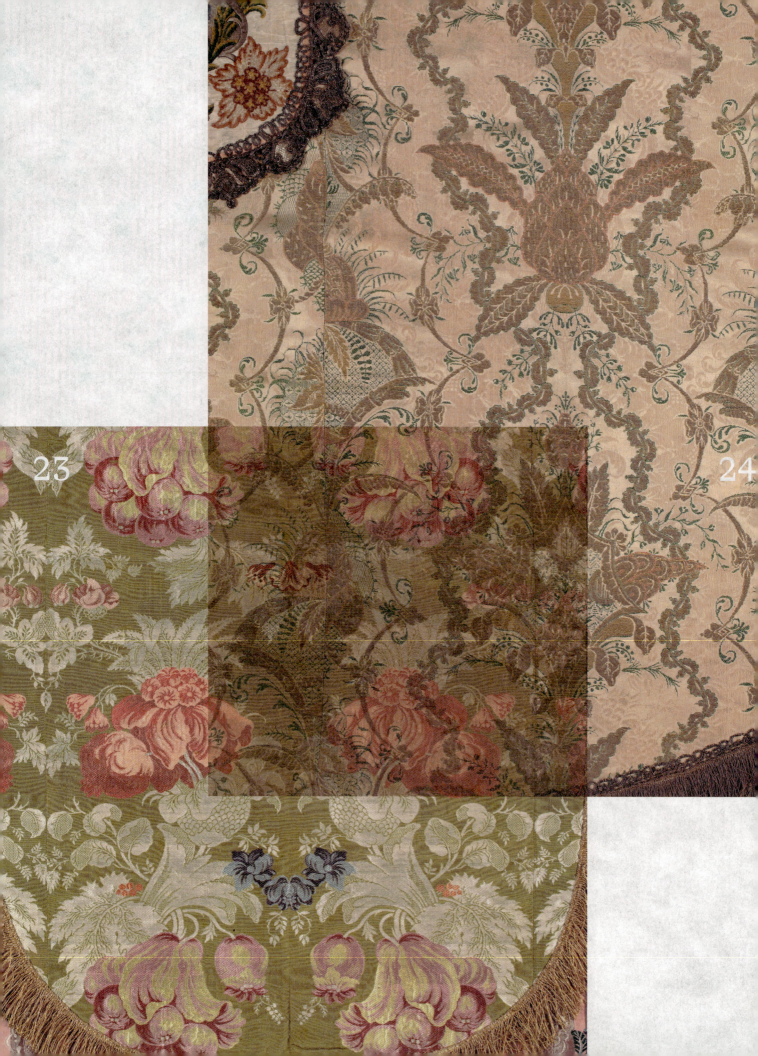

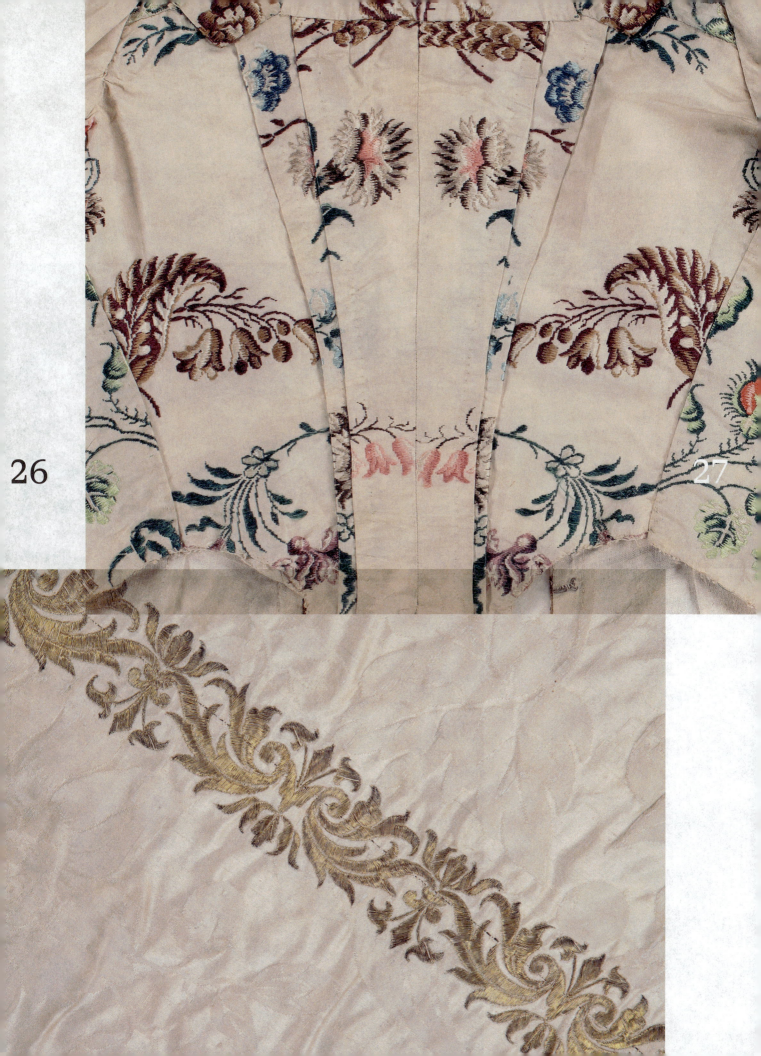

26   27

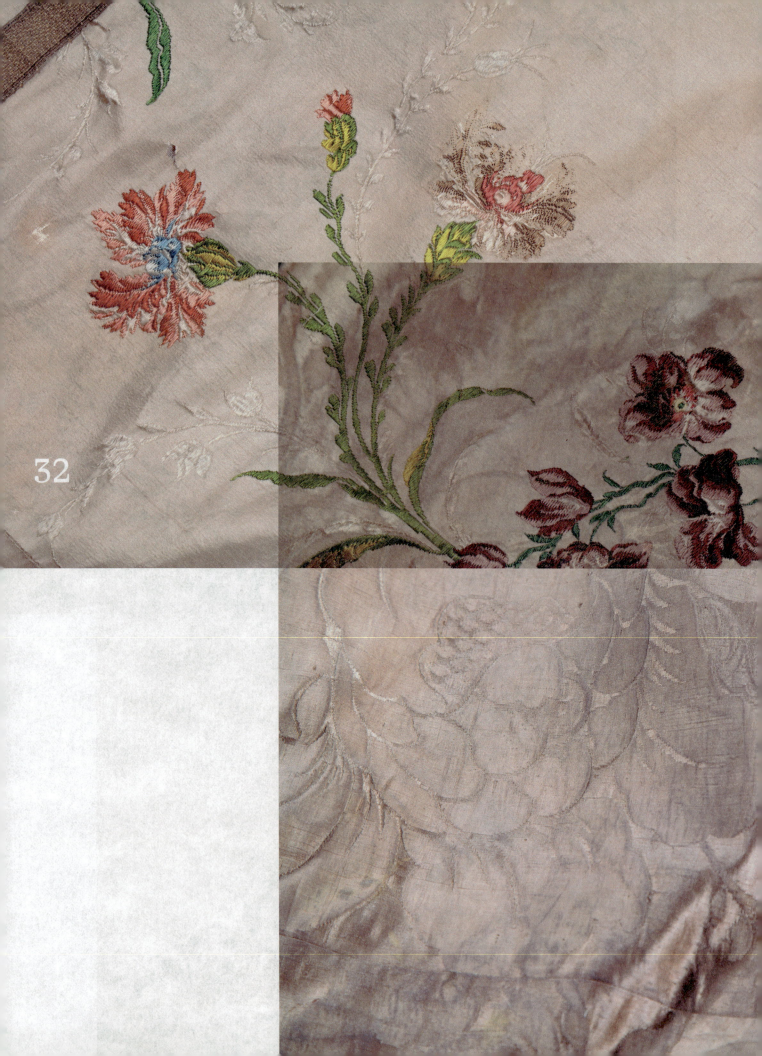

32

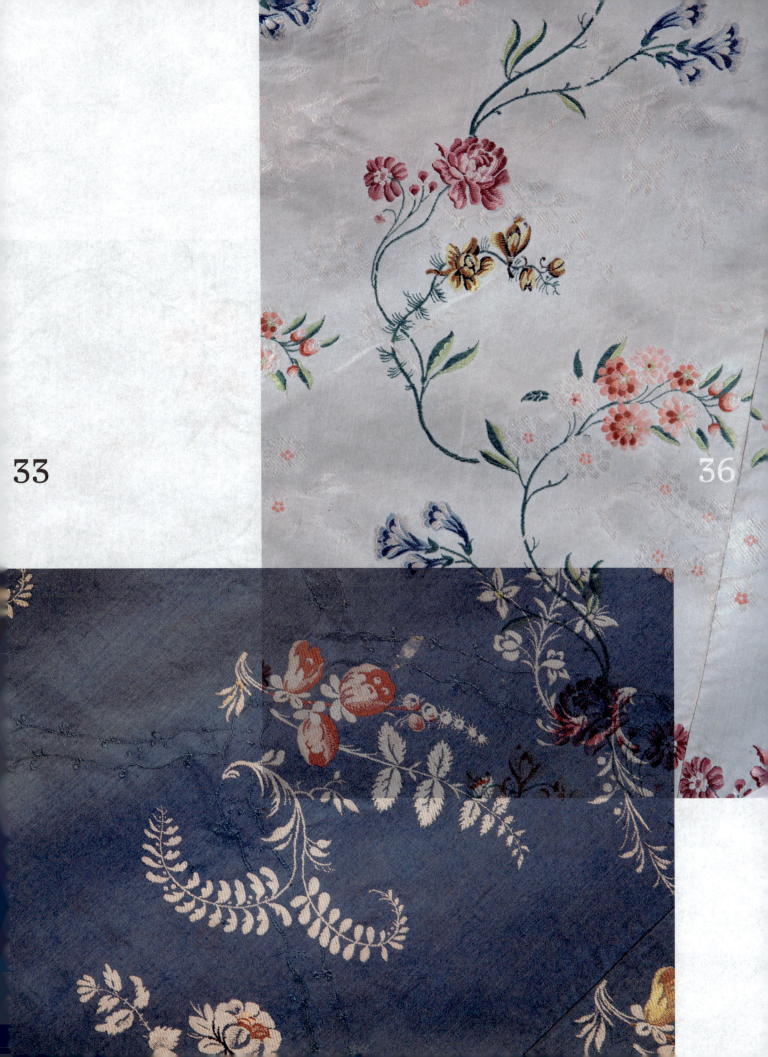

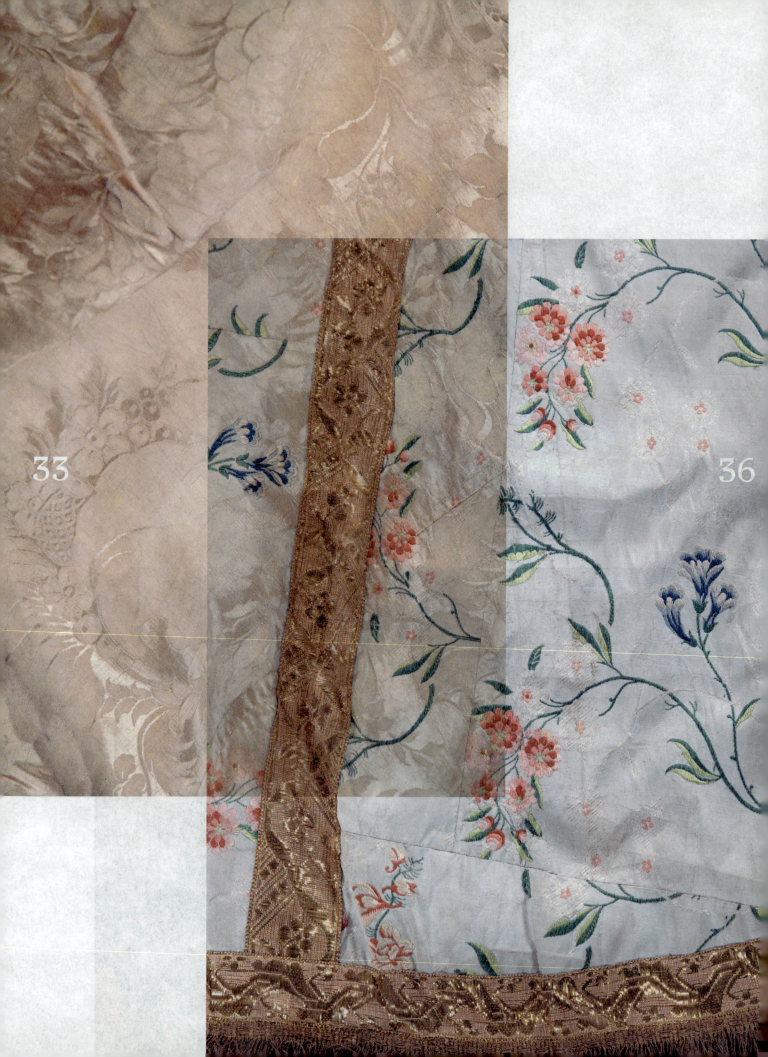

38 39

39

40

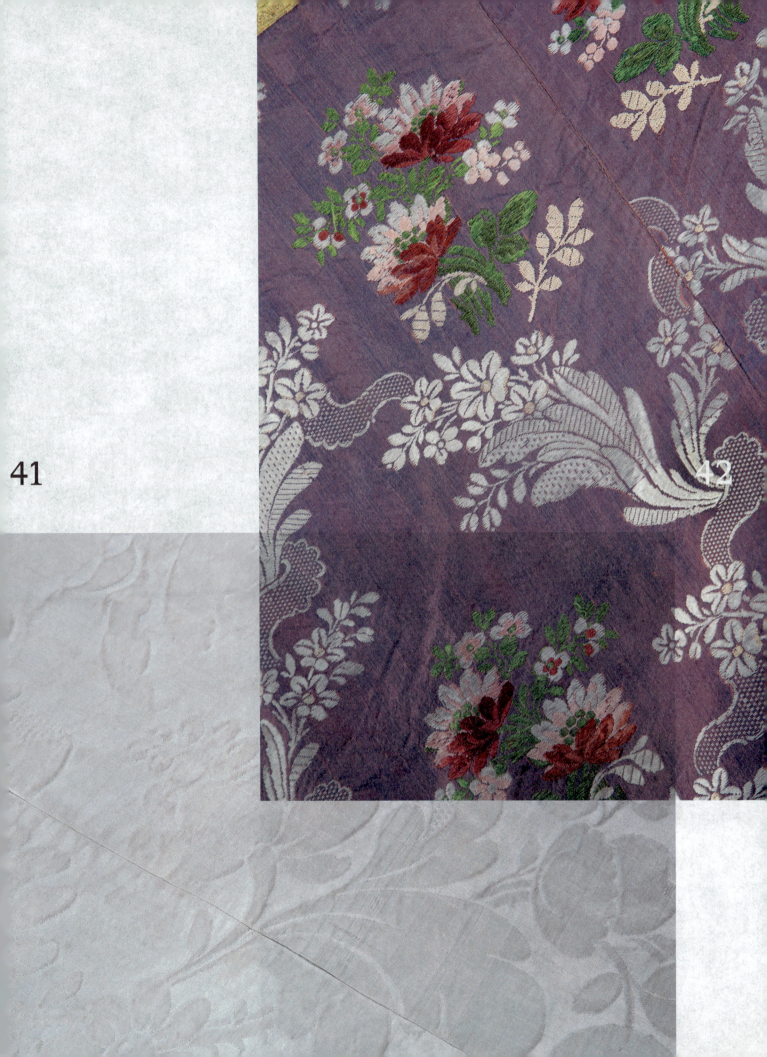

41  42

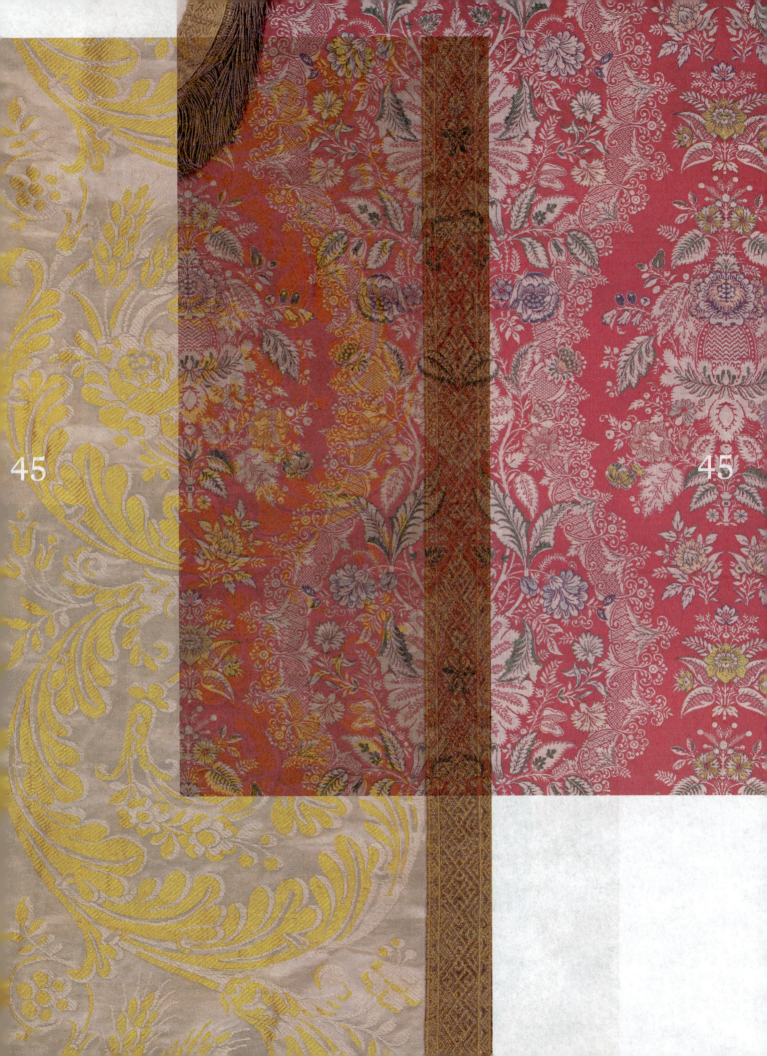

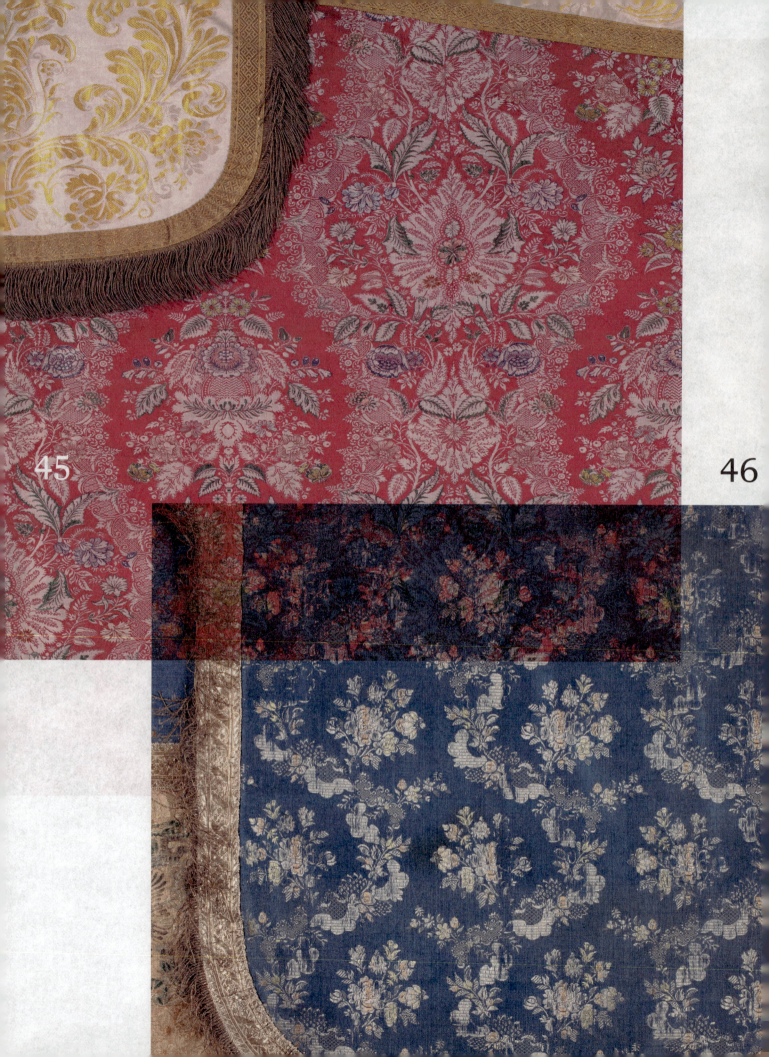

45  46

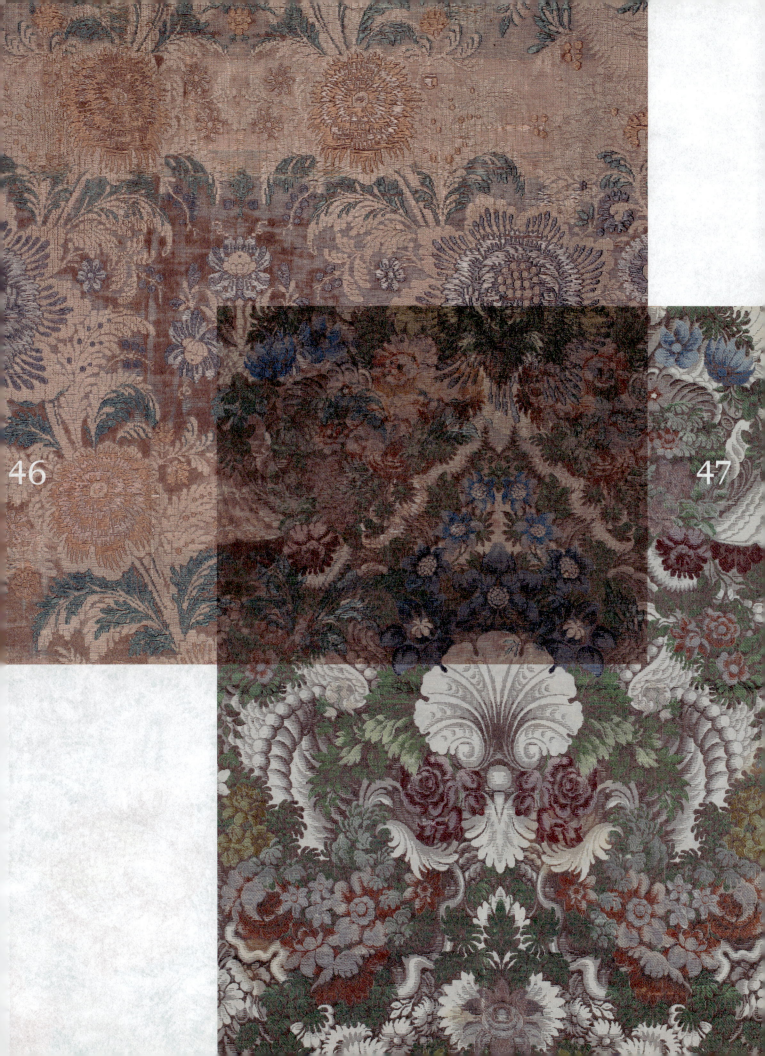

46  47

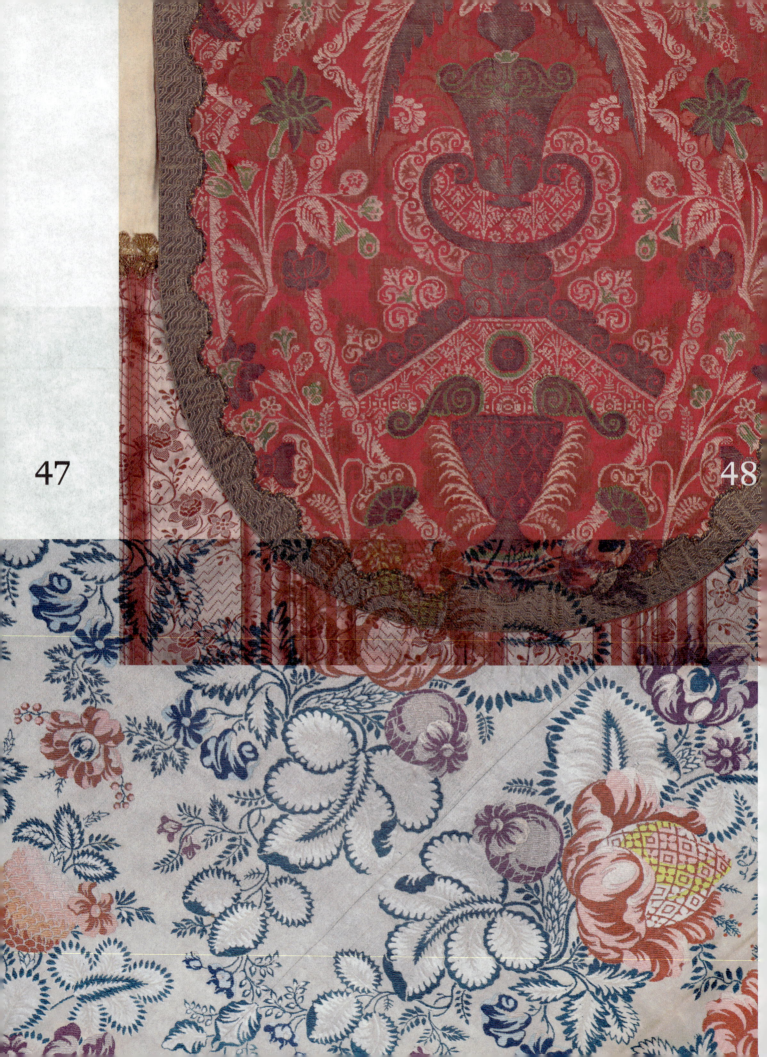

# Catalogue

82-151    Seventeenth century
152-214   Eighteenth century

# 1 Two paintings of Willibrord and Boniface, and a red cope and white cope with two cope shields

A Saint Willibrord,
Jan Franse Verzijl, 1639.

Oil on canvas, 222 × 133 cm. Gouda, Museum Gouda, 53719; on long-term loan from the Old Catholic Church of St. John the Baptist in Gouda. Provenance: originally at the former clandestine church of St. Willibrord ('De Tol') in Gouda.

B Saint Boniface,
Jan Franse Verzijl, 1639.

Oil on canvas, 222 × 133 cm. Gouda, Museum Gouda, 53720; on long-term loan from the Old Catholic Church of St. John the Baptist in Gouda. Provenance: originally at the former clandestine church of St. Willibrord ('De Tol') in Gouda.

C Red cope, Northern Netherlands (Gouda?), c. 1475-1500 (orphreys and cope shield), c. 1650-1700 (base fabric).

Velvet, silk, gold thread, 144 × approx. 220 cm. Gouda, Museum Gouda, 10775a and 10775b; on long-term loan from the Old Catholic Church of St. John the Baptist in Gouda. Provenance: originally at St. Catherine's Convent in Gouda.

D White cope, Northern Netherlands (Haarlem?), c. 1540-1550 (orphreys and cope shield), 1725-1750 (base fabric).

Silk damask, silk, gold thread, pearls, approx. 155 × approx. 340 cm. Gouda, Old Catholic Church of St. John the Baptist, 1978-77. Provenance: originally at the Convent of St. Mary Magdalene in Gouda.

These monumental paintings from 1639 show Willibrord and Boniface, the first men to preach Christianity in the Northern Netherlands. They are depicted as bishops, dressed in late medieval copes painted 'from life'. The two copes still exist today, though the original base fabrics were replaced after 1639.[1]

Both paintings were made in 1639 by Gouda artist Jan Franse Verzijl (1599-1647) for the clandestine church of St. Willibrord in Gouda, also known as 'De Tol', where they probably flanked the main altar.[2] They were commissioned by the parish priest, Willem de Swaen (1607/1608-1674). A few years previously, he had received a set of late-medieval church vestments as a gift from the parish priest of the neighbouring clandestine church of St. John the Baptist, Pieter Purmerent (1587-1662). They included the blue and red cope. Pastor Purmerent had acquired the costly paraments in around 1620 from the last remaining sister of the wealthy Convent of St. Catherine in Gouda.[3]

Willibrord's cope has two shields. The one in the exhibition (from 1475-1500) features the main patron saints of St. Catherine's Convent: Catharine of Alexandria, Mary and Elizabeth of Thuringia (fig. 01)[4]; the other (from circa 1525) shows St. Catherine disputing with the pagan philosophers of the Roman Emperor Maxentius.[5] Her glorious triumph in the dispute would lead to her martyrdom (fig. 02). Boniface's cope has a shield (from circa 1540-1550) with an image of Christ appearing to Mary Magdalene as a gardener (fig. 03).[6]

Pastor De Swaen used the paintings of Willibrord and Boniface in combination with the two copes as material aids to strengthen the identity of his congregation, and as propaganda for the local Catholic church. Paraments played an important role in these efforts. They were powerful symbols whose sacred nature emphasised both the ritual itself and the authority of those who wore them. With a good grasp of history and sense of tradition, church vestments were used in Gouda as a means of identification. The copes

A-B

of the old, pre-Reformation church were worn by the fathers of the Dutch church, underlining their continuity with the past. Though the Catholic church in the Netherlands had suffered some harm from the advent of the Reformation, it was still alive and present. Furthermore, the Catholics regarded themselves as the first Christians in the Netherlands. They therefore believed that they had an advantage over other denominations.

The paintings and copes are also symbolic of the self-confidence and splendour of the church interiors in the first heyday of the Catholic church after the implementation of the Reformation. What they could not show outwardly, they more than compensated for in terms of interior display. Furthermore, they reveal the extent to which the parish priests in Gouda valued their historical textiles. Pastor De Swaen had the venerable paraments immortalised on canvas, so that they would be on permanent display in his clandestine church.

01 Cope shield showing Catharine of Alexandria, Mary and Elizabeth of Thuringia, Northern Netherlands (Gouda?), c. 1475-1500. Gouda, Museum Gouda, 10775b (cat. 1C).

02 Cope shield showing the Dispute of St. Catherine of Alexandria, Leiden / Amsterdam, c. 1525. Amsterdam, Rijksmuseum, BK-NM-12713.

03 Cope shield showing Christ appearing to Mary Magdalene as a gardener, Northern Netherlands (Haarlem?), c. 1540-1550. Gouda, Old Catholic Church of St. John the Baptist, 1978-77 (cat. 1D).

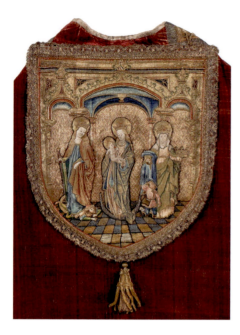
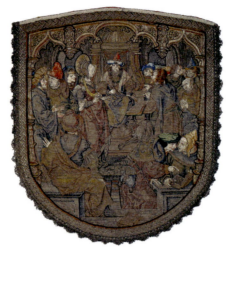
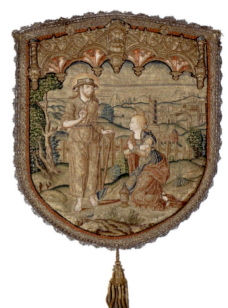

C

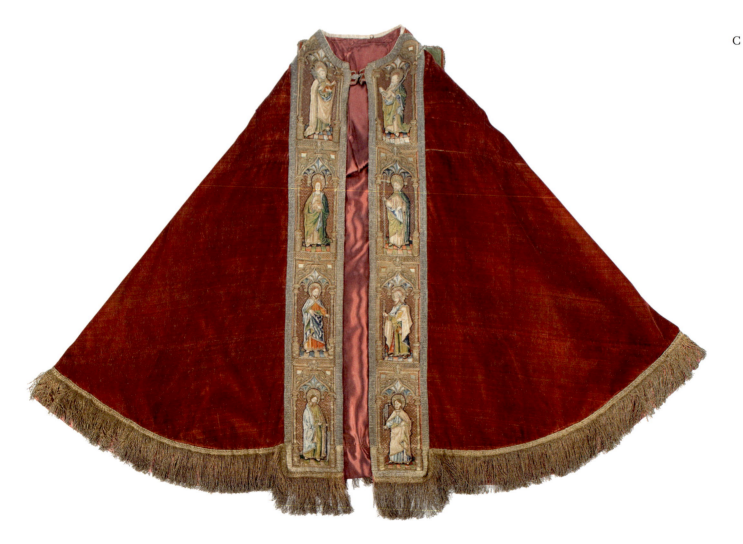

84 Fashion for God

D

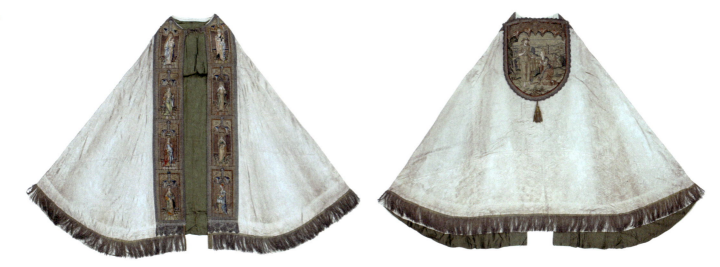

Nevertheless, the original base fabrics of the copes were replaced and adapted to new liturgical requirements in the second half of the seventeenth century and the second quarter of the eighteenth century respectively. The cope of blue brocade velvet dedicated to Catherine of Alexandria was given a base fabric of red velvet, the colour associated with remembrance of martyrs. Blue had not been a liturgical colour since the late sixteenth century. The cope of red brocade velvet whose main subject was Jesus' Appearance to Mary Magdalene — an Easter scene — was given a base fabric of white silk damask in the second quarter of the eighteenth century, white being the colour worn at Easter.

One might imagine that some tension arose between the desire to uphold one's own traditions and reforms imposed from above. Such radical alterations to paraments were not however common in the Northern Netherlands. More often, the old vestments were left intact, notwithstanding all the new requirements, and a conscious choice was made to visibly continue the practices of the past. In Gouda, wear and tear to the base fabrics will probably have been the factor that prompted the decision to replace them. The costly embroidery was, incidentally, carefully protected and transferred.

(RdB)

1  De Beer 2015-I, pp. 106-108 (fig. 9.2 [Willibrord], fig. 9.3 [Boniface]), 113; De Beer 2023-I, pp. 101-110, fig. 7.4, 7.5; De Beer 2023-II, pp. 200-203, figs. 424-426, 428-429, 436-437.

2  Van Eck 1994, pp. 71, 72 (fig. 26), 73 (fig. 27).

3  De Beer 2015-I, pp. 106-108, fig. 9.1 (red cope).

4  Leeflang / Van Schooten 2015, pp. 173-174, cat. no. 34.

5  Leeflang / Van Schooten 2015, pp. 187-188, cat. no. 43.

6  Filedt Kok / Halsema-Kubes / Kloek 1986, p. 296-298, cat. no. 171; Leeflang / Van Schooten 2015, pp. 191-192, cat. no. 46.

# 2 Red chasuble from Oudewater with chalice veil, burse and pall set

A Red chasuble, Northern Netherlands, c. 1510-1520 (forked cross); Italy, sixteenth century (base fabric).

Gold brocade, silk, gold thread, pearls, 130 × 74 cm. Utrecht, Museum Catharijneconvent, OKM t202; on long-term loan from the Old Catholic Church of St. Michael and St. John the Baptist in Oudewater. Provenance: originally at the medieval Church of St. Michael or St. Ursula's Convent in Oudewater (?).

B Red chalice veil, Oudewater, spiritual virgins (?), c. 1625-1650.

Satin, silk, gold thread, 62 × 60 cm. Oudewater, Old Catholic Church of St. Michael and St. John the Baptist, 4192-74a. Provenance: originally at the clandestine church of St. Michael in Oudewater.

C Red burse, Oudewater, spiritual virgins (?), c. 1625-1650.

Satin, silk, gold thread, 24.7 × 24.5 cm. Oudewater, Old Catholic Church of St. Michael and St. John the Baptist, 4192-74b. Provenance: originally at the clandestine church of St. Michael in Oudewater.

D Red pall, Oudewater, spiritual virgins (?), c. 1625-1650.

Satin, silk, gold thread, 19.7 × 19.7 cm. Oudewater, Old Catholic Church of St. Michael and St. John the Baptist, 4192-74c. Provenance: originally at the clandestine church of St. Michael in Oudewater.

The late-medieval chasuble with matching accessories from Oudewater clearly reflects the struggle in the first half of the seventeenth century between the desire to hold on to the practices of the past and the need to adapt to the demands of the new age. The chasuble has embroidered forked crosses front and back with images associated with the Birth of Jesus from the studios of the Master of Alkmaar and Jacob Cornelisz van Oostsanen.[1] The base fabric is a very expensive Italian red brocade, which was nevertheless radically altered around 1620 to restyle the chasuble on the 'Roman model'. This happened to all surviving chasubles from the old church in the Northern Netherlands. The chasuble was first narrowed significantly and slits were made in the front to afford the priest some freedom of movement with his arms. The embroidery was however carefully left intact. The pieces of fabric left over were probably used to make a matching red altar frontal, possibly also in the second quarter of the seventeenth century.[2] None of the costly consecrated fabric was wasted.

In terms of the accessories, only the stole and the maniple were required up to circa 1570. The chalice veil, burse and pall were added as new elements thereafter, in compliance with the requirements of the new Roman Missal. In Oudewater, they date from the second quarter of the seventeenth century, and were made by spiritual virgins, who seem to have been present in Oudewater and the surrounding area in large numbers at that time.[3] A complaint from the magistrate and the Protestant church council of Oudewater submitted to The Hague in 1636 states: '*As regards the spiritual*

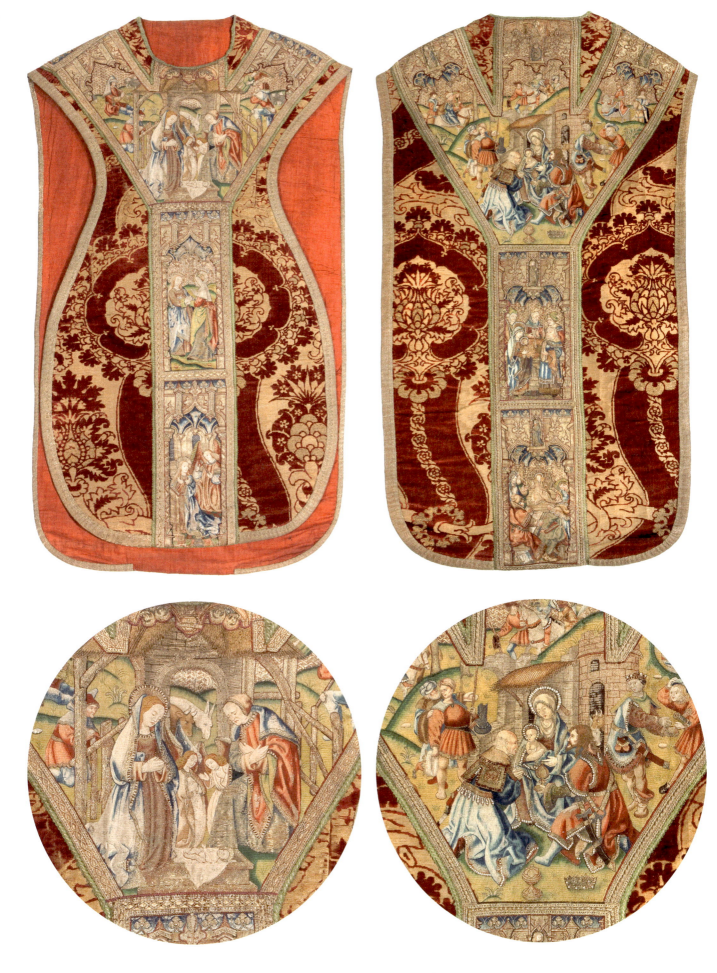

Fashion for God

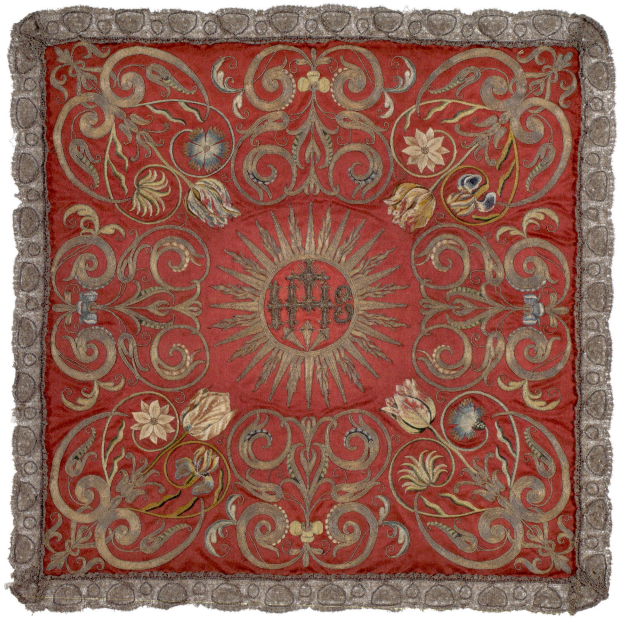
B

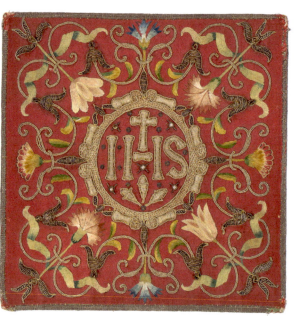
C-D

88  Fashion for God

04  Red altar frontal, Oudewater,
c. 1625-1650 (altar frontal),
c. 1510-1520 (medieval fragments)
and modern lace. Oudewater,
Old Catholic Church of St. Michael
and St. John the Baptist, 4192-49.

*virgins, there are many here in the town and the surrounding countryside, their numbers growing continually, several living together, and meeting daily to practice their common devotions while we are unable to do anything against it without further orders.'*[4] The spiritual virgins apparently attempted to match the decorations on the new accessories to the sixteenth-century fabrics of the chasuble. They did so in a style of embroidery typical of the first half of the seventeenth century, featuring small flowers and sprigs in symmetrical patterns on a plain silk background. To the spiritual virgins, the flowers symbolised virtues, and as such they played an important role in their visual culture. However, in our opinion, they did not entirely succeed in matching the late-medieval fabrics, and the chalice veil, burse and pall are clearly recognisable products of the seventeenth-century baroque style. (RdB)

1   Defoer 2015, pp.37-48, esp. p. 39;
    Leeflang / Van Schooten 2015,
    pp. 216-218, cat. no. 62.
2   De Beer 2015-I, pp. 111-113, fig. 9.12.
3   De Bodt 1987-II, p. 124, cat. no. 97,
    pp. 236-237 (fig.) (chalice veil and pall);
    De Beer 2023-I, p. 102-103, figs. 7.2, 7.3;
    De Beer 2023-II, p. 94-96, figs. 122-130.
4   De Oud-Katholiek 1956, p. 167.

Fashion for God

# 3 Purple cope by the Haarlem Virgins

This cope also clearly shows the attempt to combine old material from before the Reformation with newly manufactured elements. The base fabric of purple silk damask in Renaissance style with a pattern of pomegranates in crowned ovals with gridwork comes from Italy and probably dates to between 1575 and 1625. Older late-medieval orphreys from around 1500 have been applied to the fabric. They are fairly narrow, so are undoubtedly from a dalmatic. The orphreys feature three saints in a vertical arrangement, each in a gothic niche, standing on a tiled floor in front of a cloth of honour. On the left they are, from bottom to top, the apostle James the Great, Catherine of Alexandria and St. Peter; on the right, from bottom to top, Bartholomew the Apostle, St. Barbara and St. John the Evangelist.

The cope shield has a depiction of Christ's Entry into Jerusalem on Palm Sunday in the distinctive embroidery style of the Haarlem Virgins.[1] The image is a pastiche of an engraving by Claes Jansz Visscher of Amsterdam (circa 1587-1652), made in circa 1610-1650 after a 1585 drawing by Maerten de Vos of Antwerp (1531/1532-1603).

The cope, which was apparently paired with a purple chasuble of the same silk damask which has not survived, was part of the inventory of the clandestine church of the Haarlem Virgins, St. Bernard in den Hoeck, until 1851-1852. The inventory list of the clandestine church from 1791 describes the set as *"N15 A purple Damask ornament with Its accessories For two Lords"* and in 1852 as *"A purple silk ditto (chasuble) A ditto (purple silk) Cope with antique shield and edging"*. The Haarlem Virgins thus not only made new church vestments, but also repurposed late-medieval material that had survived the turmoil of the iconoclasm and the transition to the Reformation, such as the orphreys on this cope.[2] (RdB)

Purple cope, Northern Netherlands, c. 1500 (orphreys); Italy, c. 1575-1625 (base fabric); Haarlem, Maagden van den Hoeck, c. 1600-1625 (cope shield).

Silk damask, silk, gold thread, silver thread, 155 × 323 cm. Utrecht, Museum Catharijneconvent, BMH t623a and BMH t623b. Provenance: originally at the former clandestine church of St. Bernard in den Hoeck in Haarlem.

Detail cope shield.

05 Entry into Jerusalem, Claes Jansz Visscher (II) after Maerten de Vos, c. 1587-1652. Engraving. Utrecht, Museum Catharijneconvent, BMH g876.7.

1 Stam 1999, pp. 12-14; Stam 2001-I, pp. 256-261, esp. p. 257; De Beer 2023-II, p. 144, figs. 226-229.
2 NHA 2106.5, 1852 Inventory of all that belongs to the disbanded Roman Catholic clandestine churches of St. Bernard and St. Francis and to the fund of the clandestine church of St. Bavo in Haarlem (St. Bernard's), disbanded in 1816; NHA 2106.6, Clandestine Church of St. Bernard in den Hoeck, Haarlem, inventory of goods 1791.

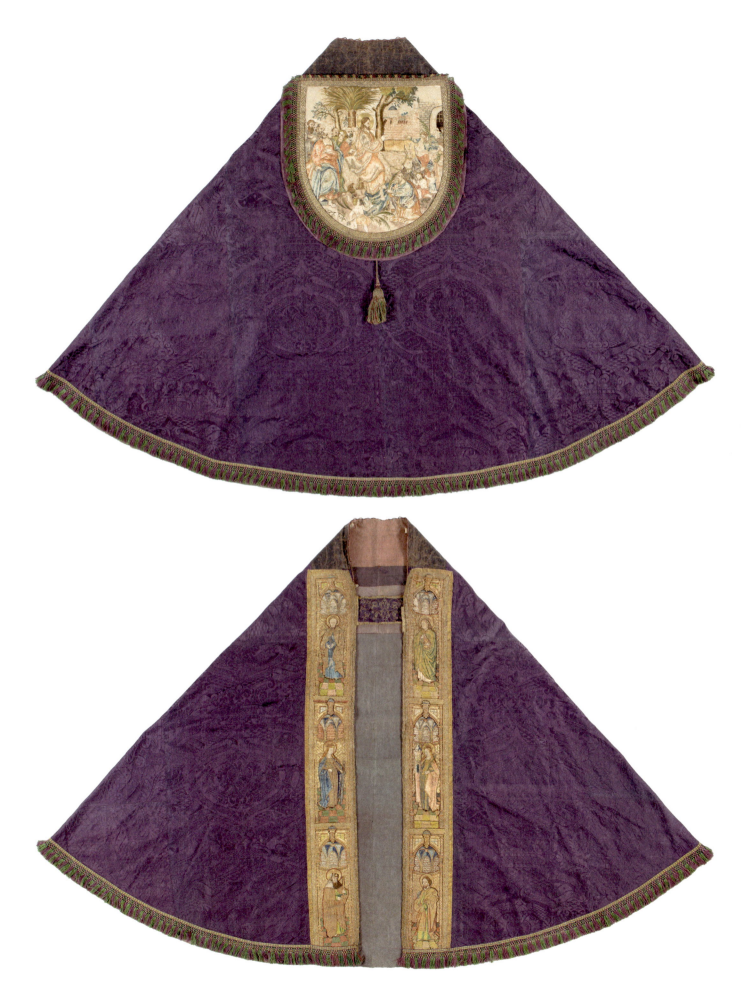

Fashion for God

# 4 Red chasuble belonging to Sasbout Vosmeer with burse and portrait of Sasbout Vosmeer

A Red chasuble, Brussels, workshop of Bernard van Orley (?), c. 1510-1520 (cross); Delft / Cologne, Sasbout Vosmeer, c. 1600-1610, possibly with use of niches of 1525 from Amsterdam (column on front); Northern Netherlands, c. 1800-1900 (base fabric).

Silk velvet, silk, gold thread, 127 × 74 cm. Utrecht, Metropolitan Chapter of Utrecht, 90440-353. Provenance: originally at the Collegium Alticollense in Cologne.

B Red burse, Delft / Cologne, Sasbout Vosmeer (?), c. 1600-1610 (embroidery); Netherlands, 1910-1940 (base fabric).

Silk velvet, silk, gold thread, 20 × 20 cm. Utrecht, Metropolitan Chapter of Utrecht, 90440-348e. Provenance: originally at the Collegium Alticollense in Cologne.

C Northern Netherlands, Sasbout Vosmeer, 1598.

Oil on panel, 44 × 34,3 cm. Utrecht, Old Catholic Cathedral of St. Gertrude, 469-232. Provenance: originally at the clandestine church of St. Gertrude in Utrecht.

The first leader of the oppressed Catholic church in the Northern Netherlands was Sasbout Vosmeer (1548-1614). He was the titular Archbishop of Philippi and vicar apostolic of the Dutch Mission (1602-1614), though in the tradition of the Old Catholic Church he is regarded as the Archbishop of Utrecht. the portrait shown here, which was the basis for numerous later engravings, depicts him in his fiftieth year, just before he was appointed vicar apostolic.[1]

Sasbout Vosmeer came from an aristocratic and fervently Catholic Delft family. He was regarded as a stubborn and uncompromising man, qualities which were probably essential in the first period of the oppression of the Catholic church. He attempted to make the best of the situation, and had not had much opportunity to think about the organisation of the Catholic church. He took a very personal interest in old liturgical vestments that had survived the Reformation, attempting to make them suitable for the reformed liturgy. He thought it important to make his new priests aware of his ideas about the new liturgy. The obvious place to do so was the new institute for the training of priests from the Northern Netherlands, which he had established in 1602 in Cologne, outside the territory of the Dutch Republic. It was known as the Collegium Alticollense, or Hoge Heuvelcollege. Quite appropriately, he dedicated the college to Willibrord and Boniface, who had brought Christianity to the Northern Netherlands.

Most of the church vestments worn in the chapel of the college dated partially or entirely from the fifteenth and sixteenth centuries, and had lavish embroidery. He had probably received some as gifts from the papal nuncio, or from Archdukes Albrecht and Isa-

A

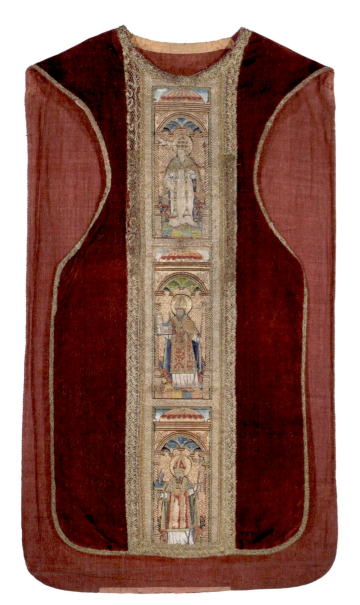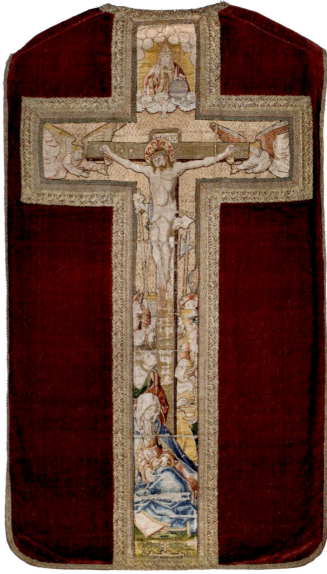

B

93                                                Fashion for God

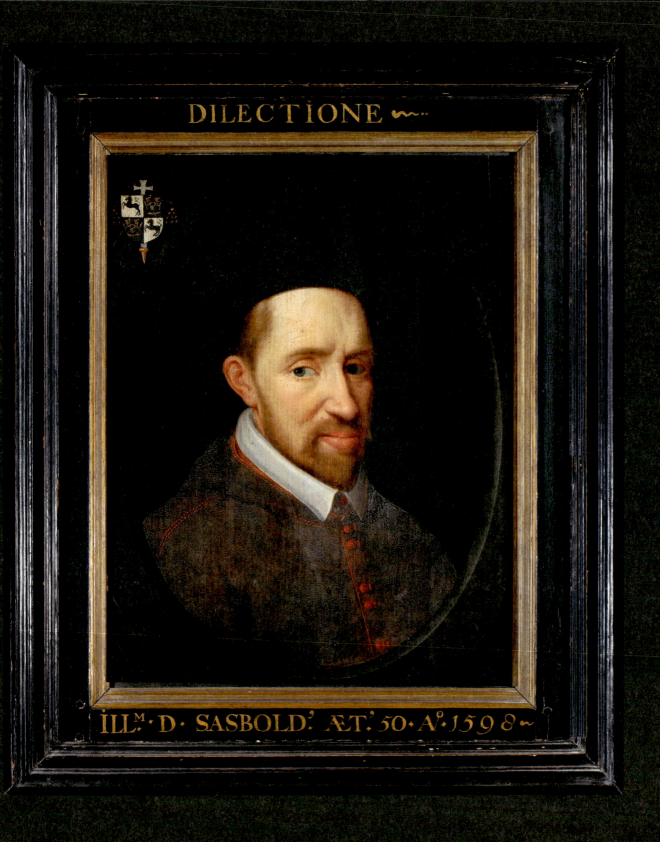

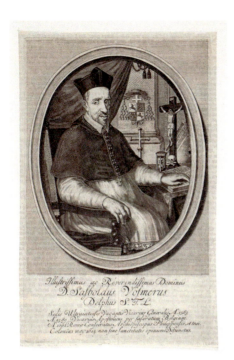

06  Sasbout Vosmeer after the painted portrait, first half of eighteenth century. Engraving. Utrecht, Museum Catharijneconvent, ABM g1690.

bella in Brussels. By using these vestments, Sasbout demonstrated his preference for the continuation of the old forms and traditions, rather than the introduction of new and initially much less opulent baroque vestments.

Sasbout assembled a chasuble for his own personal use from old and new elements, adding his coat of arms at the bottom of the cross on the back; only the top edge still survives.[2] He may have acquired the nicely embroidered crucifixion scene made in circa 1510-1520 by an embroiderer from the circle of Bernard van Orley of Brussels; he probably embroidered the column depicting three saints — Willibrord and Boniface, the patron saints of the college, and St. Gregory the Great, patron saint of students and scholars — himself, in a historical style. It was reported of Sasbout in 1716: "*When he had free time, it was his custom, even when he had become Archbishop, to make Chasubles, Chalice veils and divers other church ornaments himself. He has already made a large number of such ornaments to aid the impoverished Churches, like a second St. Paul, by the work of his own hand*".[3] He will have made the chasuble here specially for his college in Cologne, and will undoubtedly have worn it himself.

The medallion on the burse that is currently used with another chasuble from the Collegium Alticollense in Cologne may also have been made by Sasbout Vosmeer, possibly for his personal chasuble.[4] A rayed medallion features top centre, surrounding an embroidered bust of Mary dressed in a red robe under a blue mantle or veil. The burse, along with the chalice veil and pall, belonged to the new accessories added to pre-Reformation chasubles in the early seventeenth century. (RdB)

---

1   De Beer 2023-II, p. 120, note 474, fig. 148.
2   De Beer 2015-I, p. 110; Leeflang / Van Schooten 2015, pp. 183-184, cat. no. 40 (with fig.); De Beer 2015-II, pp. 10-12 (with fig.); De Beer 2015-III, p. 23 (with fig.); De Beer 2023-II, pp. 120-124, figs. 158-163.
3   Van Heussen 1716, p. 194.
4   De Beer 2023-II, p. 123, figs. 164-165.

# 5 Three *Levens der maegden* manuscripts

A *Levens der maegden* manuscript, I [...], Haarlem, Trijn Jans Oly, c. 1625-1651.

Ink on paper, 21 × 17 cm. Utrecht, Museum Catharijneconvent, BMH Warm h92B13. Provenance: Maagden van den Hoeck, Haarlem.

B *Levens der maegden* manuscript, II [...] preceded by a brief account of the life of the second superior, Joost Cats, Haarlem, Trijn Jans Oly, c. 1625-1651.

Ink on paper, 21 × 18 cm. Utrecht, Museum Catharijneconvent, BMH Warm h92B14. Provenance: Maagden van den Hoeck, Haarlem.

C *Levens der maegden* manuscript, III [...], Haarlem, Trijn Jans Oly, c. 1625-1651.

Ink on paper, 22 × 19 cm. Utrecht, Museum Catharijneconvent, BMH Warm h92C10. Provenance: Maagden van den Hoeck, Haarlem.

The phenomenon of spiritual virgins emerged in the Northern Netherlands after the implementation of the Reformation around 1580. Young women and older unmarried women or widows were no longer able to enter a convent. Nevertheless, the desire for a spiritual life persisted. Many women chose as an alternative a spiritual life out in the world. These semi-religious women lived in private homes, alone or in groups, had their own possessions and theoretically enjoyed full legal capacity. There would in fact be one or more spiritual virgins in every town or large village with a Catholic community. They regarded making liturgical vestments and accessories as part of their calling, and a useful way of spending their time.

The oldest community of spiritual virgins in the Northern Netherlands was established in Haarlem in 1583, at the Hoek bij Bakenes; they are therefore known in Dutch as the *Maagden van den Hoeck*, and in English more commonly as the Haarlem Virgins.[1] From the outset, the congregation of the Haarlem Virgins was centrally organised, though they initially lived in several places in the town. A central chapel had been set up, dedicated to St. Bernard of Clairvaux. The virgins would become an example and an ideal for other groups of spiritual virgins, and individual spiritual virgins in the Northern Netherlands. The Haarlem congregation would soon evolve into the largest community of spiritual virgins in the Northern Netherlands. Some two hundred virgins lived in 'de Hoek' in Haarlem throughout the seventeenth century.

Trijn Jans Oly (1585-1651), one of the first leaders of the Haarlem Virgins, began writing accounts of the lives of deceased virgins in 1625-1651, with the idea that they might serve as examples for the young community of virgins. They were entitled *Levens der maegden* ('Lives of the Virgins'). These accounts are an important source of information about how spiritual virgins in the Northern Netherlands lived, including their goals, how they spent their days, and the work they did.[2]

07 Interior of the Church of St. Bernard in den Hoeck in Haarlem during Holy Week, Alkmaar / Haarlem, J.J. Graaf after J.P. van Horstok (1819), c. 1900. Engraving on paper, 360 × 447 mm. Utrecht, Museum Catharijneconvent, BMH te203.

96  Fashion for God

A

smorgens te vier uren ontsloot sy de kercken
verwachten dan de maechden, op datsy met een
ghemeene eendrachticheyt souden gaen opofferen
de offerhande haerder lippen; die ghebeden wt
synde gaf haer tot innicheit ende devotie.
Ten anderden is oock oorsaeck gheweest dat de
kerckelicke sang int musyck hier onder de ver-
gaederinghe is ghesonden; heeft oock ettelicke
tyt selfs mede ghesongen, alhoewel sy geen lief-
lycke stem en hadde, hier in beoeffende de ghe-
hoorsaemheyt
Ten derden is oock de eerste gheweest int per-
dueren, maeckende veel frie cieraeden inde ca-
pellen ende andere devote beelden. Aengaende
t' cieraet vanden outaer heeft sy zeer fray
bevallyck ende oncostelyck connen ordineren.
Ende tot het einde haers levens heeft sy zeer
wenich gheweest omte vercieren den outaer
ende tempel des Heeren, ende daer en is oock
geen merckelicke cieraet opgheweest of het is
al door haer gheordineert. t' perdueren, t' geen
sy int leste van haer leven soo int conde doen
om dat haer ghesicht begaf, heeft sy gedaen door
andere levende diende cunst, en vervorderent
met haer aenporringhe, nam opset swaerste
ende moeielikste werck alst goede ghevoet te
maecken de vaemen te spannen; te pappen en
 dier-

dierghelycken, ende alst de sommighen wat claechachtich
waeren onden arbeydt ende moeyten, vermaende
die selfde met liefde seggende; inden hemel sul-
len wy altyt rusten, laet ons hier wat ter ee-
ren gods arbeyden. Ende alhoewel haer mid-
delen niet groot en waeren, heeft nochtans veel
frie ornamenten ghegeven ter eeren gods; be-
nauwende hier in haer selven.
Sy was oock zeer devoot in beeldekens ende brief-
kens afte setten, deelende dien mede aenden ar-
men omden tot devocie te verwecken; vervorden
tot dese exercitie oock andere maechdekens om
tselfde ter eeren gods te doen. Leerden dese
cunst, als oock vant perdueren, voort aen twe
arme maechdekens (met veel moeitens) dien
eerlycken haer cost daer mede wonne, ende dient
perdueren conde dede het selfde om een clein loon,
soo dat daer door de devocie vande menschen ver-
meerderden, also datter veel frie ornamenten
tot dienst vant H. Sacrificie hier door gemaect
worden. Ende dese E. was hier in oock zeer ghe-
voechelyck omten besten te raeden ende te hel-
pen den geen die eit ter eeren gods wilde
maecken.
Laet ons eens sien watten vasten fondament
dese religieuse maecht gheleyt heeft, waer op alle
haer duechden een groote vasticheyt ghehadt
 heb-

B

haer niet te, waert sake Godt haer spaerden int
leven, sy nu noch eerst soude beginnen haer
daer inte oeffenen; want sy daer soo veel volmaect-
heden in vont, dat sy niet soude durven seggen
haer daer een ingheoeffent te hebben, oft minst
bekent of naeghevolcht.
Int leste haers levens sy gevoelende haer ae-
tenderste verswaerden, en vilden Doctor ver-
merckten haer leven nu haest soude eindighen
gevoelden daerom in die minste verschrietz
voor die doot, seggende tegens den Doctor, ick
weet niet hoe het is, ick en gevoele geen schroom
te voor dit doot; welcke antwoorden men leest
van een H. man dien hem soo nade doot ghe-
steldt hadt, dat doen den tyt van sterven quaem sy in
en vreesden, soo denck ick het goede met vroede
sy selfs belede en seyden daer ons tegens familie
haer mede was, datsy van haer eerste beginst-
sel af haer altoos gheoffert hadt aende doot,
waerom sy dien als nu niet en vreesden.

Inde vergaderinghe synde oeffende en haer veel
iaeren int perdueren en weren voorde kercke
opmaeckende die rahoffels outerckede en soetelycke
 ornamenten

ornamenten, alhoewel syde cunste daer niet van en
gadt, maer doode ghehoorsaemheyt, ende met lief-
den daer toesettende, verkreech die selfde, nie-
mende dien arbeyt gaving ter eeren gods am
smorgens vroech en savonts laet daer in were-
ckende, oock haer nacht ruste daer wel om ontbeert
alst selfde door believen van haer oversten wat
haest most ghedaen syn.

Dese E. bruidt Chisti blonck ook sonderling wt
in een ootmoedich cleyn ghevoelen haer selfs
nimmermeer eit ophaelende tot haer eyghen
lof, soo van haer zeeven als van haer vrunde
iae ook niet van einige innighe oeffeninn-
ghe; Also haer niet by haer woordde, noch syde
ionste maechdeken, by haer begonnen ghe-
beende Godt te dienen, daer sy over was als oock-
telicke moeder, en gaf sy niet als geestelicke
moeder einige ondervysinghe met woorden, maer
gink voor met exempelen; Als die selfde haer
ootmoedich hadt en geestelicke leevinghe als een
testament in haer wteerste, en conde dese
niet wt krygen, seggende sy en wist niet, sy
was onbekent in sulcks, daer en was geen goet
in haer, nu niet een druesk, daerom alst sy
stirf en soude de Biechtvader van haer niet
 weten

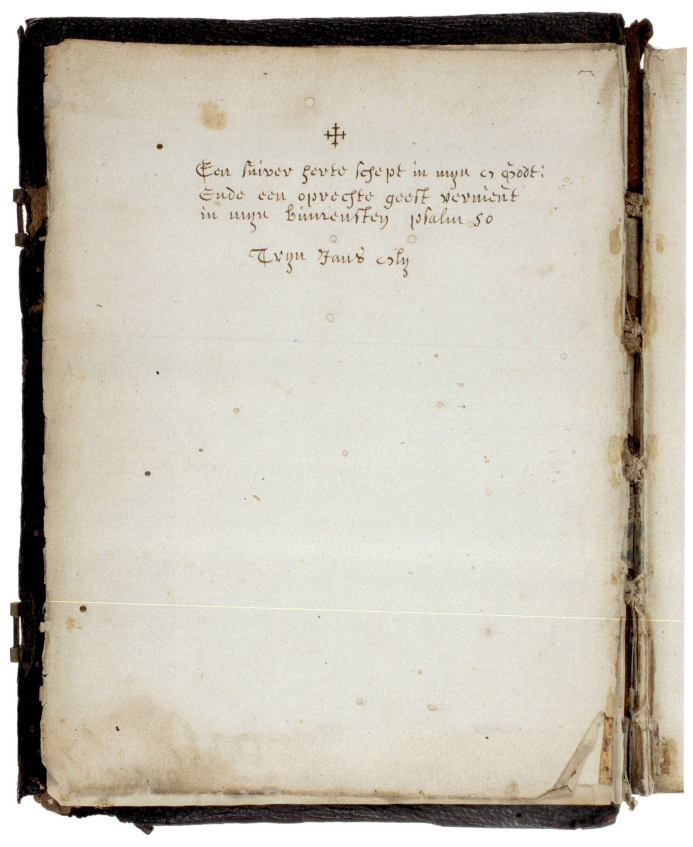

The *Levens* also discusses the production of liturgical vestments. It seems to have been the Haarlem Virgins, in particular Agatha van Veen (1569-1623) of Leiden, who initiated the more or less systematic production of fairly uniform paraments of very high quality in the Northern Netherlands. It is said of Agatha van Veen that '[she] *was*

*Levens der maegden*, I

08 Portrait of Cornelis van Veen (1519-1591) and his family, including (in the centre) Agatha van Veen, Otto van Veen, 1584. Oil on canvas, 176 × 250 cm. Paris, Musée du Louvre, 1911.

*also the best in embroidery, making many fine crosses on chasubles and other devout images*', and: '*Embroidery, which was something she was unable to do in later life because her sight deteriorated, was done by others, learning said art [...]*'.[3] Agatha was the sister of painter Otto van Veen, mentor to Rubens. The Haarlem Virgins had a role and influence beyond Haarlem itself, so the paraments were distributed further afield, initially within the diocese of Haarlem. They did not therefore work only for their own church, but also for other clandestine churches.

The Haarlem Virgins founded a training centre or needlework school for young girls, known as the 'Maagdenhuis'.[4] There, young girls learned embroidery and other skills. Some of the Haarlem Virgins will thus have therefore spent many years making paraments. The 'Maagden van den Hoeck' were probably the leading producers of paraments in the seventeenth century. Spiritual virgins, particularly those in Haarlem, literally shaped the spiritual life and the identity of the clandestine Catholics. (RdB)

1 Spaans 2012.
2 Spaans 2012.
3 Oly 1625...-I, f. 104v.
4 Spaans 2012, pp. 44-46.

# 6 Painting showing a meeting of five Haarlem Virgins (?)

This painting may show several Haarlem Virgins with their spiritual leader Trijn Jans Oly (1585-1651)[1], who is probably seated on the far right. The painting shows the spiritual virgins assembling wreaths in preparation for their mystical marriage to Christ. The renaissance interior may be based on a print, and could be fictitious.

(RdB)

Interior with Five Haarlem Virgins (?), Northern Netherlands, 1645-1650.

Oil on panel, 94.1 × 141.8 cm. Amsterdam, Rijksmuseum, SK-A-4246.

1  Noted by Evelyne Verheggen in 2018.

# 7  Accounts of the Lives of the Virgins: *Het leven der HH. maegden, die van Christus tijden tot dese eeuwen in den saligen staet der suyverheyt in de wereldt geleeft hebben. Met een cort tractaet vanden maeghdelijken staet*

This is an example of what was known as a 'kloppenboek', produced as a guide to the religious life of the spiritual virgins, containing recommendations on how to live the ideal religious life. The recommendations were based on common practices in the late-medieval beguine communities: liturgical song, sacristy duties, spinning, lacemaking, embroidery (particularly on paraments), the making of miniatures and wire work, and the copying of books.[1]

This book containing accounts of the lifes of sacred virgins is open at the life of St. Maura, who was held up as an example to the spiritual virgins. She made and laundered sacred vestments and linens: '*This life of St. Maura is an example to spiritual daughters who, in the honour of God, are engaged with ornaments for the Holy Church, namely the making and washing of Chasubles, Albs, Chalice Veils, Corporals. And to inspire equal devotion to the Ecclesiastical vestments (on which great Princesses have also laboured) with great merit, I cannot neglect to relate how greatly it has pleased God almighty that the virgins give themselves wholly to the advancement of religion by such works.*'[2] (RdB)

*Het leven der HH. maegden, die van Christus tijden tot dese eeuwen in den saligen staet der suyverheyt in de wereldt geleeft hebben. Met een cort tractaet vanden maeghdelijken staet*, Antwerpen, François Fikkaert (publisher), Heribert Rosweyde (author), 1626.

Ink on paper, 17 × 11.5 cm. Utrecht, Museum Catharijneconvent, BMH od1434.

1  Verheggen 2006, p. 55.
2  Rosweyde 1626, pp. 404-405.

# 8 White chasuble from Philippus Rovenius' quartet with engravings of the Annunciation and the Visitation

A White chasuble from Philippus Rovenius' quartet, Southern Europe (Italy, Spain, Portugal?), c. 1600 (base fabric); Maagden van den Hoeck, c. 1628-1641 (cross and column).

Satin, gold thread, silk thread, 134 × 77 cm. Utrecht, Museum Catharijneconvent, BMH t127a. Provenance: originally at the former clandestine church of St. Bernard in den Hoeck in Haarlem.

B The Visitation, Haarlem, Hendrick Goltzius, 1593.

Engraving on paper, 48 × 35.5 cm. Utrecht, Museum Catharijneconvent, BMH g857.

C The Annunciation, Munich, Johann Sadeler I after Peter de Witte, c. 1588-1595.

Engraving on paper, 43.2 × 28.3 cm. Amsterdam, Rijksmuseum, RP-P-1985-140.

This chasuble is part of a four-part episcopal set which the Maagden van den Hoeck (the Haarlem Virgins) made for vicar apostolic Philippus Rovenius (1574-1651) in 1628-1641 (see also cat. 22).[1] The highly expensive base fabric is similar to that of the dress which Margherita of Savoy (1589-1655) wears in a portrait painted by Federico Zuccaro (1542-1609) in circa 1605[2], and was probably made in southern Europe. The base fabric is therefore entirely contemporary. But in the embroidered scenes on the cross and column of the chasuble, an attempt has been made to imitate late medieval work.

Of all the embroidery on the surviving chasubles made by the Haarlem Virgins, the work on this one and on the chasuble from Alkmaar (cat. 10) is the most archaic in terms of its style. Apart from the use of a combination of silk and gold thread in the embroidery, a technique known as nué, on the chasuble pictured here, the use of a baldachin with hanging vaults was also inspired by the Middle Ages. The baldachins resemble simplified versions of the late gothic baldachins on two chasubles from circa 1510-1520 in Amsterdam, one at the Roman Catholic parish church in Loenen op de Veluwe[3], the other in the treasury of St. Bartholomew's Cathedral in Frankfurt am Main[4]. The baldachins on the chasuble made by the Haarlem Virgins for Alkmaar (cat. 10) are identical to those on the chasuble described here. Interestingly, the chasuble for the set that belonged to Rovenius and the chasuble from Alkmaar are fairly late examples of the work of the Haarlem Virgins, dating from the second quarter of the seventeenth century.

The parament set to which the chasuble belongs may as a whole have been intended for solemn services at which the vicar apostolic himself officiated, but the chasuble was above all a festive item created by the virgins, who chose the images depicted. On the chasuble, they depict the Virgin Mary: on the back, from bottom to top, they show the Visitation, the Circumcision of Jesus, and at the

Detail of the chasuble showing an embroidered image of the Presentation of Jesus in the Temple.

A

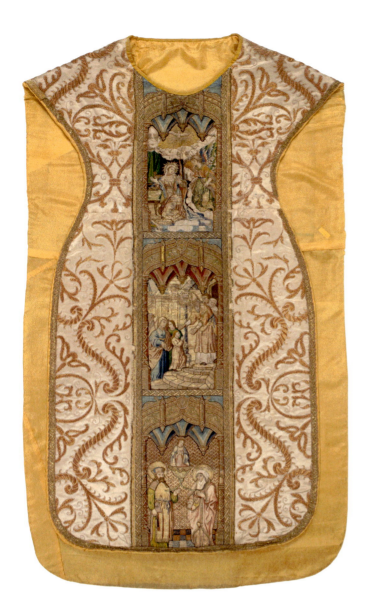
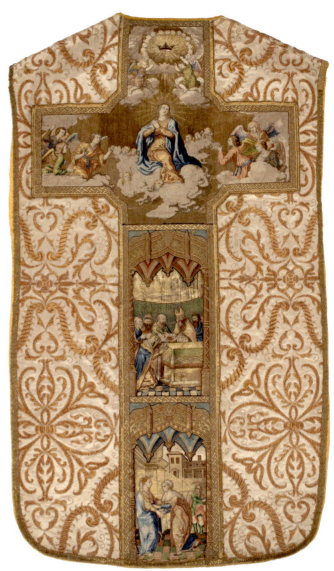

centre of the cross the Glorification of the Virgin; on the front, from bottom to top, they are Mary with St. Joachim and St. Anne, the Presentation of Mary at the Temple, and the Annunciation. Given that a virgin would preferably enter the community on a Marian feast day, and that this important ceremony was commemorated each year until her death as a kind of birthday, we can imagine that this chasuble would have played a key role in the congregation of the Haarlem Virgins.

The individual images also had deeper mystical meanings for the virgins.[5] They identified with the Virgin Mary. The Annunciation and Visitation could for example be seen as metaphors for the entry of the spiritual virgin into the community. At the Annunciation Mary received the message that she would conceive and bear Jesus, and immediately afterwards she went to Elizabeth to share this miraculous news with her. On entering the community a spiritual virgin would receive a similar message, after which she would go to the other virgins. The Presentation of Mary, when she was received by the priest at the temple, also bears a clear resemblance

103   Fashion for God

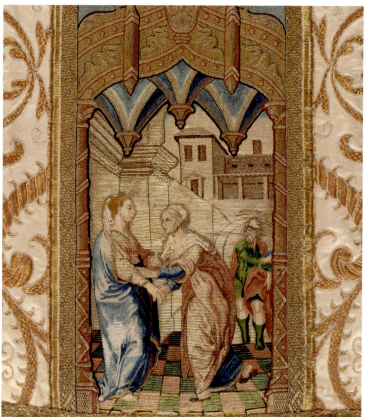

B

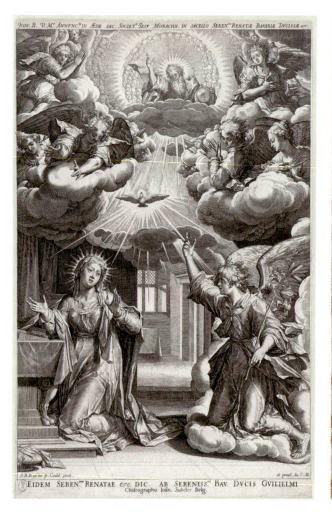
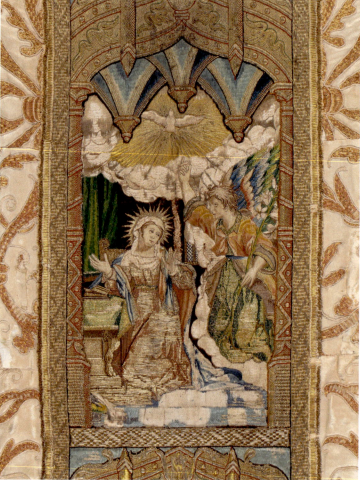

C

Fashion for God

09  Portrait of Margherita of Savoy [1589-1655], Federico Zuccaro, c. 1605. Oil on canvas, 120 × 99.1 cm. London, Philip Mould & Company Fine Paintings.

10  The Glorification of Mary, Hendrick Bloemaert, 1667. Oil on canvas, 195.5 × 193.5 cm. Amersfoort, Old Catholic Church of St. George, 461-109.

to the ceremony of acceptance of the spiritual state. The spiritual virgins imagined that after death they would receive a reward akin to the Assumption or Mary's glorification in heaven.

The virgins drew inspiration for their embroidery from contemporary engravings and paintings, not from late medieval images. The overall composition of the chasuble is thus based on two notions, as it were: an archaic concept with modern elements.

The main image of the Assumption of Mary depicted on the cross is probably based on an unknown engraving or painting made in the circle of Abraham Bloemaert (1566-1651) or his son Hendrick (1601/1602-1672). Compare, for example, Hendrick Bloemaert's painting of the Glorification of Mary from 1667 at the Old Catholic Church of St. George in Amersfoort. The angels on either side of Mary have postures very similar to those on the altarpiece showing the Visitation by Peter de Witte (1587) after an engraving by Jan Sadeler. The embroidered scene is virtually identical to that on the cross of the chasuble from circa 1650 at Museum Catharijneconvent (OKM t69), which came from the clandestine church of St. Gertrude's in Utrecht.

The embroidered image of the Visitation at the bottom of the cross was based on a 1593 engraving by Hendrik Goltzius (1558-1617).[6] The Annunciation at the top of the column on the front of the chasuble is taken from an engraving by Jan Sadeler I (1550-1600) after an altarpiece made by Peter de Witte (or Pietro Candido) (c. 1548-1628) for the Jesuit church in Munich in 1587. The image of the Presentation of Mary beneath this also occurs in a small engraving by Karel van Mallery (1571-1635?) published in Antwerp by Johannes Galle (1600-1676). This print was pasted in the front of a small book containing handwritten texts which one of the Haarlem Virgins, Maria van Wieringen, gave to Johanna Cousebant when she entered the community of the Haarlem Virgins on 21 November 1662, the feast day of the Presentation of the Virgin Mary.[7] An engraving from a Roman Missal made in Antwerp in 1589 may have served as an example for the image of the Meeting of Anne and Joachim. (RdB)

1  Graaf 1905, pp. 320-321 (De 'Vergaderinghe'); Caron 1987, pp. 20-31; Stam 2001-II, pp. 10-12; De Bodt 1987-II, pp. 122-123, cat. no. 86, p. 226, fig. 86; De Beer 2023-II, pp. 148-150, 420-423, figs. 250, 251, 262, 263, 264, 265, 266, 267.

2  At Philip Mould & Company Fine Paintings, London in 2023.
3  Utrecht, Museum Catharijneconvent, ABM t2298.
4  Frankfurt am Main, Domkirche St. Bartholomäus, inv. no. 132. I-II.
5  Verheggen 2006, pp. 65, 87.

6  Graaf 1905, pp. 320-321 (De 'Vergaderinghe'); Caron 1987, pp. 20-31; Stam 2001-II, pp. 10-12; De Bodt 1987-II, pp. 122-123, cat. no. 86 (quartet), p. 123, cat. no. 87 (shoes and gloves), p. 227, fig. (shoes and gloves).
7  Verheggen 2006, p. 87, 300, fig. D1.

Fashion for God

# 9  Dark pink chasuble from Enkhuizen, chasuble cross from a chasuble in Haarlem, red chasuble from Maarssen

A  Dark pink chasuble, Haarlem, Maagden van den Hoeck (Brechgen Pietersdochter?), c. 1608-1626.

Ribbed silk, moiré, velvet, linen, gold thread, paint, 120 × 70 cm. Utrecht, Museum Catharijneconvent, OKM t157a. Provenance: originally at a house church in Enkhuizen.

B  Dark green chasuble cross, Haarlem, Maagden van den Hoeck, c. 1600-1625.

Velvet, silk, linen, gold thread, paint, 126 × 54 cm. Utrecht, Museum Catharijneconvent, BMH t505. Provenance: originally at the former clandestine church of St. Bernard in den Hoeck in Haarlem.

C  Red chasuble, Haarlem, Maagden van den Hoeck, c. 1612-1625.

Red velvet, silk, linen, gold thread, beads, spangles, paint, 123 × 72 cm. Utrecht, Museum Catharijneconvent, ABM t2006. Provenance: probably originally in Maarssen.

The Maagden van den Hoeck in Haarlem (the Haarlem Virgins) set up their parament production operation like a workshop, led by Agatha van Veen (1569-1623). They worked on the basis of a structured division of labour, making it easier to produce larger quantities of paraments. There are various similarities between figures and decorations that are often repeated like stencils (angels, saints like Peter and Paul, Michael, Willibrord and John the Evangelist). The Haarlem Virgins were the only one to produce embroidery in this manner in the Northern Netherlands during this period. The chasubles of the Haarlem Virgins were consistent with medieval examples when it came to the positioning of the saints. This was their attempt to adhere to familiar traditions, and achieve continuity. The figures themselves and the majority of the related decorations were however executed in a contemporary baroque style.

This group of two chasubles and a chasuble cross are part of the core production of the Haarlem Virgins, and they were executed in their typical manner. We see appliquéd embroidered figures on a background of dark red or dark green velvet, strewn with silver stars and spangles. Above the figures there are baldachins of symmetrically grouped vines with flowers, some of them in relief embroidery made with gold thread (tinted blue and green here and there), resting on small pillars of gold thread on either side of the figures. Beneath the figures, tiled and curved grounds alternate in the colours green, white and blue.

The virgins probably chose the images themselves. St. Peter and St. Paul (on the chasubles from Enkhuizen and Maarssen) were popular saints, who underlined ties with the church of Rome. They also depicted Willibrord and Boniface (on the chasuble from Maarssen), who brought Christianity to the Netherlands, and therefore strengthened the identity of the oppressed church. John the Evangelist (on the chasuble from Enkhuizen) played the role of priest in depictions of the Mary receiving the eucharist in the seventeenth century; this was a metaphor for the mystical union with Christ. St. Augustine (on the chasuble cross from Haarlem and the chasuble

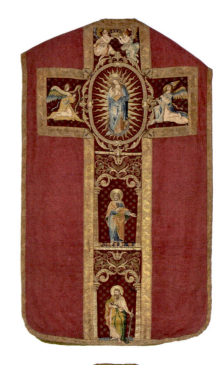

A

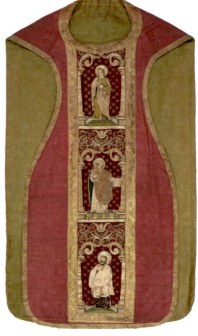

Fashion for God

B-C

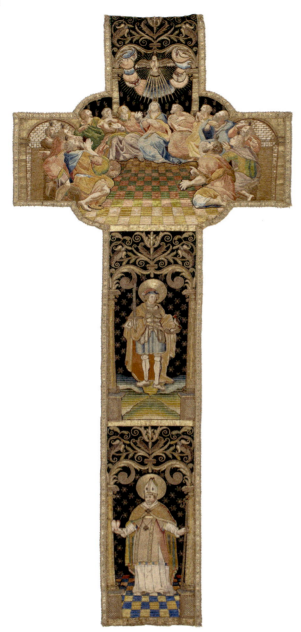
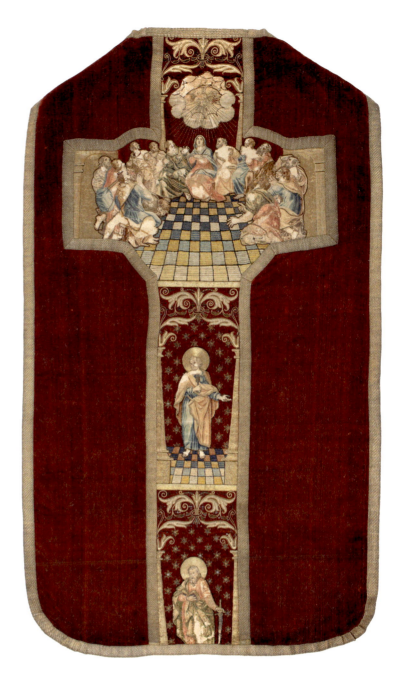

from Maarssen) was popular with the spiritual virgins for his devotional writing. Local patron saints would also be included, such as Bavo on the chasuble cross from Haarlem, and saints special to particular orders, such as Ignatius of Loyola and Francis Xavier, patrons of the Order of the Jesuits (Enkhuizen chasuble).

Most of the figures were taken from engravings made in the circle of the Haarlem master Jacob Matham (1571-1631) and his pupil Jan van de Velde II (1593-1641), and sometimes from engravings after works by Peter Paul Rubens (1577-1640) (Ignatius of Loyola and Francis Xavier on the Enkhuizen chasuble). It is striking that, at a time when engravings by all kinds of artists were widely available, the spiritual virgins of Haarlem mainly chose examples by Haarlem engravers, while work by Utrecht artists served as a basis for embroidery done in Utrecht.

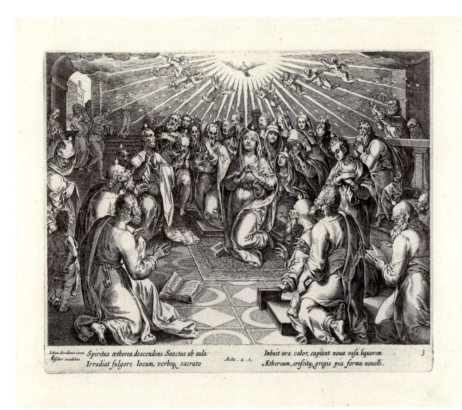

11  Saints worshipped in the diocese of Haarlem: Martin, Boniface, Frederick etc., Haarlem, Jacob Matham or Jan van de Velde II, 1632. Engraving on paper, 207 × 265 mm. Utrecht, Museum Catharijneconvent, BMH g64.

12  Pentecost, Amsterdam, Claes Jansz Visscher (II) after Philips Galle naar Jan van der Straet, c. 1643-1646. Engraving on paper, 205 × 265 mm. Amsterdam, Rijksmuseum, RP-P-1904-909.

13  Saints Ignatius of Loyola and Francis Xavier, Schelte Adamsz Bolswert after Peter Paul Rubens, 1622. Engraving, 345 × 245 mm. Amsterdam, Rijksmuseum, RP-P-BI-2558 (cat. 20-B).

Bible scenes were embroidered at the centre of chasuble crosses, including Mary as an apocalyptic figure standing on a crescent moon, surrounded by a halo (Enkhuizen), and the Descent of the Holy Spirit (Pentecost) in the presence of Mary and the apostles (on the Haarlem and Maarssen chasuble crosses). Pentecost was a particularly important feast in the liturgical year of spiritual virgins and beguines. It was regarded as the first congregation of the church, and as such an example to the spiritual virgins. Furthermore, the virgins hoped that they too would receive the Holy Spirit, just as it had descended to Mary and the apostles, and that Jesus would speak to them. A print of the first Pentecost, published in Antwerp by Theodoor Galle (1570/1571-1633), was pasted into the front of a 1668 handwritten set of rules and regulations of the Haarlem beguines. The print bears a striking similarity to the image on the chasuble cross. An even better example, albeit not exact, is the engraving by Claes Jansz Visscher of Amsterdam after Philips Galle (1537-1612) from 1643-1646.

The chasuble from Enkhuizen is the most intact product of the Haarlem Virgins' workshop.[1] The images of Ignatius of Loyola and Francis Xavier, both Jesuit saints, suggest that the chasuble may have originally been made for Jesuits who visited Enkhuizen from circa 1612 onwards. It was not until 1652 that the first clandestine Jesuit church was founded in Enkhuizen. The chasuble may already have come into the possession of one of the two secular clandestine churches in Enkhuizen (of St. Gummarus and St. Pancras), between 1622 and 1652, which might tell us something about the good relations between parish priests and priests who were members of monastic orders at that time.

108                          Fashion for God

13  St. Willibrord, Haarlem, Jacob Matham, 1608. Etching on paper. Haarlem, Noord Holland Provincial Archives, Voorhelm Schneevoogt Collection, Haarlem, Noord-Holland Provincial Archives, 1477-53010719.

15  St. Boniface, Haarlem, Jacob Matham, 1612. Etching on paper, 12.4 × 7.5 cm. Amsterdam, Rijksmuseum, RP-P-OB-78.022.

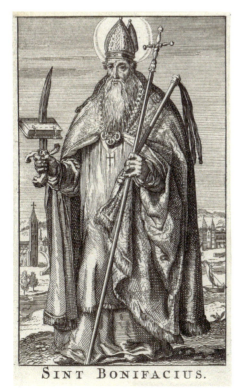

There is a chance that the chasuble in question was made by Brechgen Pietersdochter of Enkhuizen (died 1626), one of the Haarlem Virgins. The description of her life in the *Levens der Maagden* ('Lives of the Virgins') says that she practised 'the making of ecclesiastical ornaments, being of help to many Catholics who received the liturgical vestments, to perform God's ministry in their house [...].'[2] Her father, Pieter Corneliszoon, who was mayor of Enkhuizen in the Catholic era, and her mother, Gierte Pietersdochter, opened their home to itinerant Catholic priests and probably had a chapel there. 'Her father was named Pieter Cornelizson and her mother Gierte Pietersd. Very decent Catholics, so the Priests had access to their home.' This chasuble may have been used there for a time. This and the chasuble fragments from Grootebroek (cat. 11) make it clear that the Haarlem Virgins made paraments during the first period of oppression of the Catholic church (1583-1625), when priests went to private individuals in their homes to preside over religious services, and there were as yet no permanent house churches. The spiritual virgins in Haarlem were related to families who welcomed priests into their home; they probably also made paraments for priests who celebrated mass with their own family.

The chasuble from Enkhuizen is of a higher quality than some of the others from the workshop of the Haarlem Virgins, which was undoubtedly due to Brechgen's training. She had learned how to make paraments in Amsterdam: '[...] at a certain point arriving in Amsterdam, where she associated with the exemplary, since deceased, virgin Anna Jacobs van Campen, with whom she performed many holy works, such as the making of ecclesiastical ornaments [...]'.[3]

Given its workmanship, iconography and history, the chasuble to which the cross from Haarlem belongs was probably made by the Haarlem Virgins for use in their own church, St. Bernard's in den Hoeck.[4] The provenance of the chasuble from Maarssen is uncertain.[5] (RdB)

1  Stam 1988, p. 5; Dirkse 1989, pp. 89-90, cat. no. 73, fig. 75; Dirkse/Haverkamp 1991, p. 91, cat. no. 81 (with fig.); Begheyn 2003, p. 313, note. 55; De Beer 2023-II, pp. 150-155, 413-415, figs. 292, 293.
2  Oly 1625...-I, f. 205r-205v.
3  Oly 1625...-I, f. 205v.
4  De Bodt 1987-II, p. 121, cat. no. 74, p. 214, fig.; De Beer 2023-II, pp. 143-144, 150-155, 401-403, figs. 230, 231.
5  Stam 1987, pp. 32-50; De Bodt 1987-II, p. 121, cat. no. 73, p. 213, fig.; De Beer 2023-II, pp. 150-155, 416-417, figs. 299, 300.

# 10 Cross and column from a chasuble from Alkmaar

The chasuble cross and column are executed in the style of the work of the Haarlem Virgins that most closely approximates late-medieval examples. This may indeed be a background from a late-medieval parament, on which the Haarlem Virgins appliquéd new figures (and baldachins?). The floor tiles beneath the saints and the backgrounds of diagonal brickwork are executed entirely in the late-medieval manner. Above the figures are gothic-style baldachins like those on the chasuble from the quartet made for Rovenius in 1628-1641 [cat. 8], from the clandestine church of St. Bernard in den Hoeck in Haarlem. These baldachins consist of three-part gothic vaults with decorations in a renaissance style.

The iconography and history indicate that the chasuble from which this cross and column come could have been made in the seventeenth century for one of the two secular clandestine churches in Alkmaar, either the clandestine church of St. Lawrence, or the clandestine church of St. Matthew. At that time, nine spiritual virgins from Alkmaar had joined the congregation of the Haarlem Virgins, but the accounts of their lives in the *Levens der maegden* ('Lives of the Virgins') suggest that none of them was engaged in the making of paraments. They could of course have played a role in the acquisition of the chasuble from which the cross and vertical column come.

At the centre of the cross is a medallion with scrollwork, surrounding a contemporary baroque image of the Adoration of the Shepherds. This image is a detail from a painting by Peter Paul Rubens, one of the predella panels of the altarpiece he painted in circa 1618 for St. John's Church in Mechelen (now at the Musée des Beaux-Arts in Marseille). At the centre of the image is the Virgin Mary lifting Jesus' blanket to allow a kneeling shepherdess to see the Child. An engraving of precisely the same detail in mirror image was pasted into a 1637 manuscript from Den Hoeck in Haarlem (Utrecht, Museum Catharijneconvent, BMH warm H92D6) (fig. 17), published by Theodoor Galle, and in the 1662 manuscript by Johanna Cousebant, one of the Haarlem Virgins (opposite f. 36) (fig. 16). This print was published by Michiel Snijders of Antwerp, and was based on a 1620 engraving by Lucas Vorsterman. During the Christmas period the Adoration of the Shepherds appealed in particular to the maternal sensibilities of religious women at convents in the Late Middle Ages and Early Modern Period, as did the cradling of the Child. On either side of the medallion are two kneeling angels that are the mirror image of those on the crosses of the chasubles from Enkhuizen [cat. 9] and Den Burg [cat. 11].

Again, all the saints depicted on this chasuble cross and column are embroidered on the basis of contemporary engravings made in

A Gold chasuble cross, Haarlem, Maagden van den Hoeck, c. 1619-1650.

Gold thread, silk, linen, paint, 124 × 56,5 cm. Utrecht, Museum Catharijneconvent, BMH t9025a. Provenance: originally at either the former clandestine church of St. Lawrence in Alkmaar, or the former clandestine church of St. Matthew in Alkmaar.

B Gold column, Haarlem, Maagden van den Hoeck, c. 1619-1650.

Gold thread, silk, linen, paint, 110 × 19 cm. Utrecht, Museum Catharijneconvent, BMH t9025b. Provenance: originally at either the former clandestine church of St. Lawrence in Alkmaar, or the former clandestine church of St. Matthew in Alkmaar.

A

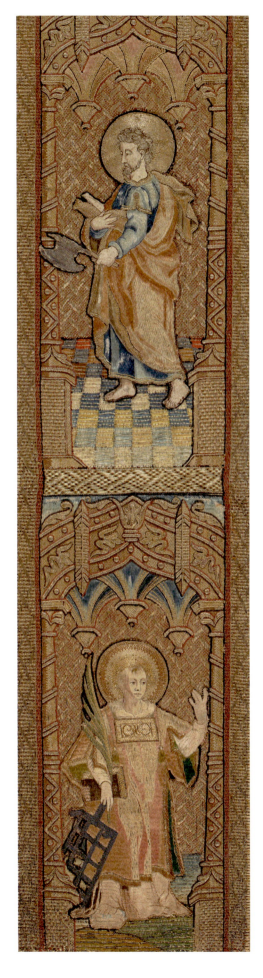
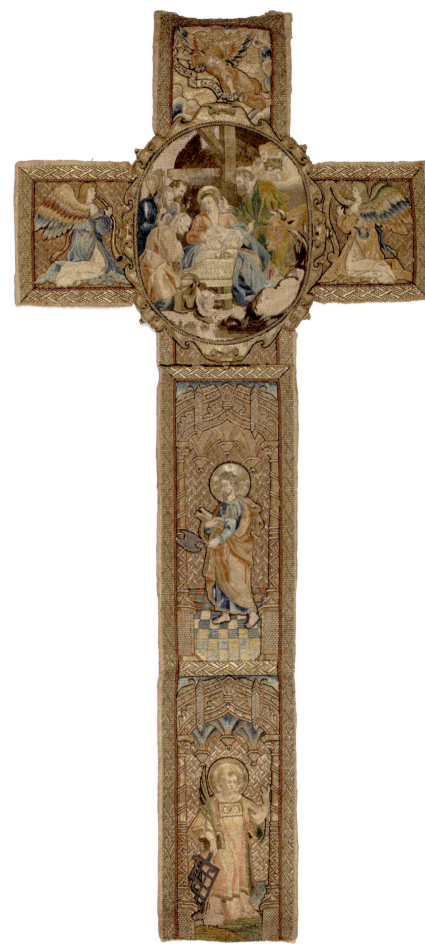

111  Fashion for God

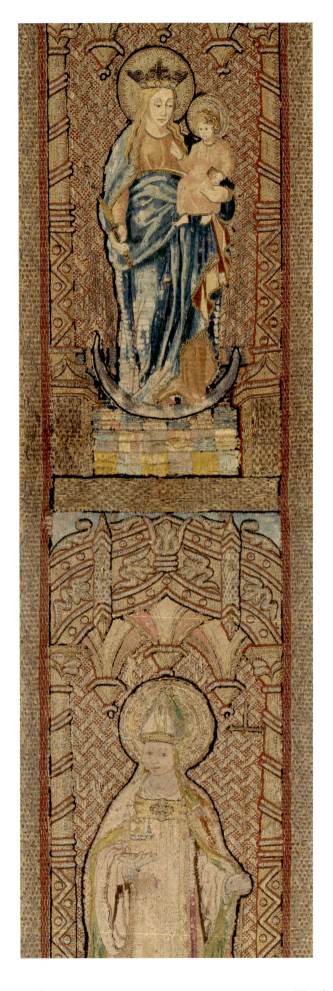
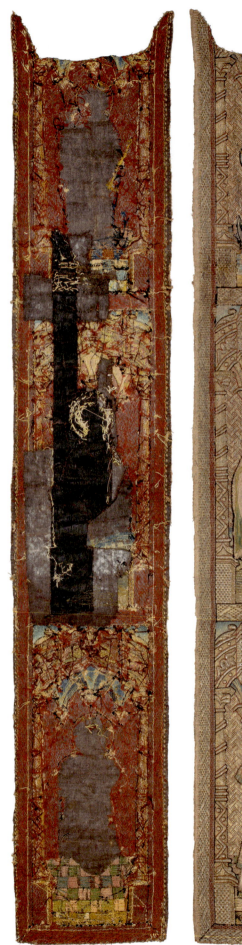
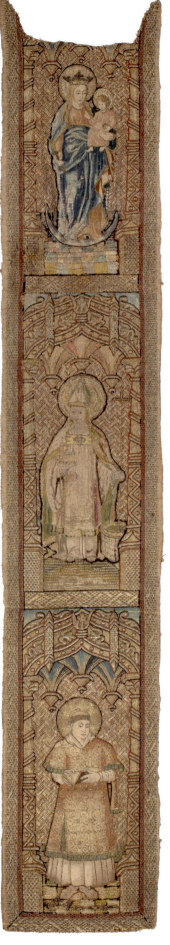

112  Fashion for God

16  Adoration of the Shepherds, Lucas Vorsterman I (engraving) and Lucas Vorsterman II (publisher) after Peter Paul Rubens, 1620. Engraving on paper, 283 × 440 mm. Utrecht, Museum Catharijneconvent, BMH g222.

17  Adoration of the Shepherds in the manuscript of Maria van Wieringen f. 169v, Theodoor Galle (publisher) after Peter Paul Rubens, 1637-1638. Engraving on paper, 175 × 120 mm. Utrecht, Museum Catharijneconvent, BMH Warm H92D6; on long-term loan from the Roman Catholic Diocese of Haarlem.

Detail Gold chasuble cross (BMH t9025a).

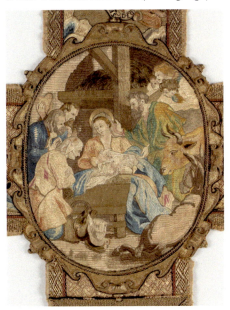

the circle of the Haarlem master Jacob Matham and his pupil Jan van de Velde II. On the vertical beam of the cross, beneath the central tondo, there are two saints, one above the other: at the bottom St. Lawrence as a deacon with a lattice and palm branch, and Matthew the Apostle with an axe above. Apart from the fact that Lawrence was the patron saint of the town and its main church, he and Matthew were the respective patron saints of the two secular Catholic house churches in Alkmaar in the early seventeenth century.

Furthermore, St. Adalbert is embroidered on the column on the front of the chasuble. He was the patron of the abbey at Egmond near Alkmaar, which had been destroyed. He is pictured as a deacon with a crown and sceptre at his feet. Above him, Willibrord has been embroidered on the column, with a model of a church and a cross-staff resting in a well, after an engraving by Jacob Matham of 1608.

Church leaders explicitly encouraged the use of images of Willibrord (and Boniface), who brought Christianity to the Netherlands, to strengthen the identity of the oppressed church. In the late sixteenth century the first vicar apostolic of the Dutch Mission, Sasbout Vosmeer (1548-1614), set up a new brotherhood of clerics and laity named 'Sodalitas Gratiae Dei' ('Brotherhood of the Grace of God') with Willibrord and Boniface as its patron saints. His successor Philippus Rovenius (1574-1651) also sponsored the brotherhood, helping it to flourish. (RdB)

1  De Beer 2023-II, pp. 150-155, 417-420, figs. 301-306.

2  Bruinvis 1896-I, pp. 190-219; Bruinvis 1896-II, pp. 410-422.

Fashion for God

# 11 Cross and column from a chasuble from Grootebroek, Cross and column from a chasuble from Den Burg, two fragments

A  Dark green chasuble cross, Haarlem, Maagden van den Hoeck (Reinou Gerretsdochter?), c. 1600-1624.

Velvet, silk, linen, gold thread, pearls, spangles, paint, 121 × 55 cm, 101 × 20 cm column). Utrecht, Museum Catharijneconvent, BMH t398a. Provenance: originally at the former clandestine church of St. John the Baptist in Grootebroek.

B  Dark green column, Haarlem, Maagden van den Hoeck (Reinou Gerretsdochter?), c. 1600-1624.

Velvet, silk, linen, gold thread, pearls, spangles, paint, 101 × 20 cm. Utrecht, Museum Catharijneconvent, BMH t398b. Provenance: originally at the former clandestine church of St. John the Baptist in Grootebroek.

C  Dark red chasuble cross, Haarlem, Maagden van den Hoeck, c. 1608-1625.

Velvet, silk, linen, gold thread, paint, 129 × 54.5 cm. Utrecht, Museum Catharijneconvent, BMH t571a1. Provenance: originally at the former clandestine church of St. John the Baptist in Den Burg, Texel.

D  Dark red, Haarlem, Maagden van den Hoeck, c. 1608-1625.

Velvet, silk, linen, gold thread, paint, 104 × 18 cm. Utrecht, Museum Catharijneconvent, BMH t571a2. Provenance: originally at the former clandestine church of St. John the Baptist in Den Burg, Texel.

E  Fragment a from a red orphrey or red chasuble column, Haarlem, Maagden van den Hoeck, c. 1600-1625.

Velvet, gold thread, 36.5 × 17.5 cm. Utrecht, Museum Catharijneconvent, ABM t2241a. Provenance: formerly in collection of Archdiocesan Museum.

F  Fragment b from a red orphrey or red chasuble column, Haarlem, Maagden van den Hoeck, c. 1600-1625.

Velvet, gold thread, 37.5 × 18 cm. Utrecht, Museum Catharijneconvent, ABM t2241b. Provenance: formerly in collection of Archdiocesan Museum.

These fragments show in detail the techniques used by the Haarlem Virgins. The saints and Bible scenes were embroidered separately and later applied to the vestments, where space had been reserved for them, as can clearly be seen on the back of the embroidery on the chasuble from Grootebroek[1] and on the two separate fragments showing niches in which, judging by the outlines of the missing appliqués, there must have been images of the Flagellation of Christ and of St. Martin of Tours.[2] All other ornamentation was embroidered directly onto the garment, rather than being added as a separate appliqué. This can be seen, for example, in the unfinished baldachins on the chasuble from Den Burg,[3] which are only present in outline. This way of working had much in common with late medieval methods.

The embroidery on the remnants of church vestments also bear all the characteristic hallmarks of work produced in the Haarlem Virgins' workshop: baldachins of symmetrically grouped vines of flowers, some in relief embroidery in gold thread, resting on pillars of gold thread on either side of the saints; backgrounds of dark green or dark red velvet, sprinkled with stars made of spangles; tiled floors alternating with blue, green and white grounds under the saints. Again, the appliquéd figures on the crosses and columns of the chasubles from Grootebroek and Den Burg were based on engravings from the circle of Jacob Matham (1571-1631) and Jan van de Velde II. Once more, there are many similarities between these and

A-B

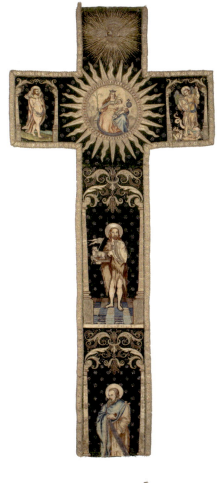

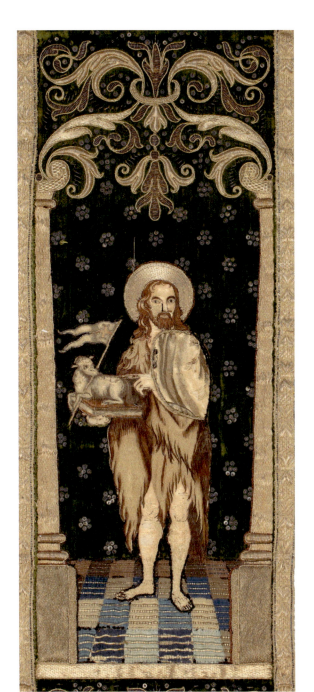
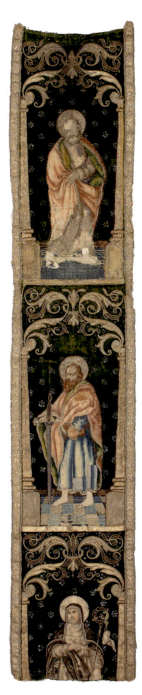

saints on other chasubles by the Haarlem Virgins from Alkmaar [cat. 10], Enkhuizen [cat. 9A], Maarssen [cat. 9C], Oude Schild, and at the Old Catholic Churches of Aalsmeer and Krommenie.

There is however a noticeable difference in the quality of the embroidery. The saints on the chasuble from Grootebroek (and on the chasubles at the Old Catholic Churches of Aalsmeer and Krommenie) were made by a much less skilled hand than the sublime figures on the chasuble from Den Burg. The difference in quality is confirmed in the *Levens der Maegden* ('Lives of the Virgins'), in the description of the life of Anna Sicxtus van Emmingha (died 1632), for example: 'In the community she practised for many years embroidering and sewing for the church [...], although she did not have the skill for it [...]'.[4]

115                      Fashion for God

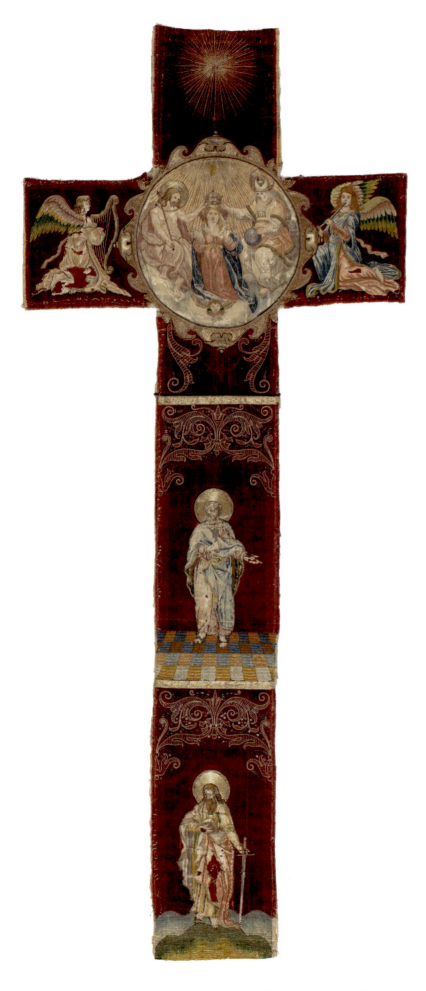
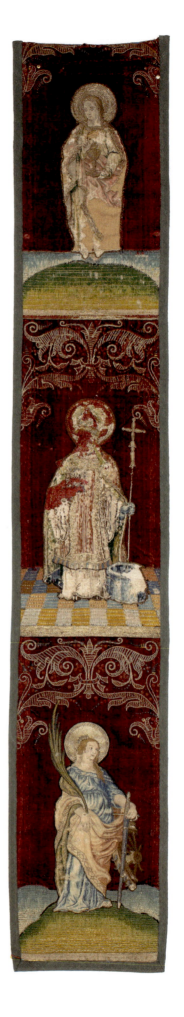

116            Fashion for God

E

F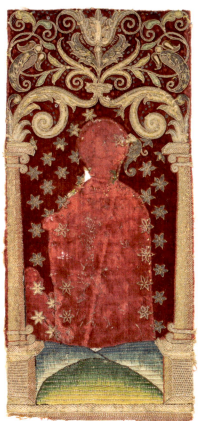

The chasuble from Grootebroek, from which the cross and column originate, might be linked to the three sisters Reinou Gerrets (died 1624), Dieuwer Gerrets (died 1599) and Machtelt Gerrets (died 1618) who were all spiritual virgins in the community of the Haarlem Virgins. Reinou worked on the production of paraments there. At some point, the spiritual leader of the Haarlem Virgins, Cornelis Arents Lichthert (1522-1613), ordered Dieuwer and Machtelt to remain in their hometown of Grootebroek: 'For in these desolate and anxious times there [were] few priests'.[5] The two women took over some of the duties of a priest; they 'gave education to the ignorant [and] also those outside the Catholic faith' were converted by the sisters. They and their parents also received priests in their home. Their brother Hercke (or Harcke) Gerretz was a consecrated priest.

It is thus clear, as in Enkhuizen (cat. 9), that the Haarlem Virgins were already making paraments in the first period of oppression suffered by the Catholic church (1583-1625), when itinerant priests still visited the faithful in their homes. The Haarlem Virgins made their paraments for the house churches of relatives, and it is quite possible that Reinou Gerrets did the same herself, including for her brother, the priest Hercke Gerretz. Perhaps this cross and vertical column are from one of her chasubles.

Despite the fact that few priests came to Grootebroek, the region between Hoorn and Enkhuizen — known as 'De Streek' — appears to have remained largely Catholic after the Reformation; the people there were sensitive about the matter, and far from passive.[6] On the island of Texel, too, there was fierce resistance to the anti-Catholic measures introduced by the national government. Men attacked the schout (a local law enforcement officer) who came to disrupt a papist assembly with pitchforks, while the women loudly announced their intention to 'sew him up in a blanket'.[7]

(RdB)

1 De Bodt 1987-II, p. 121, cat. no. 75, p. 214, fig.; De Beer 2023-II, pp. 150-155, 396-398, figs. 270, 271.
2 De Beer 2023-II, pp. 151, 407-408, figs. 367, 368.
3 De Beer 2023-II, pp. 150-155, 157-158, 409-411, figs. 288, 289.
4 Oly 1625...-II, f. 82v and 83r.
5 Oly 1625...-I, f. 17v, f. 147r.
6 Rogier 1945, pp. 507-509.
7 Rogier 1945, pp. 507-509.

Fashion for God

# 12 Jacob Olycan and Aletta Hanemans

Haarlem brewer Jacob Olycan and his wife Aletta Hanemans had their portraits painted by Frans Hals in 1625, a year after they married. They are shown in their finest clothes, which are lavishly embroidered. Jacob was 29 at the time, and Aletta was 19.

Hals was born in Antwerp, but grew up in Haarlem and was a member of the Haarlem branch of the Guild of St. Luke from 1610. He specialised in portraiture, and in the 1620s was one of the most sought-after portraitists in Haarlem. He portrayed the new generation of wealthy citizens, many of whom — like Hals himself — hailed from the Southern Netherlands.

The more established families were also faring well. The Haarlem brewers had found new markets in the provinces of Noord-Holland and Friesland, and there were approximately a hundred breweries in the town around 1625. Members of the wealthiest brewing families often held seats on the town council. Jacob Olycan came from two of these brewing families, the Olycans and the Voogts. His father Pieter Jacobsz Olycan traded in oil and grain in Amsterdam and was the owner of the brewery on Vogelstruis in Haarlem. Jacob's grandfather and uncles from the family of his mother, Maritje Claesdr Voogt, ran their own brewery. Nothing is known of Aletta Hanemans' parents, but her father was probably a business associate of her father-in-law. As the oldest son, Jacob followed in his father's footsteps, setting up his own brewery, 't Hoefijzer.

The portraits clearly demonstrate the family's wealth. Jacob and Aletta are wearing the latest fashions. Jacob's clothes are made of black silk damask and satin. Black silk signified wealth. Obtaining such a dark black was a complex and costly process. His white linen ruff, edged with lace, is tied with cords from which tassels hang. These small knotted tassels were extremely popular. Everyone wore them, though most were simpler than those worn by Jacob. There is no embroidery on his clothing, but his sleeves are richly decorated with silk ribbon, a product made in large quantities in Haarlem. Rich, colourful embroidery was actually only worn by young bachelors. Married men, who had a more serious position in life, wore black, perhaps with a narrow embroidered belt, though there is none in this portrait.

The most popular embroidered accessories for women were gloves, and the most opulently decorated was the 'borst', a type of bodice of which only the visible front was decorated.[1] The bottom (known as a 'snibbe') often protruded quite far to the front, or a separate, protruding peplum would be attached. A wedding was the ideal occasion to wear a new, lavishly decorated bridal bodice and wedding gloves. Both feature in Aletta's portrait. She is wearing a bridal bodice with gold embroidery, and holds wedding gloves with

A Portrait of Jacob Olycan, Frans Hals, 1625.

Oil on canvas, 125 × 97.5 cm.
The Hague, Mauritshuis, 459.

B Portrait of Aletta Hanemans, Frans Hals, 1625.

Oil on canvas, 124 × 98.5 cm.
The Hague, Mauritshuis, 460.

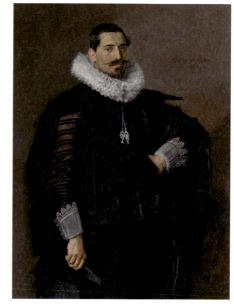

A

118  Fashion for God

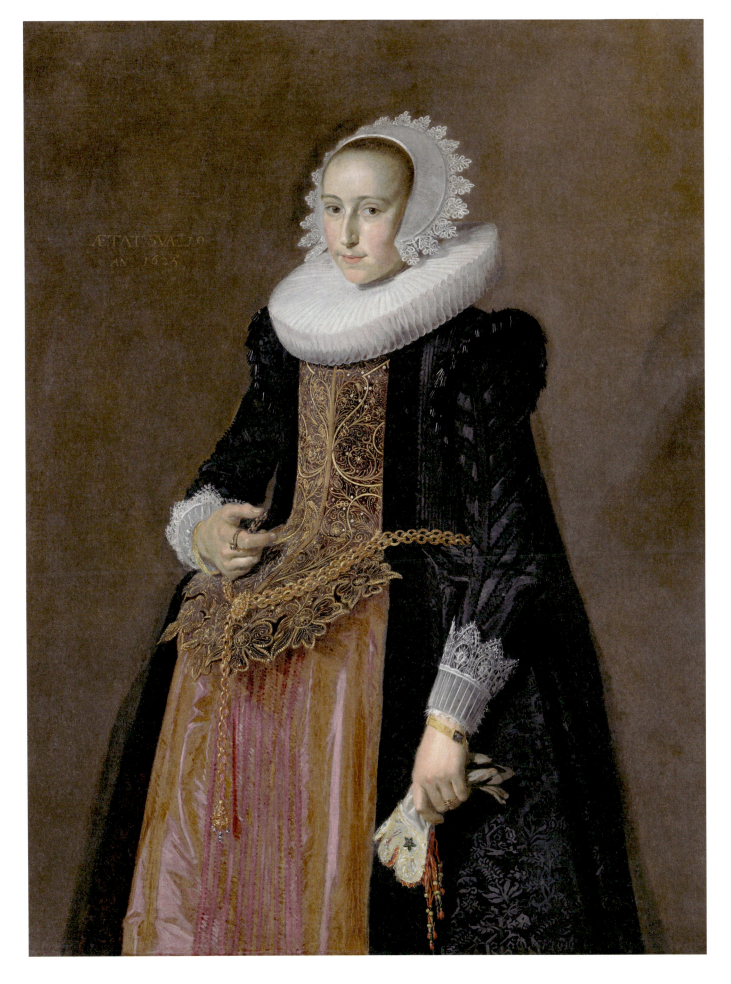

119 Fashion for God

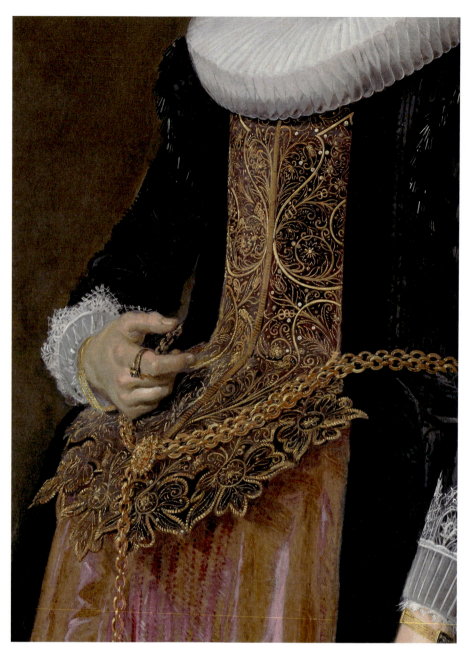

18  Detail of Aletta Hanemans' bridal bodice. The festoons and flowers are only outlined in gold thread, with purls between, and interspersed with spangles.

19  Portrait of a young woman by Nicolaes Eliasz Pickenoy, 1632. Oil on panel, 118,7 × 91,1 cm. The J. Paul Getty Museum, Los Angeles, 54.PB.3.

The women's bridal bodice is lavishly decorated with gold embroidery in high, detailed relief, made in different types of gold thread. The spangles and strips of purl can clearly be seen among the festoons. See also detail on page 123.

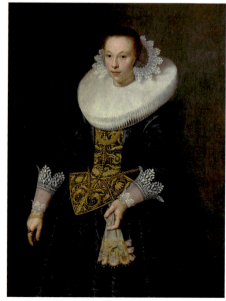

embroidered cuffs in her left hand. The rings on her right index finger and the bracelets on both wrists indicate that she is newly married. Her clothes show the two dominant styles at the time: rich gold embroidery on a dark background mixed with colourful motifs on a light background. Elegant festoons of small floral motifs meander down the front sections of the bodice, and the seam of the protruding 'snibbe' is particularly lavishly decorated with openwork floral motifs set off with gold galloon [fig. 18]. It can clearly be seen that the gold thread is couched and attached with invisible stitching. The small circles represent spangles, and the small stripes are pieces of purl. Only the outlines of the flowers and leaves are depicted, which is exceptional, as they would generally be filled with relief at that time. This form of decoration literally and figuratively reached a high point in the 1630s. Look, for example, at the bridal bodice which Amsterdam artist Nicolaes Pickenoy painted in 1632 [fig. 19].

Fashion for God

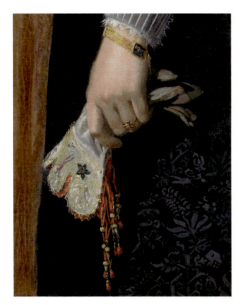

20 Detail of Aletta Hanemans' gloves, showing colourful flowers and birds — possibly a parakeet and a dove — among the gold embroidery and pearls.

21 Detail of the cuff of a glove featuring a parakeet and a greenfinch, circa 1625-1640. Six Collection, Amsterdam.

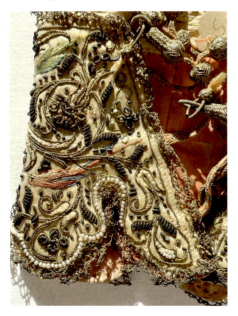

It features leaves, flowers and monstrous creatures embroidered in various kinds of gold thread, like small sculptures against the black velvet.

The decoration on Aletta's gloves is very typical of the time. Delicate festoons are embroidered in gold thread on the white satin, with leaves in relief, interspersed with colourful flowers and birds (fig. 20). Festoons of small pearls accentuate the decoration. The lobed cuffs are edged with gold lace. Braided cords of red silk and gold thread, with tassels, are used to fasten the gloves. The red lining contrasts sharply with the white satin, while the gloves, in turn, are a sharp contrast with the restrained tones of the clothes — a coat in black silk damask over a bluish-purple skirt. The skirt now appears bright pink and brown in the portrait due to the discolouration of unstable pigments.[3]

The cuffs of Aletta's gloves are similar to those on a set in the Six Collection (fig. 21). These cuffs, which are also scalloped, feature the same composition of delicate festoons in gold and silver thread and small pearls, with colourful birds among them. The birds were not a chosen randomly; they symbolise good qualities for a married woman.[3] The brightly coloured parakeet, with its hooked beak and long tail, symbolises inquisitiveness, the white dove simplicity. These gloves also have the same contrasting (though now faded) pinkish red cords and lining.

We do not know where the embroidery on Aletta Hanemans' bodice and gloves was done. Jacob Olycan grew up in Amsterdam, and married Aletta in Zwolle, but they moved to Haarlem soon after the wedding, and it was there that their portraits were painted. There were good embroiderers in both Haarlem and Amsterdam. We know that in 1634 thirteen embroiderers were members of the Guild of St. Luke in Haarlem.[4] We have no reason to believe there were substantially fewer a decade earlier. There were also at least as many embroiderers in Amsterdam. Both places had a wealthy and fashion-conscious elite, so there was a good market for costly embroidery. The customers were both Reformed and Catholic; denomination was irrelevant when it came to fashion, and their clothes and accessories were made by the same craftsmen. (MvR)

1 Kruseman/Bos 2022, pp. 78-91.
2 Ibrahim 2021.
3 Du Mortier 1984, pp. 189-201.
4 Miedema 1980.

Fashion for God

# 13 White gloves with embroidered cuffs

Aletta Hanemans' gloves [cat. 12] were richly decorated, yet they were quite restrained compared with this pair. These were made slightly later, around 1630, probably for a lady with connections to the court in The Hague. They come at any rate from the Van der Heim family of The Hague. There were two very high-ranking ladies in The Hague in 1630: Amalia von Solms-Braunfels and Elizabeth Stuart. Amalia had been lady-in-waiting to Elizabeth, the exiled Queen of Bohemia, but after she married Prince Frederick Henry in 1625 their relationship changed. The two ladies competed in displays of opulence, and they had a lot of impact on court culture, as these gloves demonstrate.

There is a set at the Bayerisches Nationalmuseum in Munich that includes an almost identical pair of gloves [fig. 22], along with a pincushion and a German prayer book in an embroidered binding, printed in Sedan in 1629.[1] This small Protestant state in France had relations with the Northern Netherlands. Elisabeth of Nassau, one of William of Orange's daughters, had married Henri, Duke of Bouillon and Prince of Sedan in 1595. The small town was home to some important printers who also supplied the Northern Netherlands. When the set was acquired in 1962, it was thought that it had belonged to Elizabeth Stuart, but it is now clear that it could not have belonged to her.[2] The items were clearly made for a wedding, and Elizabeth was already married in 1613. Furthermore, a woman of such high rank would have worn unique gloves. The set was probably made for a wedding that took place in or near The Hague around 1630, of a couple that had connections with Germany.[3]

Both sets have cuffs of dark purple satin featuring gold embroidery in the typical workshop style, with outlines in gold thread, filled with purl over relief, with spangles and strips of purls scattered between them. They both have rows of small pearls and are decorated with motifs of burning hearts, hearts pierced by arrows, and flowers. Both sets feature three-coloured pansies and roses. The gloves at Kunstmuseum Den Haag are also decorated with lilies and carnations, while the set in Munich features tulips, trillium and a wood violet [fig. 22]. These flowers symbolise marital fidelity, love, simplicity and modesty, qualities regarded as essential for a good housewife at that time. The cuffs of both pairs are edged with gold lace, from which teardrop-shaped spangles hang. Similar lace with spangles can be seen in the 1632 portrait by Nicolaes Pickenoy [fig. 23]. The painting gives a good impression of the dramatic effect of the shimmering spangles. (MvR)

Gloves, c. 1625-1635.

Leather, satin, gold thread, silver thread, silk thread and pearls, gold lace, spangles, 34 × 23 cm. The Hague, Kunstmuseum Den Haag, 151201.

1 Borkopp-Restle 2002, pp. 148-150.
2 Braun-Rönsdorp 1963, pp. 1-16.
3 Hahn 1928, no. 361, fig. XV.

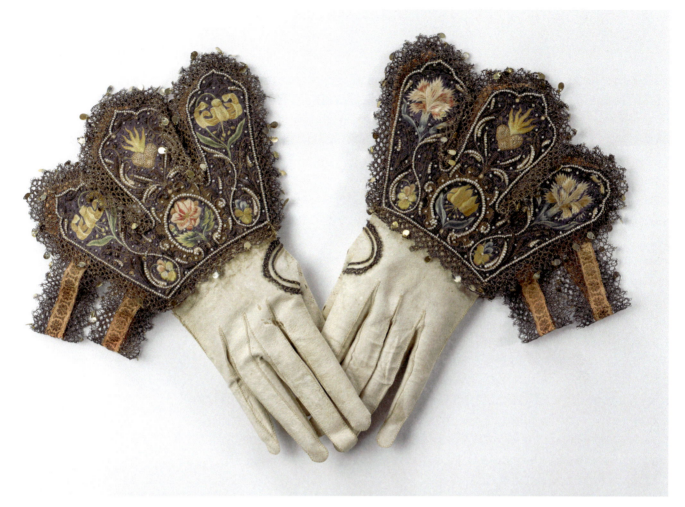

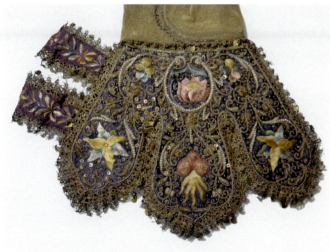

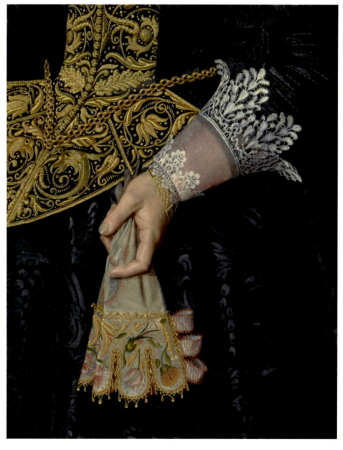

22 Cuff of a glove belonging to a set that also includes a pincushion and a psalter and prayer book printed in Sedan in 1629. The Hague (?), circa 1630-1635. Munich, Bayerisches Nationalmuseum, 62/21.1-3

23 Detail of a portrait of a young woman by Nicolaes Eliasz Pickenoy, 1632. The J. Paul Getty Museum, Los Angeles, 54.PB.3.

The scalloped cuffs of these gloves decorated with gold and silk embroidery are edged with lace made of gold thread, from which teardrop-shaped spangles hang.

Fashion for God

# 14  An embroidered church book

After the Reformation the Book of Books, the Bible, became the most frequently read book in the Northern Netherlands. Every Reformed household had a Bible or church book which contained the New Testament and the Psalms. They could be decorated in a particularly lavish way.

A couple's engagement was regarded as the ideal moment for a man to give his intended a Bible with an embroidered binding. Such a gift demonstrated his wealth. The bindings were full of the symbols of marriage, and this one is no exception.[1] A carnation and a rose feature prominently on the front and back. The carnation symbolises fidelity, the rose love, and the combination of the two represents marriage. Around these flowers there are fruits, a peacock, a parrot, a goldfinch and a greenfinch, combining symbols of marriage and Christianity.

The binding shows what the embroiderers of the time were capable of. This is the very best workshop production, combining gold and silk embroidery. The contours in couched gold thread filled with silver purl over relief and featuring tiny spangles, pieces of purl and pearls, are typical of the time. The binding is however exceptional in terms of the great diversity of embroidery stitches and the beautiful silk embroidery in satin stitch.

As well as a Bible, the volume also contains the *Voet-pat der eenvoudigher menschen. Ofte Den conincklijcken wech tot den hemel* (*Plaine man's path-way to heaven*) by Arthur Dent.[2] This work is full of admonitions, but Dent's call to dress in a restrained manner is certainly not reflected in the binding on this volume. (MvR)

Bible and Puritan book in embroidered binding, c. 1615-1620.

Silk satin, gold thread, silver thread, silk thread, pearls, silver, 16 × 9.5 cm. The Hague, Royal Library, KW 1769 E 1.

Contains: *Biblia dat is De gansche Heylige Schrift*. Uldrich Cornelisz, Leiden, for J.E. Cloppenburch, Amsterdam, and I.J. Canin, Dordrecht, 1615, and: Arthurus Dentus, *Voet-pat der eenvoudigher menschen. Ofte Den conincklijcken wech tot den hemel*. A. van Herwijck, Utrecht, for H. Laurensz, Amsterdam, 1614

24 'Maegde-wapen', print from: J. Cats, *Hovwelyck. Dat is het gansche gelegenheyt des echten-staets*. Middelburg 1625. Amsterdam, Rijksmuseum, RP-P-OB-15.626.

The personifications in this print represent the ideal qualities of a housewife. 'Leer-sucht' ('Inquisitiveness') carries a parrot or parakeet, which is capable of learning all kinds of things, as can the dog seated on its hind legs at her feet. An embroidery frame hangs from her arm, and books and tools for embroidery and lacemaking lie on the ground. The more plainly dressed 'Een-voudcheyt' ('Simplicity') carries a dove on her hand, and is accompanied by a lamb. She holds a wreath of roses. The tulip in the coat of arms illustrates the motto 'lateat dum pateat', 'it hides until it opens'. In other words, the tulip remains closed to the bees trying to make their way in. The symbols of love seen here also featured regularly in embroidery.

1  Van Roon 2023.
2  Op 't Hof 1987.

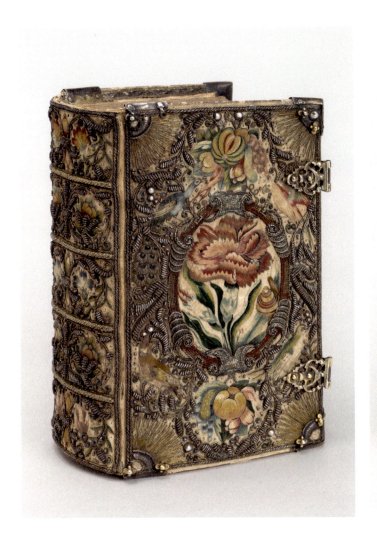 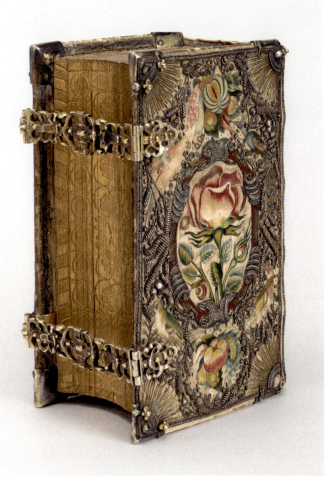

125　　　　　　　　　　　　　　　Fashion for God

# 15 Song book belonging to Elisabet Reid

Many accessories had embroidered decoration, particularly gloves and attributes that ladies would hang from their belts on cords, such as purses and pincushions. Books could also have an embroidered binding. These would mainly be church books, though they also included song or friendship albums belonging to young, unmarried women. These albums are full of beautifully penned song lyrics, verses, sayings and drawings on the subject of friendship and love.[1]

This song book, which belonged to Elisabet Reid, is one example.[2] It begins with a printed copy of P.C. Hooft's *Emblemata Amatoria* from 1611, which is full of small prints and pieces of writing featuring Cupid, and it describes the pleasure and perils of love. This is followed by several handwritten Dutch and French love songs and verses, dating to 1618-1624.[3]

The red velvet binding was made in in 1617, before Elisabet started using the album. Her name and the year are embroidered on the front, and the words 'Naest God Eer' appear on the back. The letters in these words overlap, which is a typical feature of this type of album, in which intricate designs might also be made with the lettering in the verses. The embroidery is fairly simple, consisting of single gold thread used for couched work in the form of curling vines pomegranates that twine around the frame. It is a decorative design, probably from an ornamental print.

We know nothing about Elisabet Reid, but she will have been under the age of twenty when she started using the album. Entries by Adrien Gerard de Sueserenghe and A. van Ruetenberch of Utrecht suggest she lived in or near that city. And there is another entry that suggests Utrecht as the setting: three drawings of Cupid, one of which is identical to a known drawing by Utrecht artist Joachim Wtewael, now at the Wallraf-Richartz-Museum in Cologne.[4] In both drawings, the little god of love sits quite relaxed, on the ground, his bow drawn back, ready to shoot his arrow (fig. 25). Beside him is a burning torch, symbolising the fire of love.

Though the contents of the volume are largely cheerful or teasing, there is a serious aspect to the decoration on the binding. The words on the back, 'Naest God Eer' (literally 'Besides God Honour'), occur in a number of nationalistic texts, including a 'Geuzen' song book of 1597. In essence, it means that honour is due both to God and to Prince Maurits. Grotius also used these words, in his case in reference not to a specific person but to the legitimate government which, after God, also deserves honour. (MvR)

Song book with embroidered binding, 1611-1624.

Silk velvet, gold thread, 14.5 × 18.5 cm. The Hague, Royal Library, KW 76 H 4.

Contains: P.C. Hooft, Emblemata amatoria / Emblems of Love / Emblemes d'amovr. Willem Jansz Blaeu, Amsterdam 1611, followed by handwritten and drawn entries from c. 1618-1624.

25 Cupid, Joachim Wtewael (attributed to), c. 1617-1624, in Elisabet Reid's album.

Elisabet Reid's album also includes a set of drawings of Cupid. In one of them, Cupid pulls back his bow, as he does in the drawing by Wtewael, and the torch burns brightly. In the second drawing, Cupid's bow is broken and the torch extinguished. Success and failure in love were popular themes in such albums for young women.

1 Reinders 2017.
2 Van Roon 2023.
3 Leerintveld 2014, pp. 75-87.
4 Robels 1983, no. 95.

# 16 White floral chasuble and mitre of Boudewijn Catz and portrait of Boudewijn Catz

A White floral chasuble, Haarlem, Maagden van den Hoeck, c. 1662-1663.

Silk, gold thread, silver thread, floss, paint, pearls, semi-precious stones, glass, spangles, 132 × 63 cm. Utrecht, Museum Catharijneconvent, BMH t129a. Provenance: originally at the former clandestine church of St. Bernard in den Hoeck in Haarlem.

B White mitre, Haarlem, Maagden van den Hoeck, c. 1662-1663.

Silk, gold thread, floss, silver galloon, spangles, 37 × 32 cm (excl. orphreys). Utrecht, Museum Catharijneconvent, BMH t42a. Provenance: Haarlem: originally at the former clandestine church of St. Bernard in den Hoeck in Haarlem.

C Portrait of Boudewijn Catz (1602/03-1663), Pieter Fransz de Grebber (attributed to), 1643.

Oil on panel, 109.5 × 87 cm. Utrecht, Museum Catharijneconvent, BMH s9212. Provenance: originally in the chapter room beneath the former clandestine church of St. Bernard in den Hoeck in Haarlem.

This white floral chasuble with accessories, which was probably originally part of a quartet with an altar frontal, was made by the Maagden van den Hoeck (or Haarlem Virgins) for Boudewijn Catz in 1662-1663, when he was appointed vicar apostolic against his will.[1] He must have been around sixty years of age and his health was no longer good. He would not at any rate have looked the same as he did in the portrait, which shows him as a still vital forty-year-old man. Catz lost his mind in April 1663, and died on 18 May 1663 in Louvain, where he had been cared for.

Catz had been the superior of the Haarlem Virgins from 1641 to 1661, before being appointed vicar apostolic. It is therefore likely that they made this set of paraments with particular pride and zeal.

The 1791 inventory of the clandestine church van St. Bernard in den Hoeck describes the set as 'N9 A White fabric ornament with Coloured flowers with a Vesper cope two Dalmatics A Chasuble and maniples and Stoles belonging to it'.[2] The set also includes a white mitre with a floral motif. When the chapter of Haarlem laid claim to this set of paraments in 1727, the spiritual virgin Elisabeth van de Werve opposed it. In a letter to the chapter she swore that these vestments were made and paid for by the Haarlem Virgins specially for Boudewijn Catz.[3]

The parament set is an example of a later phase of the embroidery produced by the Haarlem Virgins. In the second half of the seventeenth century they too gradually shifted to designs that were in keeping with the latest developments. The chasuble that they made for vicar apostolic Boudewijn Catz is a mix of the old and new forms. The columns on the chasuble still feature the medieval positioning of saints one above the other, as a kind of final expression of this style, while the rest of the chasuble has a rich pattern of trailing foliage and colourful flowers (irises, carnations, tulips, daffodils, cornflowers and roses). The front and back of the mitre also feature vertical bands of colourful embroidered flowers (columbines, fritillaries, carnations, cyclamen, cornflowers and lilies), which are not entirely consistent with the style of the chasuble.[4]

A

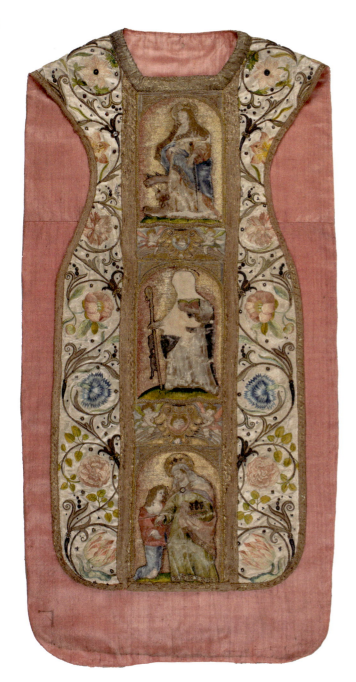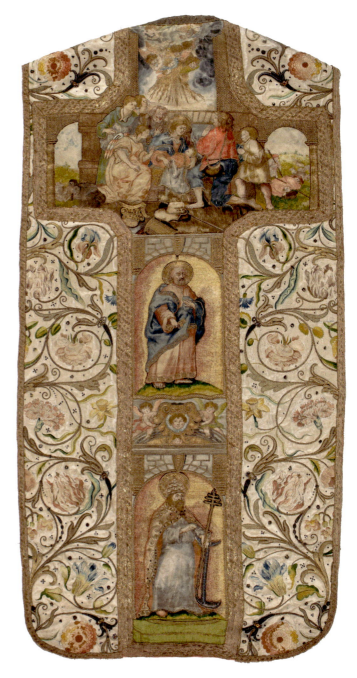

The spiritual virgins in the Northern Netherlands had already introduced flowers on chalice veils, burses and palls on a modest scale in the first half of the seventeenth century. The flowers symbolised virtues and played an important role in the visual culture of the spiritual virgins. The craze for flowers that emerged around 1640-1650 was influenced by international movements in the baroque, prompted by the Jesuits and the French court, among others. The French queen Marie de' Medici (1575-1642) encouraged the use of flowers to decorate paraments for example. Her passion for both flowers and embroidery was well known. It is said that she started the fashion for embroidery featuring naturalistic flowers in France. The artist and engraver Pierre Vallet published his florilegium *Le Jardin du très Chrestien Henri IV* in Paris in 1608. Some of the illustrations in

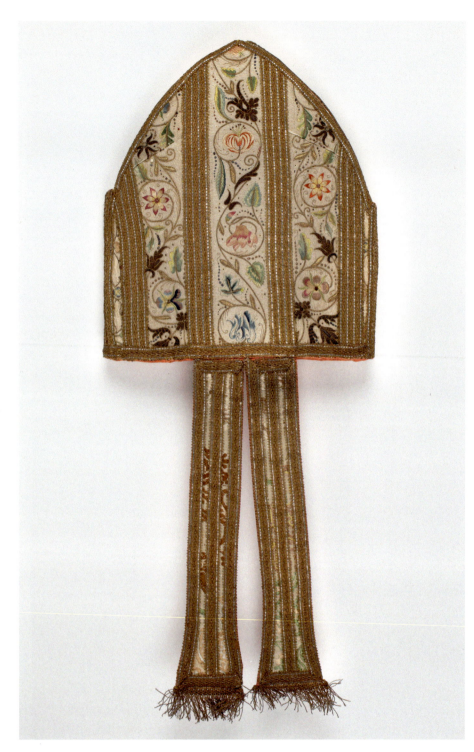

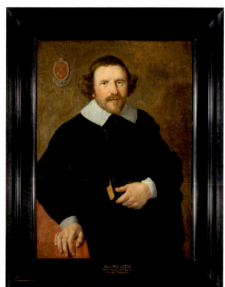

the book were images of flowers grown by the royal gardener Jean Robin specially for the use of embroiderers and silk weavers. Vallet called himself 'brodeur ordinaire' to the king, and dedicated his book to Queen Marie.[5]

The broad, sturdy figures of the individual saints on the chasuble associates them with the engravings of Haarlem painter Pieter Soutman (c. 1580-1657, active from circa 1616). Two saints are pictured one above the other on the vertical beam of the chasuble cross: Pope Clement with the papal tiara, anchor and papal cross, and Peter with his keys. On the vertical column on the front of the

130  Fashion for God

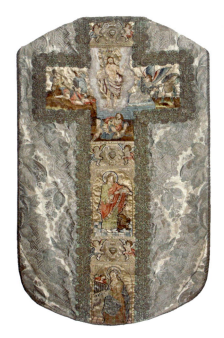

26 Cross from the chasuble that is said to have belonged to Stalpaert van der Wiele, Haarlem, Maagden van den Hoeck or Delft, spiritual virgins, c. 1625-1650. Silk, gold thread, gold galloon, 124 × 74 cm. Delft, Old Catholic Church of St. Mary and St. Ursula, 294-177.

27 St. Willibrord, Haarlem, Pieter Soutman (designer and publisher) and Cornelis Visscher II (engraver), 1650. Engraving on paper, 440 × 310 mm. Utrecht, Museum Catharijneconvent, BMH g76.18.

chasuble there are three saints: Elizabeth of Thuringia with a beggar at the bottom, above her Gertrude of Nivelles as an abbess, with staff and mice, and Catherine of Alexandria with a wheel and sword at the top. At the centre of the chasuble cross there is a baroque depiction of the Adoration of the Shepherds; the image on which it is based has not been identified. It may have been taken from an image made in the circle of Pieter de Grebber (c. 1600-1652/1653) or Jan de Bray (c. 1627-1697). The subject is fairly general — although there is also a female shepherd present — and appears to have been largely devised by spiritual virgins, who were particularly fond of such Christmas scenes, given the intimate maternal relationship with Jesus with which they are associated. They also identified with the female saints on the front of the chasuble. The virtues of these saints inspired imitation. There is no immediate explanation for the choice of Peter and Clement on the back.

The niches with the figures of saints on this chasuble resemble those on the chasuble which we know to have belonged to Pastor Stalpaert van der Wiele (1579-1630) at the Old Catholic church in Delft.[6] Between the niches on Catz's chasuble there are cartouches containing masks held by two putti. These are the same as the cartouches between the niches on Stalpaert's chasuble. Again, the sturdy figures of the saints in the niches in Delft suggest the work of Pieter Soutman.

The embroidery on Stalpaert's chasuble was made for the church on Bagijnhof in Delft either by spiritual virgins in Delft, influenced by the work of the Haarlem Virgins, or in Haarlem itself. There was a lot of contact and exchange between the spiritual virgins in Delft and Haarlem. Whatever the case, a great deal of time passed between Stalpaert van der Wiele's time as te parish priest in Delft (1612-1630) and the production of Catz's chasuble (1662-1663). It is of course possible that Soutman's engravings were kept in Haarlem for use in all kinds of commissions, and that these reference works were used over a long period. Or it may be that the Delft chasuble was not in fact made for Stalpaert, but came into being some thirty years later. (RdB)

1  De Beer 2023-II, pp. 146-148, figs. 240-244.
2  NHA 2106.6, inventory of goods 1791.
3  NHA 2106.52, f. 2r; De Beer 2023-II, pp. 146-148.
4  De Beer 2023-II, pp. 146-147, figs. 245-246.
5  Johnstone 2002, pp. 90-92.
6  De Beer 2023-II, pp. 164, 215-217, figs. 399-402.

131  Fashion for God

# 17 White floral chasuble from Amsterdam and white chasuble from Haarlem

Both chasubles have almost identical crosses decorated with flowers embroidered in chenille, and almost identical columns. At the centre of the crosses there is a pelican embroidered in silver thread (in mirror image on the two chasubles), feeding her young with her blood, symbolising Christ sharing his blood with the faithful during the ritual of the mass. The Amsterdam chasuble also has lavishly embroidered flowers and insects around the cross and column.

The Haarlem chasuble, the base fabric of which was replaced around 1750, comes from the clandestine church of St. Bernard in den Hoeck in Haarlem, the church of the Haarlem Virgins.[1] The chasuble is not very clearly mentioned in the various inventories made at the Church of St. Bernard between 1791 and 1852. In 1791 a reference is made to 'N10 A General white satin ornament Embroidered for Sundays with A Chasuble And A stole and A maniple and A separate Veil And A separate Chasuble With the passementerie cross Applied to it. A Ditto stole And A Veil Ditto with A pelican embroidered on it with A White Satin Cope also Embroidered And Besides the Sunday White ornament A Further Chasuble Embroidered with fruit With a maniple And A stole',[2] and in 1852 to 'A white silk banner with chenille flowers and a pelican made of silver thread and false fringing'.[3] Fairly mysterious inventory numbers, which might perhaps relate to this chasuble. This would make the chasuble part of a parament set with two chasubles, each with a stole and maniple, a cope, two chalice veils, one of which was decorated with a pelican, and a matching sacrament banner (also referred to as a veil) with a pelican.

Other almost identically decorated chasubles and related paraments have survived at Old Catholic churches in Noord-Holland and Zuid-Holland provinces, some in vibrant colours and some more tonal.[4] The chasuble from Amsterdam shown here, with vines of flowers and horns of plenty in almost primary colours is a focal point in this group. The possibility that this was produced at a later stage of the Haarlem Virgins' activity, when they abandoned archaic depictions of saints and Bible scenes in favour of more modern baroque designs, cannot be ruled out. The Haarlem Virgins had already embarked on this path when they decorated Boudewijn Catz's chasuble in 1662-1663 (cat. 16). Figurative embroidery has been abandoned completely, making way for a single symbolic image, such as the pelican with its young. (RdB)

A White floral chasuble, Northern Netherlands (Haarlem?), Maagden van den Hoeck (?), c. 1650-1675.

Silk, gold thread, 122 × 69 cm. Amsterdam, Old Catholic Church of St. Peter and St. Paul ('De Ooievaar'), 5052-119. Provenance: originally at the former Old Catholic Church of St. Willibrord and St. John on Brouwersgracht in Amsterdam.

B White chasuble, Northern Netherlands (Haarlem?), Maagden van den Hoeck (?), c. 1650-1675 (chasuble cross and vertical column on front); France / Northern Netherlands, c. 1750 (base fabric).

Silk damask, silk, gold thread, metal, 121 × 70 cm. Utrecht, Museum Catharijneconvent, BMH t128a. Provenance: originally at the former clandestine church of St. Bernard in den Hoeck.

1 Graaf 1900, p. 695, no. 565; De Beer 2023-II, pp. 379-381, figs. 222, 223.
2 NHA 2106.6.
3 NHA 2106.5, 1852 inventory of everything belonging to the suppressed R.C. clandestine church of St. Bernard and St. Francis and to the fund from the clandestine church of St. Bavo in Haarlem [St. Bernard's], suppressed in 1816.
4 Chasuble with accessories and altar frontal from the Old Catholic church in Leiden, chasuble with accessories, altar frontal and candlestick frontals from the Old Catholic church in Zaandam, cope from the Old Catholic church in Rotterdam, originally from the former Old Catholic Church of St. James Buiten de Weerd in Utrecht. De Beer 2023-II, p. 146, note 610, pp. 380-381.

A-B

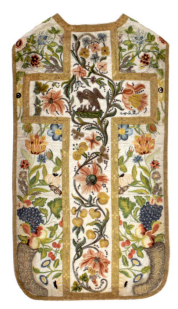
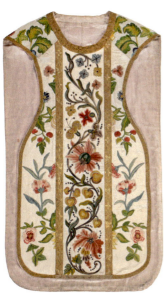
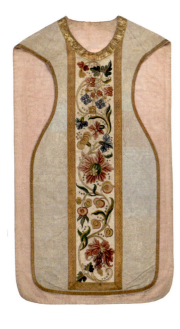
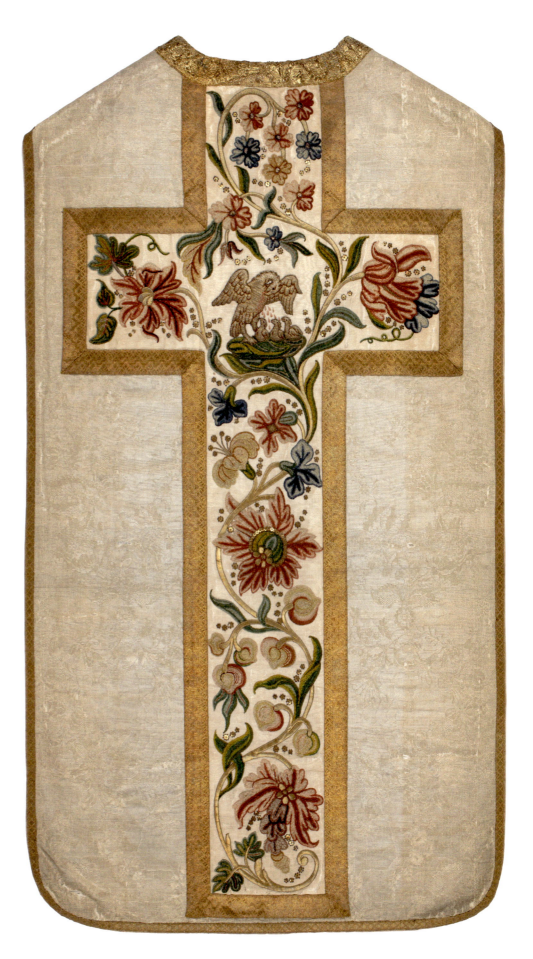

Fashion for God

# 18 White cope with beadwork from Haarlem, white beaded altar frontal and white beaded chalice veil from Rotterdam

A White cope, Haarlem, Maagden van den Hoeck, c. 1650-1700 (medallion at centre of cope shield); Haarlem, Maagden van den Hoeck or professional workshop, c. 1650-1700 (beaded edging around cope shield and beaded orphreys); Frankrijk, c. 1750 (base fabric).

Silk, glass beads, gold thread, 150 × 324 cm. Utrecht, Museum Catharijneconvent, BMH t624. Provenance: originally at the former clandestine church of St. Bernard in den Hoeck in Haarlem.

B White beaded altar frontal, Rotterdam, spiritual virgins of Paradijskerk or professional workshop, c. 1647-1675.

Satin, coloured glass beads, 100 × 231,5 cm. Rotterdam, Old Catholic Church of St. Peter and St. Paul ('Paradijskerk'), 3718-77. Provenance: originally at the former first Paradijskerk of 1647 in Rotterdam.

C White beaded chalice veil, Rotterdam, spiritual virgins of Paradijskerk or professional workshop, c. 1647-1675.

Satin, coloured glass beads, 56 × 56 cm. Rotterdam, Old Catholic Church of St. Peter and St. Paul ('Paradijskerk'), 3718-77. Provenance: originally at the former first Paradijskerk of 1647 in Rotterdam.

The Haarlem cope in its current form originates from several different periods.[1] The base fabric is French and dates from the mid-eighteenth century. This type of fabric, with large machine-woven flower and plant motifs was produced in many variations as curtain or upholstery fabric in the weaving mills of Lyon and Paris. The wild, dynamic forms and subtle colour nuances of these specific flowers were popularised around 1740 by fabric designer Jean Revel, the 'Raphael of Lyon'.

The more interesting elements of this cope are the beaded orphreys, shield and fastener. They are older and date from the second half of the seventeenth century. This means that the current base fabric replaced the original fabric, which was undoubtedly also white, around the mid-eighteenth century. The embroidered image at the centre of the shield shows the Presentation of Mary in the Temple, and the liturgical colour for this feast day was white. Like the other Marian feast days, this one also had great symbolic significance for spiritual virgins in the seventeenth and eighteenth centuries. They identified with Mary, and saw in the Presentation of the Blessed Virgin close similiarites with their own ceremonial acceptance of their spiritual state in the presence of the priest. The engraving which was used as a basis for this embroidery was made in Antwerp by Hieronymus Wierix (1553-1619) and is printed at the front of the book by Heribert Rosweyde, *Het leven der HH. maeghden die van Christus tijden tot deze eeuwe inden salighen staet der suyverheydt inde werelt gheleeft hebben, met een cort tractaet vanden maeghdelycken staet* (Antwerp, published by Jan Cnobbaert, 1626). This is regarded as a 'kloppenboek', which was intended to guide

28 Presentation of Mary in the Temple, Amsterdam, Hieronymus Wierix, c. 1590-1649. Engraving on paper, 102 × 66 mm. Amsterdam, Rijksmuseum, RP-P-1898-A-19888.

134 Fashion for God

A

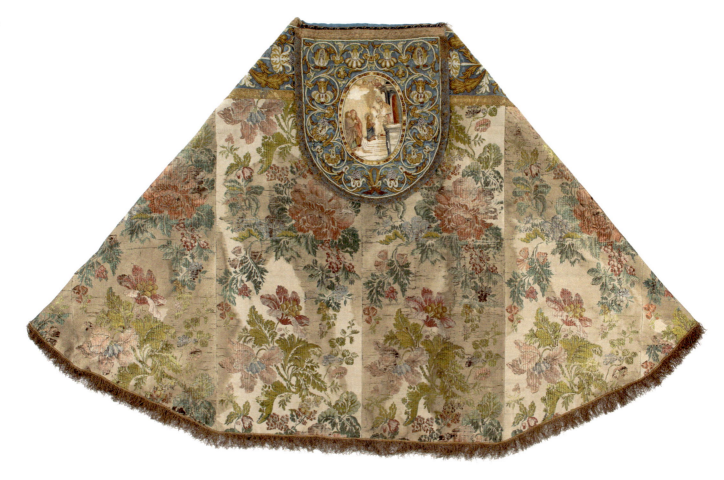

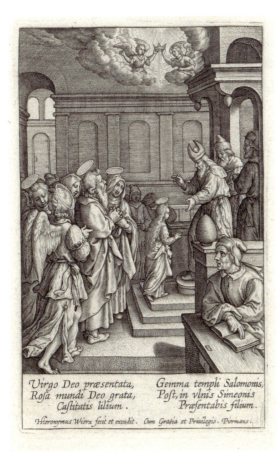

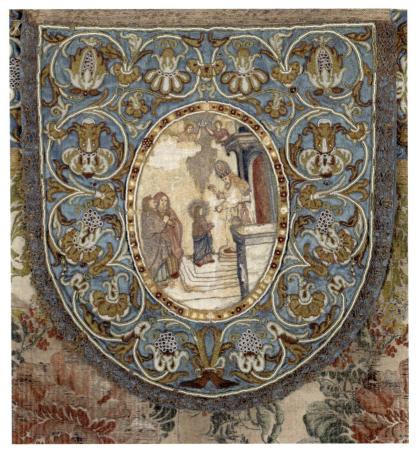

Fashion for God

the religious life of spiritual virgins. They were often written by their spiritual leaders on the basis of the writings of ecclestiastical authors. Some 'kloppenboeken', such as the one under discussion here, also provided a spiritual basis for the virgins' work on church vestments.

B

Given the fact that the cope comes from the clandestine church of St. Bernard in den Hoeck in Haarlem, the Haarlem Virgins' own church, it is likely that they chose and made the embroidered image on the cope shield themselves. It was probably part of a 'Coraale' (= 'beaded') quartet with accessories and frontals used at that church. The inventories of the clandestine church include various items that mention the set, or parts of it. In 1791: 'N8 A *Coraale* ornament with A Chasuble two Veils A stole And A maniple'[2]; in 1847 and 1850: '11 idem (= frontals) with beads large 1 small 2.'[3]; in 1852: 'A frontal, white silk for three altars in six parts with false fringeing and false beads and with liturgical vestments for three Gentlemen and a Vespers cope'.[4]

Whether the symmetrical embroidery featuring trails of flowers with coloured beads on the cope shield, the fastener and the orphreys were also made by the Haarlem Virgins or, for example, a professional workshop, is not clear at present. In this connection, it is interesting to note the cream-coloured parament set with coloured floral vines made of glass beads produced for the Paradijskerk in Rotterdam around 1650.[5] This church was founded in 1647 in the centre of Rotterdam by Chaplain Bernardus Hoogewerff (1613-1653), exclusively for the community of spiritual virgins, that was entrusted to his care 'in the manner of the Beguinage', which must have been symbolically important to the virgins.[6] The church was built opposite the main Catholic church of Rotterdam — known as

C

136            Fashion for God

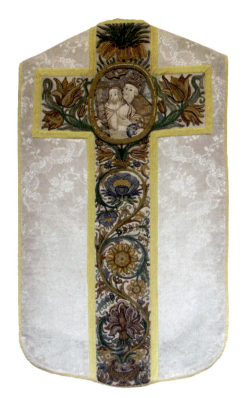

29 Beaded chasuble, Rotterdam, spiritual virgins of the Paradijskerk or professional workshop, c. 1647-1675 (cross on back and column on front); Frankrijk, c. 1750-1775 (base fabric). Silk, beads, pearls, gold thread, 123 × 71,5 cm. Rotterdam, Old Catholic Church of St. Peter and St. Paul ('Paradijskerk'), 3718-77.

the 'Oppertse kerk', which had become too small for the ever-growing community of spiritual virgins — on the site of the former fourteenth-century beguinage, known as the 'Clooster ten Paradyse'. That is why the church, officially dedicated to St. Peter and St. Paul, was nicknamed 'Paradijskerk' ('Paradise Church'). The parish priests of the church were also known as the 'priests of the Beguinage'.

At the centre of the beaded cross on the back of the chasuble from this set there is an oval medallion with an embroidered image in silk and gold thread depicting the Holy Trinity or Mercy Seat Trinity: God the Father holding Christ with the cross under his right arm, while the Holy Spirit hovers above in the form of a dove. This image is taken from a picture of the same subject from the early seventeenth century by Antwerp painter Artus Wolffort (1581-1641). Wolffort was an assistant to Otto van Veen, brother of Agatha van Veen, who initiated the production of paraments by the Haarlem Virgins. Here, too, we cannot rule out the possibility that this set of paraments was produced by Bernardus Hoogewerff's community of spiritual virgins themselves. Like the Haarlem cope, the Rotterdam parament set was made largely in the new baroque floral style, though with some elements reminiscent of the first half of the seventeenth century. (RdB)

1 De Beer 2023-II, pp. 383-385, figs. 234-236.
2 NHA 2106.6.
3 NHA 2106.5, inventory of goods 1847 and 6 July 1850.
4 NHA 2106.5, 1852 inventory of everything belonging to the suppressed R.C. clandestine church of St. Bernard and St. Francis and to the fund from the clandestine church of St. Bavo in Haarlem [St. Bernard's], suppressed in 1816.
5 De Beer 2023-II, p. 80, fig. 59.
6 De Oud-Katholiek 1931-II, p. 366; De Beer 2023-II, p. 117.

# 19 Green Willibrord chasuble from Delft and engraving of Willibrord

This baroque chasuble poses a number of puzzles. The medallion in the cross on the back contains an image of Willibrord, an almost perfect copy in the nué technique of the well-known 1630 engraving by Cornelis Bloemaert (II) after Abraham Bloemaert.[1] This depiction of the father of the church in the Northern Netherlands might suggest that the chasuble was made in the Dutch Republic. The border surrounding the medallion in relief embroidery in gold thread reveals its origin to be the Southern Netherlands, however. The accessories could also be from the Southern Netherlands.

There are five other virtually identical medallion borders in Delft, on altar frontals and chasubles.[2] Three currently have no central image, and the other two have a slightly inept embroidered image of the Annunciation and the Good Shepherd. The chasubles are otherwise very simple in their execution, with gold galloon as their only other decoration.

One conclusion might be that the borders were imported ready-made from the Southern Netherlands around 1650 and were then applied to paraments made in the Northern Netherlands. This might also be true of the accessories and the image of Willibrord, though it remains uncertain. The choice of the iconic saint, who defines the image of the church in the Northern Netherlands, would at any rate be consistent with the Willibrord images on paraments from the Northern Netherlands from the first half of the seventeenth century. Interestingly, this chasuble on which the image of this saint was used more or less for the last time was worn in the place which, shortly afterwards, played a major role in the conflict between Rome and the church of Utrecht, as a result of the involvement of Antoine Arnauld (1612-1694), who had fled from France, and parish priests like Joan Christiaan van Erckel (1654-1734). Perhaps the production of this chasuble was associated with the building of the new St. Hippolytus' Church on the Bagijnhof, by Pastor Suitbert Purmerent (1587-1650) in 1647. (RdB)

A  Green chasuble, Northern Netherlands (?) (chasuble), Southern Netherlands (?) (central medallion in cross), c. 1650.

Silk velvet, gold thread, silk thread, gold galloon, 25 × 75 cm. Delft, Old Catholic Church of St. Mary and St. Ursula at the Bagijnhof, 294-175. Provenance: originally St. Hippolytus' Church at the Bagijnhof in Delft.

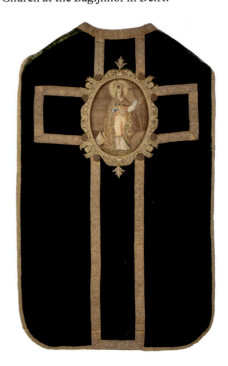

B  St. Willibrord, Cornelis Bloemaert (II) after Abraham Bloemaert, 1630.

Engraving, 293 × 202 mm. Museum Catharijneconvent, Utrecht, BMH g77.

---

1  Roethlisberger/Bok 1993, pp. 281-284, no. 431.
2  De Oud-Katholiek 1931-I, pp. 235-236; De Beer 2023-II, pp. 222-223.

A-B

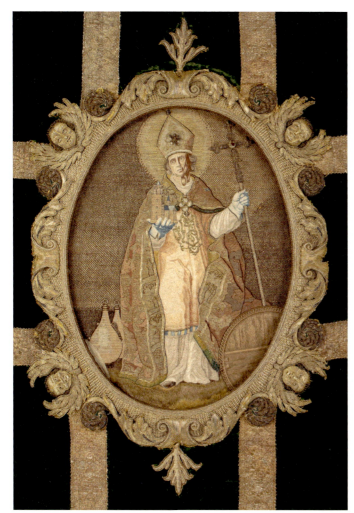

S. WILLIBRODVS seu Clemens Primus Vltraiectensium Archiepiscopus, et Frisiæ Hollandiæ, Zelandiæ,
Flandriæ Campaniæ Brabantiæ Geldriæ, Transwelaniæ, confiniumq, populorum Apostolus Consecratus Romæ

# 20 Red Rubens chasuble from Enkhuizen, engraving of St. Ignatius of Loyola and St. Francis Xavier and red altar frontal from Gouda

A  Saints Ignatius of Loyola and Francis Xavier, Schelte Adamsz Bolswert after Peter Paul Rubens, 1622.

Engraving, 345 × 245 mm. Amsterdam, Rijksmuseum, RP-P-BI-2558.

B  Red chasuble, Southern Netherlands (Antwerp, Lier?), c. 1650.

Silk velvet, gold thread, oil on linen (medallion in cross), 124 × 84 cm. Enkhuizen, Roman Catholic Church of St. Francis Xavier, 4895-113. Provenance: originally at the clandestine Jesuit church of St. Francis Xavier and St. Ignatius of Loyola in Enkhuizen.

C  Red altar frontal, Southern Netherlands (Antwerp, Lier?), 1648.

Silk velvet, gold thread, silver thread, gold lace, gemstones, pearls, spangles, 103 × 255 cm. Gouda, Old Catholic Church of St. John the Baptist, 1978-82. Provenance: originally at the clandestine church of St. John the Baptist in Gouda.

Imports of paraments from the Southern Netherlands started in the mid-seventeenth century, probably as a result of the end of the Eighty Years War. The peace between the Dutch Republic and the Spanish countries will have made it easier to import and export larger, expensive products. It can be no coincidence that the first set of paraments in Gouda from the Southern Netherlands, one of the most opulent baroque sets in the Northern Netherlands, has the date 1648 on its altar frontal, the year of the Peace of Münster.[1]

The end of the Eighty Years War made a return to the old pre-1580 situation unlikely. Under the influence of the baroque and the new situation in the Dutch Republic, the material culture of the church, including the liturgical vestments, gradually shed its references to the past, as people began to look forward rather than back. This precipitated a further break in the continuity of the Catholic church in the Northern Netherlands since the late Middle Ages. The Dutch church turned to the international church — an inevitability given all the developments in the church and state. The only identity-defining aspect that remained was the wealth of the Catholic church, which distinguished it from other denominations. The new paraments were the perfect vehicle for signalling this wealth.

Embroidery produced in the Southern Netherlands at this time is characterised by thick relief, and the use of silk and, above all, gold thread. The large baroque designs, combined with highly regular execution means that almost all of the embroidery must be the work of professional workshops. The use of gold thread in this way and on this scale would require a certain level of technique and training, at any rate. Flanders had had parament workshops since the late sixteenth century that provided the churches, stripped of their material culture during the Calvinist interlude, with new baroque textiles suited to the grand designs of painters Peter Paul Rubens and Anthonie van Dijck.

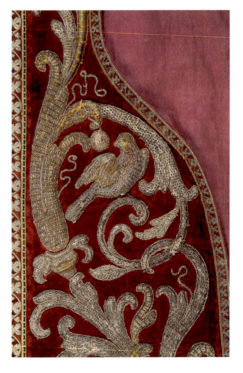

Detail of the front red chasuble, Southern Netherlands (Antwerp, Lier?), c. 1650.

Fashion for God

S. IGNATIVS DE LOIOLA *Societatis Iesv auctor obijt anno* M.D.LVI. *ætatis suæ* LXV. *confirmatæ Societatis* XVI. *constitutis Prouincijs* XII. *miraculis in vita et post illam clarus. paralyticos, cæcos, comitiali morbo laborantes, febribus inæstuates, varijs morbis, vulneribus, angoribus, tentationibusq̀; oppressos, mortuosq̀; sibi ac vitæ restituit: vaticinijs, frequentibusq̀; cælestibus visis illustris, orationis et lacrymarũ dono inter primos muneradus. à* SS.D.N. Greg. XV. A°. 1622. 12. *Martij in Sanctorum numerũ relatus.*

S. FRANCISCVS XAVERIVS *obijt anno* M.D.LII. *initæ Societatis* XIII. *verus Orientis Apostolus. cuius manu quinque supra viginti mortui vitæ redditi. supra decies centena millia salutaribus aquis tincti: stitit verbo exercitus, pluit oratione cineres, sedauit oceani tempestates, nobilissimarum victoriarum auctor et vaticinator. omniumq̀; propè ægritudinum depulsor. finit beatissimè vitam dum Sinarum subijcere Christo regna parat. à* SS. D. N. Greg. XV. A°. 1622. 12. *Martij in Sanctorum numerum relatus.*

The influence of the Jesuits in guiding developments should not be underestimated. Antwerp and Lier were the most important centres of embroidery in the seventeenth century. Churches in Flanders today still have considerable quantities of baroque paraments in very much the same style as the items imported to the Northern Netherlands, which can all be dated to the second half of the seventeenth century. The parament set in Gouda may have been purchased by Pastor Pieter Purmerent, possibly with Flemish Jesuits as intermediaries [see also cat. 21].

The red chasuble from the clandestine Jesuit church in Enkhuizen follows the designs of Rubens very closely. Meandering vines of

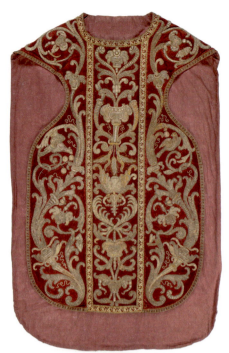

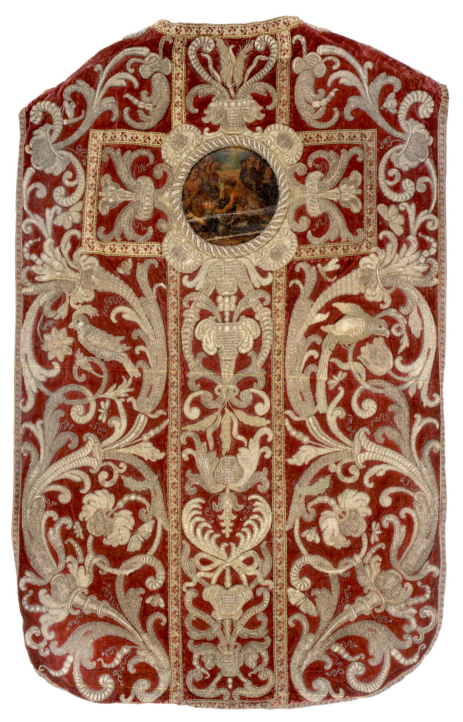

142                   Fashion for God

C

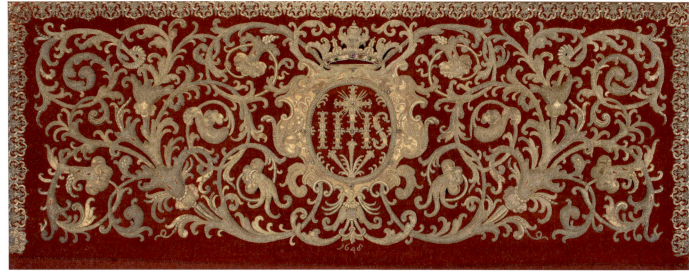
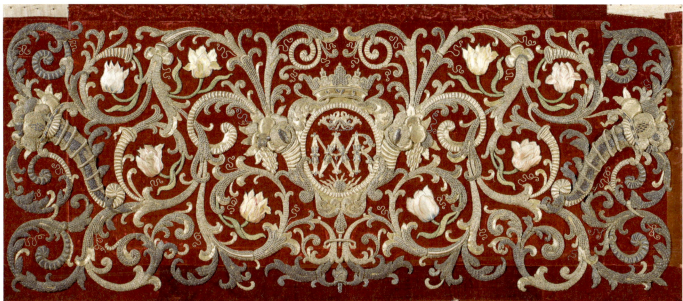

30  Red altar frontal in Antwerp, Southern Netherlands, c. 1650-1700. Silk, gold thread, 100 × 229 cm. Antwerp, Roman Catholic Church of St. Catherine ('Beguinage Church'), 59623.

foliage in relief embroidery in gold thread cover the entire surface of the front and back. There are striking similarities with the chasuble that St. Ignatius of Loyola, founder of the Jesuit order, wears in paintings and engravings by Rubens. In an engraving by Schelte Adamsz Bolswert after Rubens Ignatius' chasuble is virtually identical to the chasuble from Enkhuizen.[2] (RdB)

1  Van Eck 1994, pp. 57, 196.
2  Hollstein 1950, p. 82, cat. no. 239.

143       Fashion for God

# 21 White chasuble and white altar frontal of Pastor Pieter Purmerent of Gouda and painting of Bernard of Clairvaux Converting William X, Duke of Aquitaine

A  White chasuble, Gouda, spiritual virgins (?), 1640.

Silk satin, gold brocade, silk thread, gold thread, seed pearls, gemstones, 122 × 85 cm. Gouda, Museum Gouda, 20840a; on long-term loan from the Old Catholic Church of St. John the Baptist in Gouda. Provenance: originally at the clandestine church of St. John the Baptist in Gouda.

B  White altar front, Gouda, spiritual virgins (?), 1639.

Silk satin, gold brocade, silk thread, gold thread, seed pearls, gemstones, 104 × 260 cm. Gouda, Old Catholic Church of St. John the Baptist, 1978-81. Provenance: originally at the clandestine church of St. John the Baptist in Gouda.

C  Bernard of Clairvaux Converting William X, Duke of Aquitaine, Wouter Pietersz (II) Crabeth, 1641.

Oil on canvas, 141 × 237 cm. Gouda, Museum Gouda, 06741. Provenance: originally at the clandestine church of St. John the Baptist in Gouda.

The lavishly embroidered chasuble, a fairly broad Roman model, and the altar frontal are part of a parament set that took some two years to complete, from 1639 to 1640.[1] The altar frontal bears the date '1639' (bottom centre) and the chasuble has the date '1640' on the front. With its motifs of symmetrically grouped vines of foliage with colourful flowers — including roses, peonies, carnations, tulips, fritillaries and crown imperials — that cover the entire surface of the paraments, it is very much in the spirit of the international baroque, and is reminiscent of the designs created in the Southern Netherlands in the seventeenth century, under the influence of the Jesuits and Peter Paul Rubens. There are also similarities with the floral chasuble that the Haarlem Virgins made for vicar apostolic Boudewijn Catz in 1662-1663 (cat. 16), though the patterns here are more complex and sophisticated. While the cross and column on Catz's chasuble were still somewhat in line with the Dutch pre-Reformation traditions, these were abandoned entirely in the production of this chasuble and altar frontal.

We cannot rule out the possibility that this set was made by the community of spiritual virgins on Spieringstraat in Gouda. Around 1628, under the supervision of Jesuits from the Southern Netherlands, a small private school had been established where girls were educated by at least eight spiritual virgins or 'Jesuitesses', who were themselves from aristocratic or otherwise very eminent families. Such an education would include learning embroidery, and they might have been able to bring such a large, long-term project to fruition.

The parament set is dedicated to Mary. A crowned monogram of Mary, 'MRA', has been embroidered in gold thread, seed pearls and gemstones on a gold brocade background at the centre of the cross on the back of the chasuble. The central feature of the altar frontal is an embroidered version of the renowned icon of Mary at Santa Maria Maggiore in Rome, a miraculous image of the Virgin

31  Icon at Santa Maria Maggiore, Hieronymus Wierix, c. 1590-1600. Amsterdam, Rijksmuseum, RP-P-1898-A-198.

144  Fashion for God

A

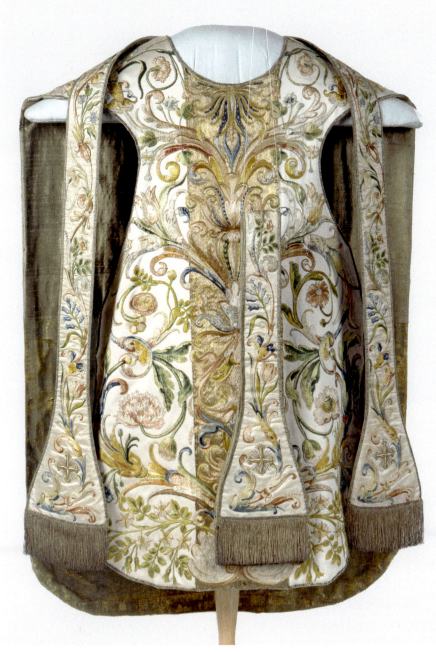

32 Pastor Pieter Purmerent, Ludolf de Jongh (design), Reinier van Persijn (engraving), c. 1650-1668. Utrecht, Museum Catharijneconvent, BMH g1602.

B

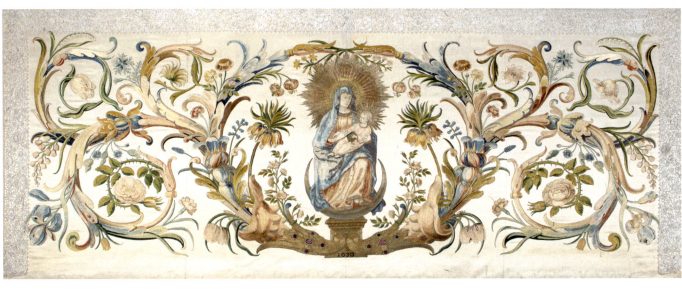

Fashion for God

and Child that was distributed throughout Western Europe from the sixteenth century onwards in graphic form, mainly by the Jesuits, and was also very popular among spiritual virgins.[2]

This set was probably commissioned by Pieter Purmerent, parish priest of the distinguished clandestine church of St. John the Baptist in Gouda (1615-1662). It is also possible that he received it as a gift, perhaps from spiritual virgins in his parish who had made it for him. The exact circumstances are not known. Though Purmerent had been the parish priest in Gouda for 25 years in 1640, the anniversary of a parish priest would not usually occasion major celebrations. Commemorating the consecration of a priest was much more important, but Purmerent had been a priest for thirty years in 1640, and this too was no anniversary associated with large celebrations.

Pastor Purmerent is shown in his brand new chasuble in a portrait historié from the Church of St. John the Baptist. It was painted in 1641 by Gouda artist Wouter Crabeth II (1584-1644), grandson and namesake of the famous Gouda glass painter, and it shows the conversion of William X, Duke of Aquitaine by St. Bernard of Clairvaux. Pieter Purmerent is the main character, Bernard. To the right of him is his assistant, recognisable as Willem de Swaen, the pastor of the clandestine church in Gouda known as 'De Tol'.[3] He wears the ceremonial stole belonging to the chasuble over his surplice, and he holds the crosier of the Bishop of Poitiers, who is standing to Bernard's right. Vicar apostolic Philippus Rovenius modelled for the bishop figure.[4] He wears red episcopal gloves and is wrapped in a medieval cope which is undoubtedly also painted 'from life', though

33 Vicar apostolic Philippus Rovenius, Bartholomeus Breenbergh (design), Jan Brouwer and Jacob Matham (engraving), Frederik de Wit (publisher), c. 1657-1662. Utrecht, Museum Catharijneconvent, BMH g1606.

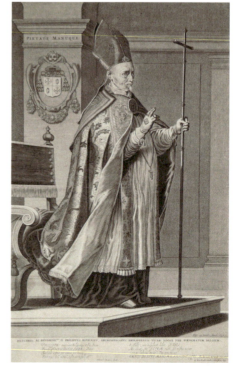

146            Fashion for God

34   Florentius Schoonhovius, Arnoud van Halen, c. 1700-1732. Amsterdam, Rijksmuseum, SK-A-4568.

the garment itself has not survived. Two of the women on the far right in the painting can probably be identified as spiritual virgins, recognisable thanks to the typical white cap on their heads, covered with a black cloth.[5] Could they be the Jesuitesses from the 'Maagdenhuis' community on Spieringstraat, who oversaw the production of the parament set, including the chasuble which Purmerent wears in the painting?

The painting was made out of gratitude for one or more conversions, brought about by the Dutch Mission, probably by Pieter Purmerent himself. The converts are grouped on the left around the Duke of Aquitaine, who lies on the ground. The convert on the far right can be identified as the Gouda humanist Florentius Schoonhovius, a Protestant of the Remonstrant persuasion who was converted to Catholicism by Purmerent in circa 1624, and became a parishioner of the clandestine church of St. John.[6]

Rovenius observes the group with pleasure. He was very keen on conversions, recognising their great polemical and propaganda value. He kept lists of converts which he proudly communicated to Rome. They were regarded as evidence of the predominance of the Catholic church over the churches of the Reformation. The painting and, indirectly, the chasuble thus bear witness to the self-assured identity that the Catholic church had managed to build up again after sixty years of oppression.

With a similar historical awareness and sense of tradition, liturgical vestments were used in Gouda as a vehicle of identity. Purmerent wore his new baroque chasuble, during his own lifetime, in a historical painting of Bernard of Clairvaux, and the old copes from the pre-Reformation era [cat. 1] are worn by the fathers of the Dutch church, Willibrord and Boniface, thus emphasising the continuous lines linking the church with the past. (RdB)

35   Willem de Swaen, Ludolf de Jong, 1652. Rotterdam, Museum Rotterdam, 10547-A-B.

1   Van Eck 1994, pp. 56-59, fig. 20 (chasuble), fig. 21 (altar frontal).
2   Noreen 2008, pp. 19-37; De Beer 2017, pp. 40-42.
3   Van Eck 1994, pp. 43-50, fig. 13, pp. 174-185.
4   Dudok van Heel 2008, pp. 122-123.
5   Abels (M) 2009, pp. 123-127.
6   Abels (P) 2002, pp. 442-443, 463-465, 485; Lenarduzzi 2019, pp. 156-157, 158, 311. They do not however recognise Florentius Schoonhovius in the painting.

# 22 Two dalmatics and a cope from Philippus Rovenius' quartet, with mitre, gloves and shoes, Aegidius de Monte's crosier, and portrait of Rovenius

A Dalmatic from Philippus Rovenius' quartet, Haarlem, Maagden van den Hoeck, c. 1628-1641 (dalmatic); Southern Europe (Italy, Spain, Portugal?), c. 1600 (base fabric).

Satin, gold thread, 112 × 121 cm. Utrecht, Museum Catharijneconvent, BMH t127b. Provenance: originally at the former clandestine church of St. Bernard in den Hoeck in Haarlem.

B Dalmatic from Philippus Rovenius' quartet, Haarlem, Maagden van den Hoeck, c. 1628-1641 (dalmatic); Southern Europe (Italy, Spain, Portugal?), c. 1600 (base fabric).

Satin, gold thread, 112 × 122 cm. Utrecht, Museum Catharijneconvent, BMH t127c. Provenance: originally at the former clandestine church of St. Bernard in den Hoeck in Haarlem.

C Cope from Philippus Rovenius' quartet, Haarlem, Maagden van den Hoeck, c. 1628-1641 (cope); Southern Europe (Italy, Spain, Portugal?), c. 1600 (base fabric).

Satin, gold thread, 159 × 324 cm. Utrecht, Museum Catharijneconvent, BMH t127d. Provenance: originally at the former clandestine church of St. Bernard in den Hoeck in Haarlem.

D Mitre, Haarlem, Maagden van den Hoeck, c. 1628-1641; Southern Europe (Italy, Spain, Portugal?), c. 1600 (base fabric).

Satin, gold thread, 43 cm (excl. fanons). Utrecht, Museum Catharijneconvent, BMH t42e1. Provenance: originally at the former clandestine church of St. Bernard in den Hoeck in Haarlem.

E Two sandals, Haarlem, Maagden van den Hoeck (embroidery), c. 1628-1641.

Leather covered with silk, gold thread, spangles, 12 × 9 × 27 cm (each). Utrecht, Museum Catharijneconvent, BMH t42e2, BMH t42e3. Provenance: originally at the former clandestine church of St. Bernard in den Hoeck in Haarlem.

F Two gloves, Haarlem, Maagden van den Hoeck, c. 1628-1641.

Silk, gold thread, spangles, 15.5 × 30 cm (left glove), 16 × 29.5 cm (right glove). Utrecht, Museum Catharijneconvent, BMH t42h1 (left glove), BMH t42h2 (right glove). Provenance: originally at the former clandestine church of St. Bernard in den Hoeck in Haarlem.

G Aegidius de Monte's crosier, Antwerp, 1570.

Gilded copper with gilded silver, ebony, gilded metal, 43.5 (excl. staff) / 193.5 (incl. staff) × 10 cm. Utrecht, Museum Catharijneconvent, OKM m161a. Provenance: originally at the Church of St. Lebuinus in Deventer.

H Portrait of Philippus Rovenius (1574-1651), Haarlem, Pieter Fransz de Grebber, 1631.

Oil on panel, 105,5 × 93 cm. Utrecht, Museum Catharijneconvent, BMH s9130. Provenance: originally in the chapter room beneath the former clandestine church of St. Bernard in den Hoeck in Haarlem.

The bishop's set, which includes the chasuble with cat. no. 8, was in all probability made by the Maagden van den Hoeck, or Haarlem Virgins, for their own church, St. Bernard in den Hoeck, specifically for vicar apostolic Philippus Rovenius. The virgins will have taken pride in making these vestments for their archbishop. And it will also have given Rovenius pleasure to preside over services at the Church of St. Bernard in den Hoeck dressed in such splendid vestments, when he was there for meetings with the Haarlem chapter.

The quartet and matching mitre are made of a very costly late renaissance white satin fabric, on which decorations of curling

A

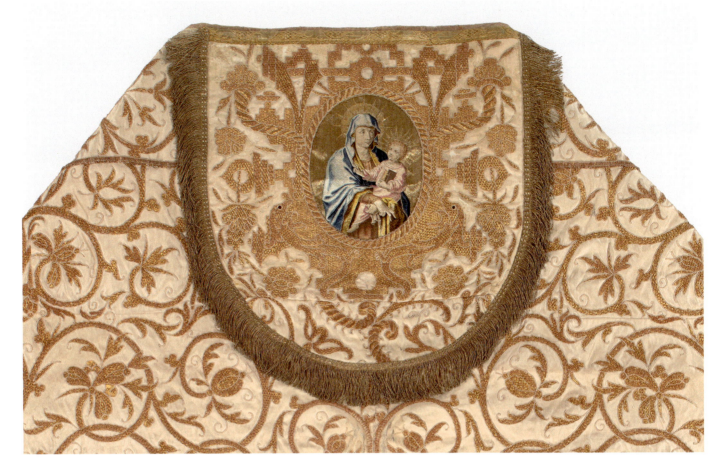

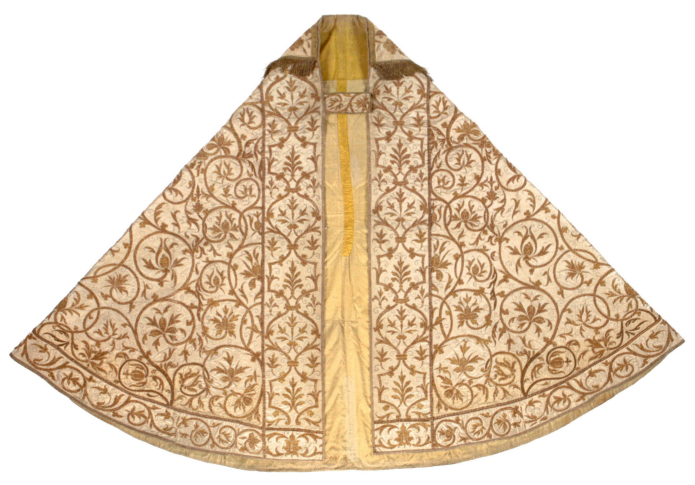

Fashion for God

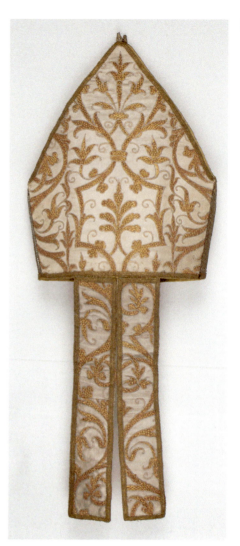
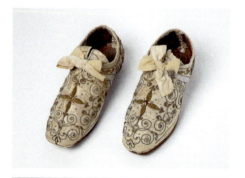
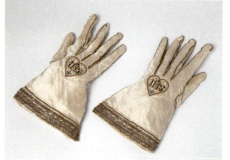

vines and buds bursting into flower have been embroidered in gold thread. The fabric bears some similarity to the dress which Margherita of Savoy (1589-1655) wears in her portrait of circa 1605 by Federico Zuccaro (1542-1609), and was probably made in Southern Europe.

The chasuble in the set <sup>(cat. 8)</sup>, which has a richly embroidered cross and column, was also the festive chasuble of the virgins themselves. They had a lot of influence over what was depicted on the chasuble. The choice of image on the cope shield was undoubtedly also theirs. It shows the venerated icon of the Virgin Mary at the basilica of Santa Maria Maggiore in Rome, rendered in the nué technique.[1] Since the nineteenth century this icon has been known as the Salus Populi Romani (the salvation of the Roman people). The traditional Christian story holds that it was painted by the evangelist Luke on the top of a table made by Jesus himself in Joseph's workshop. The icon in fact dates from the sixth century, and has Byzantine origins. It was believed to have the power to bring about miracles. The copies, spread mainly by the Jesuits, were also deemed to have extraordinary powers. Indeed painted copies from the Jesuit churches of Bratislava and Ingolstadt took on lives of their own.[2] The Haarlem Virgins may have had an engraving of this icon made by Hieronymus Wierix in Antwerp in 1590-1600.

Along with other prints of saints and symbolic graphic works, engravings of this Roman icon and other icons were very popular

150  Fashion for God

G

H

among beguines and spiritual virgins, not least because of the miraculous powers attributed to them. They will have been convinced that this power would also be transferred to the cope and whoever wore it.

Whether Philippus Rovenius, who was consecrated bishop in 1620 and had been appointed titular Archbishop of Philippi, also carried a crosier at services in the seclusion of the clandestine churches is not known. Vicars apostolic were actually more likely to use a cross-staff. The crosier was for bishops in charge of their own territory (diocese). However, it is not unthinkable that Rovenius might have used a crosier, given the fact that he also regarded himself as Archbishop of Utrecht. He could not however use this title in public, not only because it would likely have caused difficulties with the States-General, but also because of a difference of opinion with the church in Rome. The issue among Catholics was whether the oppressed Catholic church in the Dutch Republic could call itself the full successor to the Dutch medieval church, or was in fact merely a group of missionaries in a heretical region under the direct authority of Rome, as was generally thought in Roman circles. Although, as vicar apostolic, Rovenius' loyalty was above all to Rome, he was also in favour of restoring the old situation, as far as possible, with himself at the head, as Archbishop of Utrecht. This difference of opinion with Rome concerning the status of the church in the Northern Netherlands would be one of the causes that eventually led to a schism in the Dutch Catholic church in 1723.

If Rovenius wanted to use a crosier as Archbishop of Utrecht, he would no longer have had the old crosiers of Utrecht at his disposal, as they had all been lost with the advent of the Reformation. He was, however, free to use the crosier that had belonged to Aegidius de Monte, the last bishop of Deventer (1570-1577).[3] Given the fact that Rovenius was appointed vicar-general of the diocese of Deventer in 1606 and as such was now in charge of that diocese — in the absence of a bishop — he would have been the one to use the crosier from Deventer. He must have taken it with him to Utrecht after he was consecrated bishop. Though he might, incidentally, have used the fourteenth-century staff of the abbots of Egmond in Haarlem [BMH m10416a], which was kept at the Church of St. Bernard in den Hoeck. (RdB)

1  De Beer 2023-II, pp. 148-150, 420-425, figs. 252-261.
2  Noreen 2008, pp. 19-37; De Beer 2017, pp. 40-42.
3  Van Hemeldonk 1988, p. 105, cat. no. 53, fig.; Dubbe 1992, pp. 234-279, esp. p. 238, coloured fig. 19, pp. 252-253, fig. 211.

Fashion for God

# 23 A new era dawns

This impressive set of paraments comes from the Roman Catholic Church of Our Lady of the Assumption in Zwolle.

All four vestments are made of two different silk fabrics: a green and a pink fabric. Although pink did occur in the liturgical calendar of the Catholic church (it could be worn on the third Sunday of Advent and the fourth Sunday of Lent, instead of purple, which was also permitted), it was not mandatory to have paraments in this colour, and so it was not be a standard feature of a church's inventory.

The regular occurrence of pink paraments in the eighteenth century is more likely related to the fact that pink was a fashionable colour, particularly in the second half of the eighteenth century [cat. 38]. In the eighteenth century, paraments were often made from used gowns donated or bequeathed to the church by wealthy ladies. Sometimes paraments would be made from new material, but again, these would generally be fashion fabrics. It was almost impossible to obtain fabrics woven specifically for liturgical vestments in the Protestant Republic, and elsewhere, for that matter. It was common to donate gowns to the church in other countries, too. Furthermore, the sight of mass being conducted by a priest wearing fashion fabrics was so familiar that they also tended to be used for paraments made of new materials.

The development of pattern designs for silk fabrics in the eighteenth century is reasonably well documented. These developments generally occurred quite rapidly, driven by annual changes in fashion, and silk manufacturers responding to the small innovations that occurred each year, not least to boost their own turnover. The catalyst behind these developments was the French court, which was a big customer, and protector, of the silk industry in Lyon. They also found fertile soil in England and the Dutch Republic, where the domestic silk industries naturally made their own designs, but also often variations on the fashion fabrics coming from France.

The green silk fabric with large flowers in this set of vestments can be dated to around 1730-1740, the point at which floral motifs were at their largest on French fashion fabrics. By around 1740-1750 England was going its own way, using the silk designs of Anna Maria Garthwaite [cat. 31], for example, which featured smaller flowers, generally on a white background. When the centre of the English silk industry, Spitalfields in London, hit a crisis in the mid-1760s — partly because printed cotton (chintz) was gaining in popularity, driving down the price of silk and prompting weavers to strike to fend off pay cuts — the English silk manufacturers fell back on examples from contemporary French fashion.[1] In France, meandering floral motifs were the trend at the time, increasingly

A Green and pink chasuble, c. 1730-1740 (base fabric), c. 1775 (column and cross).

Silk, gold galloon, 118 × 73 cm. Utrecht, Museum Catharijneconvent, ABM t2269a; on long-term loan from the Roman Catholic Church of Our Lady of the Assumption in Zwolle.

B Green and pink dalmatic, c. 1730-1740 (base fabric), c. 1775 (columns).

Silk, gold galloon, 98 × 117 cm. Utrecht, Museum Catharijneconvent, ABM t2269b; on long-term loan from the Roman Catholic Church of Our Lady of the Assumption in Zwolle.

C Green and pink dalmatic, c. 1730-1740 (base fabric), c. 1775 (columns).

Silk, gold galloon, 98 × 117 cm. Utrecht, Museum Catharijneconvent, ABM t2269c; on long-term loan from the Roman Catholic Church of Our Lady of the Assumption in Zwolle.

D Green and pink cope, c. 1775 (base fabric), c. 1730-1740 (cope shield and orphreys).

Silk, gold galloon, gold fringing, 140 × 289 cm. Utrecht, Museum Catharijneconvent, ABM t2269d; on long-term loan from the Roman Catholic Church of Our Lady of the Assumption in Zwolle.

A

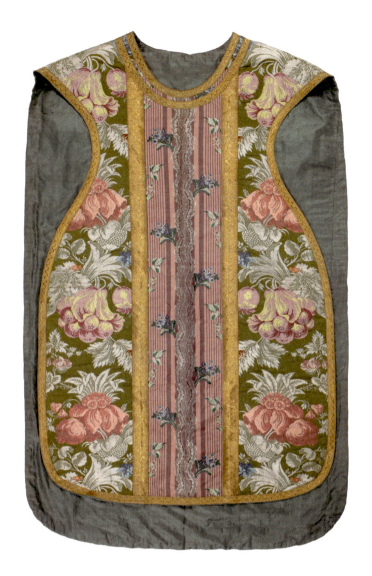 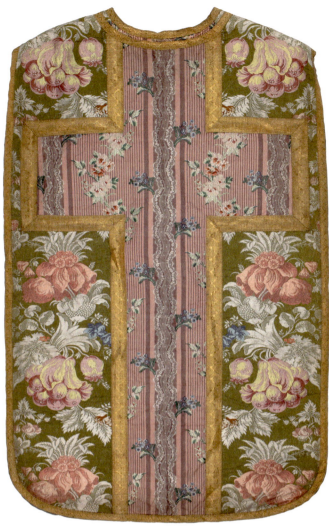

B

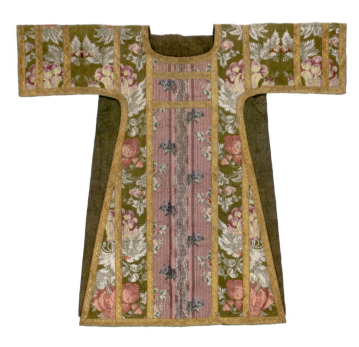 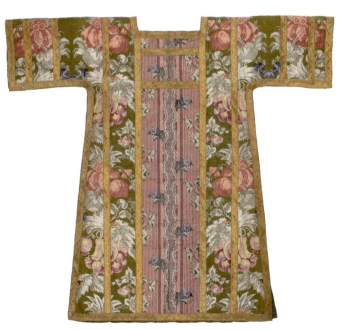

combined with stripes, as the flowers grew smaller, as seen in the pink fabric used in this set for the cross on the chasuble and as the base fabric for the cope, for example. This gives us a relatively firm date of around 1775 for the pink fabric.

The set consists of a chasuble, a cope, two dalmatics, three stoles, two maniples and a chalice veil. There is no burse or altar frontal, though the set probably included them at one time. Since the base of the set consists of four vestments, it is referred to as a 'quartet'.

The chasuble is a consecrated parament, and therefore sacred. This is also true of the stole which — at least until the reforms in the Catholic church in the 1960s — was always worn under the chasuble. The priest would wear the chasuble during mass, a church service that included the eucharist. During services without the eucharist, such as vespers or evensong, no chasuble is worn. The priest may then wear a cope.

The deacon and subdeacon, who assist the priest during mass, wear a dalmatic. Originally, there were subtle differences between the vestments worn by a deacon and a subdeacon: a dalmatic for a deacon had a horizontal stripe across the chest, while the tunicle for the subdeacon did not. But this difference gradually disappeared. The distinction between the dalmatic and the tunicle is not apparent on these two dalmatics from Zwolle. They are in fact identical. The deacon wore a stole under his dalmatic, while the subdeacon did not. All three would wear a maniple over their left forearm.

At mass on high days — when four priests would be present rather than three (in chasuble and dalmatics) — a cope would also be worn, though not by the priest celebrating the eucharist.

The chalice veil is a square or rectangular cloth used during mass, before the eucharist, to cover the chalice, paten and pall. During the eucharist the chalice and paten are place on a corporal, a linen cloth. The corporal is kept in a burse — a fairly small square case — before and after the eucharist. The chalice veil and burse are generally made of the same silk fabric as the other paraments. They have barely been used in the Roman Catholic church since the modernisation introduced in response to the Second Vatican Council, and they also fell into disuse in the Old Catholic church. (PA)

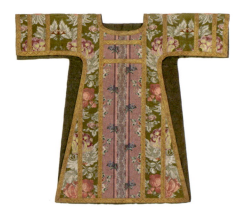

C

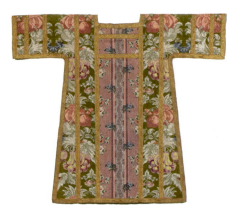

1   Rothstein 1994-II, pp. 9-10.

154        Fashion for God

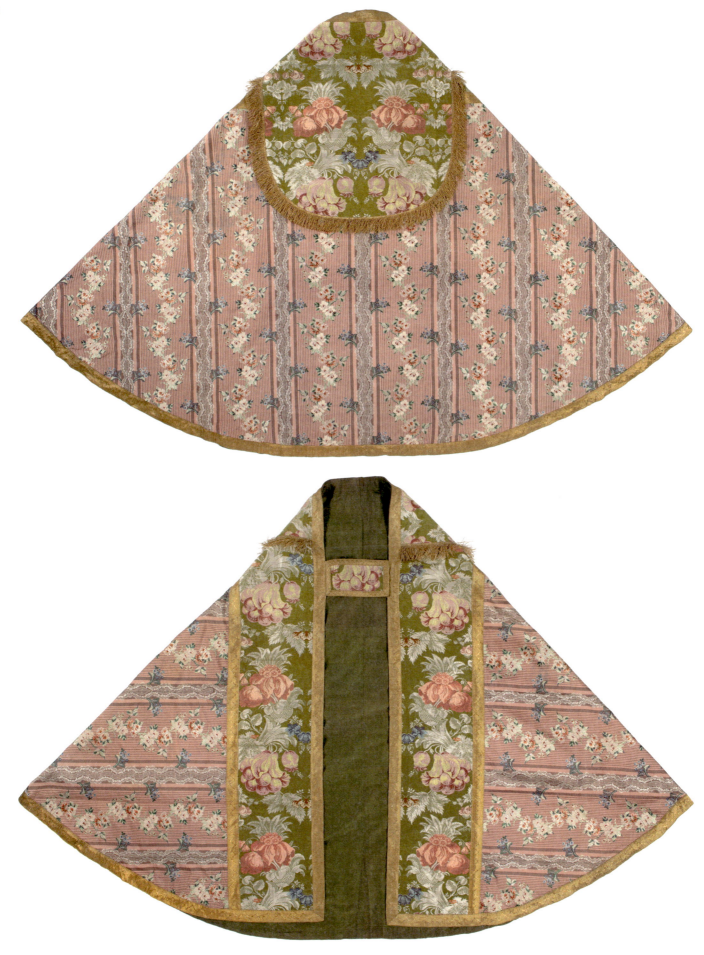

Fashion for God

# 24 An all-seeing eye from Amsterdam

The cope is made of ivory silk damask with a lace pattern motif dating from the late 1720s [see also cat. 40]. The woven pattern in green and gold features fantastical flowers and leaves, garlands and fields of lacework. The orphreys and cope shield have chenille and silver embroidery and spangles. Chenille is yarn woven from short threads, so both the yarn and the embroidery have a velvety texture. The decoration on the orphreys consists of flowers, fruits, fruit baskets, lambrequins with latticework and horns of plenty. The two orphreys are entirely symmetrical.

An all-seeing eye in a triangle, surrounded by a halo and clouds, with festoons of flowers and palm branches around them, feature on the cope shield. The all-seeing eye in a triangle symbolised the omnipresence and providence of God, and the Holy Trinity. The festoons, sun rays and triangle are embroidered in silver thread. There is a zig-zagging cord beneath the silver embroidery of the triangle, to create extra relief. The clouds are raised from underneath, producing a pronounced relief effect. The orphreys and cope shield are edged with costly silver lace, and the cope itself has silver fringing.

The embroidery is in a typical Louis XIV style, and might date to around 1725-1750. At that time embroidered vestments were already slightly old-fashioned. Having said this, chenille was particularly fashionable from the eighteenth century, so more in keeping with the times.

It is not clear whether the material of the cope had been used previously, in the form of a gown, for example. The cope is made of narrow strips of silk damask, and diagonal seams that are not common in copes can be seen only at the bottom, on either side of the orphreys.

The cope is part of a set, and comes originally from the Old Catholic Church of St. Willibrord and St. John in Amsterdam, but was transferred to the St. Mary Magdalene Church in Zaandam when the Amsterdam church closed in 1952. In 1974 the cope, stole, pall and burse were added to the collection of the Old Catholic Museum, which became part of Museum Catharijneconvent in 1979. A second stole, a maniple, a chalice veil and a pall box are at the Old Catholic Church in Delft, and the altar frontal belonging to the set is at the Old Catholic Church in IJmuiden. (PA)

---

White cope, c. 1725-1730 (base fabric), c. 1725-1750 (cope shield and orphreys).

Silk damask, silver thread, silk chenille thread, spangles, 133 × 299 cm. Utrecht, Museum Catharijneconvent, OKM t138a. Provenance: originally at the Old Catholic Church of St. Willibrord and St. John, Amsterdam ('Brouwersgrachtkerk').

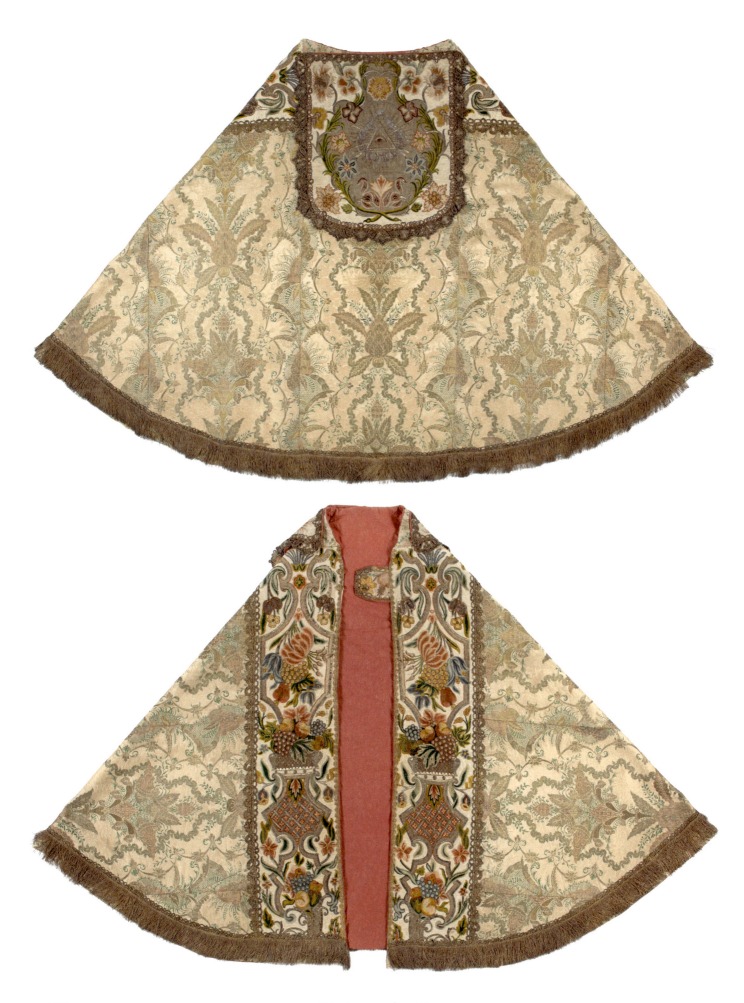

Fashion for God

# 25 Ladies' and gents' fashions

Verheyden painted these full-length, virtually life-sized portraits of Gerard Cornelis van Riebeeck and his wife Charlotte Beatrix Strick van Linschoten, probably for their country homes in Voorburg.[1] But the wealthy impressed not only with their homes outside the city that impressed, but also with their attire. The clothing worn by the couple commands all the attention in the foreground. Both are dressed extremely fashionably, Charlotte in a robe à la française without a box pleat (which would normally hang from the shoulders, extending to a small train) and Gerard in a justaucorps (a knee-length jacket) and breeches. They have clearly coordinated their outfits, as both the justaucorps and the gown are in a base fabric that appears to be white satin with exuberant gold and silver brocade, floss embroidery in floral and foliage motifs and strips of lace at the cuffs and neckline. With a sword, watch, chatelaine, fan and jewellery too, the couple are equally matched in their conspicuous consumption.

From a nineteenth-, twentieth-, or even twenty-first-century viewpoint, it might seem strange that both ladies' and gents' fashions in the eighteenth century were so colourful, floral and opulent. These portraits show that the nineteenth-century concepts of masculinity and femininity had no validity yet in the eighteenth century, when neither colour nor decoration implied any particular gender identity. It was more important to dress in the latest fashions, and according to one's status, and that might be very colourful indeed.[2]

This therefore means that when a Catholic priest in the eighteenth century wore a chasuble or other church vestment in, say, pink and green silk with garlands of flowers, or red silk damask with white lace motifs, this should not be regarded as particularly feminine. It is more likely to have evoked a sense of familiarity among churchgoers, as they may have recognised in the chasuble a gown that once belonged to one of their fellow parishioners. A Catholic lady who donated her gown to the church not only secured the salvation of her soul, she also gave herself extra status during her lifetime. As with Van Riebeeck and Strick, the costlier and more fashionable the clothes were, the greater the assumed prestige. (PA)

Portrait of Gerard Cornelis van Riebeeck, Mattheus Verheyden, 1755.

Oil on canvas, 206 × 122 cm.
Amsterdam, Rijksmuseum, SK-A-816.

Portrait of Charlotte Beatrix Strick van Linschoten, Mattheus Verheyden, 1755.

Oil on canvas, 206 × 122 cm.
Amsterdam, Rijksmuseum, SK-A-817.

1 De Fouw 2020, p. 111.
2 North 2022, p. 93.

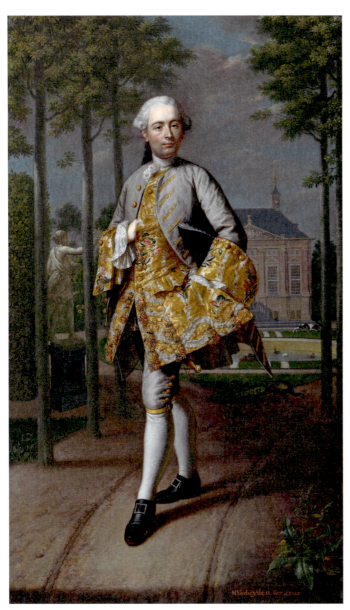 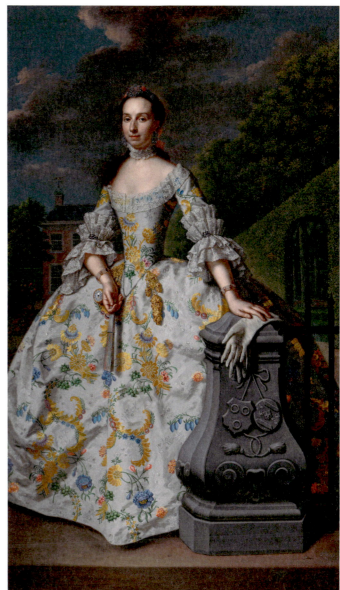

159　　　　　　　　　　　　　　　Fashion for God

# 26 Portrait of Dominique-Marie Varlet, four portraits of Archbishops of Utrecht, Varlet's travel chasuble and chalice veil of Paradaens

A **Portrait of Dominique-Marie Varlet (1678-1742),** Northern Netherlands, c. 1725-1750.

Oil on panel, c. 47 × c. 38.5 cm. Utrecht, Old Catholic Cathedral of St. Gertrude, 469-257. Provenance: originally at the Old Catholic Church of St. Gertrude in Utrecht.

B **Portrait of Cornelis Steenoven (1661-1725),** Archbishop of Utrecht (1723-1725), Northern Netherlands, c. 1725-1750.

Oil on paneel, c. 47 × c. 38.5 cm. Utrecht, Old Catholic Cathedral of St. Gertrude, 469-256. Provenance: originally at the Old Catholic Church of St. Gertrude in Utrecht.

C **Portrait of Cornelis Johannes Barchman Wuytiers (1692-1733),** Archbishop of Utrecht (1725-1733), Northern Netherlands, c. 1730.

Oil on panel, c. 47 × c. 38.5 cm. Utrecht, Old Catholic Cathedral of St. Gertrude, 469-258. Provenance: originally at the Old Catholic Church of St. Gertrude in Utrecht.

D **Portrait of Theodorus van der Croon (1668-1739),** Archbishop of Utrecht (1733-1739), Northern Netherlands, c. 1735-1750.

Oil on panel, c. 47 × c. 38.5 cm. Utrecht, Old Catholic Cathedral of St. Gertrude, 469-259. Provenance: originally at the Old Catholic Church of St. Gertrude in Utrecht.

E **Portrait of Petrus Johannes Meindaerts (1684-1767),** Archbishop of Utrecht (1739-1767), Northern Netherlands, Hendrik Pothoven (?), 1744.

Oil on panel, c. 47 × c. 38.5 cm. Utrecht, Old Catholic Cathedral of St. Gertrude, 469-260. Provenance: originally at the Old Catholic Church of St. Gertrude in Utrecht.

F **Travel chasuble belonging to Dominique-Marie Varlet,** chasuble (reversible: green side and cream-coloured side), France (Paris?), c. 1700-1724.

Silk damask, gold thread, 109 × 74 cm. Utrecht, Old Catholic Cathedral of St. Gertrude, 469-533. Provenance: originally at the Old Catholic Church of St. Gertrude in Utrecht.

G **White chalice veil of Paradaens,** Southern Netherlands, sisters of Pierre Paradaens, abbot of the Benedictine Abbey of Vlierbeek, c. 1720-1724.

Silk, floss, gold thread, silver thread, gold lace, 89 × 86 cm. Utrecht, Museum Catharijneconvent, OKM t58. Provenance: originally at the Old Catholic Church of St. Gertrude in Utrecht.

In the second half of the seventeenth century the differences of opinion between Catholics in the Dutch Republic and in Rome concerning the status and identity of the oppressed church in the Northern Netherlands took on a theological dimension. It concerned aspects of the doctrine of divine grace which Cornelis Jansenius (1585-1638) had set out at the University of Louvain.

The views of Jansenius, which were stricter than those of the Jesuits, received a great deal of support, particularly in the Southern and Northern Netherlands and in France, around the Cistercian Convent of Port Royal. The Jesuits, the pope and King Louis XIV of France did not agree. The French king closed down the abbey at Port Royal in 1709-1710, and Jansenius' French sympathisers fled to the Southern and Northern Netherlands.

Meanwhile, the leader of the Catholics in the Dutch Republic, Petrus Codde (1648-1710), had been removed from office by Rome in 1704 for holding those same views. This event and the persuasiveness of the French who had fled to the Republic led, on 27 April 1723, to Cornelis Steenoven being elected as Archbishop of Utrecht, circumventing the authorities in Rome. Despite repeated attempts at reconciliation with Rome, on 15 October 1724 Steenoven was con-

A-B

C-E

Fashion for God

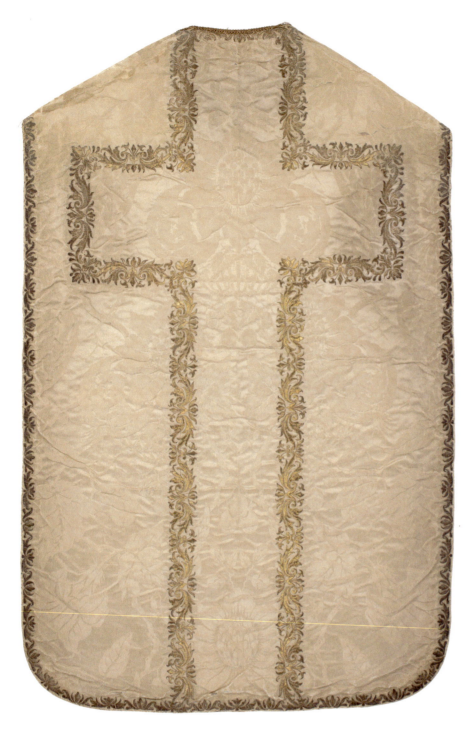

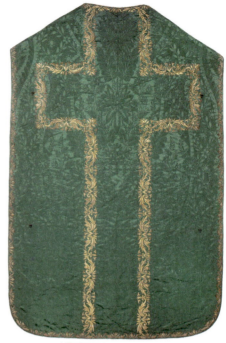
F

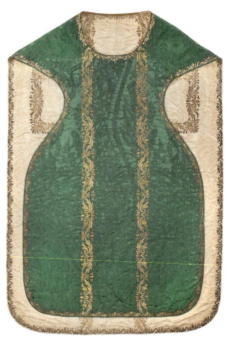

secrated bishop by Dominique-Marie Varlet (1678-1742), a mission bishop who had been suspended by Rome.[1] Varlet, who also supported the views from Port Royal and the church of Utrecht, would also consecrate Steenoven's three immediate successors: Cornelis Barchman Wuytiers, Theodorus van der Croon and Petrus Meindaerts. This break from Rome led later to the formation of the Old Catholic church. Only a small proportion of Catholics in the Northern Netherlands were prepared to take things this far, however, and the majority remained loyal to Rome after 1724.

Steenoven's consecration took place at the home of Amsterdam bookseller Arnold Joseph Dubois de Brigode, at 160 Keizersgracht,

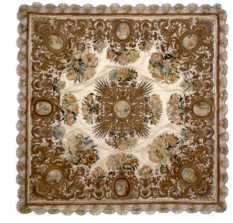
G

162  Fashion for God

36 Consecration of Mgr. Marinus Kok as Old Catholic Archbishop of Utrecht on 7 September 1969.

Cor Unum et Anima Una Photo Collection (depicted in: C. van Kasteel, de Utrechtse kerk van de belofte. Gedenkboek van 100 jaar oud-katholieke Sinte Gertrudiskathedraal 1914-2014, Utrecht 2014, p. 97). Mgr. Kok is wearing Varlet's travel chasuble with the cream-coloured silk showing.

37 Interior of the oratory at the former presbytery of St. Gertrude's Church in Utrecht, c. 1875 and 1911.

Photo, 295 × 235 mm. Utrecht, Museum Catharijneconvent, OKM f294. The Paradaens chalice veil can clearly be seen on a stand beside the altar.

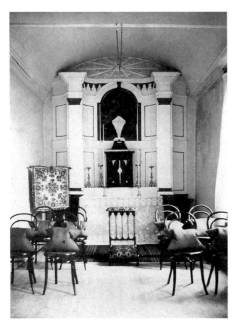

where Bishop Varlet was living at the time. Varlet is said to have consecrated Steenoven wearing the travel chasuble shown here. After that, it was worn by archbishops at their consecration until just a few years ago. It thus has great symbolic significance for the Old Catholic church.[2] The chasuble is a more refined garment than most chasubles made in the Northern Netherlands in this period, which supports the theory that it originated in Paris.

A particularly lavishly embroidered chalice veil was also used at the consecration ceremony in the early morning of 15 October 1724; it, too, is not a typically Dutch item.[3] The French Benedictine monk Thierry de Viaixnes (1659-1735) mentioned the veil in his meticulous description of the event. He acted as master of ceremonies, and sent his report to his ally Ernest Ruth d'Ans: '[...] C'est la 1.ere fois qu'on s'est servi du beau et riche voile de calice, et de sa bande brodées [sic] par M.elles Paradanus, que je salüe tres affecttueusement [...]' ('This is the first time that the beautiful, ornate chalice veil with its edges embroidered by the ladies Paradanus, whom I greet with affection, has been used').[4]

The chalice veil was specially embroidered by the sisters of Pierre Paradaens (Paradanus) (1655-1728), abbot of the Benedictine abbey of Vlierbeek near Leuven from 1699 to 1728. Paradaens sympathised with those who supported Jansenius' doctrine, including Thierry de Viaixnes, mentioned above. We do not known exactly which of the sisters of abbot Paradaens were actually responsible for the chalice veil. It could have been Cecilia, who died in 1730, and perhaps Maria, who was prioress of the Convent of the Holy Sepulchre in Turnhout. She had died in 1716, however. Like the spiritual virgins of the Northern Netherlands, they too mainly depicted scenes from the life of the Virgin Mary: the Presentation of Mary at the Temple, the Annunciation, the Visitation, the Assumption and the Coronation of Mary in Heaven. The embroidery could have been done by spiritual virgins or nuns in the Southern Netherlands. The sisters of Paradaens used Italian engravings and other sources for embroidering the small medallions. The image of the Assumption, for example, seems to have been taken from an engraving of the 1600-1601 altarpiece by Annibale Caracci at the Cerasi Chapel at the Basilica of Santa Maria del Popolo in Rome. The chalice veil was displayed as a special memento in the oratory of the presbytery of St. Getrude's Cathedral in Utrecht until 1911 (afb. 37). (RdB)

1 Bronkhorst 1972, p. 93, no. 139.
2 Lagerwey 1932, p. 55; Bronkhorst 1972, p. 93, no. 139.
3 Bronkhorst 1972, p. 88, no. 120.
4 HUA 215.1610, 2: letter of 18 October 1724 from Thierry de Viaixnes to Ernest Ruth d'Ans. Thanks to Koenraad Ouwens for bringing this account to our attention.

Fashion for God

# 27 Engelberta Groen

This cope is part of a set, along with a stole. It may once have included a chasuble and several altar accessories, but they have not survived.

The cope is made of a taffeta fabric with a brocaded floral motif in the style of London fabric designer Anna Maria Garthwaite. Her designs typically feature asymmetrical, flowing motifs in a naturalistic style. Individual meadow flowers and ears of corn appear here as garlands in vertical bands. The principal colours in the woven motif are red-brown, sea green, grass green and red.

The cut of the cope is not typical of the eighteenth century. It has a round neck and a few pleats have been added at shoulder height. The pleats were hidden beneath the shield. The shield is separate, and is attached to the mantle using eyelets.

The bodice is close-fitting, with sewn pleats on the back, and it fastens with hooks on the front. Ruffled engageantes have been sewn onto the sleeves, which are edged all round with silk passementerie featuring red, blue, yellow and green touches. Stitch holes indicate that the gown was altered several times.[1] The original design was a robe à la française, an overdress with a broad box pleat at the back, worn over a matching petticoat. In the course of the second half of the eighteenth century, fashions changed and a more close-fitting style of dress came into use. The two styles common at the time were called the robe ajustée (fitted gown) and the robe à l'anglaise (fig. 38). The latter had a separate bodice and skirt that were sewn together. Engelberta's robe à la française was adapted to this new fashion. The wide box pleats in the back were sewn flat, as in a robe ajustée (fig. 38).

As well as the cope itself and the bodice, a broad length of fabric measuring 23 by 232 cm has also survived. All three are made of the same fabric. The colours of the bodice and the length of fabric are still fresh and bright, in contrast to the cope. Clear stitch holes and folds in the mantle also show the origin of the fabric (fig. 40). The false pleats in the orphreys and the mantle itself are vestiges of pleats characteristic of a robe à la française.

The provenance of the cope and the bodice are known from oral history. The story in the parish is that the gown was donated by a family called Van der Bergh, several members of which played an important role in the Old Catholic church. Contrary to more common practice in the eighteenth century, this gown was not donated by the owner herself, but was probably given St. Mary's Church on Achter Clarenburg by her children or grandchildren in the nineteenth century. With the story of the Van der Bergh family as a starting point, coupled with archive research, a possible owner has been identified for the robe à la française.[2] It is likely to have been

A White cope, after c. 1860 (cope), c. 1750 (ground fabric).

Silk, gold galloon, gold thread fringing, silver, h. 143 cm. Utrecht, Old Catholic Cathedral of St. Gertrude, 469-272. Provenance: originally a dress belonging to Engelberta Groen (1736-1816), probably donated to the Old Catholic Church of St. Mary on Achter Clarenburg in Utrecht after c. 1860.

B Bodice of the dress, c. 1750.

Silk, linen, h. 44 cm. Utrecht, Old Catholic Cathedral of St. Gertrude, 469-272. Provenance: originally a gown belonging to Engelberta Groen (1736-1816), probably donated to the Old Catholic Church of St. Mary on Achter Clarenburg in Utrecht after c. 1860.

38 Schematic representation of the back of three types of gown commonly worn in the eighteenth century: from left to right, a robe à la française, a robe ajustée (fitted gown) and a robe à l'anglaise. The first type remained in use for formal wear throughout the eighteenth century. The other two became fashionable after 1760. Drawing by Garry Dijkema, from Lugtigheid, 2021, p. 98.

A

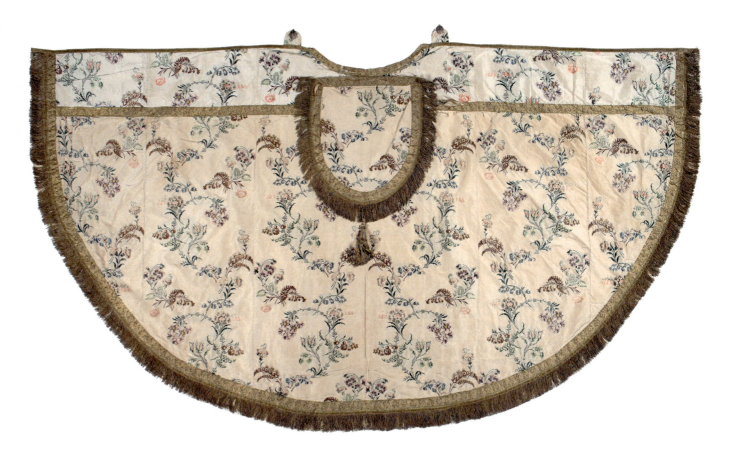

B

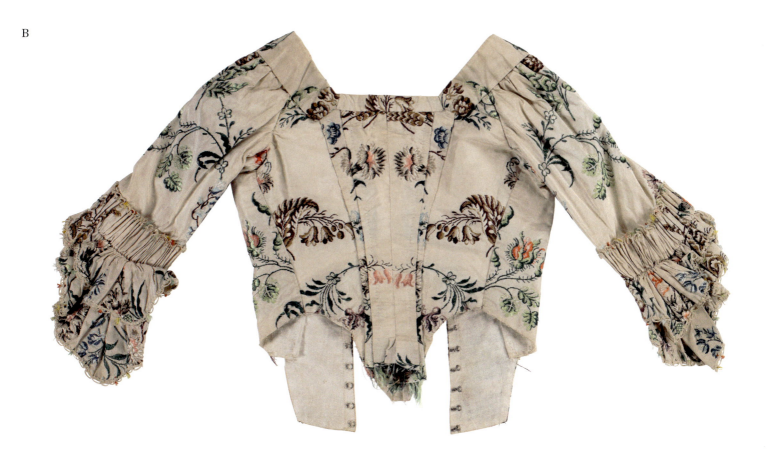

Fashion for God

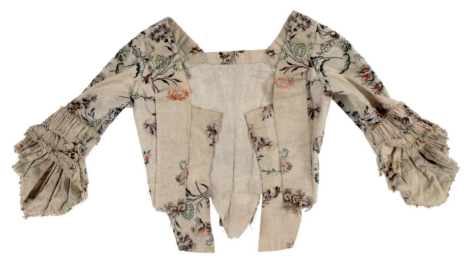

39 The back of the bodice. Stitch holes show that it was altered several times, and adapted to the latest fashion. At some point the separate box pleats were moved and sewn down, so that the upper part of the gown fitted more closely to the body.

40 Stitch holes and traces of folding show that the fabric had had a previous life as a robe à la française.

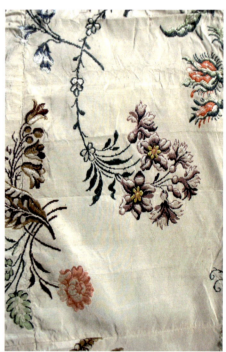

the wedding gown of Engelberta Groen (1736-1816), who married in Utrecht in 1755. In those days, women would get married in a beautiful gown which they could wear again later. White did not become a typical colour for wedding gowns until the nineteenth century. The design of the fabric and style of the gown were fashionable around the time of her wedding. Engelberta continued to wear the gown for many years, as evidenced by the alterations made to convert it to a robe ajustée.

In her will of 1790 Engelberta left all her possession to her children. Her daughter Johanna (1775-1838) probably received the dress. Johanna's daughters all died at a young age, so it is likely that the dress passed to her son Theodorus van den Bergh. He became church warden of St. Mary on Achter Clarenburg in 1854. As a church warden, he was aware of what vestments the church had. In 1856 he compiled an inventory, and will have known whether there was a need for new vestments. Theodorus van der Bergh died in 1873. He may have donated his grandmother's gown to the church, or his heirs may have donated it in his memory. Judging by the condition of the separate lenght of fabric, the quality of the silk was still excellent a century after the gown was first made. The next inventory of the vestments at St. Mary's was not drawn up until 1885. From that point on it is possible to trace the white cope. However, no record was made of the bodice. Nevertheless, it was stored with care all that time, and after St. Mary's closed in 1986 it was transferred to St. Gertrude's Cathedral, along with the cope and stole.

(RL)

1 Lugtigheid 2021, pp. 235-245.
2 Lugtigheid 2021, pp. 235-245. HUA 34-4.1584, doc. no. 35, last will and testament of Engelberta Groen, 1790. HUA 842-2.219.

# 28  Gertrudis Clara van Halteren

White altar frontal, after 1799 (frontal), c. 1754-1770 (ground fabric).

Silk, gold galloon and gold fringing, white cotton lace, 150 × 240 cm. Amersfoort, Old Catholic Church of St. George, 461-73b. Provenance: originally a dress belonging to Gertrudis Clara van Halteren (1739-1799), bequeathed to the Old Catholic seminary in Amersfoort in 1799.

The altar frontal is part of a set, along with a chasuble and two candlestick frontals. The ground fabric consists of a beige silk with a woven motif in meandering vertical bands, featuring floral garlands and bouquets brocaded in red-brown, red, pink, blue, dark green, light green and beige in between. The colours are very faded [fig. 42]. The fabric dates to between 1754 and 1770. The chasuble has a cross woven in shape of a later date, Lyon, France, 1800-1825 [fig. 43]. The monogram IHS surrounded by golden rays is woven into the centre of the cross, which also features red roses, blue flowers and gold whorls. The chasuble is in very poor condition.

This vestments set was made from one of the silk dresses that Gertrudis Clara van Halteren (1739-1799) of Amersfoort bequeathed to the Roman Catholic Church of the Episcopal Clergy (later known as the Old Catholic church).[1] The wealthy Gertrudis and her only brother had both remained unmarried, and were the last of their line when they died. In her will she left money and goods to various relatives, staff, poor people and several clandestine churches of the Episcopal Clergy, but she appointed the Roman Catholic Seminary in her hometown as the overall heir to the considerable family fortune.[2] Her executors compiled an extensive record of her property.[3] It lists nine silk gowns, ordered by colour, a quantity befitting a lady of her distinguished social status. The silk garments were distributed among a number of clandestine churches. Besides the vestments discussed here, another chasuble is known to have been made from a striped dress that once belonged to Gertrudis [cat. 28].

The white altar frontal was restored several years ago. The white lace edging was removed during the conservation treatment.

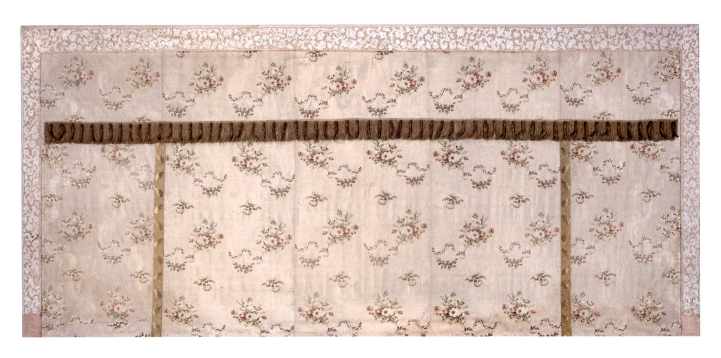

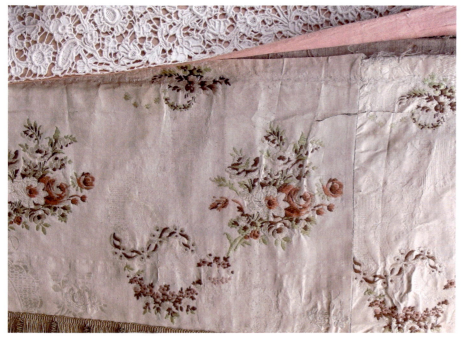

The cotton guipure lace mounted on a strip of pink fabric is a later addition. Stitch holes and signs of folding under the edge clearly show that the altar frontal was made from a gown (fig. 41). The pleats created when the skirt was attached to the waistband are still clearly identifiable. The voluminous skirt was simply unpicked from the bodice leaving the five lenghts of fabric joined together. The width of fabric thus obtained, measuring some 2.5 metres, was stretched over a wooden frame to make the altar frontal. This, and the candlestick frontals, have remained in use at the church ever since, in memory of the generous donor, but also to adorn the interior of the church. (RL)

41  Detail of the top of the altar frontal, with a decorative edge partially unpicked during restoration work. The lace edging covered the stitch holes and folds which show that the fabric was previously used in a lady's gown.

42  The original colours of the silk fabric are still quite clear and vivid in places, as can be seen in this detail of the chasuble.

43  White chasuble made of the fabric from a gown belonging to Gertrudis Clara van Halteren, with a cross woven in Lyon.

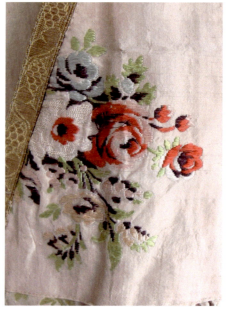

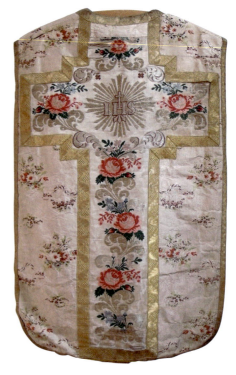

1  Lugtigheid 2021, pp. 225-235.
2  AEA 83.AT 049a006, fol. 22 and 48, last will and testament of G.C. van Halteren, 1799.
3  HUA 1836.592.

Fashion for God

# 29  Gertrudis Clara van Halteren

**Purple chasuble, after 1799 (chasuble), c. 1780-1790 (base fabric).**

Silk, gold galloon, 115 × 66 cm. Utrecht, Old Catholic Cathedral of St. Gertrude, 3880-186. Provenance: gown originally donated by Gertrudis Clara van Halteren (1739-1799), bequeathed to the Old Catholic seminary in Amersfoort in 1799.

After her death in 1799 Clara van Halteren left nine silk gowns to the Old Catholic church [cat. 28]. They are listed as follows in the inventory attached to her last will and testament:

> 1 silk gown and skirt
> 1 ditto with ditto
> 1 ditto, without skirt
> 1 striped satin ditto
> 1 black silk ditto
> 1 ash-grey ditto
> 1 red silk ditto
> 1 yellow ditto
> 1 blue ditto ditto [1]

Among the church's vestments is one striped chasuble made of a silk fabric dating from the final quarter of the eighteenth century. It was most probably made from the 'striped satin' gown that had belonged to Clara van Halteren. A matching maniple, chalice veil and pall are all made from the same striped fabric. There is no stole in the set.

Although silk fabrics with a checked or striped motif (as here), rather than floral patterns, occurred throughout the eighteenth century, they were particularly fashionable towards the end of the century.[2]

At the church of the seminary in Amersfoort where this chasuble was used, and was known as 'Van Halteren's stripe', it was felt quite soon after it was made that the striped pattern was perhaps not so suitable for use during mass. (PA)

44  The list of gowns that Clara van Halteren left to the church. HUA 1836.592.

1  HUA 1836.592.
2  Rothstein 1994-II, p. 10.

Fashion for God

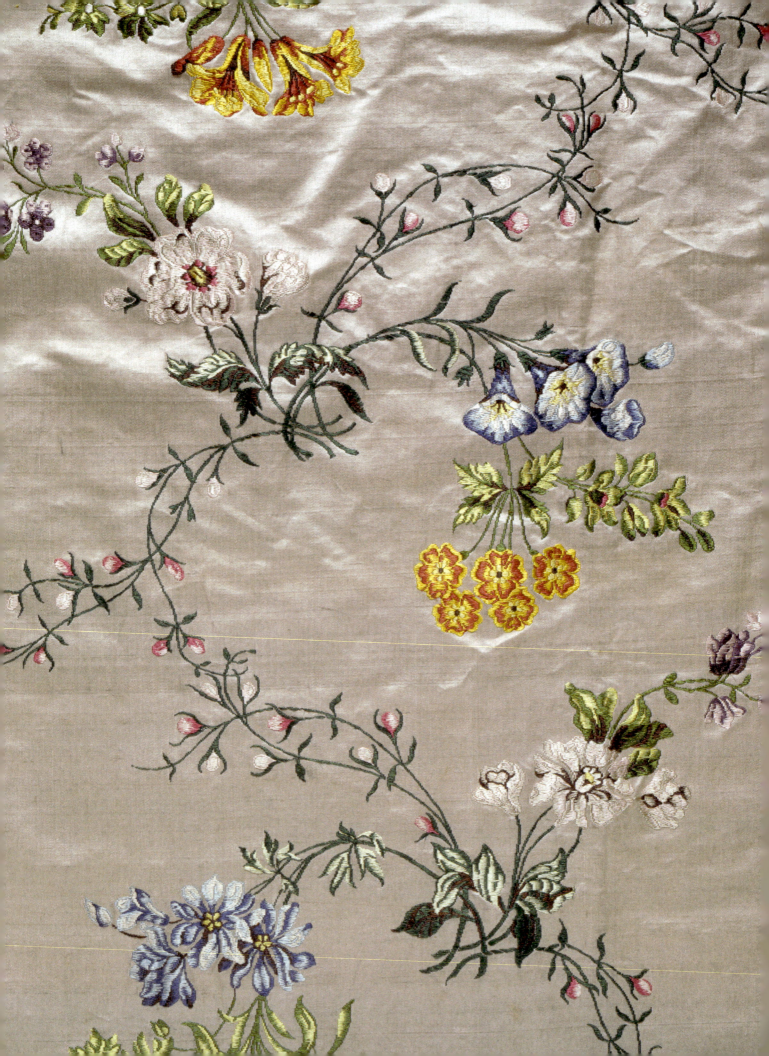

# 30 A gown of Garthwaite silk

Lady's gown, c. 1745-50 (original gown), c. 1780-1790 (altered), 1744 (design of base fabric by Anna Maria Garthwaite).

Silk, h. ca. 135 cm. London, Victoria and Albert Museum, T.264-1966; donated by Mrs Olive Furnivall.

This gown shows the great changes in fashion that affected almost all garments during the course of the eighteenth century. Originally, in the late 1740s, the gown was probably a 'robe sac', or sack, and was probably worn with a matching underskirt. This ensemble would have been the height of fashion at the time, made in brocaded silk satin, with a motif designed by Anna Maria Garthwaite, that was woven in Spitalfields, London. It is also a fine example of an elegant floral motif in rococo style.

Although the 'robe sac' style was no longer fashionable by the 1780s, brocade silk was still highly valued. After thirty years, the gown had probably been passed on or left to another woman, and required alteration. In the meantime, the cuffs and later ruching had fallen out of fashion, and the bodice, which had previously been open at the front, was replaced by a closed bodice. The sack was therefore adapted to the latest fashion.

The use of different patches of fabric, and the pleating and traces of stitching on the gown suggest that it was radically altered in the 1780s. The back right section of the sack appears to have been removed, and parts of it used to make a new bodice and sleeves. A small piece of fabric by the right shoulder has a scalloped edge, possibly a reused ruche from a sleeve, or from the decoration on an underskirt. Large parts of the original sack may have become damaged or stained, or a clever mantua maker may have transformed it into two gowns with matching underskirts. The more informal gown was often worn with a padded underskirt in raw silk, which meant that less silk was needed for the bodice.

It was common for ladies' and gents' clothing to be reused multiple times in the eighteenth century. It might be given to servants or sold. It would also often be used to make children's clothes or soft furnishings such as cushion covers or upholstery, or it would be transformed into accessories like work bags and ladies' shoes. Many fashionable gowns from the eighteenth century were used again for dressing up in the nineteenth century. Amateur theatre and fancy dress balls were very popular in the Victorian era. Anyone who did not have the money to have a special costume made, or to buy one off the peg, could turn to granny's clothes chest, making just a few adjustments to create a decent alternative. In its final guise, this gown was a Victorian fancy dressing outfit, with lace ruching on the sleeves and ribbons on the front. When we acquired the gown, they were removed to restore it to its final eighteenth-century style.

(SN)

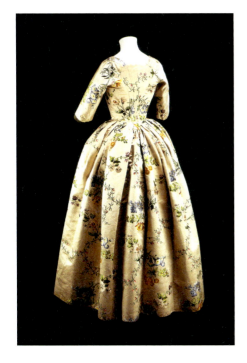

# 31 Designs by Anna Maria Garthwaite

The design for the brocaded silk satin used to make the gown from the V&A (cat. 30) is part of the collection of prints and drawings at the museum. It is one of several hundred in its collection drawn by Anna Maria Garthwaite (1690-1763). Garthwaite would become one of the leading designers of fabric motifs in the English silk industry, though it is not certain that she had any formal training regarded as necessary for this profession. She produced up to eighty designs a year — including this one — commissioned by master weavers and textile merchants who sold silk fabrics. Her interest in natural forms remained a key feature of her designs throughout her career, which lasted from the late 1720s to the 1750s. Garthwaite's designs epitomise the rococo style. From the early 1740s onwards, she adhered to William Hogarth's 'line of beauty' theory, which he developed during that decade and published in 1753 in *The Analysis of Beauty*.[1]

Garthwaite dated the design on the left April 1744, and sold it to master weaver Gregory. It is one of forty surviving designs which she drew between May 1742 and September 1745, including motifs for damask and brocaded lustrine, satin, taffeta and other fabrics. The weaver was one of several with the surname Gregory at the Weavers' Company.[2] In this design, and the woven satin, two large sprays of flowers fill the width of the repeat, linked by upwards and downwards trails of pink and white berries or buds. Identifiable flowers include auricula, morning glory and roses. Gregory stuck to the colours Garthwaite had used in her watercolour: blue for the morning glory, red and yellow for the auricula and white roses.

The design on the right closely resembles the silk of the cope from St. Gertrude's Cathedral in Utrecht (cat. 32). The design is dated 17 August 1747 and was produced for Mr Vautier, from a family of Huguenot silk weavers who originally came from Luneray in Normandy, but lived in Spitalfields by the mid-eighteenth century. Several members of the Vautier family worked in the silk industry, including Isaac, Lewis and a number of weavers called Daniel. Between 1741 and 1751 one of the Vautiers bought 122 designs for damask and brocaded lustrine, satin, taffeta and moiré from Garthwaite. He was probably a master weaver with multiple looms, who employed several weavers.

A Anna Maria Garthwaite, Spitalfields, design for silk fabric, 1744.

Watercolour on paper, 378 × 261 mm. London, Victoria and Albert Museum, 5982:10.

B Anna Maria Garthwaite, Spitalfields, design for silk fabric, 1747.

Watercolour on paper, 550 × 267 mm. London, Victoria and Albert Museum, 5985:9.

Comparing the two designs reveals how Garthwaite's style developed. Rather than the continuous stems in her earlier work, we now see separate sprigs of roses and carnations, both commonly used flowers in the patterns from 1747. The mirrored repeating pattern used in both designs is frequently seen in Garthwaite's work from the 1740s. It creates the asymmetry that is typical of the rococo style.[3]

Before they were woven, Garthwaite's designs were transferred to squared paper, so that the loom could be configured.[4] (SN)

A-B

1  Rothstein 1990, pp. 48-49, 223, 314-315.
2  Rothstein 1990, pp. 230, 342, pl. 242.
3  Rothstein 1990, p. 50.
4  Rothstein 1990, p.27.

173                             Fashion for God

# 32  Garthwaite cope in Utrecht?

The silk fabric of this rococo cope is particularly decorative, and the pattern closely resembles those designed by Anna Maria Garthwaite in 1743-1744. Many of Garthwaite's designs have survived, in the collection of the Victoria and Albert Museum in London. Though there is no exact match with any of the surviving designs, given the fact that they did not all survive it is impossible to conclude with any certainty whether she designed this fabric or not. The resemblance to patterns 5982:10 and 5985:9, for example [cat. 31], is however so strong that it is quite possible that this is a Garthwaite design. The patterns on the orphreys and the shield date from considerably later, possibly the first quarter of the nineteenth century.

The design and manufacture of the silk rococo fabric are of a very high standard, and it must have been used to make a spectacular gown. Signs of alterations in the cope and various fabric fragments in the collection of Museum Catharijneconvent clearly show that the cope had had a previous life in another guise. The current state of the cope is poor, however. Both the back and front have sustained severe water damage in the past. Nevertheless, the cope and the silk fabric are still stunningly beautiful. (PA)

White cope, c. 1743-1744 (design of base fabric by Anna Maria Garthwaite [?], Spitalfields, London); c.1800-1825 (cope shield and orphreys).

Silk, 139 × 303 cm. Utrecht, Museum Catharijneconvent, OKM t216a; on long-term loan from de Old Catholic Cathedral of St. Gertrude, Utrecht. Provenance: originally at the Old Catholic Church of St. Gertrude in Utrecht.

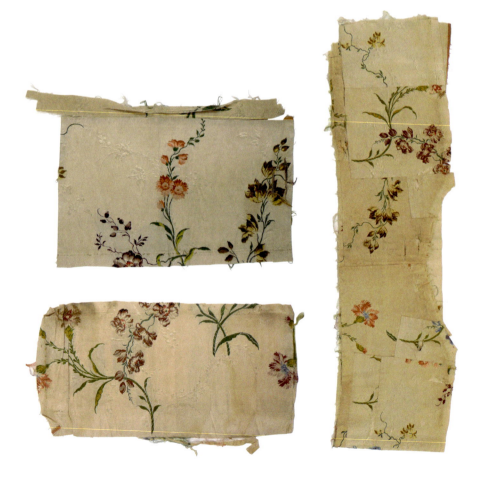

Silk fragments, c. 1743-1744, Spitalfields, London, Anna Maria Garthwaite? (pattern). Utrecht, Museum Catharijneconvent, OKM st35a/b/c.

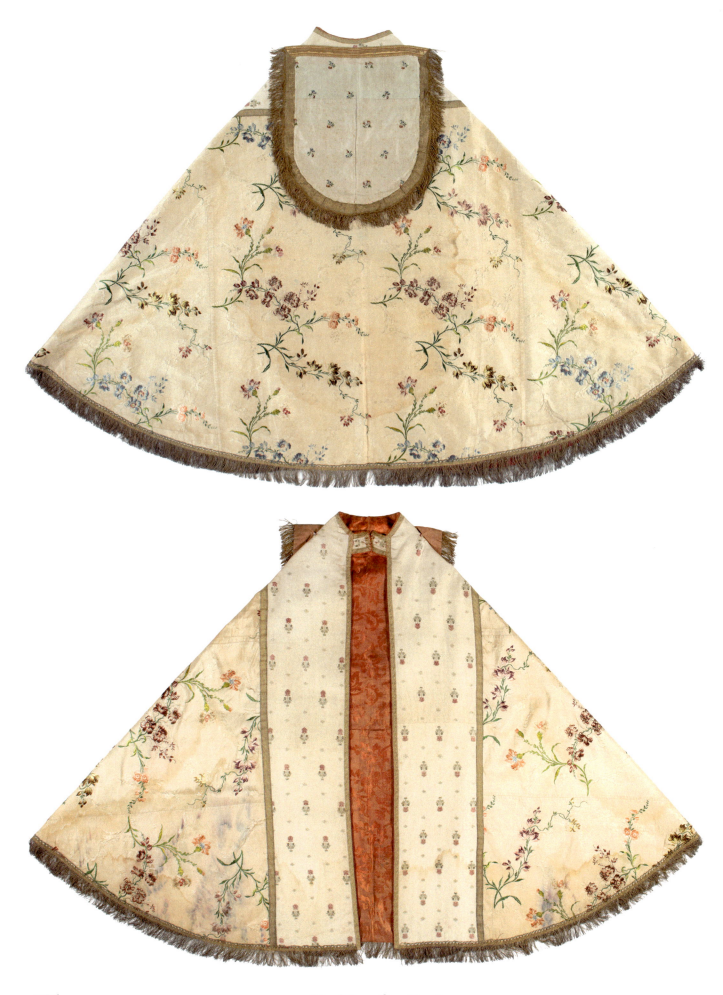

Fashion for God

# 33 Blue as a liturgical colour

A Blue cope, c. 1765 (base fabric).

Silk, gold galloon, gold fringing, h. 128 cm. The Hague, Old Catholic Church of St. James and St. Augustine, 2198-112.

B Blue chasuble, c. 1765 (base fabric).

Silk, gold galloon, 112.5 × 70 cm. Utrecht, Museum Catharijneconvent, OKM t208a, on long-term loan from the Old Catholic Cathedral of St. Gertrude in Utrecht. Provenance: originally at the Old Catholic Church of St. Gertrude in Utrecht.

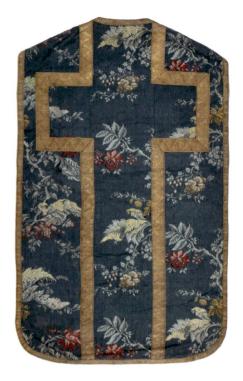

A

Blue has not been an official liturgical colour in the Catholic church since the definition of the liturgical colours at the Council of Trent and the Roman Missal issued subsequently (1570). The officially approved colours are green, white, red, black, purple and pink. The absence of blue from this list does not however mean that blue paraments were not used in the Catholic church. In the eighteenth century, blue was a popular fashion colour (cat. 43) in the Netherlands, and blue silk gowns were often worn. They were therefore also occasionally donated to Catholic churches to be used for paraments. Blue paraments would generally be worn during celebrations on Marian feast days, as blue traditionally symbolises the Virgin Mary.

The cope and chasuble have a similar motif of white and coloured flowers and leaves woven into the blue silk background. Both motifs can be dated to the 1760s. The cope has a shield of pink silk with woven flowers integral to the fabric and a white motif of ornamental vines.

The chasuble is part of a set of vestments that originally came from the Old Catholic Church of St. Gertrude in Utrecht. Nowadays, the set consists of a chasuble, two stoles, a maniple, a chalice veil and a burse (all currently on long-term loan to Museum Catharijneconvent). A second maniple is still at St. Gertrude's Cathedral. The set must have been bigger originally, however, possibly including a second cope, a dalmatic and tunicle, and at any rate an altar frontal and four candlestick frontals. The latter are shown in a painting of the interior of St. Gertrude's Cathedral in 1896 (fig. 45).

The cope has probably always been at the church in The Hague; it is not clear whether it was once part of a set. (PA)

45 J. (Johannes?) Steffelaar, Interior of the clandestine church of St. Gertrude in Utrecht, 1896. Oil on canvas, 64.5 × 52 cm. Utrecht, Old Catholic Cathedral of St. Gertrude, 469-231.

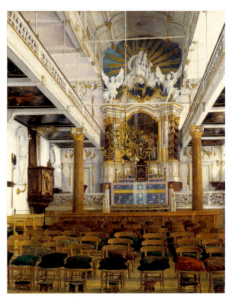

176  Fashion for God

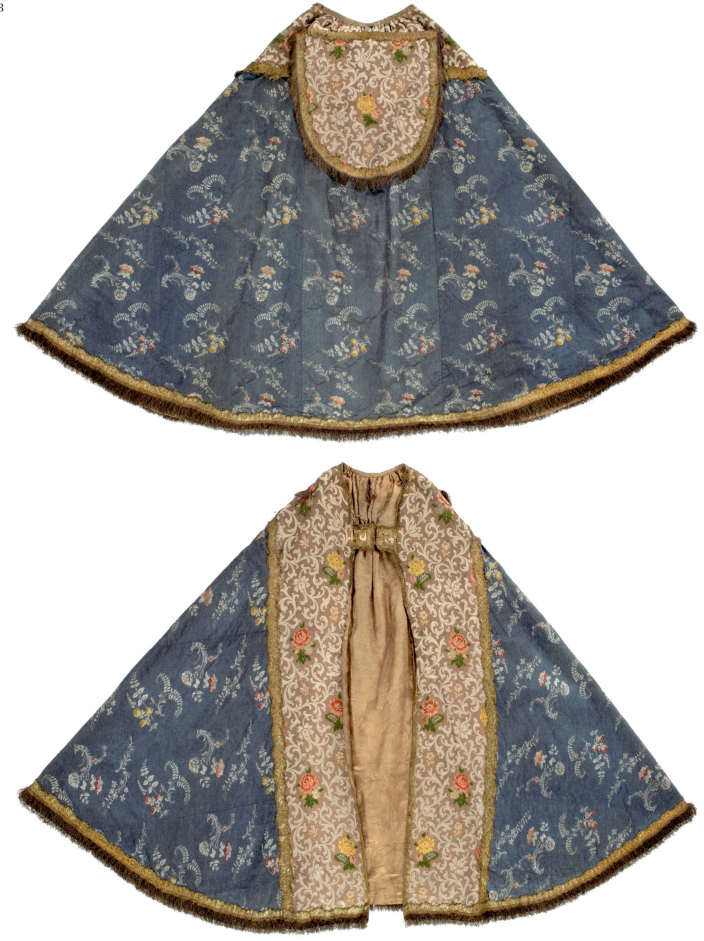

Fashion for God

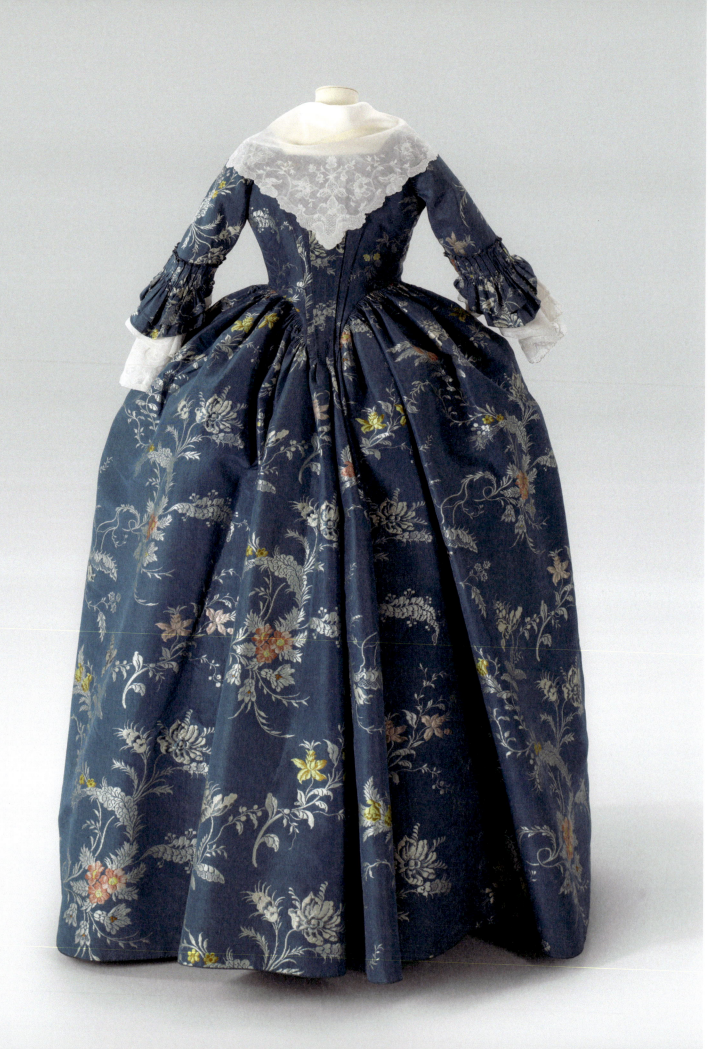

# 34  A blue robe ajustée

Robe ajustée with overdress and tablier, c. 1765.

Blue taffeta with weft-patterned white vines and brocaded flowers in pink, yellow, grey and brown, h. 140 cm. The Hague, Kunstmuseum Den Haag, K 53-1963, 0322319. Gift of Mrs G. van Son-Beelaerts van Emmichoven.

46  Bernardus Accama, Portrait of Anne of Hanover, Princess of Orange-Nassau, 1736. Oil on canvas, 92 × 71 cm. The Hague, Orange-Nassau Historical Association, A 3651.

In this portrait Anne of Hanover wears a 'simple English gown' of red silk damask with a close-fitting back.

This gown of blue silk with a woven floral motif is a robe ajustée, a gown with a fitted back. This term was coined in the twenty-first century to denote this type of gown, which for a long time was referred to as a robe à l'anglaise. This is not entirely correct, however.[1] A robe à l'anglaise was made from an overdress whose back section had been cut and stitched in place. In a robe ajustée the back section was folded into shape and stitched in place, also creating a fitted back line. One advantage of this method was that if the gown was to later be converted to something else, the stitching need only be removed and a large piece of fabric would become available.

This type of gown, the robe ajustée, was common in the Netherlands and England, unlike France, where the robe à la française, with its loose-fitting back, was the style of choice (cat. 37). The robe ajustée was not worn there at all. This was because the French robe à la française had developed from the manteau or robe volante, loose-fitting gowns that had been in fashion earlier in the eighteenth century. The robe à la française was often worn in the Netherlands. In Britain, however, the mantua, a gown with a folded back and drapery on the back, developed into the court mantua, which had a folded back, like the robe ajustée. This type of gown was also worn in the Netherlands, as was the later robe ajustée.

It is not surprising that the Netherlands looked to both France and Britain on matters of fashion at that time. By that time, Paris was no longer the centre of international fashion. English fashion was regarded as 'simpler' — despite all the pomp and splendour of the British court — given the fact that the British were keen on freedom of movement and comfort, which also suited Dutch tastes.

The Dutch interest in English fashion was also prompted by the ties between the Dutch Protestant stadtholder family and the British Anglican royal family, which led to a great deal of intermarriage between the two. The influence of Anne of Hanover, Princess Royal and Princess of Orange, the daughter of the British King George II, who married Stadtholder William IV in London in 1734, was certainly also a factor. In the years that followed, she lived mainly at the court in The Hague, where she died in 1759. Portraits show her wearing simple English gowns, or even riding gear (fig. 46).

During the 'anglomania' of the second half of the eighteenth century — a time when everything had to be 'English', from landscape gardening and architecture to carriages and tea parties — the robe à l'anglaise came into fashion, in the 1770s-1780s.[2] This resulted in an international fashion that even became all the rage in France.

Fashion for God

47 Simon Fokke, Dutch merchants submit to Princess Anne a complaint about the English attacks, 1758. Pencil and ink on paper, 168 × 237 mm. Amsterdam, Rijksmuseum, RP-T-00-1597.

Anne of Hanover appears to be dressed in a riding costume here, or at any rate a combination of a waisted jacket, skirt and something resembling a cap on her head.

It is said that this gown was worn in the Netherlands as a wedding dress.[3] It has been widened, possibly as the figure of the wearer changed. Labour costs for dressmaking and alteration work were not high, certainly not compared with the high price of textiles at the time. Special silk fabrics, certainly those that included gold or silver thread, cost hundreds of florins.[4] To illustrate the low cost of making clothes, by contrast: in 1790 dressmaker J.C. Ruppelt of The Hague made a bridal gown for Princess Louise, daughter of Stadtholder Willem V, for just ten florins. Two sets of alterations to existing ballgowns on the same bill cost even less, at just over three florins each. It is thus no surprise that it was so common for clothes to be altered at that time. (MH)

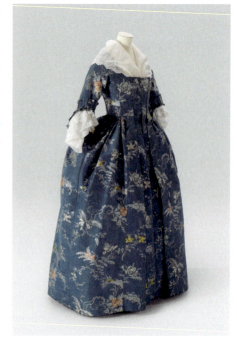

1 Gorguet Ballesteros / Hohé 2005-II, p. 109.
2 Chrisman-Campbell 2005, pp. 50-53.
3 Meij 1998, p. 17.
4 Hohé 2005, pp. 120-125. KHA Princess Louise, 349-358 and 356, bills from J.C. Ruppelt 22 October 1790 listing the orders and sums charged (F 409-14).

180  Fashion for God

# 35  Made of Dutch silk

Robe ajustée with overdress and tablier, c. 1765 (overdress and tablier), possibly 1800-1900 (stomacher).

Light blue-green satin with liseré, brocaded with a pattern in green, red, yellow and blue, h. 146 cm. The Hague, Kunstmuseum Den Haag, OW 18, K 3-x-1936, K 84-1976, 0634245. Gift of Miss C.M. van Beek.

This pale blue-green gown was loaned to Kunstmuseum Den Haag in 1936, and donated to the museum in 1976. It was therefore one of the first gowns in its collection. In 1936 it featured as one of the highlights of an exhibition that was very important in Dutch costume history — *Het Costuum onzer Voorouders* ('Costumes of Our Ancestors') — shown at the Knights' Hall in The Hague. The exhibition featured costumes and accessories dating from the eighteenth to the twentieth century from a host of Dutch families and collections, both public and private. Some of them went to Dutch museums after the exhibition, becoming a key element or even the seed of many Dutch costume collections.[1] The exhibition itself was a huge success, attracting 33,000 visitors in The Hague alone.[2] It travelled on to Arnhem and Amsterdam, after which this gown eventually went to the collection in The Hague. When it arrived at the museum it was noted that the embroidered stomacher was a nineteenth-century addition.[3] This suggests that the gown was reused for fancy dress or a costume ball outfit in the nineteenth century or later.

The fabric of the gown is beautiful, and the overdress and tablier are in good condition and in their original state. The silk used to make the gown is 47 cm wide, a size regarded as typical of silk produced in the Netherlands, and differing from many French silks, which were broader from selvedge to selvedge.[4]

There are two other examples of silk with precisely the same integral woven floral motif in Kunstmuseum Den Haag's collection, both of which are also made of fabric sold in 47 cm widths.[5] One is a robe tunique in dark blue silk satin (c. 1797-1800). This gown was made from an earlier gown, a robe à la française (c. 1750-1780). The stitch holes and structure suggest that it was worn as a maternity gown, an attempt having been made to alter it to the style of a robe tunique.[6] The collection also includes a women's jacket of light blue satin with the same woven pattern (c. 1780). The jacket comes from Noord-Holland province and is of a different order than the fashionable gowns. It was combined with a skirt, and was probably worn as 'traditional dress', as reflected in the addition of some distinctive accessories.

Is it a coincidence that all three silks have blue or blue-green as their basic colour? It is striking that women's gowns from the eighteenth century in Dutch collections are often made of blue silk.[7] One possible explanation of the preference for this colour lies in Protestantism. The church had had long exercised a great deal of influence over the meaning of colours in society. Anyone who was strictly devout regarded vibrant colours as the dangerous trickery of the Devil, or as worldly temptation that must be avoided.[8] In the Late

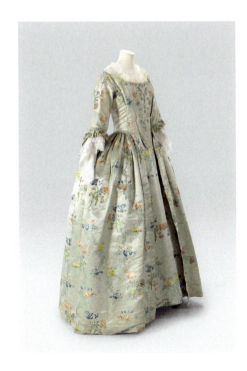

181                                                      Fashion for God

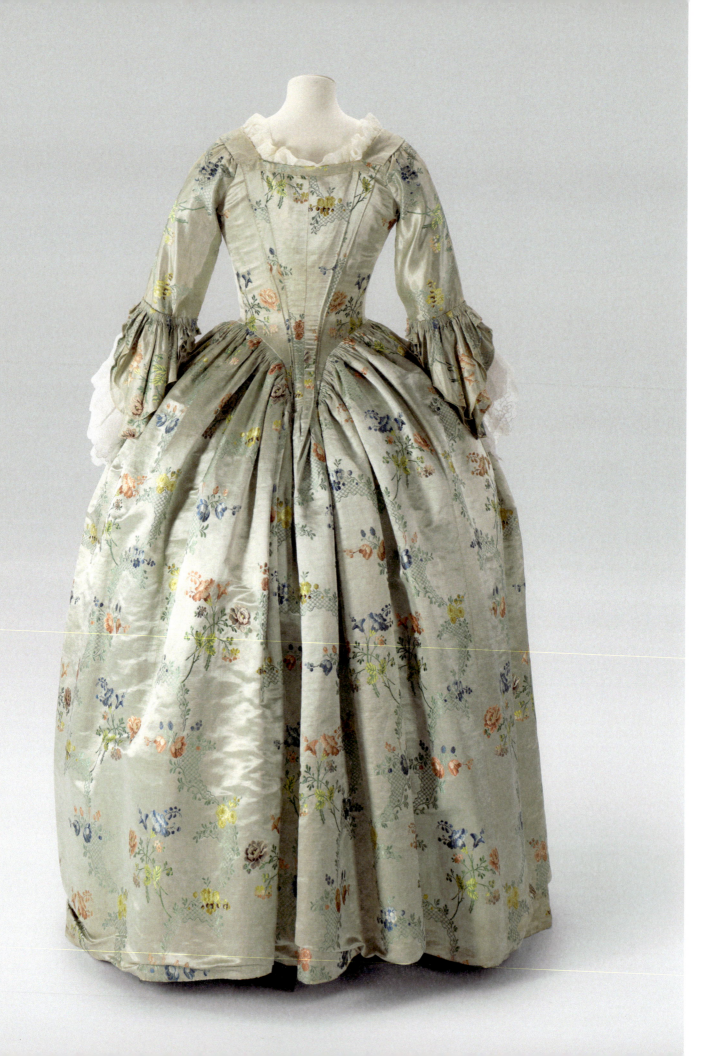

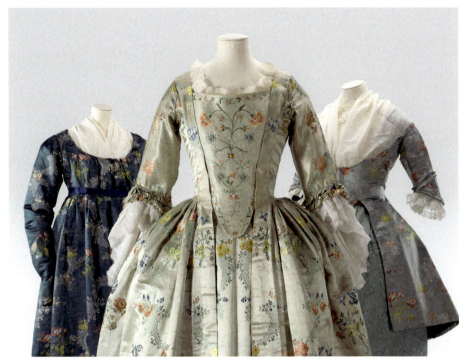

Middle Ages, therefore, the colourful fashions of the time prompted a change in attitude to colour, a kind of 'decolouring'.[9] Henceforth, a distinction was drawn between 'decent colours' (black, grey, blue) and 'indecent colours' (bright shades like red, green and yellow). The Protestants embraced this attitude.[10] Their love of modest, decent blue was further enhanced by its association with the cult of Mary, which emerged in the Late Middle Ages.[11] This probably goes some way to explaining the excessive amount of blue in Dutch fashion collections, particularly in items from the eighteenth and nineteenth centuries.[12] (MH)

48  The same floral motif on brocaded silk satin in dark blue, light blue-green and light blue, from the collection of Kunstmuseum Den Haag. Left to right: Gown made from robe à la francaise, c. 1797-1800. The Hague, Kunstmuseum Den Haag, 1025638; Robe ajustée, c. 1765. The Hague, Kunstmuseum Den Haag, 0322319; Jak (Caraco), c. 1780. The Hague, Kunstmuseum Den Haag, 0300392.

49  Album made by the organisers of the exhibition 'Costumes of Our Ancestors' (1936) by way of documentation, including robe ajustée, no. 100 in the exhibition, Kunstmuseum Den Haag.

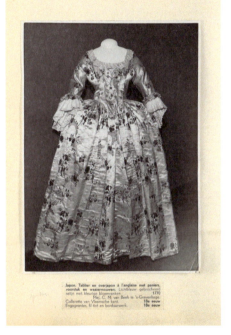

1   De Jonge 1936.
2   Graafschap-bode 1936, p. 1.
3   When it arrived at the museum, the following note was made: 'Gown à l'anglaise of light green silk with woven rococo decorations and colourful flowers. Tablier. Sleeves with engageantes of fils tiré. Stomacher 19th century, embroidery on light green silk. Collerette new.' The 'collerette' was numbered OW-19 on arrival, and is now obj.no. 1026482.
4   Colenbrander 2010.
5   Gorguet Ballesteros/Hohé 2005-1, p. 233.
6   Thanks to Jacoba de Jonge and Tirza Westland who studied and documented the alterations to this gown.
7   The Haags Gemeentemuseum (now Kunstmuseum Den Haag) even staged an exhibition on the subject in 1995, entitled 'Silhouetten in Blauw' ('Silhouettes in Blue'), see Meij 1998.
8   Pleij 1994, pp. 54-55, 57; Pastoureau 2001, pp. 99-100.
9   Pleij 1994, pp. 59-61.
10  Pastoureau 2001, pp. 99-104.
11  Pastoureau 2001, pp. 50-55.
12  Hohé 2021, pp. 53-67.

Fashion for God

# 36 Green and white from The Hague

This light blue-green cope was used at the Old Catholic Church of St. James and St. Augustine in The Hague as a white cope because of the paleness of the blue-green. A stole of the same white silk as the cope shield survives in the sacristy of the church in The Hague, but as far as is known it was not part of any larger set, and was probably used in combination with other white paraments from the sacristy.

The design of the brocaded motif of fine sprigs of white and coloured flowers and leaves is very similar to the designs which Anna Maria Garthwaite produced in London in 1743-1744 [cat. 31], but they were also made in Lyon around 1760.

The cope shield is of a different material than the cope itself. The white silk has a motif of woven vertical red stripes, overlaid with painted sprigs of flowers. Painted silk came from China, where it was made in the mid-eighteenth century specially for export to Europe [cat. 39]. It is however known that this technique was imitated in Europe, because of import restrictions. It is unusual for striped silk to be painted, and it is unclear whether this fabric was made in China or in Europe.

Signs of alterations seem to suggest that this gown was reused. The light blue-green robe ajustée from Kunstmuseum Den Haag gives a good impression of how the gown from which this cope may have been made might have looked [cat. 35]. Some of the alterations might actually be repairs. The large bands of fabric both on the back and in the orphreys, edged with gold galloons, have been applied symmetrically. (PA)

Light blue-green cope, c. 1760 (base fabric), c. 1750 (cope shield).

Silk, gold galloon, gold fringing, h. 129 cm. The Hague, Old Catholic Church of St. James and St. Augustine, 2198-113.

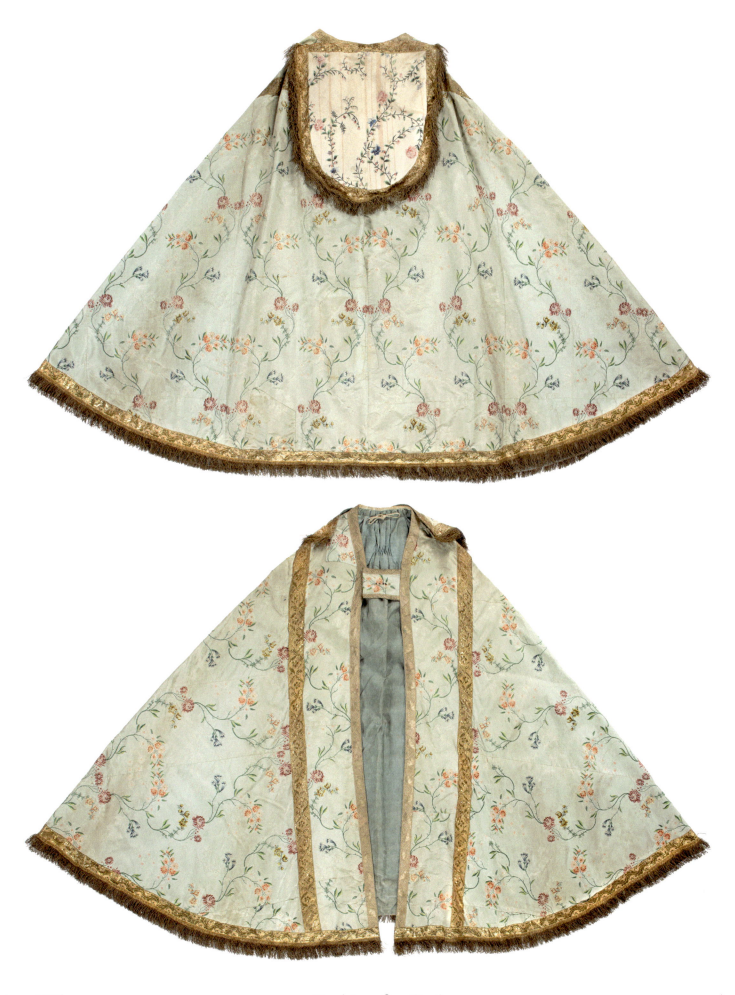

Fashion for God

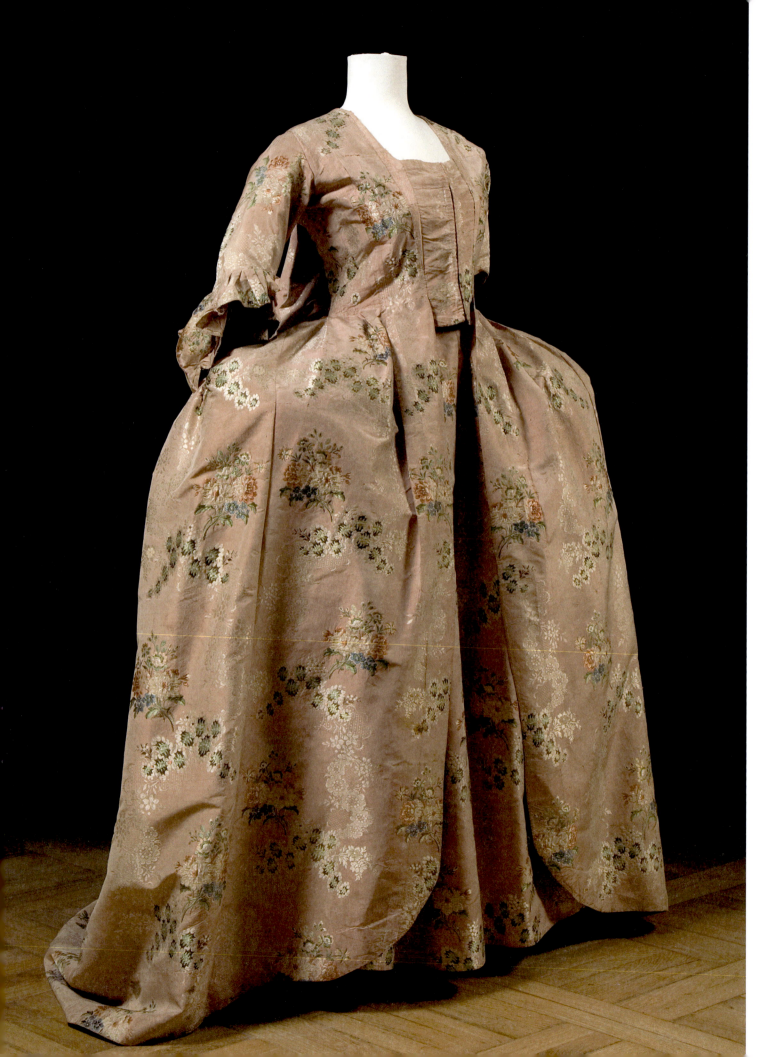

# 37 Rococo gown with floral and lace motifs

Robe à la française,
c. 1760-1770.

Silk, linen, h. 155 cm. Brussels,
Royal Museums of Art and History,
C.0270.00 and C.0271.00.

This gown from the Royal Museums of Art and History in Brussels is a real eyecatcher. The dress of pink taffeta brocaded with multi-coloured floss and chenille yarn was particularly fashionable in 1765-1775. It is easy to date the dress thanks to the striking fabric with a beautiful motif of bunches of flowers interspersed with a white lace motif, known as a lace trail motif.[1] This lace motif continues over the entire fabric of the dress.

The best-known manufacturer of fabric with such a continuous lace motif was Louis Galy, Gallien et Compe of Lyon.[2] Textile designers who had graduated from the *école de dessin* in Lyon and went to work for textile manufacturers in the city introduced radical innovations in fabric designs. Several examples of the same type of textile with a lace trail motif, in other colours, still exist at the Royal Museums of Art and History.[3] The lady who once ordered this dress will certainly have been aware of the latest trends. The dress is still in good condition, though not perfect. Here and there, holes in the fabric have been backed with a silk gauze in an early restoration. The various old stitch holes and folds are also striking. Yet all the original stitch holes remain. Triangular pieces of fabric were inset into the armpits at some point in the past to allow more freedom of movement for the arms. One sleeve is missing its cuff. Two narrow strips have also been inset into the bodice to the left and right of the front panels, the compères, to enlarge the dress around the chest.

The dress is a classic robe à la française with the typical double box pleats or pli watteau.[4] It is not lined, as it would have been worn as an overdress with a matching skirt in the same fabric. Only the bodice and hem have a linen lining. This linen corset is sewn to the dress, and has a cord in the back laced through nine holes, to ensure the bodice was as close-fitting as possible. The bodice was fastened down the front with hooks and eyes attached alternately on the left and right. To save on the expensive silk fabric, a horizontal strip of linen measuring 27 by 100 cm has been inserted into the back of the matching skirt, across the posterior. This is not visible because the overdress covers the back of the skirt. This was common practice in gowns of this type. Pink was a very popular colour in the rococo period, as it gave the wearer a fresh and youthful look.[5]

The dress ended up in the museum's collection in 1922 by means of a bequest.[6] Albert Glibert Esq. of Brussels (1832-1916) had drawn up a will stipulating that the historical garments he had collected during his lifetime should be transferred to the museum in the event of his death. The museum received a treasure trove of eighteenth- and nineteenth-century costumes. Glibert had worked for the Belgian state as a civil servant, but he was also a very accomplished

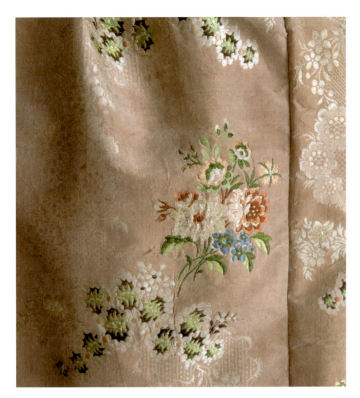 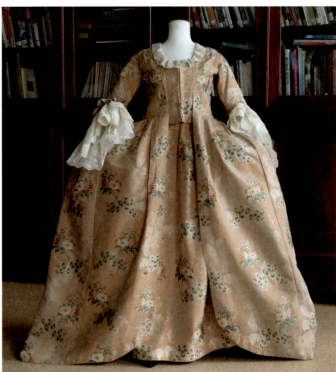

amateur painter. He painted sophisticated genre scenes in eighteenth-century settings.[7] Many of the items of clothing he left to the museum can be seen in his paintings. He probably had his models pose for him wearing eighteenth-century clothes.

Frequent use caused damage to some of the dresses. This pink gown with bunches of roses, forget-me-nots and anemones has some pin holes here and there, perhaps caused during alterations, or because the garments were pinned during modelling sessions. Dresses from the past were thus not merely recut to make religious clothing or paraments, but also for use as historical garments in genre paintings. (RC)

1  Rothstein 1990, pp. 52-53.
2  Miller 2002, pp. 87-131.
3  Royal Museums of Art and History, Brussels: Textile collection: Inv.nos.: Tx.1936 and en Tx.1937.
4  Arnold 2021, pp. 34-35.
5  Rothstein 1984, p. 28.

6  KMK&GB: Extract from the Belgian Government Gazette: Moniteur Belge, jeudi 21 septembre 1922: *M. Albert Glibert, ex-administrateur de la Caisse des Propriétaires, à Bruxelles, décédé à Bruxelles, le 2 novembre 1916, dise comme suit: je donne et lègue à l'Etat Belge, pour être placée aux Musées du Cinquantenaire, ma collection de costumes anciens.*

7  Two of the paintings are in the collection of the former Ridder Smidt van Gelder Museum in Antwerp, currently on loan to the City of Antwerp: *The Conversation*, oil on panel, inv. no. 0992 and *Forbidden Fruit*, oil on panel, inv. no. 0993.

# 38   A pink rococo cope from Krommenie

**Pink cope, c. 1775.**

Silk, gold galloon, gold fringing, 111 × 700 cm (hem). Krommenie, Old Catholic Church St. Nicholas and St. Mary Magdalene, 5981-73a.

Like the pink robe à la française [cat. 37] this cope is made of pink taffeta (taffeta is a fabric whereby every weft thread is passed alternately under and over the warp thread during the weaving process). The pattern of white garlands and lace trails, plus multicoloured bunches of flowers, is brocaded, applied during the weaving process with silk weft threads that are present only in the patterned areas, rather than across the entire width of the fabric. The patterns on the gown and cope both date to circa 1765-1775. The cope and shield are edged with gold fringing and the shield has a gold tassel. Wide, undulating gold galloons define the orphreys on the front.

The size of the cope is remarkable. Copes generally form a semi-circle when laid flat, but this one is virtually circular. There is therefore almost twice as much material in it as would normally be in a cope.

It is said locally that the cope was made of a bridal gown. If so, it was almost certainly a robe à la française, which would take several metres of silk. At the bottom on the back there are clear signs of old pleats, seams and stitch holes, indicating how the gown was originally constructed. The quality of the material and the state of the cope are so good that the possibility that the gown was used only once, as a wedding dress for example, cannot be ruled out.

It is not however known who gave this gown to the church or when. If it was indeed a bridal gown worn only once, the cope will not have been made much later than 1775 (the date of the silk fabric). As far as is known, the cope and a matching stole have always been at the Old Catholic Church of St. Nicholas and St. Mary Magdalene in Krommenie. According to the church's register of marriages, 41 weddings took place there between 1764 and 1800. Did one of those brides marry in pink, perhaps?[1] (PA)

Detail of the cope. Folds, seams and stitch holes indicate that the silk fabric had been used before.

1   NHA 257.193.

Fashion for God

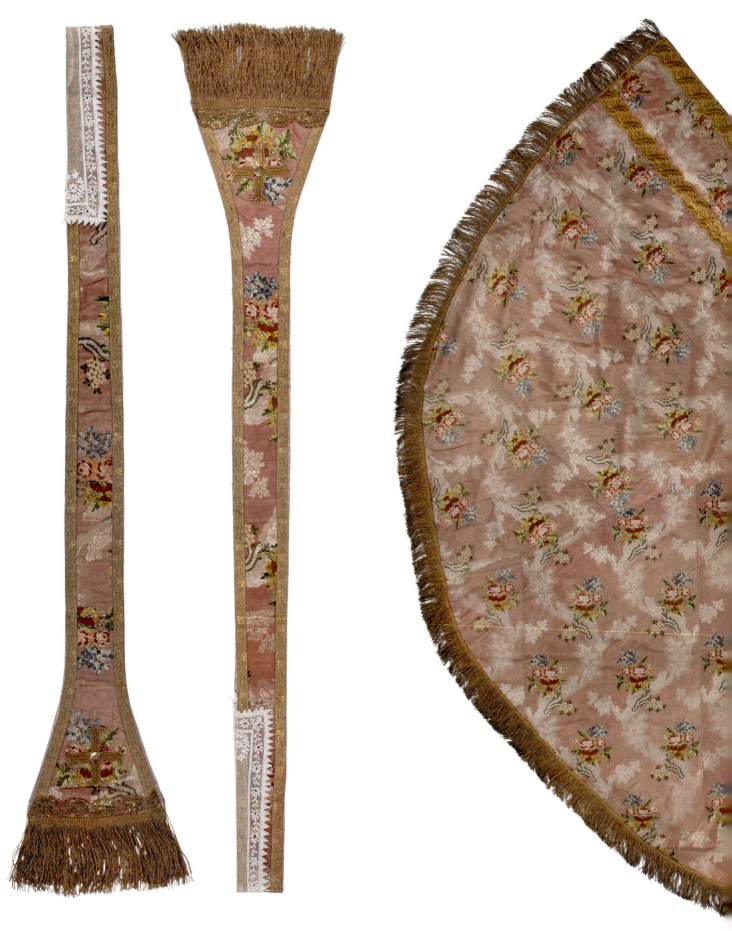

Pink stole, c. 1775. Silk, gold galloon, gold fringing, 246 × 20 cm.
Krommenie, Old Catholic Church St. Nicholas and St. Mary Magdalene, 5981-73b.

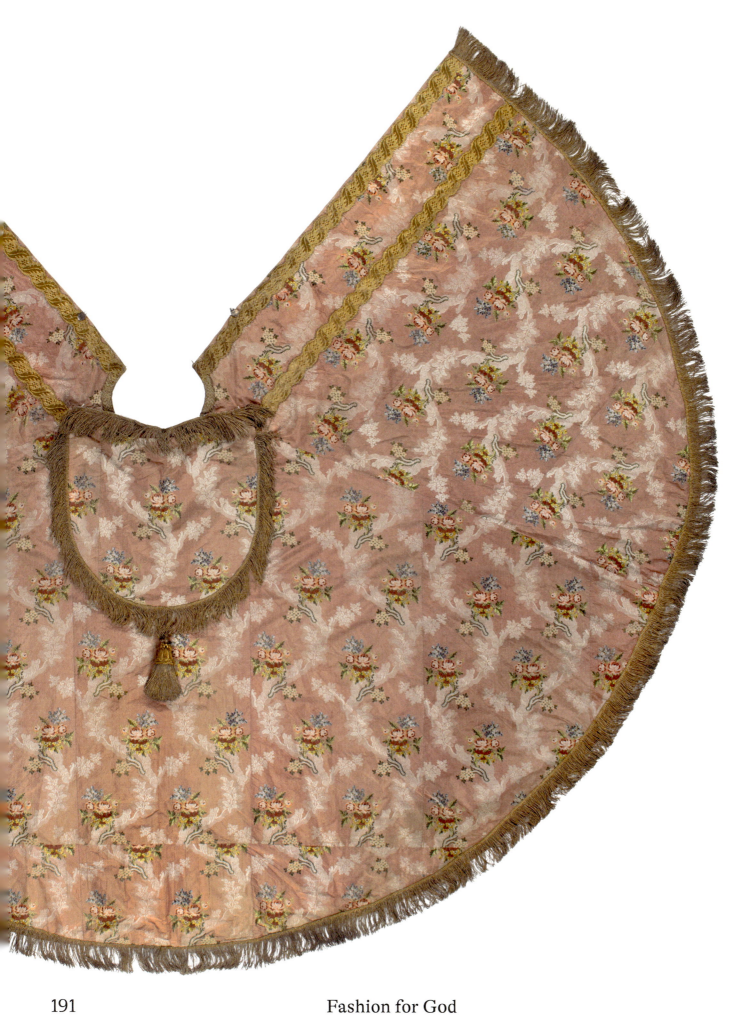

# 39 Chinese silk in a Utrecht church

A White chasuble, c. 1775-1800 (original chasuble), c. 1900 (altered); Guangdong, China, c. 1750 (base fabric).

Silk, gold galloon, gold thread, 120 × 72.5 cm. Utrecht, Museum Catharijneconvent, OKM t209a. Provenance: Old Catholic Church of St. Gertrude in Utrecht.

B White maniple, c. 1775-1800 (maniple); Guangdong, China, c. 1750 (base fabric).

Silk, gold galloon, gold thread, 62 × 16.5 cm. Utrecht, Museum Catharijneconvent, OKM t209b. Provenance: Old Catholic Church of St. Gertrude in Utrecht.

C White chalice veil, c. 1775-1800 (chalice veil); Guangdong, China, c. 1750 (base fabric).

Silk, gold lace, gemstones, 61 × 53 cm. Utrecht, Museum Catharijneconvent, OKM t209c. Provenance: Old Catholic Church of St. Gertrude in Utrecht.

D White burse, c. 1775-1800 (burse); Guangdong, China, c. 1750 (base fabric).

Silk, gold galloon, gold lace, gemstones, 23.5 × 23 cm. Utrecht, Museum Catharijneconvent, OKM t209d. Provenance: Old Catholic Church of St. Gertrude in Utrecht.

E White pall, c. 1775-1800 (pall); Guangdong, China, c. 1750 (base fabric).

Silk, gold galloon, gold lace, 18.5 × 18.5 cm. Utrecht, Museum Catharijneconvent, OKM t209e. Provenance: Old Catholic Church of St. Gertrude in Utrecht.

F 16 fragments of white silk, Guangdong, China, c. 1750.

Largest fragment 76.5 × 23 cm. Utrecht, Museum Catharijneconvent, OKM st15. Provenance: Old Catholic Church of St. Gertrude in Utrecht.

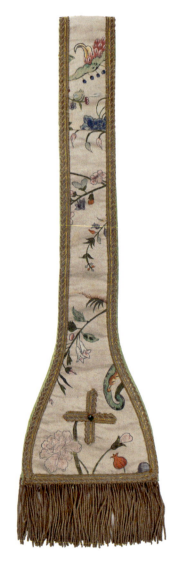

B

For as long as anyone can remember, the collection at Museum Catharijneconvent has included a group of sixteen fragments of white silk: 'chinoiserie', as it was listed in the catalogue. Apart from the fact that they were part of the collection that had come from the Old Catholic Museum, one of the forerunners of Museum Catharijneconvent, nothing further was known about the provenance of the fragments, and they were regarded as original or founding collection of the Old Catholic Museum. Fragments of fabric were often collected in the past to create a museum record of liturgical fabrics from the rich history of the Catholic church.[1] The fragments of chinoiserie were undoubtedly carefully stored for all those years with this purpose in mind.

In 2017, under the supervision of Richard de Beer, researcher and curator of Old Catholic heritage at Museum Catharijneconvent, a set of paraments made of white silk with a floral motif was added to the collection. It comprised a chasuble, maniple, chalice veil, burse and pall, all from the Old Catholic church. This set, with a badly damaged chasuble, turned out to be made of the same material as the chinoiserie fragments. It soon became clear that the fragments and the paraments had once been a gown.

The motif on the fabric indicates that it was made in the mid-eighteenth century. Further study showed that the motif was not printed on the fabric, as had initially been thought on the basis of the fragments, but was hand-painted. This is unusual, as silk is not normally painted (neither the fabric, nor the yarn before it is woven). Applying a motif with paint and brush is not customary in Europe. Such fabrics were however made in China in the mid-eigh-

A

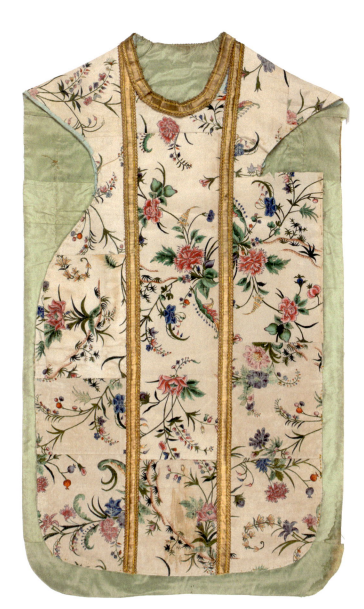 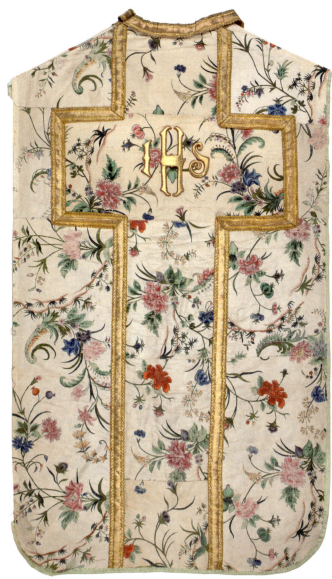

teenth century specially for the European market. Indeed, there was an entire industry in the Guangdong (Gangzou) that specialised in this technique. Although there are chasubles for which a specific painted motif was composed in the required shape[2], most of the silk was simply made by the metre and shipped to Europe, where it would be used to make both clothes and soft furnishings.[3] Hand-painted Chinese silk was imitated in England and France during the eighteenth century, however, as direct imports of this product from China were banned for several years. This was not however the case in the Netherlands, and the Dutch even exported some of these silks to France and England.[4]

The silk itself was often slightly heavier than normal (achieved, for example, by weaving a weft thread over and under two or more warp threads, to produce ribbed silk), which also made it easier to paint. Even though the silk was heavier, however, we now know that some of the pigments used in the paints were not good for the silk. One commonly used green paint based on malachite, which

contains copper, could corrode the silk, causing holes in the fabric.[5] There is barely any trace of this in the Guangdong silk items at Museum Catharijneconvent, however. The material is in relatively good condition, with few holes or splits, and the painted motifs are still largely fresh and in good condition.

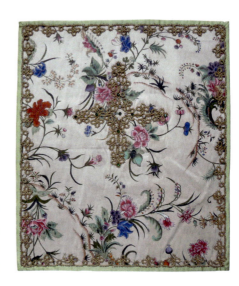
C

The state of the chasuble as a vestment is an entirely different matter, however. After the gown from which the fabric was taken had been dismantled, a chasuble was made from the larger pieces. It appears, however, that sometime later, around 1900, alterations were begun but never completed. Though the position of the cross and column on the back and front of the chasuble is indicated with gold galloons, they are held on with only temporary stitching in some places, and not at all in others. Some seams are still open, and others have been sewn up with a mechanical zigzag stitch. By the slit for the left arm on the front, we can see that the basic shape was not even completed. The bottom left corner on the back is not attached to the lining and is therefore open, revealing that not one but two layers of the painted silk were applied, one on top of the other. There are also no trimmings on the edges of the chasuble.

The maniple, chalice veil, burse and pall, probably all eighteenth-century, are in reasonably good condition. The sixteen fragments of fabric have lots of stains and tears, which is probably why they were not used for the paraments.

The entire ensemble comprising the unfinished chasuble, accessories and fragments provides a perfect opportunity to investigate the history of the objects and the process of converting a gown into church vestments. Original pleats, seams and stitch holes can clearly be identified in both the chasuble and a number of fragments. Along with the shape of certain fragments, they show how the original gown would have been constructed. One of the fragments, for example, has a shape that seems to come from the bodice of a gown, while another has converging folds that might indicate pli watteau, the box pleats of a robe à la française. The fragments, some of which have a selvedge, allow the width of the silk fabric to be determined (81 cm), as well as the repeat of the motif (56 cm).

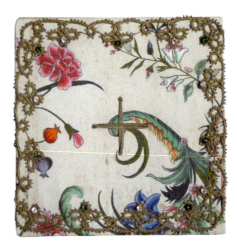
D

The incomplete chasuble itself reveals that vestments would be repeatedly adjusted in order to be reused. Chasubles were consecrated, so they needed to be handled with care and respect.

The problematic state of the chasuble thus actually becomes an advantage, allowing a unique glimpse of the history of this object, and the use and reuse of paraments in general

In summer 2022 another discovery at Museum Catharijneconvent revealed a further piece of the history of these paraments. A fragment of the same painted silk was found under the cope shield on a cope from the former Old Catholic parish of St. Gertrude.[6] It seems that a stock of fragments of this fabric was available in the parish, and that they were used to repair other paraments. (PA)

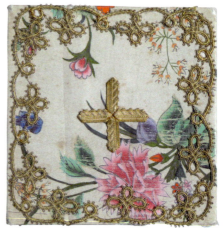
E

194  Fashion for God

F

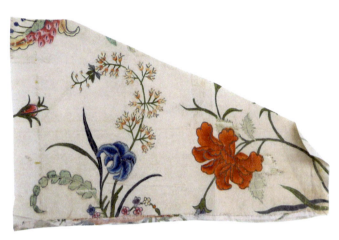
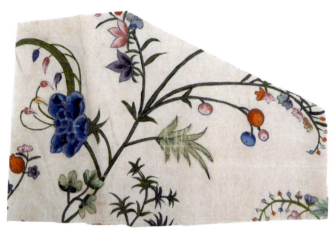
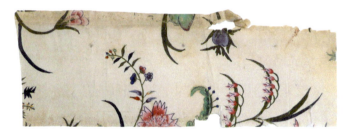
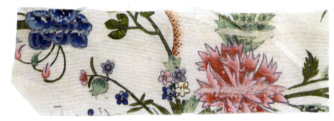

1 Staal 2015, pp. 115-116.
2 Wilson 1987, p. 35.
3 Jolly 2009, pp. 167-178.
4 Jörg 1982, pp. 84-85.
5 Lee-Whitman / Skelton 1983, pp. 42-43.
6 This is cope OKM t211a, which was acquired along with OKM t209a from the Old Catholic parish In de Driehoek in Utrecht, created in 1986 as the result of a merger of three Old Catholic parishes: St. Gertrude, St. Mary Minor and St. James the Great.

195  Fashion for God

# 40 Red lace motif from Alkmaar

This cope is part of a set of eight paraments, of which a chasuble, stole, maniple, chalice veil, burse, pall and altar frontal also survive. It is not clear whether the original set also included a dalmatic and tunicle.

The cope is made of two different silk fabrics. The base fabric is a red silk damask from circa 1750, with a motif of large flowers and trails of foliage. The cope shield and orphreys are made of a slightly earlier red silk fabric with a brocaded pattern in white, green and silver (circa 1730). The brocaded or woven pattern is an imaginative yet relatively formal and symmetrical design of lacework, leaves, flowers and pomegranates. This lacework gives this type of pattern its name: Spitzenmuster (Spitzen is German for Lace). It was generally manufactured in the 1720s and early 1730s, in England, Italy and France as well as the Netherlands.[1] The shield and orphreys are edged with gold lace, and there is gold fringing along the bottom of the cope.

The chasuble, altar frontal, stole, maniple and accessories are made entirely of lace-patterned silk. Assuming that the red silk damask was originally used for the cope, the set must have been made after 1750. There is no evidence that the material was previously used, in a gown, for example.

The paraments originally belonged to the Old Catholic Church of St. Willibrord and St. John on Brouwersgracht in Amsterdam. The altar frontal was given to the Old Catholic Church of St. Engelmund in IJmuiden in 1890. The rest of the set went to the Old Catholic Church of St. Mary Magdalene in Zaandam in 1952, when the church on Brouwersgracht closed, but when the Zaandam church merged with the Old Catholic Church of St. Nicholas in 1974, it ended up in Alkmaar, where the paraments are still used at the Old Catholic Church of St. Lawrence. (PA)

Red cope, c. 1750 (base fabric), c. 1730 (cope shield and orphreys).

Silk, gold and silver thread, gold lace, h. 138 cm. Alkmaar, Old Catholic Church of St. Lawrence, 4626-39b. Provenance: originally at the Old Catholic Church of St. Willibrord and St. John in Amsterdam ('Brouwersgrachtkerk').

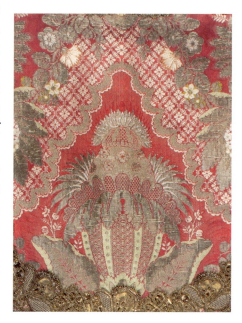

Detail cope shield.

50  Red altar frontal, c. 1730 (base fabric). Silk, gold thread, silver thread, gold galloon, 89,5 × 174,5 cm. IJmuiden, Old Catholic Church of St. Engelmund and St. Adalbert, 6254-76.

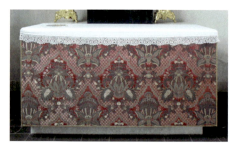

1  Jolly 2018, pp. 20-28.

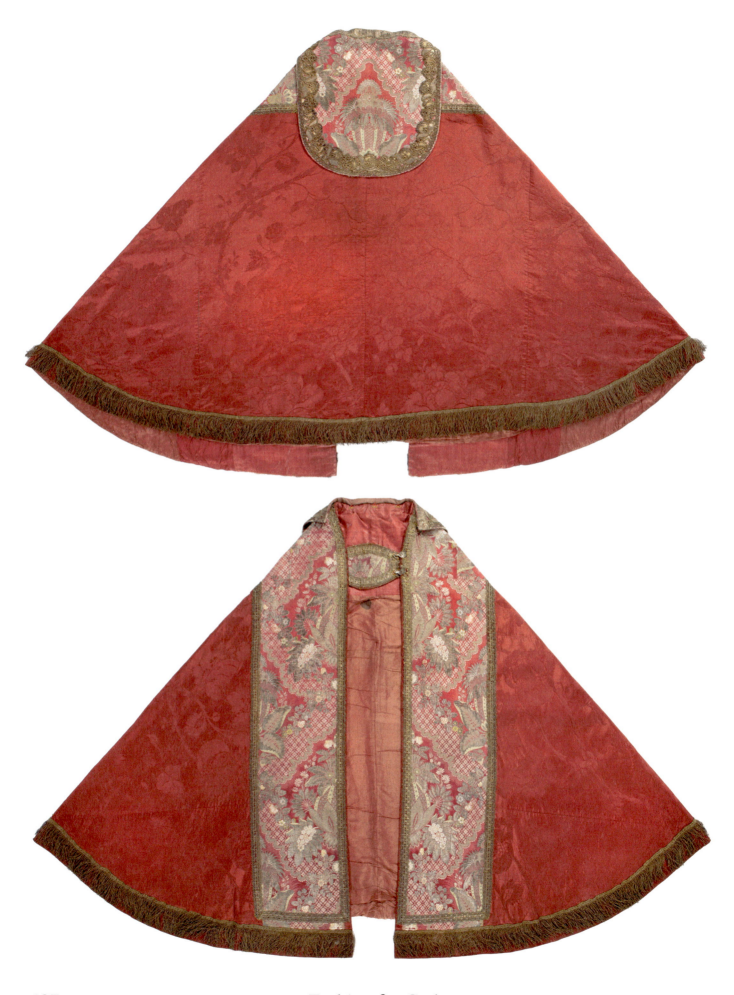

Fashion for God

# 41 Licht blue cope from Rotterdam

This pale blue, silk damask cope is in use as a white cope in the Old Catholic Church of St. Peter ande St. Paul, also known as 'Paradise Church' in Rotterdam. The cope is part of a set that also comprises a chasuble, two stoles, a maniple, chalice veil, burse, pall and sacrament banner. It may have included an altar frontal in the past, but this seems to have been lost.

The silk damask can be dated to between 1730 and 1750. The set may have been gifted to the church in Rotterdam in the eighteenth century by the Osij-Broekhals family.[1] Adrianus Osij and Anna Maria Broekhals married in 1795. He was aged 47 and already a widower, she was 46 and had never previously been married. If they gave the set to the church on this occasion, the light blue silk damask was no longer new when it was donated. Indeed, the silk fabric was probably older than either the bride or bridegroom.

The embroidery in gold and silver thread with spangles on the cope shield is striking. This type of embroidery was rare in the eighteenth century, but is typical of the nineteenth-century neo-baroque. The Lamb of God was a popular iconography for paraments at that time.[2] Furthermore, the current morse was added to the cope in 1804. The hallmarks show that it was made that year by Gerardus van Es, a Rotterdam silversmith. It is not clear how this relates to the wedding in 1795.

The timeline of this cope thus poses a number of mysteries. As with so many paraments, it is clear that materials and techniques from different periods have been used in the different phases in the lives of these paraments, but we do not know the precise ins and outs of the matter. (PA)

Light blue cope, c. 1730-1750 (base fabric), 1804 (morse), c. 1800-1850 (embroidery).

Silk, gold thread, gold fringing, gold galloon and gold, h. 123 cm. Rotterdam, Old Catholic Church of St. Peter and St. Paul ('Paradijskerk', or 'Paradise Church'), 3718-94b. Provenance: originally at the Old Catholic 'Second Paradise Church' in Rotterdam.

1 Paradijskerk 1953, no. 69.
2 Van Roon 2010, p. 46.

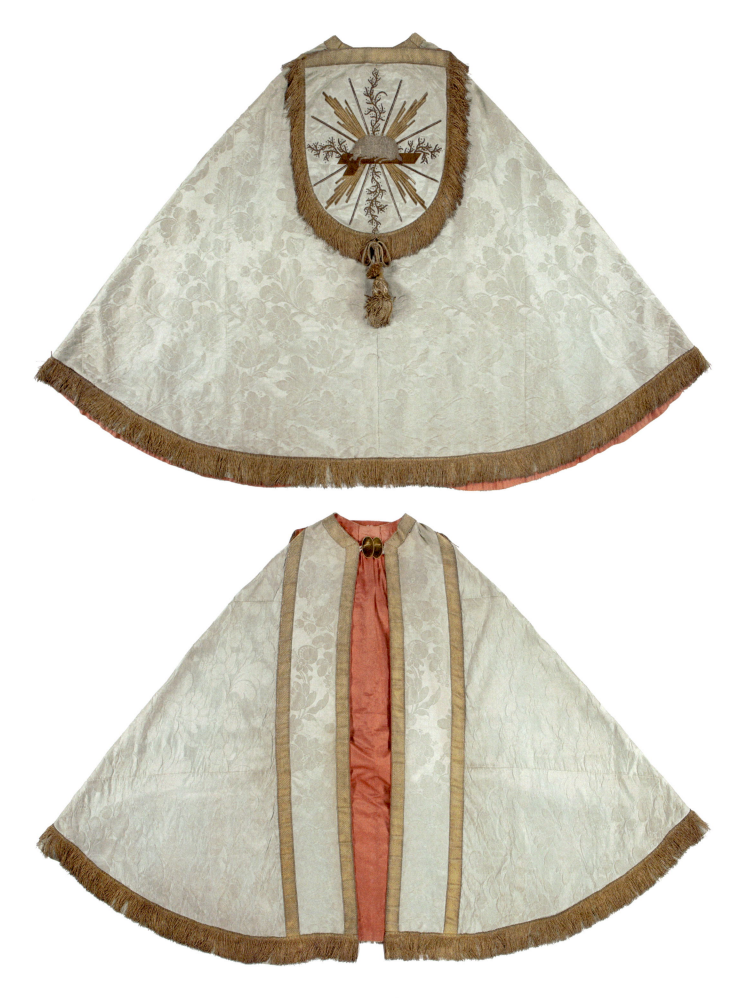

Fashion for God

# 42 Purple cope from Haarlem

This cope is from the impressive collection of paraments belonging to the the Old Catholic Church of St. Anne and St. Mary, the cathedral of the Old Catholic diocese of Haarlem. The church building dates from 1938, but its history goes back to a much older clandestine church established in the attic of a brewery behind Bakenessergracht in Haarlem in 1636. Although the church was dedicated to St. Anne and St. Mary in 1799, it has always been known as the Zolderkerk ('Attic Church'). In the current building the space used for worship is on the first floor, rather than the ground floor.

There is a matching stole in the same fabric. Although a stole is generally worn under a chasuble or dalmatic, a priest can also wear it under a cope during a service (without a eucharist, so not a mass).

The blue-purple changeant or shot silk of the cope and stole has a meandering pattern of white lace trails and white and coloured bunches of flowers, which is typical of the 1760s. The cope shield and orphreys are edged with gold galloon and there is gold fringing along the bottom of the cope itself. (PA)

Purple cope, c. 1765 (base fabric).

Silk, gold galloon, gold fringing, 132 × 286 cm. Haarlem, Old Catholic Church of St. Anne and St. Mary, 5649-210.

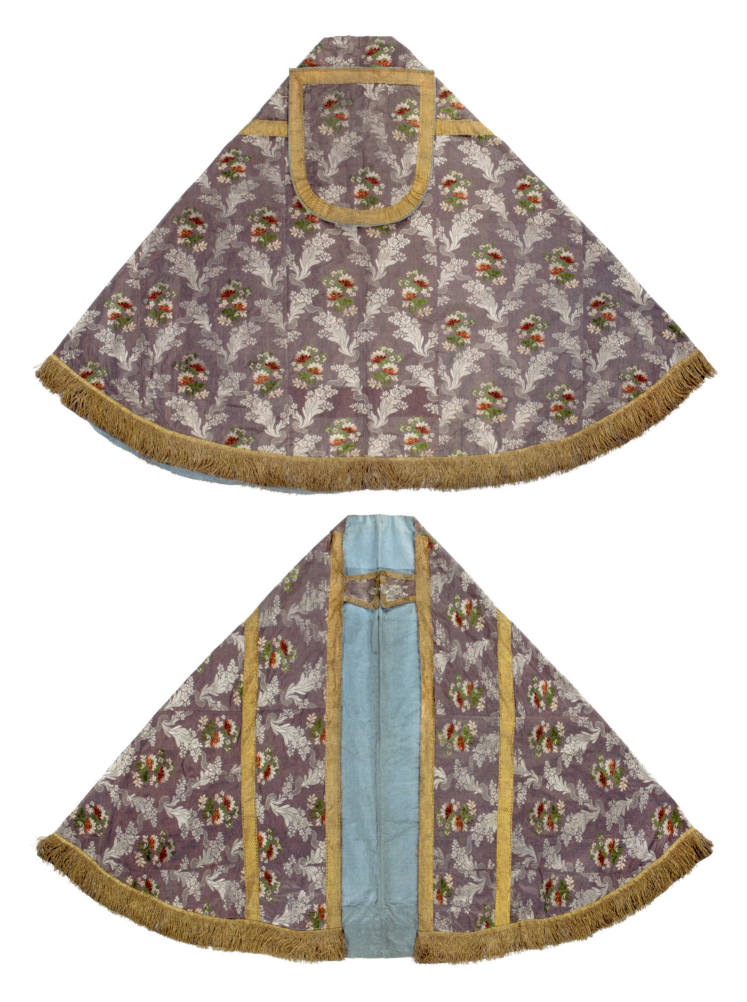

# 43 Purple cope from Rotterdam

This cope comes from the Old Catholic Church of St. Peter and St. Paul in Rotterdam. The church is nicknamed 'Het Paradijs' ('Paradise'), and is the third church in Rotterdam to be known by this name. In 1647 Chaplain Bernardus Hoogewerff (1613-1653) founded a new church in the house where he was born, when other clandestine Catholic churches were unable to accommodate their large congregations, largely as a result of the large number of spiritual virgins who had flocked to the old church [cat. 18]. Since his house was called 'Het Paradijs', the church soon became known by the same name. This first Paradijskerk was beside the Delftse Vaart canal. In 1718, the second Paradijskerk was built at the same spot, as the first was now too small.[1]

This purple cope was probably first used in the baroque church. The purple silk damask with a pattern of meandering vines with flowers, pomegranates, grapes, large pods and latticework dates to 1730. The cope, orphreys and cope shield are edged with expensive gold lace, while the cope itself also has gold fringing along the bottom. A tassel of gold fringing hangs from the shield.

The inventory and paraments, and also most of the interior of the second Paradijskerk, were transferred in the early twentieth century to the current Old Catholic Church of St. Peter and St. Paul on Binnenweg (the third Paradijskerk), one of the few buildings in the city centre to have survived the bombing of 1940. As a result, both the baroque vestments and the baroque interior have been preserved.[2] (PA)

Purple cope, c. 1730 (base fabric).

Silk, gold lace, gold fringing, h. 129 cm.
Rotterdam, Old Catholic Church of St. Peter and St. Paul ('Paradijskerk', or 'Paradise Church'), 3718-85a.
Provenance: originally at the Old Catholic 2nd Paradijskerk ('Paradise Church') of 1718, Rotterdam.

1 Verheul 1939, p. 22.
2 Schade van Westrum 2010, p. 138.

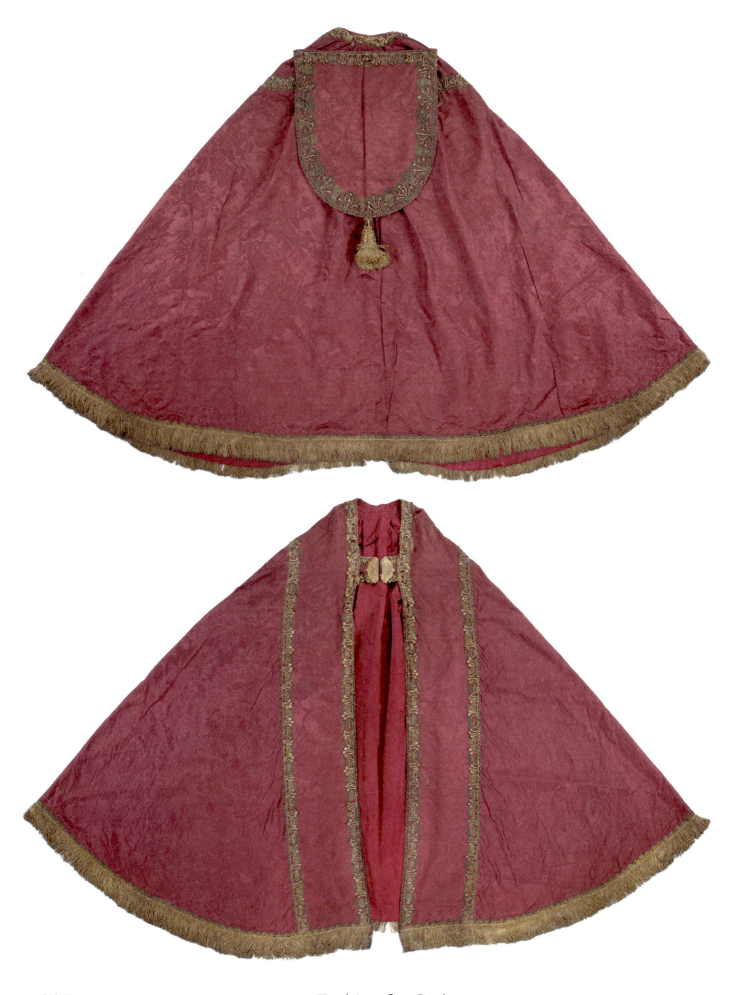

Fashion for God

# 44  A mourning cope from St. Mary's on Achter Clarenburg

This black cope was worn during funeral services. Black was not only the colour of mourning in secular European fashion, it had also been the official colour of mourning and grief in the Catholic church since the Council of Trent (1545-1563). As such, it was listed in the Roman Missal of 1570.

The black silk damask of the cope has a dense pattern of meandering vines and small flowers that can be dated to the second half of the eighteenth century. The entire garment is edged with cream galloons and fringing made of silk and linen. The absence of silver galloons and silver fringing is consistent with common practice during mourning; no silver or gleaming jewellery would be worn during the early mourning period.

The many seams in the cope seem to suggest it was made from a gown. There are several black paraments in the collection of the Old Catholic Cathedral of St. Gertrude in Utrecht, but none is of the same silk damask. Perhaps the gown from which the cope was made was not large enough for a set of paraments. Before the cope came to St. Gertrude's Cathedral, it was used until 1986 at the Old Catholic Church of St. Maria Minor (St. Mary) on Achter Clarenburg in Utrecht. (PA)

Black cope, c. 1750.

Silk, linen, 134 × 320 cm. Utrecht, Old Catholic Cathedral of St. Gertrude, 469-545. Provenance: originally at the Old Catholic Church of St. Maria Minor (St. Mary) on Achter Clarenburg in Utrecht.

51  Black cincture, c. 1750. Utrecht, Old Catholic Cathedral of St. Gertrude, no accession number. Provenance: originally at the Old Catholic Church of St. Maria Minor (St. Mary) on Achter Clarenburg in Utrecht.

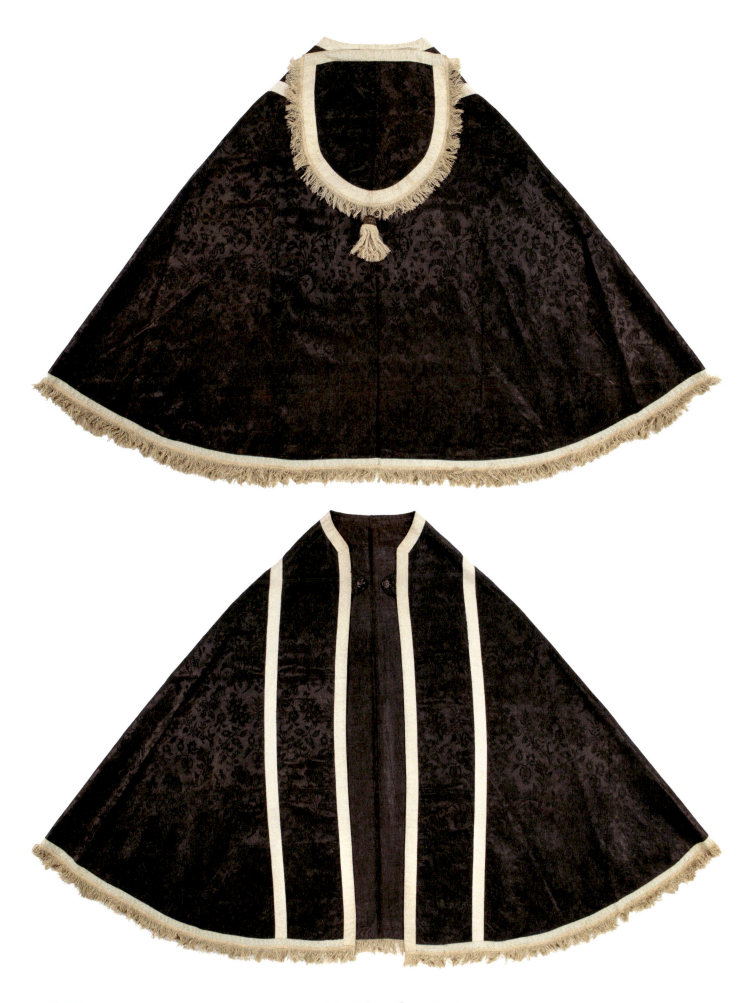

Fashion for God

# 45   Pink and yellow cope from Abcoude

Abcoude has always had a large, active Catholic community, even during the time of the Dutch Republic. This cope comes from the Roman Catholic Church of St. Cosmas and St. Damian in Abcoude. The neo-gothic church that stands there today was built in 1888, but a wooden pulpit and wooden statues of St. Joseph and the two patron saints (all attributed to sculptor Willem Hendrik van der Wall, 1716-1790) recall the rococo church built in 1772 to replace the wooden clandestine church that had stood at the same spot since 1672.

Although we know little about the pink and yellow cope, we must assume that it was used in the rococo church. In contrast to the statues and pulpit, however, the two silk fabrics do not date from the time when this church was built (1772). The pink "Spitzenmuster" fabric [cat. 40] is older, and can be dated to circa 1730, while the yellow silk of the cope shield and orphreys is more recent, and appears to date from the early nineteenth century. The ears of corn and grapes that feature prominently in the decoration on the orphreys are a reference to the eucharist, and the symbolic role of bread and wine in the liturgy. The decoration of the shield also seems to be have been specially made for the shape. Such explicitly religious textile motifs did not become popular again until the nineteenth-century neo-baroque period.[1]

Pink and yellow is an unusual combination, though one that will have been highly appropriate for what was by then the slightly older rococo church of Abcoude. The cope will certainly have been quite an explosion of colour in the new neo-gothic church; it was therefore loaned to the Archdiocesan Museum in 1925. (PA)

Pink cope, c. 1730 (base fabric), c. 1820-1850 (cope shield and orphreys).

Silk, gold galloon, gold fringing, 132 × 280 cm. Utrecht, Museum Catharijneconvent, ABM t2092; on long-term loan from the Roman Catholic Church of St. Cosmas and St. Damian in Abcoude.

1   Van Roon 2010, pp. 38-39.

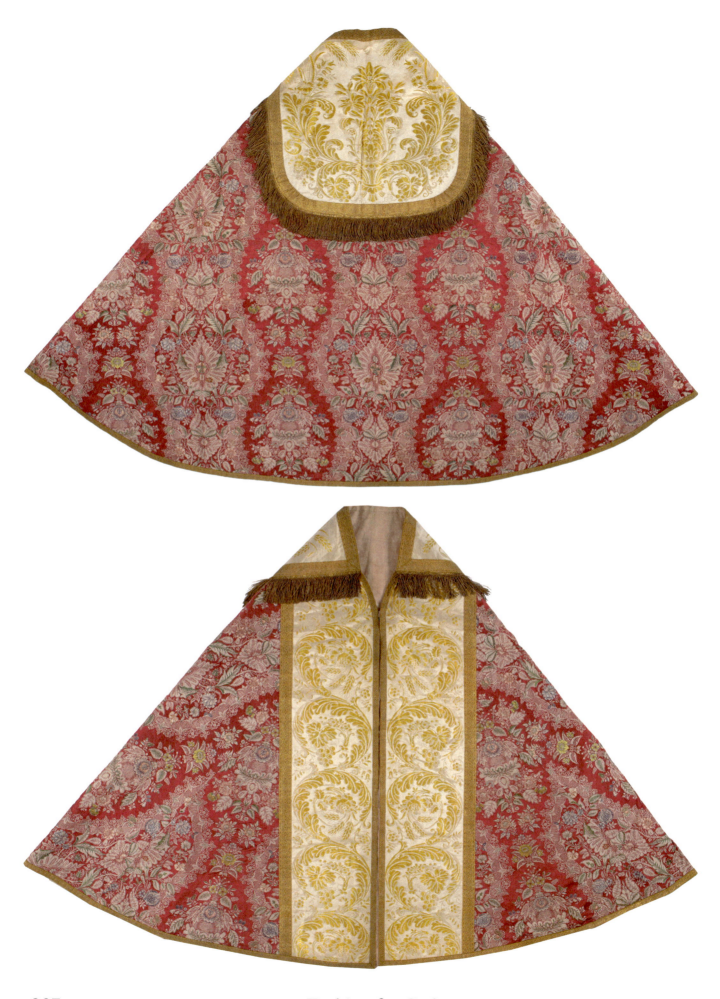

Fashion for God

## 46 White and blue cope

Little is known about this cope. It was originally part of the collection of the Archdiocesan Museum, one of the museums that merged to form Museum Catharijneconvent in 1979. How and when the cope came into the collection is impossible to determine.

The cope is made of white silk damask with a woven pattern of blue and red-brown flowers and large green leaves. These three colours alternate in horizontal registers in the fabric. The shape and size of the flowers suggest the fabric was made around 1750. At the bottom of the cope, on the back, several irregular seams suggest that the material was reused. It was probably originally a gown that was donated to the church.

The orphreys, cope shield and cope fastening are made of a blue silk fabric with woven white lace and floral motifs, which can be dated later — around 1770-1775 — on the basis of the meandering lace trails. The orphreys, shield and cope are edged with silver galloon and the shield also has silver fringing.

Neither of the two fabrics occur in other paraments in Museum Catharijneconvent's collection, nor, as far as is known, at other Dutch churches.

The white combined with blue suggests that this cope was used on Marian feast days. (PA)

White cope, c. 1750 (base fabric), c. 1775 (orphreys and cope shield).

Silk, silver galloon, silver fringing, 136 × 287 cm. Utrecht, Museum Catharijneconvent, ABM t2090. Provenance: original collection of the Archdiocesan Museum.

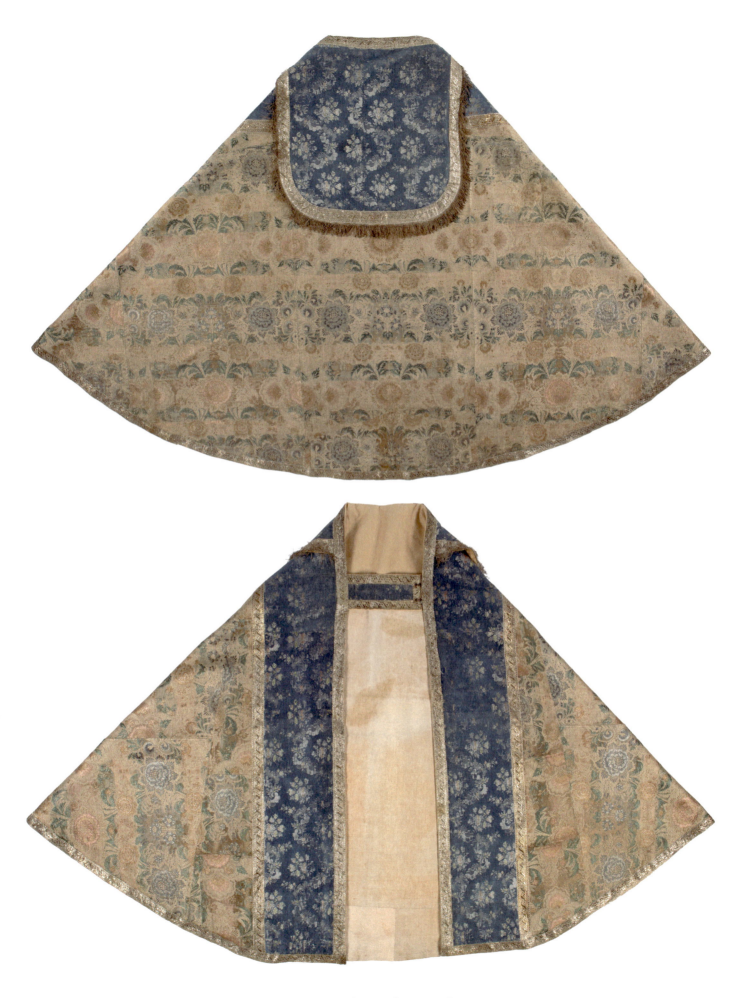

Fashion for God

# 47 Many colours combined make white

This cope is part of a large set for a bishop, consisting of a chasuble, four dalmatics, three copes, seven stoles, four maniples, a chalice veil, burse, pall and four candlestick frontals kept at the Old Catholic Church of St. Anne and St. Mary in Haarlem. The set was used for liturgical celebrations at which the bishop would also preside. The cope shown here is made of a white silk fabric with large orange and purple flowers. The shield and orphreys are more densely patterned, with a white scale motif and purple flowers in dense green foliage. Two dalmatics were made in each of these fabrics. This colourful cope with a white background was probably used as a white cope on certain Catholic holidays.

The set is the centrepiece of a collection of paraments formed by Johannes van Stiphout (1708-1777) for the church in Haarlem. Van Stiphout was initially a parish priest in Amsterdam, but he was consecrated as a second Old Catholic bishop in Haarlem in 1745. He would continue to build a considerable collection of paraments for the church until his death in 1777. We currently know of 43 paraments collected by Van Stiphout. Most of them can be identified by the monogram 'I.v.S.' embroidered in red on labels attached to the items. The majority of the items from the collection are still in Haarlem.

Museum Catharijneconvent's ABM collection (the collection of the former Archdiocesan Museum) includes a fragment of silk in exactly the same pattern as the fabric used to make the cope shield and orphreys on this cope. This must be a coincidence, as it is not possible that there was any kind of exchange between the Roman Catholic church and the Old Catholic church at some point in the nineteenth century, when the collection of textile fragments was compiled. The only logical explanation is that two individuals purchased the same fabric, independently of each other, sometime in the eighteenth century. The fabric purchased by one ended up in the ABM collection, the other at the Old Catholic Church of St. Anne and St. Mary in Haarlem. (PA)

White cope, c. 1750 (base fabric), c. 1740 (cope shield and orphreys).

Silk, gold galloon, h. 138 cm. Haarlem, Old Catholic Church of St. Anne and St. Mary, 5649-201.

52 Silk fragment, circa 1740. Silk, 64 × 49 cm. Utrecht, Museum Catharijneconvent, ABM st926.4.

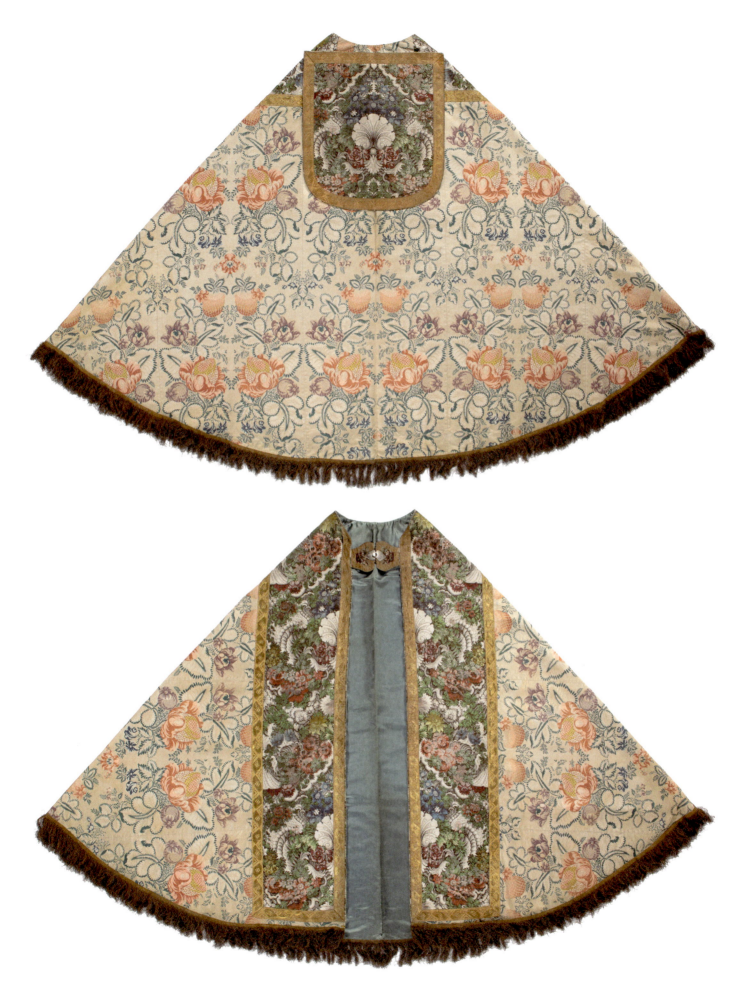

Fashion for God

# 48 An ensemble in pink

This combination of cope and cope shield is not original, but has been put together specially for *Fashion for God*. The cope is made of light pink silk with a zigzag motif and small flowers, overlaid with a second motif of dark pink bands and stripes. These bold vertical stripes combined with the small flowers represent the final phase of rococo floral motifs, around 1775.[1]

The cope shield is also pink, though it originated in the early eighteenth century. The combination of lace scrolls, imaginary flowers, palmettes and garden urns in green, yellow and white silk and silver thread makes this a 'bizarre silk', as it is known, typical of the period around 1700-1712.[2] The symmetry in the motif points to a later phase of the bizarre silks period. Museum Catharijneconvent has an altar rail cover (OKM t204b) in the same fabric, as well as a separate fragment (OKM st58b).

The cope comes from the Roman Catholic Church of Our Lady of the Assumption in Bedum; the cope shield is originally from the Old Catholic Church of St. Maria Minor (St. Mary) on Achter Clarenburg in Utrecht.

So although this combination could never have been a worn in the church, the pink ensemble spans the entire rich spectrum of eighteenth-century fashion fabrics. (PA)

A Pink cope, c. 1775 (base fabric).

Silk, gold galloon, 142 × 308 cm. Utrecht, Museum Catharijneconvent, ABM t2229. Provenance: originally at the Roman Catholic Church of Our Lady of the Assumption in Bedum.

B Pink cope shield, c. 1715 (base fabric).

Silk, 51 × 49 cm. Utrecht, Museum Catharijneconvent, OKM t204a. Provenance: originally at the Old Catholic Church of St. Maria Minor (St. Mary) on Achter Clarenburg in Utrecht.

1 Rothstein 1994-II, pp. 10-11.
2 Rothstein 1990, pp. 37-40; Ackermann 2000, p. 219-263

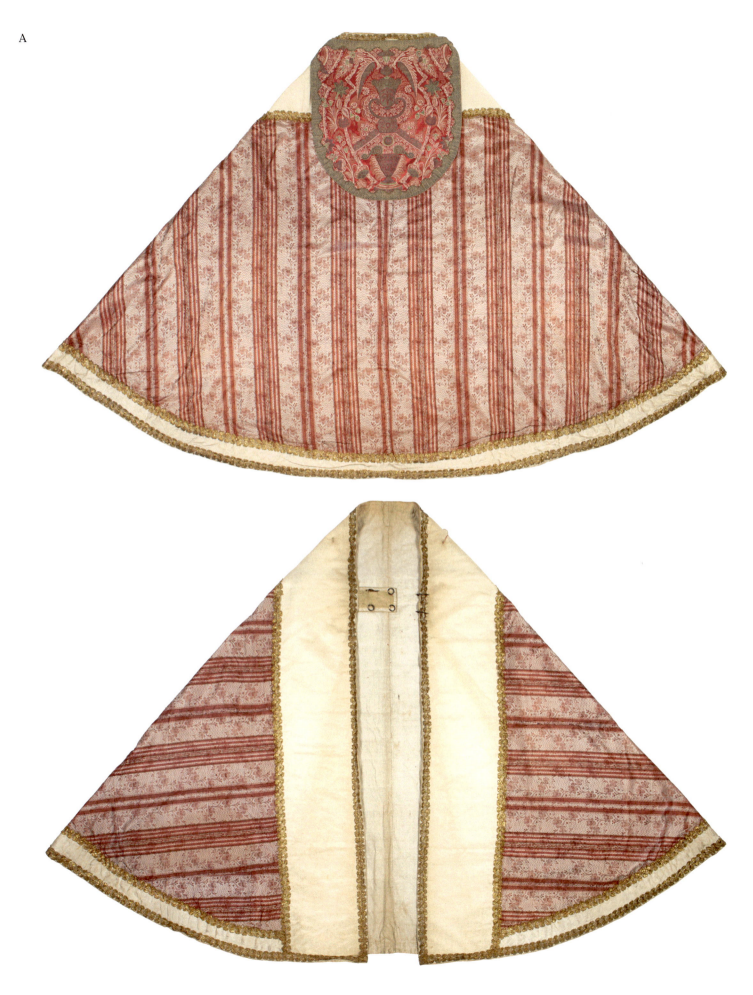

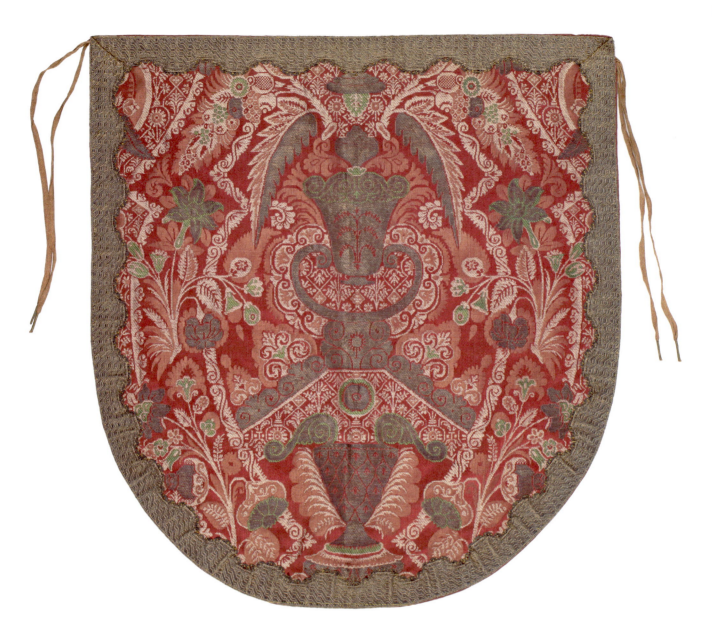

Glossary — Paraments
Archives
Bibliography
Photo credits
Credits

# Glossary — Paraments

The term paraments refers in a broad sense to all vestments and textile items used in the liturgy. In a narrower sense, it refers to the outer vestments of the celebrant, plus the accessories, including altar frontals, made in liturgical colours. Since the early modern period, these vestments can be made as sets that are generally all in the same fabric. Paraments in the narrower sense of the word are the chasuble, the dalmatic, the tunicle, the stole, the maniple, the chalice veil, the burse or pall box, and possibly also the pall, the altar frontal and the candlestick frontal. It is these paraments that are displayed in this exhibition. Although they are all regarded as sacred objects of the liturgy, only the chasuble and stole had to be specially consecrated.

Linen garments worn under the vestments and linen objects used on the altar are not included in the exhibition.

Chasuble. Outer vestment worn by the priest during mass. The name comes from the Latin casula, which means 'little house'. Originally, the chasuble was a conical cloak like that worn by the Romans in late antiquity. Both the chasuble and the stole have to be specially consecrated. As the most important of the paraments, it has also undergone the most change. Initially it was almost circular, with a round opening in the centre through which the head would pass. The decoration generally consisted of a cross on the back and a vertical column on the front. Over the centuries, the chasuble became narrower, a process that continued into the twentieth century, the garment transforming from a bell-shaped chasuble in the fourteenth century and a gothic chasuble in the fifteenth and sixteenth centuries to what is known as the baroque Roman style or 'violin case' style from the sixteenth to the twentieth century. Eventually, the sides were left open and only the chest and back are covered.

Dalmatic and tunicle. Almost identical outer garments with rectangular or narrow trapezoid front and back panels and half sleeves that are open on the underside. Each panel is decorated with two 'clavi' (narrow vertical orphreys) connected across the chest by a horizontal band. The dalmatic and tunicle are based on outer garments worn in Dalmatia in late antiquity. In the liturgy the dalmatic and tunicle are worn by the assisting priests at a solemn mass with three priests, were only the main celebrant wears a chasuble. The priest wearing the dalmatic has the role of deacon, while the priest wearing the tunicle acts as subdeacon. In Dutch, these vestments are also known as 'Levietenrokken', after the attire of the Old Testament Levites.

Cope. The cope, which is worn only at special ceremonies, originated from rainwear worn in late antiquity. The hood evolved into a lavishly decorated shield (with a tassle) that hangs from the back of the cope. The front edges are finished with decorative bands or orphreys. The cope is fastened at the top with a morse or agraffe.

Stole. A long broad band of fabric worn around the priest or deacon's neck, over the alb and under the chasuble or dalmatic. Like the chasuble, the stole has to be specially consecrated. It is generally made of the same fabric as the chasuble and dalmatic. The priest ties the stole crosswise across his chest, while the deacon wears it over his left shoulder and tied under the right arm. The stole is based on a napkin used in late antiquity.

Maniple. Short version of the stole, which in the past was worn over the arm by the priest, deacon and subdeacon. The maniple is based on a handkerchief used to wipe sweat off the face in late antiquity. This accessory has not been used since the 1960s.

Chalice veil. Square cloth used to cover the chalice. The chalice veil, which was not introduced until the late sixteenth century, is generally made of the same fabric as the chasuble. Before and after the chalice is used in the liturgy, it is covered by the paten, the pall and the chalice veil, in that order, while the burse with the corporal (the linen cloth on which the paten and chalice containing the body and blood of Christ stand during the eucharist) lies on the chalice veil.

Burse. Case consisting of two square sheets of cardboard or wood connected at one edge. The burse can be tied using cords or ribbons, and since circa 1600 has been covered with the fabric of which the chasuble is made. The corporal is kept in the burse when it is not spread out on the altar. At the beginning and end of the mass, the burse lies on the chalice, which is covered with the paten, pall and chalice veil. A pall box may be used instead of a burse.

Pall box or corporal box. Low square box made of cardboard or wood, covered in fabric which, since circa 1600, has been the same as that of the chasuble. The pall and corporal are kept in the pall box before and after mass. The pall box can be used in the liturgy instead of a burse.

Pall. A square piece of cardboard or wood, covered entirely in white linen, or covered on the bottom with white linen and, since circa 1600, on the top with the fabric of which the chasuble is made. The pall developed from a second corporal, and it is used to cover the chalice before and after the consecration, ensuring that no impurities end up in the wine. Before the chalice is used, the paten bearing the large host is first laid on it, followed by the pall, which is covered by the chalice veil; the burse containing the corporal is laid on top. Like the corporal, the pall must be specially consecrated.

Frontal. Decorative piece for the front of the altar (the large altar frontal) and the candlesticks (the smaller candlestick frontal), generally consisting of a piece of fabric stretched over a wooden frame, or made entirely of painted wood. Frontals are changed to comply with the liturgical colour regulations. The fabric on the frontals is generally the same as that used to make the chasuble.

# Archives

## Utrecht Municipal and Provincial Archives

HUA 842-2.219
Archive of the Old Catholic parish of St. Mary achter Clarenburg, archive number 842-2; inventory number 219: inventarissen roerende goederen in het kerkgebouw 1757-1911.

HUA 842-2.220
Archive of the Old Catholic parish of St. Mary achter Clarenburg, archive number 842-2; inventory number 220: aantekeningen betreffende de verkoop en vernieuwing inventaris Clarenburg, 1774-1793.

HUA 842-2.259
Archive of the Old Catholic parish of St. Mary achter Clarenburg, archive number 842-2; inventory number 259: stukken betreffende het legaat van Aletta van Wijck, 1787.

HUA 842-2.70-81
Archive of the Olc Catholic parish of St. Mary achter Clarenburg, archive number 842-2; inventory number 70-81, notulen van de vergaderingen van het kerkbestuur 1861-1899.

HUA 34-4.953
Notaries in the city of Utrecht 1560-1905, archive number 34-4; inventory number 953, Matthijs van Lobbrecht, minuten, met indices, 1717-1720.

HUA 34-4.1584
Notaries in the city of Utrecht 1560-1905, archive number 34-4; inventory number 1584, Zeger Coenraad van Leenen, minuten, 1741-1810.

HUA 1836.592
Seminary in Amersfoort of the Old Catholic Church in the Netherlands, archive number 1836; inventory number 592, Inventaris van de nagelaten goederen van Geertruydis Clara van Halteren, 1800.

HUA 215.1610
Collection Port-Royal, archive number 215; inventory number 1610, La résistance contre La Bulle Unigenitus, Les appellants, Ernest Ruth d'Ans (Paulin, Du Noyer), lettres reçues de Viaixnes, Dom Thierry de, O.S.B de St. Vannes, 1721-1727.

## Noord-Holland Provincial Archives, Haarlem

NHA 2106.6
Roman Catholic diocese of Haarlem about clandestine churches and convents in Haarlem, archive number 2106; inventory number 6, Statie S. Bernardus, Inventaris van goederen, 1791 en 1847.

NHA 2106.5
Roman Catholic diocese of Haarlem about clandestine churches and convents in Haarlem, archive number 2106; inventory number 5, Statie S. Bernardus, Stukken betreffende de opheffing van de staties S. Bernardus en S. Franciscus en de verkoop der bezittingen, 1822-1869.

NHA 257.193
Old Catholic parish St. Nicholas in Krommenie, archive number 257; inventory number 193, register van doopsels, 1765-1812, huwelijken, 1764-1851, overlijden, 1764-1815, aannemelingen 1768, 1782 en 1808 en paascommunicanten 1765, 1768 en 1773.

NHA 2106.52
Roman Catholic diocese of Haarlem about clandestine churches and convents in Haarlem, archive number 2106; inventory number 52, Statie S. Bernardus, aantekeningen van mgr. J.J. Graaf, betreffende de bisschoppelijke paramenten en ornamenten, afkomstig uit de opgeheven statie S. Bernardus te Haarlem, z.j. [c. 1900].

## Municipal Archives, Amsterdam

SAA 434.30
Archive of the parish St. Anne (De Pool), archive number 434; inventory number 30, Legaten, fundaties en schenkingen, Afschrift van een akte waarbij Dorothea de Jonge, geboren Ackerman, verklaart een codicil bij haar testament gevoegd te hebben, waarbij aan de pastoor van De Pool $f$ 4000,– en enig textiel, wordt gelegateerd, 1779.

SAA 740.26
Archive of the Beguinage, archive number 740; inventory number 29, lijsten van geschonken, gekochte en herstelde altaar- en kerkbenodigdheden, schilderijen en paramenten, 1650-1717.

## Eemland Regional Archives, Amersfoort

AEA 83.AT 049a006
Notaries in Amersfoort, archive number 83; inventory number AT 048a020, notaris G. Vogelesang.

## Archives of the Royal Museums for Art and History, Brussels

KMK&GB
Fund Acquisitions, nr. BE/380469/1/6992, legaat Gilbert.

## Royal Archives, The Hague

KHA prinses Louise
Princess Louise Archive, inventory numbers 349-358; 356, 22 oktober 1790 waarop deze bestellingen en bedragen worden genoemd (F 409-14).

# Bibliography

Abels (M) 2009
M. Abels, *Tussen sloer en heilige. Beeld en zelfbeeld van Haarlemse en Goudse kloppen in de zeventiende eeuw*, Utrecht 2009.

Abels (P) 2002
P.H.A.M. Abels, 'Van ketternest tot bolwerk van rechtzinnigheid', in: P.H.A.M. Abels et.al. (ed.), *Duizend jaar Gouda. Een stadsgeschiedenis*, Hilversum 2002, 417-454.

Ackermann 2000
Hans Christoph Ackermann, *Seidengewebe des 18. Jahrhunderts I. Bizarre Seiden*, Riggisberg 2000.

Aert/Heuvel 2007
Laura van Aert and Danielle van den Heuvel, 'Sekse als de sleutel tot succes – Vrouwen en de verkoop van textiel in de Noordelijke en Zuidelijke Nederlanden 1650–1800', *Textielhistorische Bijdragen* 47 (2007) 7-32.

Anderson / Kehoe 2023
Carrie Anderson and Marsely L. Kehoe, 'Dutch Textile Trade. Issue and Project Introduction', *Journal of Historians of Netherlandish Art* 15 (2023),

Aribaud 1998
Christine Aribaud, *Soieries en sacristie. Fastes liturgiques, XVIIe-XVIIIe siècle*, Paris and Toulouse (exh.cat. Musée Paul Dupuy) 1998.

Arnold 2021
Janet Arnold, *Patterns of Fashion 1. Englishwomen's Dresses and Their Construction 1660-1860*, London (2nd edition) 2021.

De Beer 2015-I
Richard de Beer, 'Laatmiddeleeuwse paramenten in oud-katholiek bezit', in: Micha Leeflang and Kees van Schooten (ed.), *Middeleeuwse Borduurkunst uit de Nederlanden*, Zwolle and Utrecht (exh. cat. Museum Catharijneconvent) 2015, 105-113.

De Beer 2015-II
Richard de Beer, 'Gered uit geuzenhanden. Ontdekkingen over middeleeuwse gewaden in oud-katholiek bezit', *Catharijne. Magazine van Museum Catharijneconvent Utrecht* 33, no.1 (2015) 10-12.

De Beer 2015-III
Richard de Beer, 'De apostolisch vicaris als borduurwerker', *Catharijne. Magazine van Museum Catharijneconvent Utrecht* 33, no.2 (2015) 23.

De Beer 2017
Richard de Beer, 'Maria Maggiore. Mariavoorstelling op de koorkap van Philippus Rovenius', *Catharijne. Magazine van Museum Catharijneconvent Utrecht*, no. 1 (2017) 40-42.

De Beer 2023-I
Richard de Beer, 'Liturgische gewaden in Noord-Nederland 1580-1650. Continuïteit en discontinuïteit in de katholieke traditie', in: Esther Meier and Almut Pollmer-Schmidt (ed.), *Art & Catholicism in the Dutch Republic / Kunst & Katholizismus in der niederländische Republik*, Frankfurt am Main 2023, 101-110.

De Beer 2023-II
Richard de Beer, *Kerkgewaden in de verdrukking. Paramenten in de Republiek als dragers van identiteit 1580-1650*, Utrecht 2023.

Begheyn 2003
Paul Begheyn, 'De verering van Sint Franciscus Xaverius in de Republiek', *Ons geestelijk erf. Driemaandelijks tijdschrift voor de geschiedenis van de vroomheid in de Nederlanden* 77, no. 3 (2003) 300-314.

Van Bemmel 2005
H.Chr. van Bemmel. 'Beeldenstorm in Arnhem', *Arnhem de Genoeglijkste. Orgaan van het Arnhems Historisch Genootschap 'Prodesse Conamur'* 25, no. 3 (2005) 91-99.

De Bodt 1987-I
Saskia de Bodt, *Op de Raempte off mette Brodse... Nederlands borduurwerk uit de zeventiende eeuw*, Haarlem 1987.

De Bodt 1987-II
Saskia de Bodt (ed.), *Schilderen met gouddraad en zijde*, Utrecht (tent.cat. Museum Catharijneconvent) 1987.

Borkopp-Restle 2002
Birgitt Borkopp-Restle, 'Handschuhe, Psalmenbuch und Nadelkissen', in: Birgitt Borkopp-Restle, *Textile Schätze aus Renaissance und Barock aus der Sammlungen des Bayerischen Nationalmuseums*, Munich 2002, 148-150.

Borromeus 1577
Carolus Borromeus, *Instructiones Fabricae et Supellectilis Ecclesiasticae*, 1577, ed. and translation E.C. Völker, 1977.

Bourdieu 1986
Pierre Bourdieu, 'The Forms of Capital', in: John G. Richardson (ed), *Handbook of Theory and Research for the Sociology of Education*, New York and London 1986, 241-258.

Braun-Rönsdorp 1963
M. Braun-Rönsdorp, 'Die Handschuhe der Elisabeth Stuart', *Waffen- und Kostümkunde* 5 (1963) 1-16.

Brom 1890
Gisbert Brom, 'Neerkassels bestuur van 1662 tot 1676', *Archief voor de geschiedenis van het Aartsbisdom Utrecht* 18 (1890) 173-294.

Bronkhorst 1972
Arjan Bronkhorst (ed), *Van Willibrord tot Wereldraad. Enige aspecten van het geestelijk leven in Utrecht door de eeuwen heen*, Utrecht (exh.cat. Aartsbisschoppelijk Museum) 1972.

Bruinvis 1896-I
C.W. Bruinvis, 'De statie van St. Matthias te Alkmaar', *Bijdragen voor de geschiedenis van het bisdom van Haarlem* 21 (1896) 190-219.

Bruinvis 1896-II
C.W. Bruinvis, 'De statie van St. Laurens te Alkmaar', *Bijdragen voor de geschiedenis van het bisdom van Haarlem* 21 (1896) 410-422.

Caron 1987
M.L. Caron, 'Van de geest ende meeningh daar een maaght haar hantwerck in behoort te doen. Naar aanleiding van enige bisschoppelijke paramenten uit de voormalige statie van St. Bernardus in den Hoeck te Haarlem', in: Saskia de Bodt (ed.), *Schilderen met gouddraad en zijde*, Utrecht (exh.cat. Museum Catharijneconvent) 1987, 20-31.

Cats 1637
Jacob Cats, *s'Werelts begin, midden, eynde, besloten in den trou-ringh, met den proef-steen van den selven*, Dordrecht 1637.

Chrisman-Campbell 2005
: Kimberly Chrisman-Campbell, 'Engeland en de mode in Europa in de 18de eeuw', in: Pascale Gorguet Ballesteros and Madelief Hohé (ed.) *En Vogue. Mode uit Frankrijk en Nederland in de 18de eeuw*, Zwolle and Paris (exh. cat. Gemeentemuseum Den Haag and Palais Galliera Paris) 2005, 50-53.

Colenbrander 2010
: Sjoukje Colenbrander, *Zolang de weefkunst bloeit. Zijdeweverijen in Amsterdam en Haarlem 1585-1750* (Amsterdam 2010).

Defoer 2015
: Henri Defoer, 'Borduurkunst naar ontwerpen van Noord-Nederlandse schilders', in: Micha Leeflang and Kees van Schooten (ed.), *Middeleeuwse Borduurkunst uit de Nederlanden*, Zwolle and Utrecht (exh.cat. Museum Catharijneconvent) 2015, 33-49.

Dillen 1929
: J.G. van Dillen, *Bronnen tot de geschiedenis van het bedrijfsleven en het gildewezen van Amsterdam*. Deel 1 (1512-1611), The Hague 1929.

Dillen 1933
: J.G. van Dillen, Bronnen tot de geschiedenis van het bedrijfsleven en het gildewezen van Amsterdam. Deel 2 (1612-1632), The Hague 1933.

Dillen 1974
: J.G. van Dillen, *Bronnen tot de geschiedenis van het bedrijfsleven en het gildewezen van Amsterdam*. Deel 3 (1633-1672), The Hague 1974.

Dirkse 1989
: Paul Dirkse, *Kunst uit oud-katholieke kerken*, Utrecht (exh.cat. Rijksmuseum Het Catharijneconvent) 1989.

Dirkse / Haverkamp 1991
: Paul Dirkse and Anite Haverkamp (ed), *Jezuïeten in Nederland*, Utrecht (cat. Rijksmuseum Het Catharijneconvent) 1991.

Dubbe 1992
: B. Dubbe, 'Interieur en inventaris tot 1800', in: A.J.J. Mekking (ed.), *De Grote of Lebuinuskerk te Deventer. De 'Dom' van het Oversticht veelzijdig bekeken*, Zutphen 1992, 234-279.

Dudok van Heel 2008
: S.A.C. Dudok van Heel, *Van Amsterdamse burgers tot Europese aristocraten*, The Hague 2008.

Van Eck 1994
: Xander van Eck, *Kunst, twist en devotie. Goudse katholieke schuilkerken 1572-1795*, Delft 1994.

Filedt Kok / Halsema-Kubes / Kloek 1986
: Jan Piet Filedt Kok, Willy Halsema-Kubes, Wouter Kloek (ed), *Kunst voor de beeldenstorm. Noordnederlandse kunst 1525-1580*. The Hague and Amsterdam (exh.cat. Rijksmuseum) 1986.

De Fouw 2020
: Josephina de Fouw, 'Portret van Gerard Cornelis van Riebeeck en Charlotte Beatrix Strick van Linschoten', in: Reinier Baarsen (ed.), 1700-1800, Amsterdam 2020, 110-113.

Le Francq van Berkhey 1772
: J. le Francq van Berkhey. *Natuurlijke historie van Holland*. Deel 3, Amsterdam 1772-1776.

Frijhoff 2009
: Willem Frijhoff, 'Shifting identities in hostile settings. Towards a comparison of the Catholic communities in early modern Britain and the Northern Netherlands', in: B. Kaplan, et. al. (ed.), *Catholic Communities in Protestant States: Britain and the Netherlands c. 1570-1720*, Manchester and New York 2009, 1-17.

Gaastra 1994
: Femme S. Gaastra, 'De textielhandel van de VOC', *Textielhistorische Bijdragen* 34 (1994) 50-69.

Geraerts 2019
: Jaap Geraerts, *Patrons of the Old Faith. The Catholic Nobility in Utrecht and Guelders, c. 1580-1702*, Leiden and Boston 2019.

Gorguet Ballesteros / Hohé 2005-I
: Pascale Gorguet Ballesteros and Madelief Hohé (ed.) *En Vogue. Mode uit Frankrijk en Nederland in de 18de eeuw*, Zwolle and Paris (exh.cat. Gemeentemuseum Den Haag and Palais Galliera Paris) 2005.

Gorguet Ballesteros/ Hohé 2005-II
: Pascale Gorguet Ballesteros and Madelief Hohé, 'De 18de-eeuwse kostuums in de collecties van het Gemeentemuseum Den Haag en het Musée Galliera in Parijs: een kort overzicht', in: Pascale Gorguet Ballesteros and Madelief Hohé (ed.) *En Vogue. Mode uit Frankrijk en Nederland in de 18de eeuw*, Zwolle and Paris (exh.cat. Gemeentemuseum Den Haag and Palais Galliera Paris) 2005, 109.

Graaf 1900
: J.J. Graaf, *Gids in het bisschoppelijk museum voor kerkelijke oudheid, kunst en geschiedenis, vooral van Nederland en meer bijzonder van het Haarlemsche bisdom te Haarlem*, Leiden 1900.

Graaf 1905
: J.J. Graaf, 'De "Vergaderinghe der Maechden van den Hoeck" te Haarlem', *Bijdragen voor de geschiedenis van het Bisdom van Haarlem* 29 (1905) 128-159, 272-325.

Graafschap-bode 1936
: Z.n. *De Graafschap-bode*, 19 februari 1936, 1.

Groeneweg 1991
: Irene Groeneweg, 'Enkele aspecten van mode en kleedgedrag in Nederland naar aanleiding van de brieven van de familie Van Hogendorp uit de late achttiende eeuw', *Textielhistorische bijdragen* 31 (1991) 60-98.

Hahn 1928
: Kunsthaus Heinrich Hahn, Frankfurt am Main (auction.cat.) 6-8 november 1928.

Hallebeek 2000
: Jan Hallebeek, 'Questions of Canon Law concerning the Election and Consecration of a Bishop for the Church of Utrecht. The casus resolutio of 1722', *International Journal in Philosophy and Theology* 61 (2000) 17-50.

Hallebeek 2011
: Jan Hallebeek, *Canoniek Recht in Ecclesiologische Context. Een inleiding tot het kerkelijk recht van de Oud-Katholieke Kerk van Nederland*, Amersfoort and Sliedrecht 2011.

Van Hemeldonk 1988
: G. van Hemeldonk, *Zilver uit de gouden eeuw van Antwerpen*, Antwerp (exh.cat. Rockoxhuis) 1988.

Van Heussen 1716
: H. van Heussen, *Batavia Sacra*. Deel 3, Antwerp 1716.

Heuvel 2007
: Danielle van den Heuvel, *Women and Entrepreneurship*, Amsterdam 2007.

Heuvel 2014
: Danielle van den Heuvel, 'New products, new sellers? Changes in the Dutch textile trades, c. 1650-1750', in: *Selling textiles in the long eighteenth century. Comparative perspectives from western Europe*, London 2014, 118-137.

Op 't Hof 1987
Willem Jan op 't Hof, *Engelse piëtistische geschriften in het Nederlands 1598-1622*, Rotterdam 1987.

Hohé 2005
Madelief Hohé, 'Franse mode aan het Haagse Hof. Een kijkje in de garderobes van prinses Wilhelmina van Pruisen en prinses Louise van Oranje-Nassau', Pascale Gorguet Ballesteros en Madelief Hohé (ed.) *En Vogue. Mode uit Frankrijk en Nederland in de 18de eeuw*, Zwolle and Paris (exh.cat. Gemeentemuseum Den Haag and Palais Galliera Paris) 2005, 120-125.

Hohé 2021
Madelief Hohé, 'Mode in Kleur', *Jaarboek Nederlandse Kostuumvereniging* 39 (2021) 53-67.

Hollstein 1950
F.W.H. Hollstein, *Boekhorst – Brueghel*, Amsterdam [1950].

Ibrahim 2021
Fahed Ibrahim, Frans Hals. A discolored skirt (Mauritshuis, The Hague via https://youtu.be/eOB_mEYf6GU, accessed on 4 October 2021.

Israel 1989
Jonathan I. Israel, *Dutch Primacy in World Trade 1585-1740*, London and New York 1989.

Johnstone 2002
Pauline Johnstone, *High Fashion in the Church*, Leeds 2002.

Jolly 2009
Anna Jolly, 'Painted silks from China', in: Anna Jolly (ed.), Furnishing *Textiles Studies on Seventeenth- and Eighteenth-Century Interior Decoration*, Riggisberg 2009, 167-178.

Jolly 2018
Anna Jolly, *Seidengewebe des 18. Jahrhunderts III. Spitzenmuster*, Riggisberg 2018.

De Jonge 1936
C.H. de Jonge, *Het Costuum onzer Voorouders*, The Hague (exh.cat. Ridderzaal) 1936.

Jörg 1982
C.J.A. Jörg, *Porcelain and the Dutch China Trade*, The Hague 1982.

Knuttel 1892...
Willem P.C. Knuttel, *De toestand der Nederlandsche Katholieken ten tijde der Republiek* (twee delen), The Hague 1892-1894.

Kruseman/Bos 2022
Geeske M. Kruseman and Vera Bos, 'Het vliegerkostuum, een verkenning', *Kostuum* (2022) 78-91.

Lagerwey 1932
E. Lagerwey, *Geschiedenis der gemeente van de heilige Gertrudis te Utrecht*, Utrecht 1932.

Lamberigts 2000
Mathijs Lamberigts, 'Hat jansenisme als poging tot katholieke hervorming in de Nederlanden', in: Peter Nissen (ed.), *Geloven in de Lage Landen. Scharniermomenten in de geschiedenis van het christendom*, Leuven 2000, 133-140.

Leeflang / Van Schooten 2015
Micha Leeflang and Kees van Schooten (ed.), *Middeleeuwse Borduurkunst uit de Nederlanden*, Zwolle and Utrecht (exh. cat. Museum Catharijneconvent) 2015.

Leerintveld 2014
Ad Leerintveld, 'Populair in handschrift en druk. Liederen uit het eerste kwart van de zeventiende eeuw in de collectie van de Koninklijke Bibliotheek te Den Haag', *Jaarboek voor Nederlandse boekgeschiedenis* 21 (2014), 75-87.

Lee-Whitman / Skelton 1983
Leanna Lee Whitman and Maruta Skelton, 'Where Did All the Silver Go? Identifying Eighteenth-Century Chinese Painted and Printed Silks', *Textile Museum Journal* 22 (1983) 33-52.

Lenarduzzi 2019
Carolina Lenarduzzi, *Katholiek in de Republiek. De belevingswereld van een religieuze minderheid 1570-1750*, Bloemendaal and Nijmegen 2019.

Lugtigheid 2021
René Lugtigheid, *Van Aardse Stof tot Hemels Lof. De transitie van de achttiende-eeuwse Noord-Nederlandse damesjapon van modeartikel tot kerkelijk gewaad in de katholieke eredienst*, Hilversum 2021.

Matthee 2018
Rudolph Matthee, 'The Dutch East India Company and Asian raw silk. From Iran to Bengal via China and Vietnam', in: D. Schäfer, G. Riello, L. Molà (ed.), *Threads of Global Desire: Silk in the Pre-Modern Period* (2018) 75-101.

Meij 1998
Ietse Meij, *Haute Couture & Prêt-à-porter. Mode 1750-2000*, Zwolle 1998.

Miedema 1980
Hessel Miedema, *De archiefbescheiden van het St. Lukasgilde te Haarlem 1497-1798*, Alphen aan den Rijn 1980.

Miller 2002
Lesley Ellis Miller, 'Mysterious Manufacturers. Situating L. Galy, Gallien et Compe in the Eighteenth-Century Lyons Silk Industry', *Studies in the Decorative Arts* 9, no. 2 (2002) 87-131.

Miller 2014-I
Lesley Ellis Miller, *Selling Silks. A Merchant's Sample Book 1764*, London 2014.

Miller 2014-II
Lesley Ellis Miller, 'Material Marketing. How Lyonnais Silk Manufacturers Sold Silks 1660–1789' in: Jon Stobart and Bruno Blondé (ed), *Selling Textiles in the Long Eighteenth Century. Comparative Perspectives from Western Europe*, London 2014, 85-98.

Missale Romanum 1570
*Missale Romanum ex decreto sacrosancti concilii Tridentini restitutum. Pij V. Pont. Max. iussu editum*, Venice (by Giovanni Varisco and heirs, and Bartolomeo Faletti and company), 1570.

Monteiro 1996
Marit Monteiro, *Geestelijke maagden. Leven tussen klooster en wereld in Noord-Nederland gedurende de zeventiende eeuw*, Hilversum 1996.

Montijn 2017
Ileen Montijn, *Tot op de draad, de vele levens van oude kleren*, Amsterdam 2017.

Du Mortier 1984
Bianca M. du Mortier, 'De handschoen in de huwelijkssymboliek van de zeventiende eeuw', *Bulletin van het Rijksmuseum* 32, no. 4 (1984) 189-201.

Noorman / Van der Maal 2022
Judith Noorman and Robbert Jan van der Maal, *Het unieke memorieboek van Maria van Nesse (1588-1650). Nieuwe perspectieven op huishoudelijke consumptie*, Amsterdam 2022.

**Noreen 2008**
Kirstin Noreen, 'Replicating the Icon of Santa Maria Maggiore. The Mater ter admirabilis and the Jesuits of Ingolstadt', *Visual Resources. An International Journal of Documentation* 24, no. 1 (2008) 19-37.

**North 2022**
Susan North, 'Young Englishmen Behaving Badly (and Dressing Outrageously)', in: Rosalind McKever and Claire Wilcox (ed.), *Fashioning Masculinities. The Art of Menswear*, London (exh.cat. Victoria and Albert Museum) 2022, 84-98.

**Oly 1625...-I**
Trijn Jans Oly, *Levens der maegden* I, s.a. [1625-1651] (ed. Spaans).

**Oly 1625...-II**
Trijn Jans Oly, *Levens der maegden* II, s.a. [1625-1651] (ed. Spaans).

**Oly 1625...-III**
Trijn Jans Oly, *Levens der maegden* III, s.a. [1625-1651] (ed. Spaans).

**De Oud-Katholiek 1931-I**
S.n., *De Oud-Katholiek* 47, no. 29-30 (1931).

**De Oud-Katholiek 1931-II**
S.n., *De Oud-Katholiek* 47, no. 50 (1931).

**De Oud-Katholiek 1956**
S.n., *De Oud-Katholiek* 72, no. 20 (1956).

**Paradijskerk 1953**
S.n., *Catalogus tentoonstelling herdenking Bernardus Hoogewerff*, s.l. [Rotterdam] (exh.cat. Paradijskerk Rotterdam) 1953.

**Parker 2008**
C.H. Parker, *Faith on the Margins. Catholics and Catholicism in the Dutch Golden Age*, Cambridge (Massachusetts) and London 2008.

**Pastoureau 2001**
Michel Pastoureau, *Blue. The History of a Color*, Princeton 2001.

**Pleij 1994**
Herman Pleij, *Kleuren van de middeleeuwen*, Bloemendaal 1994.

**Pollmann 2011**
Judith Pollmann, *Catholic Indentity and the Revolt of the Netherlands 1520-1635*, Oxford 2011.

**Polman 1957**
Pontianus Polman, 'Cleresie en staatsgezag. Het plakkaat van 17 augustus 1702', *Mededelingen van het Nederlands Historisch Instituut te Rome. Derde reeks* IX (1957) 163-189.

**Post 1934**
Reinier R. Post, 'De reis van apostolisch vicaris Johannes van Neercassel naar Rome. 1670-1671', *Mededeelingen van het Nederlandsch Historisch Instituut te Rome. Tweede reeks* IV (1934) 97-132.

**Posthumus 1920**
N.W. Posthumus, 'Eene kartelovereenkomst in de zeventiende eeuw in den Amsterdamschen zijdehandel', in: *Economisch-Historisch Jaarboek* 6 (1920) 215-222.

**Posthumus 1943**
N.W. Posthumus, *Nederlandsche prijsgeschiedenis. Goederenprijzen op de beurs van Amsterdam 1585-1914. Wisselkoersen te Amsterdam 1609-1914*, Leiden 1943.

**Van Ranouw 1719**
Willem van Ranouw, 'Vijfde verhandeling van het goud, waar in de gouddraadtrekkers ambacht, en het gouddraad-pletters ambacht verhandelt worden', in: *Kabinet der natuurlyke historien, wetenschappen, konsten en handwerken. Geopent met de maanden juli en augustus 1719*, Amsterdam 1719, 152-184.

**Reinders 2017**
Sophie Reinders, *De mug en de kaars. Vriendenboekjes van adellijke vrouwen, 1575-1640*, Nijmegen 2017.

**Robels 1983**
Hella Robels, *Niederländische Zeichnungen im Wallraf-Richartz-Museum Köln*, Keulen (mus.cat. Wallraf-Richartz-Museum) 1983.

**Roethlisberger/Bok 1993**
Marcel G. Roethlisberger, *Abraham Bloemaert and his sons. Paintings and prints*, Doornspijk 1993.

**Rogier 1945...**
Lodewijk J. Rogier, *Geschiedenis van het katholicisme in Noord-Nederland in de 16e en de 17e eeuw*, Amsterdam 1945-1947.

**Van Roon 2010**
Marike van Roon, *Goud, zilver & zijde. Katholiek textiel in Nederland 1830-1965*, Zutphen 2010.

**Van Roon 2023**
Marike van Roon, *Kijk mij! Geborduurde boekbanden 1585-1670*, Gorredijk 2023.

**Rosweyde 1626**
H. Rosweyde, *Het leven der HH. Maegden die van Christus tijden tot deze eeuwe in den saligen staet der suyverheyt in de wereldt geleeft hebben. Met een cort tractaet vanden Maeghdelijken Staet*, Antwerp 1626.

**Rothstein 1964**
Natalie Rothstein, 'Dutch Silks. An important but forgotten industry of the 18th century or a hypothesis?', *Oud Holland. Journal for Art of the Low Countries* 79, no. 1 (1964) 152-171.

**Rothstein 1984**
Natalie Rothstein (ed.), *Four hundred years of Fashion*, London 1984.

**Rothstein 1990**
Natalie Rothstein, *Silk Designs of the Eighteenth Century*, London 1990.

**Rothstein 1994-I**
Natalie Rothstein, *Woven Textile Design in Britain to 1750*, London 1994.

**Rothstein 1994-II**
Natalie Rothstein, *Woven Textile Design in Britain from 1750 to 1850*, London 1994.

**Sardar 2013**
Marika Sardar, 'Silk along the Seas. Ottoman Turkey and Safavid Iran in the Global Textile Trade' in: Amelia Peck (ed.), *Interwoven Globe: The Worldwide Textile Trade 1500-1800*, New York 2013, 66-81.

**Sargentson 1996**
Carolyn Sargentson, *Merchants and Luxury Markets. The Marchands Merciers of Eighteenth-century Paris*, London 1996.

**Schade van Westrum 2010**
Lia Schade van Westrum, *Oud-katholieke kerken. Drie eeuwen verborgen erfgoed van een eigenzinnige geloofsgemeenschap*, Zutphen 2010.

**Schoeser 2007**
Mary Schoeser, *Silk*, New Haven 2007.

**Schoon 2014**
Dick Schoon, 'L'Unigenitus en Hollande. Lle Clergé Épiscopal entre obéissance et indépendance', in: Olivier Andurand and Sylvio Hermann De

Franceschi (ed)., *8 septembre 1713. Le choc de l'Unigenitus*, Paris 2014, 67-80.

Schoon 2018
Dick Schoon, 'Empowering catholics in a Protestant Republic. Life and works of apostolic vicar John van Neercassel (1626-1686)', in: Peter-Ben Smit and Eva van Urk (ed.), *Parrhesia. Ancient and Modern Perspectives on Freedom of Speech*, Leiden and Boston 2018, 83-103.

Schoon 2019
Dick Schoon, *Een aartsbisschop aangeklaagd in Rome. De dagboeken van aartsbisschop Petrus Codde en zijn metgezellen Jacob Krijs en Benedict de Waal over hun reis naar en verblijf in Rome, 1700-1703*, Hilversum 2019.

Seguin 2021
Colleen M. Seguin, 'Catholic Laywomen: Activist Piety, Agency, and Strategic Resistance', in: Robert E. Scully (ed.), *A Companion to Catholicism and Recusancy in Britain and Ireland*, Leiden 2021, 155-177.

Spaans 1997
Joke Spaans, 'De katholieken in de Republiek na de Vrede van Munster', *De zeventiende eeuw* 13 (1997) 253-260.

Spaans 2012
Joke Spaans, *De Levens der Maechden*, Hilversum 2012.

Spiertz 1992
Mathieu G. Spiertz, 'Jansenisme in en rond de Nederlanden, 1640-1690', *Trajecta* 1 (1992) 144-167.

Sporbeck 2001
Gudrun Sporbeck, *Die liturgische Gewänder 11 bis 19 Jahrhundert*, Cologne (mus.cat. Museum Schnütgen) 2001.

Staal 2015
Casper Staal 2015, 'Middeleeuwse gewaden in Museum Catharijneconvent', in: Micha Leeflang and Kees van Schooten (ed.), *Middeleeuwse Borduurkunst uit de Nederlanden*, Zwolle and Utrecht (exh.cat. Museum Catharijneconvent) 2015, 115-121.

Stam 1987
Tuuk Stam, 'Loffbarlycke te onderhouden. Een visie op het conserveren en restaureren van textiel in historisch perspectief', in: Saskia de Bodt (ed.), *Schilderen met gouddraad en zijde*, Utrecht (exh.cat. Museum Catharijneconvent) 1987, 32-50.

Stam 1988
Tuuk Stam, 'Paramenten uit Enkhuizen en Utrecht', *Catharijnebrief* no. 23 (1988) 4-6.

Stam 1999
Tuuk Stam, 'Ons Heer op de ezel', *Catharijnebrief* no. 65 (1999) 12-14.

Stam 2001-I
Tuuk Stam, 'Barokke rijkdom. Kerkgewaden uit de Gouden Eeuw', *Spiegel historiael. Magazine voor geschiedenis en archeologie* 36, no. 6 (2001) 256-261.

Stam 2001-II
Tuuk Stam, 'De handvaardigheid der Haarlemse maagden', *Catharijnebrief* no. 74 (2001) 10-12.

Stoter 2016
Marlies Stoter, 'The lady of the manor. Het aantekenboek van Andriese Lucia van Bronkhorst', in: Henk Oly and Geart de Vries (ed.), *Leeuwarden in de Gouden Eeuw*, Leeuwarden 2016, 53-82.

Theissing 1935
E. Theissing, *Over klopjes en kwezels*, Utrecht 1935.

Thijs 1987
Alfons.K.L. Thijs, *Van "werkwinkel" tot "fabriek". De textielnijverheid te Antwerpen. Einde 15de – begin 19de eeuw*, Brussels 1987.

Veluwenkamp 1981
Jan Willem Veluwenkamp, *Ondernemersgedrag op de Hollandse stapelmarkt in de tijd van de Republiek. De Amsterdamse handelsfirma Jan Isaac de Neufville & Comp. 1730-1764*, Amsterdam 1981.

Veluwenkamp 1993
Jan Willem Veluwenkamp, 'De buitenlandse textielhandel van de Republiek in de achttiende eeuw', *Textielhistorische Bijdragen* 33 (1993) 70-88.

Verheggen 2006
Evelyne Verheggen, *Beelden voor Passie en Hartstocht. Bid- en devotieprenten in de Noordelijke Nederlanden 17de en 18de eeuw*, Zutphen 2006.

Verheggen 2020
Evelyne Verheggen, 'Flowerpower in de Contrareformatie. Bloemen en planten in de katholieke verbeelding van deugdzaamheid', *Jaarboek De Zeventiende Eeuw* (2020) 67-86.

Verheul 1939
J. Verheul, *De Oud-Katholieke Gemeente en haar oude kerkgebouw aan de Lange Torenstraat te Rotterdam. Beknopte geschiedenis der Oud-Kath. Gemeente. Bespreking van haar oudste kerk, alsmede beschouwingen over de gesloopte en de nieuwe Paradijskerk te Rotterdam*, Rotterdam 1939.

Verwer 1572-1581
Willem Janszoon Verwer, *Memoriaelbouck. Dagboek van gebeurtenissen te Haarlem van 1572-1581*, (ed. J.J. Temminck) Haarlem 1973.

Visser 1966
Jan Visser, *Rovenius und seine Werke. Beitrag zur Geschichte der nordniederländischen katholischen Frömmigkeit in der ersten Hälfte des 17. Jahrhunderts*, Assen 1966.

Voets 1953
B. Voets, 'Een leider van het Haarlemse Bisdom uit de vervolgingstijd. Levensschets van Leonardus Marius', *Haarlemse Bijdragen. Bouwstoffen voor de Geschiedenis van het Bisdom Haarlem* 62 (1953) 225-305.

Vredenberg 1983
J.P. Vredenberg, *"Als off sij onse eigene kijnder weren". Het Burgerweeshuis te Arnhem 1583-1742*, Arnhem 1983.

De Vries / Van der Woude 1995
Jan de Vries and Ad van der Woude, *Nederland 1500-1850. De eerste ronde van moderne economische groei*, Amsterdam 1995.

Whitfield 2019
Susan Whitfield, 'Silkworms and mulberry trees: Silk Road settlers', in Susan Whitfield (ed.), *Silk Roads. Peoples, Cultures, Landscapes*, London 2019, 310-315.

Wilson 1987
Verity Wilson, 'Chinese painted silks for export', Orientations 18, no. 10 (1987) 30-35.

Yasuhira 2019
Genji Yasuhira, *Civic Agency in the Public Sphere. Catholics' Survival Tactics in Utrecht, 1620-s-1670s*, Utrecht 2019.

Yasuhira 2022
Genji Yasuhira, 'Transforming the Urban Space. Catholic Survival Through Spatial Practices in Post-reformation Utrecht', *Past & Present* 255, no.1 (2022) 39-86.

# Photo credits

## Essays

Amersfoort NL, Old Catholic church St. George / Ruben de Heer: fig. 3
Amsterdam NL, Amsterdam Museum: fig. 17, 18
Amsterdam NL, Municipal Archives, Collection Koninklijk Oudheidkundig Genootschap: fig. 1
Antwerp BE, Museum Mayer van den Bergh: fig. 22
Antwerp BE, Roman Catholic church St. Catherine / Katrien Van Acker, KIK: fig. 15
Brussels BE, Royal Museums of Art and History: fig. 29
Delft NL, Old Catholic church St. Mary and St. Ursula: fig. 14
Dordrecht NL, Old Catholic Church St. Mary Major: fig. 16
Haarlem NL, Old Catholic church St. Anne and St. Mary / Ruben de Heer: fig. 7, 31
The Hague NL, Old Catholic church St. James and St. Augustine / Ruben de Heer: fig. 24
Krommenie NL, Old Catholic church St. Nicholas and St. Mary Magdalene: fig. 13
Krommenie NL, Old Catholic church St. Nicholas and St. Mary Magdalene / Ruben de Heer: fig. 8, 30
Leiden NL, Museum De Lakenhal: fig. 36
London UK, Victoria and Albert Museum: fig. 28, 35, 37
Los Angeles USA, The J. Paul Getty Museum: fig. 21
Paris FR, Musée du Louvre / Franck Raux: fig. 20 (left)
Paris FR, Musée du Louvre / Tony Querrec: fig. 20 (right)
Utrecht NL, Municipal and Provincial Archives: fig. 26, 32
Utrecht NL, Museum Catharijneconvent / Chris Booms: fig. 2
Utrecht NL, Museum Catharijneconvent / Ruben de Heer: Fig. 4, 5, 6, 9, 10, 11, 12
Utrecht NL, Old Catholic cathedral St. Gertrude / Ruben de Heer: fig. 27
Utrecht NL, Old Catholic cathedral St. Gertrude / R. Lugtigheid: fig. 25, 33
Vienna AT, Kunsthistorisches Museum Vienna: fig. 34
Washington DC USA, National Gallery of Art: fig. 19

Garry Dijkema: fig. 23

## Catalogue

Alkmaar NL, Old Catholic church St. Laurence / Ruben de Heer: cat. 40
Amersfoort NL, Old Catholic church St. George: cat. 10, 28
Amsterdam NL, Collection Six: fig. 21
Amsterdam NL, Old Catholic church St. Peter and St. Paul / Ruben de Heer: cat. 17-A
Amsterdam NL, Rijksmuseum: fig. 2, 12, 13, 15, 24, 28, 31, 34, 47; cat. 6, 8-C, 20-B, 25
Apeldoorn NL, Het Loo Palace: fig. 46
Brussels BE, Royal Museums of Art and History: cat. 37
Delft NL, Old Catholic church St. Mary and St. Ursula: fig. 26
Delft NL, Old Catholic church St. Mary and St. Ursula / Ruben de Heer: cat. 19-A
Enkhuizen NL, Roman Catholic church St. Francis Xavier / Ruben de Heer: cat. 20-A
Gouda NL, Museum Gouda: fig. 1; cat. 1-A, 1-B, 1-C, 21-A, 21-C
Gouda NL, Old Catholic church St. John the Baptist / Ruben de Heer: fig. 3; cat. 1-D, 20-C, 21-B
Haarlem NL, Noord-Holland Provincial Archives, Collection Voorhelm Schneevoogt: fig. 14
Haarlem NL, Old Catholic church St. Anne and St. Mary / Ruben de Heer: cat. 42, 47
The Hague NL, KB national library: fig. 25; cat. 14, 15
The Hague NL, Kunstmuseum Den Haag: fig. 48, 49; cat. 13-A, 34, 35
The Hague NL, Mauritshuis: fig. 18, 20; cat. 12-A, 12-B
The Hague NL, Old Catholic church St. James and St. Augustine / Ruben de Heer: cat. 33-A, 36
IJmuiden NL, Old Catholic church St. Engelmund and St. Adalbert: fig. 50
Krommenie NL, Old Catholic church St. Nicholas and St. Mary Magdalene / Ruben de Heer: cat. 38
London UK, Philip Mould & Company Fine Paintings / Bridgeman Images: cat. 9
London UK, Victoria and Albert Museum: cat. 30, 31-A, 31-B
Los Angeles USA, The J. Paul Getty Museum: fig. 19, 23
Munich DE, Bayerisches Nationalmuseum: fig. 22
Oudewater NL, Oudewater, Old Catholic church St. Michael and St. John the Baptist / Ruben de Heer: fig. 4; cat. 2-B, 2-C, 2-D

Paris FR, Musée du Louvre: fig. 8
Rotterdam NL, Museum Rotterdam: fig. 35
Rotterdam NL, Old Catholic church St. Peter and St. Paul: cat. 41
Rotterdam NL, Old Catholic church St. Peter and St. Paul / Richard de Beer: cat. 18-B, 18-C, 43; fig. 29
Utrecht NL, Municipal and Provincial Archives: fig. 44
Utrecht NL, Metropolitan Chapter of the Old Catholic Church in the Netherlands: cat. 4-A, 4-B
Utrecht NL, Museum Catharijneconvent: fig. 6, 7, 16, 17, 27, 32, 33, 37; cat. 8-B, 16-C, 22-H
Utrecht NL, Museum Catharijneconvent / Ruben de Heer: Cat. 2-A, 3, 5-A, 5-B, 5-C, 7, 8-A, 9-A, 9-B, 9-C, 10-A, 10-B, 11-A, 11-B, 11-C, 11-D, 11-E, 11-F, 16-A, 16-B, 17-B, 18-A, 19-B, 22-A, 22-B, 22-C, 22-D, 22-E, 22-F, 22-G, 23-A, 23-B, 23-C, 23-D, 24, 26-G, 32, 33-B, 39-A, 39-B, 39-C, 39-D, 39-E, 39-F, 45, 46, 47, 48-A, 48-B
Utrecht NL, Old Catholic cathedral St. Gertrude: fig. 45
Utrecht NL, Old Catholic cathedral St. Gertrude / Ruben de Heer: cat. 4-C, 27-A, 27-B, 29, 44
Utrecht NL, Old Catholic parish In de Driehoek / Ruben de Heer: cat. 26-A, 26-B, 26-C, 26-D, 26-E, 26-F

# Credits

This catalogue accompanies the exhibition *Fashion for God* at Museum Catharijneconvent, Utrecht, 13 October 2023 — 21 January 2024

**Publishers**
Waanders Publishers, Zwolle
Museum Catharijneconvent, Utrecht

**Editors**
Pim Arts, Richard de Beer

**Authors**
Pim Arts (PA) — curator, Museum Catharijneconvent, Utrecht
Richard de Beer (RdB) — curator of Old Catholic heritage, Museum Catharijneconvent, Utrecht
Ria Cooreman (RC) — curator of costume and lace, Royal Museums of Art and History, Brussels
Madelief Hohé (MH) — curator of fashion and costume, Kunstmuseum Den Haag
René Lugtigheid (RL) — textile conservator
Susan North (SN) — curator of fashion 1550-1800, Victoria and Albert Museum, London
Marike van Roon (MvR) — independent art historian
Dirk-Jan Schoon — Bishop of Haarlem, Old Catholic Church in the Netherlands

**Text editor**
Leef in tekst, Lilian Eefting

**Image editing**
Willem Driebergen

**Translations**
Sue McDonnell (Dutch - English)
Acolad (English - Dutch)

**Design**
Michaël Snitker, Amsterdam

**Font**
GT Alpina (Grilli Type)

**Photography**
Ruben de Heer

**Lithography**
Benno Slijkhuis, Wilco Art Books

**Printing**
Wilco Art Books, Amersfoort

© 2023 Waanders Uitgevers b.v., Zwolle; Museum Catharijneconvent, Utrecht; the authors

224

All rights reserved. No part of the content of the book may be reproduced or transmitted in any form or by any means, electronic or mechanical, including photography, recording or any other information storage and retrieval system, without the prior written permission of the publisher.

The publisher has made every effort to acknowledge the copyright of works illustrated in this book. Should any person, despite this, feel that an omission has been made, they are requested to inform the publisher of this fact.

ISBN 978 94 6262 508 2 | NUR 644

This publication has also been published in a Dutch edition ISBN 978 94 6262 507 5

www.waanders.nl
www.catharijneconvent.nl

Lenders tot the exhibition
Alkmaar, Old Catholic church St. Laurence
Amersfoort, Old Catholic church St. George
Amersfoort, Metropolitan Chapter of the Old Catholic Church in the Netherlands
Amsterdam, Old Catholic church St. Peter and St. Paul
Amsterdam, Rijksmuseum
Brussels, Royal Museums of Art and History
Delft, Old Catholic church St. Mary and St. Ursula
Enkhuizen, Roman Catholic church St. Francis Xavier
Gouda, Old Catholic church St. John the Baptist
Gouda, Museum Gouda
Haarlem, Old Catholic church St. Anne and St. Mary
The Hague, Old Catholic church St. James and St. Augustine
The Hague, KB national library
The Hague, Kunstmuseum Den Haag
The Hague, Mauritshuis
Krommenie, Old Catholic church St. Nicholas and St. Mary Magdalene
London, Victoria and Albert Museum
Oudewater, Old Catholic church St. Michael and St. John the Baptist
Rotterdam, Old Catholic church St. Peter and St. Paul
Utrecht, Old Catholic cathedral St. Gertrude

Fashion for God

With thanks to
Gertjan Arentsen, Valentijn As, Dieuwke Becker, Rianne van de Beek, Michael van den Bergh, Tommy van Berkel, Christa Bijkerk, Sieske Binnendijk, Tessa de Boer, Rosemarie Boone, Marijke de Bruijne, Nina Buitenhuis, Quentin Buvelot, Ria Cooreman, Allan Cramer, Marco Derks, Sara van Dijk, Annabel Dijkema, Steef Eman, Ton Endhoven, Mark van Es, Josephina de Fouw, Robert Frede, Erik Geleijns, Elizabeth-Anne Haldane, Ruben de Heer, Carla Hesling, Madelief Hohé, Carola Holz, Marjolein Homan Free, Wim Houben, Eveline Jansen, Maartje de Jong, Kirsten van Kempen, Dennis Kemper, Stefanie Klerks, Lottie Kok, Amy Kooij, Maranthe Lamers, Friso Lammertse, Micha Leeflang, Huigen Leeflang, Puk Leering, Klaas Lenten, Martina Liebler, René Lugtigheid, Michael Maas, Suzan Meijer, Helen van der Meulen, Froukje van der Meulen, Bianca du Mortier, Susan North, Arno van Os, Simon Out, Koenraad Ouwens, Nina Ouwens, Frans Pegt, Erna Peijnenburg, Helen Persson Swain, Maurits Pico, Peter Piets, Liesbeth van Ravels, Ingmar Reesing, Bruce Rienstra, Johannes van Riessen, Marike van Roon, Louis Runhaar, Rudolf Scheltinga, Dirk-Jan Schoon, Henk Schoon, Peter-Ben Smit, Jelle Smit-Kartiko, Jan van der Steen, Rob Tigelaar, Rens Top, Marianne van der Veer, Wietse van der Velde, Frank van der Velden, Saskia van Velzen, Evelyne Verheggen, Emile Verhey, Marloes Waanders, Bernd Wallet, Marieke Wickham, Rosa van der Wielen, Leen Wijker, Lieke Wijnia en Mieke de Winter.

This publication is made possible with the support of Stichting Sormani Fonds, Nederlandse Kostuumvereniging, J.E. Jurriaanse Stichting and Fonds Museum Catharijneconvent.